16th-Century Italian

ORNAMENT
PRINTS

in the Victoria and Albert Museum

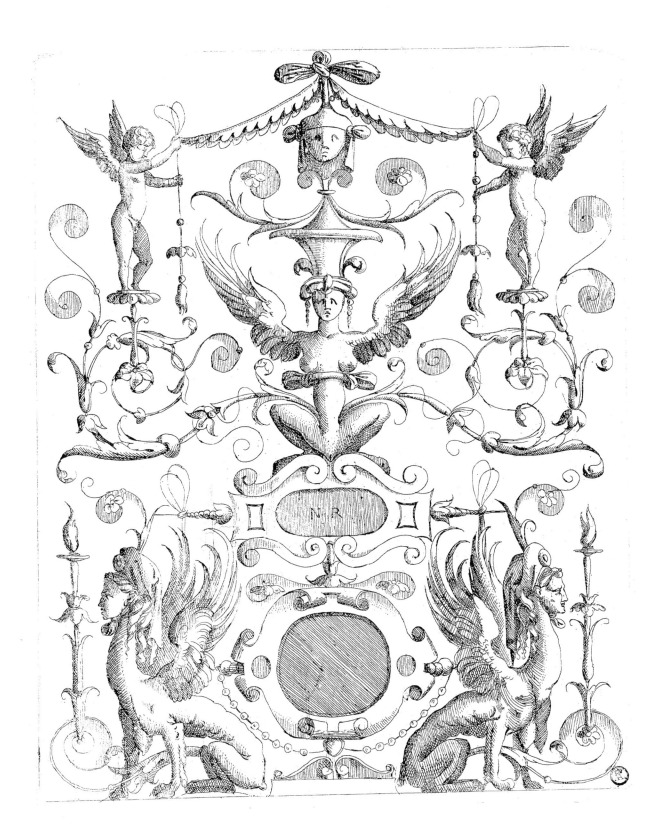

16th-Century Italian

ORNAMENT PRINTS

in the Victoria and Albert Museum

Elizabeth Miller

V&A Publications

To my mother and father

First published by V&A Publications, 1999
V&A Publications
160 Brompton Road
London SW3 1HW

ISBN: 1 85177 263 4

A catalogue record for this book is available from the British Library

Designed by Clive Dorman

Printed in Italy by Grafiche Milani

Jacket illustrations:
Front: Cat. 68b pl. XIII
Back: Cat. 9b pl. IIII upper

Frontispiece: Cat. 25 pl. 1

CONTENTS

ACKNOWLEDGEMENTS AND HISTORY OF THE PROJECT

The hard work and generous assistance of many people have helped bring this catalogue to its final form and I should like to offer them all my warmest thanks.

The idea of publishing a catalogue of all the ornament prints in the Museum was first mooted by my former colleague Harold Barkley in 1977, who took the first steps in identifying the material to be covered and commencing the cataloguing. The project received enthusiastic support from the then Keeper of the Prints, Drawings and Paintings Department, Michael Kauffmann, and his successors, John Murdoch and the present Chief Curator, Susan Lambert (who, in the final stages, has used her personal expertise on prints to advise on ways of improving the clarity of certain parts of the text).

Following the move of the department to the Henry Cole Wing in 1983, the work was taken up in 1985 by my colleagues Michael Snodin and Stephen Calloway, and together they oversaw a group of dedicated postgraduate students, who continued the tasks of sifting, sorting and producing draft catalogue entries of the sixteenth-century ornament prints. In the case of the Italian prints, the group was made up of Martin Kauffmann, Amelia Singleton, Laura Suffield and Catherine Wilson. During this period Laura Suffield and Catherine Wilson acted in the capacity of sub-editors. Catherine Wilson subsequently showed extraordinary commitment to the project over an extended period.

Progress to date was reviewed during a secondment to the Museum's Research Department in 1996. It quickly became clear that the collection of Italian ornament prints was such a rich resource for new discoveries that it merited a treatment on its own. Without this opportunity for uninterrupted study, the rediscovery and reassembling of the Lafrery Volume, which has had a transforming effect on the contents of this catalogue, would not have taken place. All the draft catalogue entries have been checked and corrected, a number have undergone substantial structural changes, and in virtually every case new notes have been written. New decisions about inclusion and exclusion, and the arrangement of the categories, were also made at this stage.

The long gap between the initial idea of publishing catalogues of the ornament print collection and the first one to appear is due chiefly to the pressures of other departmental and Museum priorities, but can also be partly accounted for by the extremely complex nature of the work involved. It has drawn heavily on the resources of all those inside and outside the Museum who have been involved with it over a long period. Such a challenging project is also very rewarding.

Since 1996 two people have made a decisive contribution. The first is Malcom Baker of the V&A's Research Department, whose unflagging commitment and support, as well as sound advice on many matters, have been invaluable. The second is the print scholar Peter Fuhring, whose unparalleled knowledge of ornament prints and keen interest in this project have been an inspiration. At every stage his suggestions have acted as a great stimulus. Every user of this catalogue owes him an enormous debt. I hope he will forgive those instances where I have deviated from what would have been his preferred option.

Contact with other print scholars – namely Suzanne Boorsch, Michael Bury, Antony Griffiths, David Landau and Peter Parshall – has also been one of the most fascinating and enjoyable parts of the process. I am very grateful to them for their interest, generosity and thought-provoking responses during our discussions.

Stuart Pyhrr and Mark Evans have been of great assistance in the preparation of the entries for Catalogue 57 and 20 respectively. Antonia Boström read the introduction at a crucial moment and Robert Wenley responded with alacrity on a point of detail.

The staffs of the Rijksprentenkabinet, Amsterdam, the Studiensaal of the Berlin Kunstbibliothek, the Kupferstichkabinett, Berlin, and the British Museum Print Room coped cheerfully and efficiently with large-scale requests to consult their holdings.

Within the Prints, Drawings and Paintings Department, past and present colleagues Catherine Bindman, Shaun Cole, Lucy Davenport, Sharon Fermor, Carolyn Kornbluth, Charles Newton and Frances Rankine all made significant contributions. Gill Saunders' good sense, and clear-headedness on all aspects of cataloguing, has been of very great help in grappling with the particular problems thrown up by ornament prints. The complicated task of arranging the photography of the prints was carried out by Rebecca Simpson and Alexandra Corney with great good humour. The latter also prepared the appendix of acquisition histories and brought a fresh eye to a number of presentational issues.

Since 1996 a number of students attached to the department have made a valuable contribution to often the most humdrum but vital parts of the work. They are Joanna Desmond, Simona Heuberger, Iris Hofer, Eszter Karpati, Karin Kolb and Harriet Parry-Williams. Roberta Franceschetti did detailed work relating to Catalogue 39 and to the Lafrery Volume, during a period in the department as part of her studies on the V&A/RCA History of Design MA Course, Renaissance Decorative Arts and Culture specialism. Kathrin Beer was of great help during a visit to Berlin.

Many colleagues in other parts of the Museum have given important help or advice. They are Marta Ajmar, Chiara Barontini, Anthony Burton, Carlo Dumontet, David Ford, Nicholas Frayling, Paul Greenhalgh, Frances Hyman, Ken Jackson, David Jillings, Reino Liefkes, Elizabeth McMurray, John Meriton, Anthony North, David Pearson, Boris Pretzel, Paul Robins, Helen Shenton, Pippa Shirley, Eric Simpson, Paul Springate, James Stevenson, John Styles, Jan Van der Wateren, Pauline Webber, Eva White and Hilary Young. The majority of the photographs were taken by Dominic Naish and Sara Hodges. The staffs of the National Art Library and V&A Picture Library exhibited their usual high standard of professionalism throughout.

Victoria Button of the Museum's Conservation Department shared the time-consuming job of survey-ing the watermarks and made what can at times be a very frustrating task very enjoyable. She made a crucial contribution in finding imaginative solutions to the problems encountered in work of this kind. Thanks are due to Sheridan Bowman, Keeper of the Department of Scientific Research at the British Museum, for agreeing to radiography being carried out on twenty-five of the watermarks. These radiographs were very kindly taken by Janet Lang of the British Museum, who also expanded our horizons by discussing the issues surrounding the recording of watermarks with us. Craig Hartley's advice was also very helpful in this area.

Nicholas Stogdon informed us that it was possible to produce an image of a watermark by scanning the print on a computer. A pilot-project was established and the work of scanning the watermarks and manipulating the images was carried out by Danny Norman of the V&A's Conservation Department.

Charles Clunas read a late draft of the entire manuscript and made many useful suggestions.

The editor Mandy Greenfield, designer Clive Dorman, and my colleagues Clare Davis and above all Miranda Harrison at V&A Publications have all risen to the challenge of an ornament print catalogue with great energy and enthusiasm.

Finally, I should like to thank Tim Miller for his advice and insights on many matters, for drawing many bibliographical references to my attention, but above all for his unwavering support and encour-agement throughout.

Elizabeth Miller

INTRODUCTION

The ornament prints in the Prints, Drawings and Paintings Department of the Victoria and Albert Museum number some 35,000 examples, dating from the fifteenth to the nineteenth century, and constitute one of the leading collections worldwide. This catalogue is the first of a series, and forms part of a much larger project to publish catalogues covering all the ornament prints in the collection.

Relatively recently, detailed work on this catalogue resulted in the startling discovery that 133 sixteenth-century Italian ornament prints in the V&A collection once formed part of a single bound volume, associated with the Roman print-publisher Antonio Lafrery (1512–77).[1] The presence of this extraordinary volume, henceforth referred to as the Lafrery Volume, gives this catalogue a significance far beyond that of the description of individual ornament prints, since nowhere in the literature on prints has such a volume ever been described. More importantly in the present context, it brings into sharper focus some key questions about the legitimacy of the ornament print as a distinctive category. The Lafrery Volume forms part of the evidence that the subject 'ornament' had a secure place in print-publishing and collecting in the sixteenth century. It adds an Italian dimension to what is already known from northern European sources about attitudes to ornament prints in the sixteenth century. Since the Lafrery Volume represents the output of a single publisher, it tells us about the marketing of ornament prints and provides a different insight, at an earlier stage in the process of production and consumption, from that which can be gleaned from looking at collecting practices.

In the sixteenth century a subject-based approach to print collecting co-existed, sometimes even within a single collection, with the alternative arrangement based on the name of the designer or maker of a print.[2] A subject-based approach to print collecting lives on in the very idea of a catalogue of ornament prints.

THE LAFRERY VOLUME

A distinction needs to be drawn between a volume of prints and an album of prints. Broadly speaking, a volume of prints is created by binding together impressions printed on paper of a uniform size, while an album of prints is created by pasting prints of differing sizes onto the pages of a blank book.[3]

Antonio Lafrery has been described as 'one of the most influential print-publishers of the sixteenth century', whose 'bottega in Via del Parione was the centre of the Roman print world from c. 1544 to 1577.'[4] As well as serving a local customer base in Rome, he traded books and prints with other commercial centres such as Venice and Paris.[5] Around 1573 he produced the first ever print-publisher's stocklist, known in a unique example surviving in the Biblioteca Marucelliana in Florence.[6] It lists almost 500 single-sheet prints and then, at the end, nineteen items that are either books or sets of prints. The stocklist has an introduction signed by Lafrery. Sandwiched between opening and closing remarks, aimed at flattering his customers, is an explanation of how the catalogue is organized:

> In order to give it a structure, I have divided it into five parts. In the first one there are all the descriptions of Geography tables or of particular places, such as noble cities or fortresses, and some drawings of actions and battles of our times. In the second I have collected a great number of things touching on the Antiquity of Rome, buildings and constructions as well as statues and other things, adding to it some models and modern drawings of excellent artists. In the third I have included a number of poetic or fantastic inventions of different and ingenious sculptors and painters. In the fourth I have included many stories and images from the New and the Old Testament. In the fifth there are many portraits and medals of identified people, isolated or collected in groups, and some books of architecture of modern authors and of ornaments belonging to it, and of perspectives and other such small things. And for the advantage of the reader we have added to those about which we knew, the name of the maker.[7]

Within the stocklist itself, the fifth section consists of a few single-sheet portraits and the list of the nineteen items that are either books or sets of prints. This list is given below in its entirety, followed by a translation of each entry, which is numbered for ease of reference:

Libri et Stampe di Rame
[Books and copper prints]

Effigie di uintiotto Pontefici, creati dopoi che tornò la Sedia Apostolica d'Auignone a Roma, con le loro uite descritte dal Reuerendo Onofrio Panuino, insino a Gregorio decimotertio.

[1] [Image(s) of twenty-eight popes, elected after the Apostolic seat came back from Avignon to Rome, with their lives described by the Reverend Onofrio Panvino, up to Gregorio XIII.]

Effigie di uintiquattro primi Imperatori, ritratti parte dalle medaglie et parte da marmi.
[2] [Image(s) of the first twenty-four emperors, depicted part after the medals, part after marble sculptures.]

Libro de Termini et Filosofi, cauati da marmi antichi, con la prefatione di messer Achille Tatio.
[3] [Book of herms and philosophers, depicted after antique marbles, with the foreword by Achille Tatio.]

Libro di huomini Illustri, cauati da uestigij antichi et annotati dal Illustr. Signor Fuluio Vrsino con somma diligentia.
[4] Book of famous men, depicted after antique remains and recorded with extreme care by Fulvio Ursino.

Libro di diuersi Iure consulti cauati del studio del signor Marco Mantou[a], clarissimo Iureconsulto Padouano.
[5] Book of various men of law, taken from the study of Marco Mantova, the famous Paduan lawyer.

Libro de gli habiti delle Done Romane.
[6] Book of costume of Roman women.

Libro delle medaglie delle Donne Auguste di Enea Vico.
[7] Book of medals with Augustan women by Enea Vico.

Libro d'Archittetura d'Antonio Labacco.
[8] Book of architecture by Antonio Labacco.

Libro d'architetura di Giacomo Vignola.
[9] Book of architecture by Giacomo Vignola.

Libri di Cornice Capitelli et Basi cauato dalle uestige de gli Antichi, quale giornalmente si trouano in Roma.
[10] Books of cornices, capitals and bases, after the antique ruins that you can discover daily in Rome.

Libro di diuersi compartimenti.
[11] Book of various frames.

Libro de Trofei cauati da dissegni di Polidoro, ad imitatione de gli Antichi.
[12] Book of trophies, after drawings by Polidoro imitating antique examples.

Libro de Maschere.
[13] Book of masks.

Libro de Grottesche.
[14] Book of grotesques.

Libro de Templetti et ruine di Roma.
[15] Book of small temples and ruins of Rome.

Libro di prospettiue.
[16] Book of perspectives.

Libro de fresi et fogliami.
[17] Book of friezes and foliage.

Libro de uasi et candelieri.
[18] Book of vases and candlesticks.

Diuerse figure d'Anatomia.
[19] Various images of anatomy.

Comparing this list with Lafrery's brief summary of the contents of the fifth section of his stocklist, items 1–7 relate to portraits and medals of identified people, items 8 and 9 are books of architecture by modern authors, item 16 is the book of perspectives. This leaves items 10–15 and 17–19 to match the phrases 'ornaments belonging to it [architecture]' and the 'other such small things' mentioned with perspectives. When the list is examined, items 10, 11, 12, 13, 14, 17, the cornices, capitals and bases, frames, trophies, masks, grotesques, friezes and foliage, and the vases that form part of item 18, all fit the description 'ornaments belonging to architecture'. This leaves item 15, the small temples and ruins of Rome, and item 19, the anatomical images, corresponding to 'other such small things'. Amongst the ornaments belonging to architecture, the candlesticks are certainly an anomaly.

It was discovered in 1996 that in 1873 the National Art Library, part of the Victoria and Albert Museum since its inception and one of the begetters of the present-day Prints, Drawings and Paintings Department, had acquired a vellum-bound volume containing all the items on Lafrery's list that fit his own description of 'some books of architecture of modern authors and of ornaments belonging to it' (items 8, 9, 10, 11, 12, 13, 14, 17 and 18).[8]

Institutional changes since 1873 mean that the contents of this volume are now divided between the two departments of the Museum and the binding is lost. The architectural books (items 8 and 9 above), which are in fact *Libro D'Antonio Labacco Appartenente A L'Architettura Nel Qval Si Figvrano Alcvne Notabili Antiqvita Di Roma*, 1552[9] and Giacomo Barozzi da Vignola, *Regola Delli Cinqve*

Ordini D'Architettura, 1563,[10] are in the National Art Library (NAL), and are now bound individually. The copy of Vignola's architectural treatise (item 9 on Lafrery's list), which was once bound together with these sets of prints, carries an unidentified collector's mark.[11] The original vellum-bound volume must have had a series of owners before it came into the possession of the Museum. The question remains as to whether it was bound by someone who purchased the books and sets of prints loose, or whether it was put together and bound by Lafrery before it went on sale. The emergence of other Lafrery Volumes from other collections in the future may answer this question.

The sets of prints (items 10, 11, 12, 13, 14, 17 and 18) are in the Prints, Drawings and Paintings Department. While the breaking up of this volume, which probably took place when the prints were individually accessioned in 1899, now seems an indefensibly cavalier act on the part of a museum, it can be partially explained in more than merely institutional terms. It is one example of a transformation that has taken place since the nineteenth century, which has seen print collections move from existing within libraries towards being free-standing entities, and which has seen the norm for the storage of prints change from the bound volume or album into the Solander box containing prints in mounts.[12]

That the very existence of the Lafrery Volume in the collection should have passed unnoticed for so long may seem astonishing, but is very easy to explain. Before the final stages of work on this catalogue began, the sets of prints in the Lafrery Volume were housed in four separate boxes, and in various folders inside those boxes. They had been assigned to boxes on the basis of the names of engravers who were known to, or were thought to, have executed them. It was only when all the prints earmarked for this catalogue were mustered in one place that it became evident that a large number of them shared many physical similarities. This group of similar sheets and a certain number of bifolia (single sheets of paper folded in half vertically down the centre to make two leaves) had all been accessioned in 1899, although the handwritten *Register of Engravings 1896–1901* preserved in the Prints, Drawings and Paintings Department revealed that these prints had only been 'Transferred from Books' to the engravings collection in that year and that they had actually been acquired from an E. Parsons on 19 March 1873.[13] When this group of similar sheets and bifolia were put together in the order of accessioning, this produced a volume, lacking a binding, made up of eighty-six folios,

each measuring 38.8 cm high by 27.4 cm wide, together with four prints trimmed to the edge of the image.[14] Each folio bears the impression of between one and four copper plates. There are large margins around all but the four trimmed impressions. One folio, bearing the last print in the set of frames, has a completely blank lower half.[15] Rows of stitching holes and scraps of sewing thread are all that is left of the binding.

The case for identifying the sets of prints in this reassembled volume with the items on the Lafrery stocklist can be made on a number of grounds. The subject of each of the sets of prints in the volume can be matched to an item on Lafrery's stocklist. Two of the sets of prints in the volume are lettered with Lafrery's name. His name appears on nine out of the sixteen plates in the set of trophies, and on the first plate of the set, which fits the description 'friezes and foliage'. Once these two sets have been securely connected to Lafrery's stocklist by means of this lettering, evidence derived from an examination of the paper used throughout the volume links all the other prints, with the sole exception of the candlesticks, to Lafrery.

The set of friezes and foliage, lettered on the first plate with Lafrery's name, is printed on a paper with a very distinctive watermark of tulips in a shield under a six-pointed star.[16] The same paper, bearing this same watermark or a pair to it of the same design,[17] is found in the paper used to print the set of cornices, capitals and bases, the frames, the masks and the grotesques.[18] The first plate of the friezes and foliage in the volume is dated 1570 in the plate, while one of the plates in the cornices, capitals and bases is dated 1535 in the plate. This use of the same paper to print copper plates of widely differing dates indicates the printing of a mixed collection of copper plates on a single stock of paper. The trophies, lettered with Lafrery's name, are printed on a paper with an entirely different watermark – that of a man's head seen in profile.[19] This same watermark is found on the paper used to print the vases. Further confirmation that the set of vases was published by Lafrery is provided by an offset, 'a reversed (i.e. wrong-reading), unintentionally transferred image on the *verso* of a sheet'.[20] The set of vases is made up of seven bifolia, each folded in half vertically to make fourteen folios, each bearing the impression of a single copper plate. On the back of one of these bifolia[21] is an offset of the second state of an anonymous copy of a print by Nicolas Beatrizet, after Michelangelo, of *Christ and the Samaritan Woman at the Well.*[22] This offset is lettered with Antonio Lafrery's name

and can be matched to the entry in his stocklist in the section on Old and New Testament subjects as *Samaritana di Mich. Ang.*[23] Since the bifolium with the offset on the back occurs in the middle of the set of vases there can be no doubt that the offsetting took place during the drying stage of the printing process – that is, before the bifolia making up the set of vases were folded and made up into a set. This clear-cut evidence is in line with the conclusion drawn by Woodward from a study of offsetting in Italian maps that 'it is reasonable to suppose that the offset and the image on the *recto* can be associated with the same print shop'.[24]

This leaves only the candlesticks, which cannot be linked to Lafrery using watermark evidence, since they are printed on a third paper with a watermark of an anchor in a circle.[25] While the vases and the candlesticks make up a single set on Lafrery's stocklist, the fact that they are printed on two different papers is curious. It is argued in Catalogue 62 that not only were the vases and candlesticks not printed at the same time, but that Lafrery did not own the plates for the candlesticks. This in turn leads to a possible explanation as to why the candlesticks are linked with the vases.[26]

This is the first time that it has been possible to match the very brief entries at the end of Lafrery's stocklist with surviving sixteenth-century prints. Conversely, this is the first time it has become clear that certain sets of sixteenth-century Italian prints were published by Antonio Lafrery. This volume provides a significant new body of knowledge on later sixteenth-century Italian prints. The set of cornices, capitals and bases (Catalogue 55a) has not been discussed as a set before, chiefly because it is the work of more than one engraver. The two components of the set of friezes and foliage (Catalogue 9b) are described in Bartsch in two separate places, and Bartsch also includes within his listing of the friezes a plate that is not part of the set.[27] The vases (Catalogue 68b) are listed in Bartsch in the wrong order, in comparison with how they appear in the Lafrery Volume, where the plates are numbered.[28]

The sets of prints in the Lafrery Volume can be recognized by the fact that they have museum numbers falling in the sequence E.1982–2114-1899. Items 10, 11, 12, 13, 14 and 17 on Lafrery's stocklist are listed in this catalogue under Catalogue 55a, 5, 50f, 39, 33d and 9b. The two separate parts of item 18 on Lafrery's stocklist, the vases and the candlesticks, are described under Catalogue 68b and 62b respectively.

SIXTEENTH-CENTURY COLLECTING PRACTICES IN RELATION TO ORNAMENT

No sixteenth-century Italian print collection has come down to us intact, so it is necessary to look to other sources for evidence of sixteenth-century collecting practices relating to ornament prints.[29]

The print collection of Ferdinand, Archduke of Tyrol

The print collection of Ferdinand, Archduke of Tyrol (d. 1596) has been the subject of an important article by Peter Parshall[30] and formed part of a further discussion of issues surrounding the early history of print collecting in northern Europe by the same author.[31] Parshall writes that Ferdinand's collection 'exemplifies a late Renaissance collector's wish to surround himself with all manner of images, artifacts and natural curiosities which might serve as a microcosm of the known world. Surely Ferdinand's collection reflects a major orientation among aristocratic patrons of his age…'[32] Ferdinand's reputation as a collector rests on his being the founder of 'the first major art and curiosity cabinet in Northern Europe, a collection of natural and artificial wonders that dazzled his contemporaries… The print albums were originally placed in the library alongside books on many different subjects, and it is important that the library itself was a part of the cabinet.'[33] Of Ferdinand's print collection, thirty-four albums of prints survive, including three devoted to a single print-maker, Albrecht Dürer.[34] Four of the thirty-four albums are of particular interest in relation to the study of ornament prints. One entitled *Grodesche et Arabesche* (Grotesque and arabesque):

> is comprised almost entirely of decorative designs – grotesques and arabesque ornaments presumably published as models for the ornamentation of architecture, furniture, metalwork, and so forth….the album presents a set of architectural medallions (E. Vico), cartouches with and without inscriptions (B. Battini, J. Ducerceau, H. Liefrinck, J. Vredeman de Vries), various strapwork designs, panels of architectural grotesques, and fantastic cars (C. Bos, C. Floris), repetitions of these motifs, and a set of trophies (A. Lafreri)…overall the album was organized by published series of designs placed together according to their appropriate formal categories (cartouches, strapwork designs, etc.)…the predominance of prints comes

from the publishing house of H. Cock (Bos, Floris, V. de Vries). French and Italian editions are also common, particularly the prints of Ducerceau and Vico.[35]

It is immediately clear that there is a considerable overlap of subject matter between the sets of ornament prints in the Lafrery Volume and the prints in this album of Ferdinand's collection, and there is a set of trophies common to both (this corresponds to Catalogue 50f). The Lafrery Volume represents the ornament print portion of a single print-publisher's stock, whereas the album *Grodesche et Arabesche* in Archduke Ferdinand's collection is the bringing together of ornament prints issued by a variety of European print-publishers. The Ferdinand album is dominated by prints whose subjects are two-dimensional in character, but just as the Lafrery Volume combines prints of this type with others that are of three-dimensional objects, such as vases and candlesticks, so the same juxtaposition is to be found in another of Archduke Ferdinand's albums. A new element is introduced in that in Archduke Ferdinand's collection this combination of what might be called 'pure ornament' and 'applied ornament' is seen as goldsmith's work in a volume entitled *Allerlaj Goltschmid Sachen* (All kinds of goldsmiths' work), which:

> opens with frieze figure compositions and animal designs of various types (biblical, mythological and satirical), hunt scenes, then strip designs of purely ornamental sort (moresques, strapwork, grotesques, medallions). These are followed by designs for jewelry and vessels... Following are various irregularly shaped panels of designs, more moresques, friezes, designs for belt buckles, swords, daggers and sheaths, then finally door handles. Prints appear by H. Aldegrever, H.S. Beham, C. Bos, A. Ducerceau, E. Horninck, V. Solis and E. Vico among others.[36]

The original title of a third album in Ferdinand's collection was lost in rebinding, but it was probably *Vasa diversa antiqua et moderna* (Various antique and modern vases), and:

> opens with I. van Meckenem's Censer copied after Schongauer. Following are designs for bowls by E. Horninck; cups, chalices and pitchers by V. Solis; flasks and copies of antique and pseudo-antique vessels by C. Floris and A. Veneziano; as well as candle sticks, snuffers and saltcellars... The organization beginning with liturgical vessels, then

contemporary designs and finally classical objects is roughly coherent.[37]

Parshall groups these three volumes and one other (*Goldtschmidt Arbet von allerlaj gaistlicher und weltlicher Historien* [Goldsmith work from various sacred and secular histories], containing allegories, biblical narratives in landscapes, nudes and figure subjects),[38] under the heading 'Pattern Books' on the basis of the titles of the volumes and their contents. He states that 'Possibly these albums were culled for designs [for metalwork] like a mail-order catalogue... More likely the pattern books... were merely collected as examples for comparison with objects acquired for the collection',[39] a view reiterated in the later article that 'They were likely more a study collection than a serviceable set of pattern books...'[40]

In 1563–4, Ferdinand negotiated the purchase of a property called Schloss Ambras, near Innsbruck, in which to house his multifarious collections. Elisabeth Scheicher has written about Spanish Hall at Schloss Ambras dating from 1569 to 1571.[41] The main decoration of the Hall consists of portraits of twenty-seven princes but these are surrounded by painted trophies and grotesques. Scheicher has observed that the lack of homogeneity in the ornamental decoration is indicative of the patron, rather than a single artist, having been responsible for the overall scheme.[42] She notes that the painted trophies and grotesques relate to Italian and Dutch prints in the album *Grodesche et Arabesche* in Archduke Ferdinand's collection, discussed above.[43] The set of trophies are those published by Lafrery, Catalogue 50f. How, in practical terms, particular prints in an album came to be translated into painted ornament in the Spanish Hall remains unclear however, since there is 'no evidence of actual use, i.e. incising, or for that matter unusual wear vis à vis other albums in the collection'.[44]

The Escorial collection

The collection of prints belonging to Philip II of Spain (a cousin of Ferdinand, Archduke of Tyrol) is the only other sixteenth-century print collection to survive intact. The recent illustrated catalogue of the Escorial collection[45] is arranged according to engraver, which is not the order in which the prints themselves are housed. However, the history of the formation of the collection and the way the collection is structured have been the subject of a recent article.[46] In it McDonald has argued convincingly that the librarian of the Escorial, Benito Arias Montano (1527–98), was probably the prime mover in the forma-

tion of the collection. Montano was in Rome in 1572 and 1575,[47] the very time during which Antonio Lafrery issued the stocklist that demonstrates the vigour of his business during this decade. Given the date of Montano's visits to Rome, instances of the overlap between sets of prints in the Escorial collection and in the Lafrery Volume are not surprising.[48]

The Escorial collection was formed in the latter part of the sixteenth century and consists of nearly 7,000 prints in thirty-six albums arranged by subject. The inventory taken in 1596, just after Ferdinand's death, indicates the contemporary understanding of the subjects of his albums, whereas in the case of the Escorial collection 'nearly all have a topical classification inked on the fore-edge of the album'.[49]

In discussing the contents of album 28-I-15, McDonald challenges the suggestion made by an earlier author that 'many of the prints [in the Escorial collection] were brought by the foreign artists who were called by Philip II to decorate the monastery as objects for artistic inspiration'.[50] McDonald's view is that 'While there is no way of definitely knowing whether these prints were brought to Spain by artists, it seems unlikely for two reasons. First the vast majority of the prints in the album are in excellent condition, and if they had travelled and were used "on site", as it were, they would not have remained in such condition. Second, it is more likely they were ordered from a dealer such as Lafrery, who had a stock of such images.'[51]

The album that concerns us particularly is bound, like most of the others in the collection, in leather and stamped with the grille of St Lawrence, dedicatee of the Escorial monastery. McDonald records this style of binding as being consistent with other library volumes dating from the late sixteenth or early seventeenth centuries.[52]

It is 'Album 28-II-9. Subject of album: ornament, architecture and some reproductive prints... Label: *GROTESCHI* inscribed in ink on the fore-edge of the book...a selection of mainly Italian with some French ornamental and decorative prints.'[53] McDonald lists the contents of these as including Vico, *Grotesques*; A. Musi, *Ornamental Motifs* after (?) Raphael/(?) Giovanni da Udine; Master of the Die, *Panels of Ornaments* after Raphael; N. Rosex da Modena, *Ornamental Panels*; a mix of ornamental prints by A. Musi, Vico, Marco da Dente, etc.; G. Mocetto, *Frieze with Tritons and Nymphs*; Vico, *Frieze of Foliage*; Vico, *Trophies*; Michele Crecchi, *Coffered Ceiling with Grotesques and other Ornamental Motifs* after

Raphael; J. Androuet du Cerceau, *Frameworks at Fontainebleau* after Rosso; Anon., *Ornamental motif*; Vico, *Roman Empresses*; A. Musi, *Terms and Busts upon Pedestals*; Bonasone, *Terms of the Gods Sylvanus and a Nymph*; Anon., *Caryatids*; J. Prevost; *Caryatids* after P. da Caldara; *Corinthian capitals* by A. Musi, Serlio, G. Agucchi and J. Prevost; J. Prevost, *Corinthian Entablature*; G. Agucchi, *Architectural Orders*; G. Agucchi, *Corinthian Bases*; Vico, *Antique Vases*; A. Musi, *Antique Vases*; Vico, *Candelabrum Designs*; Master F, *Borders with Vegetal and Geometric Motifs*.[54]

Another album in the Escorial collection, album 28-II-24, inscribed on the fore edge and upper edge *ARCHIT ORDIN* and *ARCHITECTVRAS, GROTESCOS* respectively, has comparable Netherlandish contents.[55]

The de la Gardie album

An album of ornament prints now in the Royal Library at Stockholm,[56] although slightly later in date, provides an important point of comparison with the two sixteenth-century collections discussed above. The Stockholm album is associated with the name of a later owner, the Swedish statesman Magnus Gabriel de la Gardie, but it had previously belonged to Paul Freher, an advocate born in Augsburg in 1571. It is thought that it may for the most part have been assembled by Paul Freher's older brother Marquard Freher (1565–1614), a lawyer, statesman, diplomat and one-time professor of Roman law at Heidelberg University, one of whose biographers styled him 'a lover of antiquities and the art of painting'.[57] The album contains 1,280 ornamental engravings dating from the 1510s to 1616, by German, French, Netherlandish and Italian print-makers. The prints are arranged according to subject, such as cups, tumblers and vases (nos 1–133), grotesques (nos 370–463), masks (nos 533–641), architectural ornaments (nos 642–696), jewellery (nos 697–764), cartouches (nos 899–1101) and alphabets (nos 1122–1280).[58]

The symbiotic relationship between goldsmithing and the early history of print-making has long been appreciated,[59] but on the basis of these three surviving northern European examples of print collecting — one royal, one archducal and a third by members of the professional classes — it seems that in the sixteenth century ornament prints clearly had an appeal outside craftsmen's circles.[60]

The justifications for collecting given by sixteenth-century northern European writers were moral edification, organization and stimulus for the memory, the condensation

of universal knowledge and self-promotion of the patron.[61] Apart from moral edification, ornament prints were as capable as any other type of print of contributing to these aims.

Writing about a single ornament print, Howard Creel Collinson has argued:

> Whether Aldegrever's jewel-like 1539 engraving of *Two Spoons and a Hunting Whistle* is primarily a model for goldsmith's work or a still life of three objects with symbolic meaning is not easily decided.

> Throughout the history of ornament prints, there are many works whose nature is similarly ambiguous. One reason for this may be economic. A simple pattern sheet has limited usefulness and a limited market. Designers and publishers of patterns sought to appeal not only to the broadest possible range of working craftsmen but to an audience of connoisseurs and potential patrons who collected the sheets for their own information and as works of art.[62]

If the concept of the ornament print can be shown to have had a presence in sixteenth-century print-publishing and collecting, it can also be demonstrated that it was present at the level of theoretical writing about collecting practices. The scholar and bibliophile Samuel Quicchelberg (1529–67) put forward a plan for an ideal encyclopaedic collection of objects, in his book *Inscriptiones vel tituli theatri amplissimi*, published in Munich in 1565.[63] This scheme probably in part reflects Quicchelberg's practical experience as curator/librarian for Albrecht V, Duke of Bavaria (d. 1579), in whose employ he was by the late 1550s.[64] His scheme involved this encyclopaedic collection being divided into five classes. The first class included 'pictorial material partly relevant to the general history of civilization and partly to local or regional history',[65] while the fifth class was to be made up of 'Painting (in oils and water colors) and engraving, corresponding in part, to an "art collection"; genealogy; portraits; heraldry, textiles, fittings and furnishings'.[66] Quicchelberg advised keeping the loose prints between covers, which in turn were to be equipped with clearly discernible titles, and arranging these on three shelves, with ten or eleven titles to a shelf.[67] The suggested titles for the first shelf were: 'Bible; New Testament; Apostles and Evangelists; Saints; Studies in Theology; History of Christianity; Miracles; Warfare; Portraits; Genealogy'. For the second shelf he

proposed 'Naturalia (Animals, Plants, Anatomy); Studies in Philosophy; Charts and Tables (of the Disciplines, the Arts, Mathematical Charts, etc.); Music; Ancient History; Poetry, and the "Amours" of the Gods; Sports and Pastimes, Spectacles and Triumphal Processions of Antiquity; Modern Customs and Ceremonies like Hunting, "Fêtes", Gladiatorial Games and Other Activities; Costume; Heraldry'. Finally, for the third shelf he proposed 'Geography; Topography; Architecture; Ancient Monuments; Numismatics, Past and Present; Machinery and Ships; Tools; Various Fittings and Furnishings; Pottery; *Ornamental Designs* [my italics]'.[68]

The ornamental designs were placed within the 'art collection' in the fifth class (accommodating works on the basis of their technical means of production),[69] not in the pictorial collections in the first class (works included on the basis of what they represent).[70] The position of the ornamental designs within the engravings collection is also telling. They constitute the last title on the third and final shelf, and so could be seen as those subjects remaining when all other readily identifiable subjects had been dealt with.

> After listing the titles Quicchelberg points out the need for a number of subdivisions, particularly important in respect to such titles as Bible, New Testament, Geography and Topography. For the arrangement of ornamental engravings he suggests such typical divisions as Foliage, Frames, Grotesques, Animal Designs, Trophies, Fruits and Designs of Mixed Type.[71]

There is clearly an area of agreement between the ideas put forward by Quicchelberg in 1565, regarding the type of prints it would be appropriate to include under the heading 'ornament', and the sets of 'ornaments relating to architecture' in Lafrery's stocklist of c. 1573.

Taken together, the evidence of Quicchelberg's treatise, Lafrery's catalogue, and albums in the two surviving sixteenth-century print collections demonstrate that in the second half of the sixteenth century ornament was one of the categories used to organize prints according to subject.

Lafrery begins his catalogue of prints with geography and contemporary battles, while Quicchelberg's scheme for arranging a print collection opens with biblical subjects, but both end with ornament prints. This lowly position occupied by the ornament print in the hierarchy of subjects is perhaps also echoed in Archduke Ferdinand of Tyrol's collection, where the inventory numbers of the

four volumes mentioned above are higher than those for almost all the other thirty volumes that survive, although shelving by size is also a factor here.[72]

If ornament prints did occupy the lowest position in hierarchies of print subjects in the sixteenth century, it should be remembered that certainly in Italy the same engravers and publishers were often responsible for both ornament and non-ornament prints. The most frequently occurring names in this catalogue are those of the engravers Agostino Veneziano and Enea Vico, and the publishers Antonio Salamanca and Antonio Lafrery.[73] None of these individuals was solely, or even principally, concerned with the production of ornament prints. Veneziano's reputation rests on his work as a fine-art print-maker in the circle of Raphael,[74] while Vico's *oeuvre* of around 500 images encompasses prints after works by many of the leading painters of his era,[75] including Michelangelo,[76] Raphael,[77] Parmigianino[78] and Perino del Vaga.[79] In addition to being a print-maker, Vico was a scholar and writer in the field of Roman coins, gems and cameos. From 1563 until his death four years later, he was attached to the court of Alfonso II of Ferrara as his numismatic advisor.[80] When Landau and Parshall collated the 190 images published by Salamanca,[81] they calculated that 26 per cent were architectural or ornamental subjects, with the remainder comprising 55 per cent subjects from ancient history and mythology and 19 per cent religious subjects.[82]

Since the sixteenth century the emphasis given to the idea of ornament in relation to other ways of thinking about prints has fluctuated. One other historical period is of particular significance in the present context. In the second half of the nineteenth century a new impetus was given to the subject by the creation of collections of ornament prints as part of the setting up of museums of design and the decorative arts. This institutionalization of the subject was accompanied by a stream of publications on ornament prints, either catalogues of collections or general surveys of the subject.

In recent decades the study of ornament prints has fallen out of fashion, in comparison to approaches based on the *oeuvre* of a particular print-maker or focusing on a particular period, country or centre of production. Only a handful of print curators and scholars would define their primary focus of interest as ornament, and publications devoted to the subject are relatively scarce.

The attempt to combine the description of particular sets of ornament prints in the Victoria and Albert Museum

with some indication of how these prints fitted into the frameworks of print-publishing and collecting in the sixteenth century is intended to show how the study of ornament prints can be of value to a wider audience that those who already specialize in this area.

ORNAMENT: QUESTIONS OF DEFINITION

Drawing up a comprehensive, yet watertight modern definition of what constitutes an ornament print is far from straightforward, if not impossible. Unlike, say, portrait prints, ornament prints encompass a range of images, and they cannot easily be defined by reference to a single visual characteristic. 'Luckily it is a mistake to think what cannot be defined cannot be discussed.'[83]

The catalogue of fifteenth- and sixteenth-century ornament prints in the Rijksprentenkabinet in Amsterdam gives a definition based on use, that 'an ornament print is a print where the picture is used as an example for artisans to use in the same or a different material'.[84] A set of masks in this collection (Catalogue 38), made up of a combination of copies of Netherlandish prints supplemented by original compositions, has a title page that states that it is intended for painters, sculptors and other ingenious men. This is the only example in this entire catalogue of an explicit reference to potential use, and it occurs in a set of prints most of which (including the title plate) are copied from a set of northern European prints.

The handle of a late sixteenth-century Spanish ewer in the Museum's Metalwork Department,[85] echoes in its overall form, and in its use of a beaded moulding, two plates of vases in this catalogue (Catalogue 66a, pl. 8 and 68b, pl. III).[86] Impressions of a set of grotesques dating from c. 1505–7 (Catalogue 20) are known to have been the source for the lower part and door-jambs of the choir screen at Chartres Cathedral dating from 1526.[87] This is demonstration of how prints were the means by which new design ideas travelled across Europe in a relatively short space of time.

In the eighteenth century Sir Joshua Reynolds used engravings as the source for vases employed as 'props, symbols of luxury and antique virtue for female or mixed portraits from c. 1758'.[88] Two examples of vase prints from Reynolds' collection, recognizable by his collector's mark, have found their way into the V&A.[89]

Defining an ornament print as a print capable of use by

other artists or craftsmen casts a very wide net. It is a characteristic of designers and craftsmen to seize on whatever suits their purposes, regardless of its original source or function.[90] The sixteenth-century Italian engraving by Marcantonio Raimondi, after a design by Raphael, of *The Judgement of Paris*[91] is never classed as an ornament print by print historians, because it is a mythological figure subject, but this did not prevent it being the source for at least thirty-eight objects created in northern Europe in stone, silver, enamel and glass, during the sixteenth century.[92] These include a silver tabletop in the Museum,[93] also featuring *The Triumph of Galatea* after Raphael. This tabletop is similar in style and manufacture to a frame produced in Vienna or Prague in c. 1590 and now in the Wallace Collection in London.[94]

There is little physical evidence on the prints described in this catalogue that they were ever used by artists, designers or craftsmen, although it could be argued that those that were actually used may have been destroyed through use and are unlikely to find their way into a museum. Exceptions to this general rule are some of the prints in a set of the alphabet (Catalogue 2b) and one of the plates of trophies (Catalogue 51a, pl. 2), which have been partially pricked for transfer – that is, the outlines of parts of the image have been pricked with a pin so that powdered pigment could be used to transfer the outlines onto a blank piece of paper placed below it.[95] In a single instance, a print has a clear workshop provenance. A plate of two knife handles (Catalogue 63a, pl. 2, E.1722-1979) comes from an album compiled by the woodcarver William Gibbs Rogers (1792–1875) and his son William Harry Rogers.[96] These few signs of practical use must be set against evidence of connoisseurial interest in these objects indicated by collectors' marks.

In one sense, ornament prints are simply those that nineteenth- and twentieth-century scholars, beginning with A. Bartsch in *Le peintre graveur* (Vienna, 1803–21), set apart from other types of prints by cataloguing them as ornament. Thus in volume XV of Bartsch, in the catalogue of works of Enea Vico (1523–67), architecture, vases and panels of ornament are grouped together after religious, secular, mythological, fantastic, costume, portrait and medallic subjects have been dealt with. Both conceptually and physically, in the stores of Europe's Print Rooms, ornament prints stand apart from other prints of the same century and school.[97]

At the core of ornament print studies lie prints intended neither to illustrate a narrative nor to serve a documentary purpose. Instead, they are images that depict things

which are essentially two-dimensional in character and are either conceived for, or suited to, the decoration of a two-dimensional surface.[98] The important contribution by R. Berliner's *Ornamentale Vorlageblätter des 15. bis 18. Jahrhunderts* (Leipzig, 1925–6) is confined to ornament prints of this type.[99] This body of two-dimensional subjects (sometimes viewed as pure ornament), when linked to other prints that are either actual printed designs for the decorative arts or that have the potential to be adapted to this purpose (applied ornament), creates a collection of images classed as ornament prints.

ORNAMENT PRINTS AND THE VICTORIA AND ALBERT MUSEUM

This Museum was the first in the world to have a print collection assembled as a national design resource for the benefit of trainee and practising craftsmen and designers. Ornament prints form the historic core of the Museum's print collection, which now encompasses a multitude of other sorts of prints.

Discussion of ornament came to play a leading role in design education in Britain in the middle of the nineteenth century. The amassing of reference material about ornament for the purpose of teaching budding designers and craftsmen was fundamental to the work of the Government School of Design, Somerset House, founded in 1837.[100] This in turn formed part of a renamed Department of Practical Art, overseen by Henry Cole, which moved into Marlborough House in 1852. The first sentence of the section dealing with the library, in the *First Report of the Department of Practical Art*, 1853, reads, 'The Library of the Department of Practical Art is now available to students and the public in general, and is already sufficiently advanced to be of great use to all those concerned in ornamental manufactures.'[101]

Later in the same report it is stated:

> It is proposed to make the same classification of prints and drawings as of books, that is according to their subjects...but the examples of works of this class that have been transferred as yet from Somerset House to Marlborough House can be looked upon only as the mere nucleus of a collection. Two portfolios containing about 400 miscellaneous designs and studies by the students, some few larger drawings in rolls, and a large press containing a miscellaneous collection of prints, drawings, and specimens of French paper-hangings, to perhaps the number of 500 examples, consti-

tute the whole of this portion of the library at the present moment.[102]

In a lecture on 'The Museum of Art', delivered on 14 December 1857 and published the following year, J.C. Robinson, Keeper of the Museum of Art and of the Art Library – by now housed at South Kensington – spoke of the recently formed collection of ornament prints:

Again, the Print Room of the British Museum contains an inestimable treasure of engravings, which, from want of space, it is impossible to exhibit; but there is one section even here, which obviously falls within the province of the Kensington Museum – it is that of engravings of an ornamental or decorative character, the literally innumerable engraved designs of industrial artists of every speciality, of goldsmiths, armourers, watchmakers, enamellers, embroiderers, cabinetmakers, house-decorators, &c.; these have never been adequately collected at the Print Room, because the scheme of that establishment was to illustrate the history and development of engraving as an art, and not ornamental design exemplified by engravings. In the space of a few months a collection in this speciality numbering several thousand specimens has been got together at Kensington, and a more numerous collection than is probably visible in any other public museum is already arranged and exhibited in glazed frames. These illustrations are adduced to show that the Art Museum, whilst being legitimately developed on its own methodical plan, is incidentally remedying shortcomings in categories which the more limited scope of existing public institutions has obliged them to neglect. Thus the nation is not forming collections in duplicate, and moreover several important categories are now, for the first time, represented in any public museum of this or any other country.[103]

Eleven years later, perhaps with every librarian or curator's eye for potential future acquisitions, the collection was being described in less glowing terms:

In the section of engravings the library collection is still very poor. The various schools of ornament should be well represented, and materials also brought together sufficient to illustrate the history and progress of the art. The important school of German engravers of ornament of the 16th century, the Petits Maîtres, is represented by a small collection of their works, but not sufficient to fairly display the excellence of design for which they deserve to be studied. The Italian ornamentists of the same period, and the French of a somewhat later time, are scarcely represented at all. The collection of goldsmiths', jewellers', and metal-chasers' designs may be considered as merely in embryo, yet these, some of them rubbings from fine works actually executed, are among the most suggestive examples that can be shown to modern artisans, who have not many chances of meeting with anything that rises above mere manufacture...[104]

References to ornament prints, particularly those by the so-called German 'Petits Maîtres', dominate the brief comments on the acquisition of engravings, in the appendices dealing with the National Art Library in the *Reports of the Department of Science and Art* (London, 1867–86). These comments were the work of R.H. Soden Smith (1822–90), Keeper of the Library from 1868 to 1890,[105] who was also the author of *A List of Works on Ornament in the National Art Library (Compiled for the Use of Students and Visitors)* (London, 1882).

The 'Report on the Section of Prints and Drawings by E.F. Strange, Assistant Keeper in Charge (4 June 1908)', in *Minutes and Memos of the Committee on Re-arrangement* [of the Victoria and Albert Museum],[106] points out that:

The Board Minute of 12th July 1864, in settling the constitution, scope and function of the Museum, provides under the heading 'B. Art Collections' for two separate sections, one of 'Modern Engravings and Etchings'(h); the other of 'Drawings and Engravings of Ornamental Designs'(l). These are shown apart from the 'Art Library'(n) section.[107]

When E.F. Strange, speaking from his own vantage point of 1908, enumerated the main subdivisions of the prints collection as he saw them, these were:

1. Engraved Ornament
2. Prints by Old Masters (other than Class 1)
3. Modern Etchings and Engravings
4. Japanese colour prints and European experiments in similar processes
5. Lithography
6. Engraved Portraits[108].

The year 1908, when this evidence was being taken, is a landmark in the study of the history of ornament for an entirely separate reason. This was the year in which the Vienna-based architect Adolf Loos (1870–1933) published

his essay *Ornament und Verbrechen* (Ornament and crime), setting out his creed that 'The evolution of culture is synonymous with the removal of ornament from objects of daily use... We have out-grown ornament, we have struggled through to a state without ornament.'[109] Viewed with hindsight, this influential essay has been interpreted as pointing the way to Modernism.

Pursuing its own institutional goals, the Victoria and Albert Museum Committee on Re-arrangement resulted in the setting-up, in 1909, of a new Department of Engraving, Illustration and Design, distinct from the National Art Library, to look after the collection of prints and design drawings.

James Laver, sometime Keeper of the new department, wrote in his autobiography:

> The Rosenheim collection of engraved ornament was just coming into the market, indeed Hardie was cataloguing it for Sotheby's. I helped him in this and later sat beside him in the saleroom while he struggled to acquire as much as possible of it for the Museum. Our collection of engraved ornament ('the key to the history of design') was already extensive, rivalled only by the Kunstgewerbemuseum in Berlin. Fortunately for us the German museums (it was a period of inflation) were unable to compete and, as the giant American museums had not yet awakened to the importance of engraved ornament, we secured almost everything we wanted at fairly low prices. It was my first introduction to the excitement of the saleroom.[110]

In 1967 Peter Ward-Jackson, at that time a senior member of staff in the department, published a series of articles entitled *Some Main Streams and Tributaries in European Ornament from 1500 to 1750*. As well as introducing an English-speaking audience to the nature and importance of ornament prints, the illustrations to these articles served to give a sense of the range of ornament prints in the V&A.

Looking back on a distinguished career of thirty-five years at the Museum, culminating in a period as Director, John Pope-Hennessy wrote:

> The most familiar criticism of museums is that they continue to make acquisitions while their basements are bulging with surplus works of art. At the Victoria and Albert Museum that simply was not true. A number of departments had, in addition to their primary function, a reference

character. One of them was the Department of Textiles, where the study material was freely accessible and was exceptionally rich, and another was the Department of Engraving, Illustration and Design, with its comprehensive collection of engraved ornament.[111]

In the Introductory Essay to his *Penguin Dictionary of Design and Designers*, Simon Jervis, at that time on the staff of the Museum, wrote:

> It is significant that the study of engraved ornament, surely a vital key to the general history of design, is neglected, and designers of ornament often receive summary treatment in books on the arts of design, just as in general histories of art the arts of design tend to be relegated to appendices. The neglect of ornament is of course not only the result of concentration on craft divisions, it is also a reflection of the Modern distaste for ornament. Ornament is such an important and perennial ingredient of art that it is to be hoped that the Post-Modern revival of complexity of texture, articulation and historical reference may bring with it a revival of interest in ornament.[112]

The Museum felt that the subject of ornament was of such importance that by 1992 a permanent gallery devoted to the subject of European ornament, containing some 500 objects drawn from across the Museum's collections, had been opened. This was followed by the publication of M. Snodin and M. Howard's *Ornament: A Social History since 1450*, which grew out of the work on the gallery.

In the chapter 'Ornament and the Printed Image' Snodin points out the 'tendency for a burst of engraved ornament to appear after, rather than during, the birth of a style in a court centre'.[113] He also makes the point that the humanist emphasis 'was also reflected in Italian printed ornament, which from the beginning employed the antique motifs which had become firmly established in Florentine architecture and ornament in the 1450s. As ambassadors of Renaissance decoration, Italian ornament prints of the next hundred years or so were to have an influence out of all proportion to their small number relative to those made north of the Alps.'[114]

Notes

[1] I am deeply indebted to Peter Fuhring for his help and encouragement in researching this volume. He confirmed

what I suspected, namely that the entire contents of this volume were associated in some way with Antonio Lafrery, and suggested that I use Lafrery's stocklist to pursue research on it.

[2] Parshall, 1982, pp.142, 146. The same article (p.141) also refers to sixteenth-century collections organized by size or by artist and regional school.

[3] Elaborations of this basic distinction come about when a set of prints is laid down singly on sheets of uniform size which are then bound, or when prints are inlaid, let into a larger sheet with a hole slightly smaller than the size of the print cut into the middle of it. It is also possible to find volume-like pages and album-like pages contained within one binding, but these possible variations do not detract from the usefulness of recognizing the basic distinction between a volume and an album for the discussion that follows.

[4] Landau and Parshall, p.304.

[5] Boorsch and Lewis, p.18.

[6] Reproduced in F. Ehrle, pp.54–9. The stocklist contains a map published in 1573; see Woodward, 1996, p.123, note 41.

[7] Ehrle, p.54. I am grateful to Roberta Franceschetti for this translation and that of the list that follows. The key sentence reads in the original, '*Nella quinta son posti molti ritratti e medaglie di persone segnalate, si spicciolatamente disperse, come raccolte insieme, e alcuni libri d'Architettura di auttori moderni e d'ornamenti appartenenti a quella, e di prospettiue e altri tali cosette; e per maggior sodisfattione di chi legga, s'è aggiunto a quelle, di che s'è hauuto cognitione, il nome del proprio Artefice.*'

[8] An 'Old Cataloguing Slip' in the National Art Library records the purchase for £13 3s. from E. Parsons, on 19 March 1873, of a vellum-bound volume containing the set of trophies by Enea Vico, 'Bound with G.B. da Vignola *Regola delli Cinque Ordini d'Architettura*' and 'With eight others bound with it'. The pressmark assigned to this volume, 8.G.5, is noted alongside the catalogue entry. The same pressmark indicating the same volume occurs against entries on another 'Old Cataloguing Slip' for Vico, Enea, *Fourteen Plates of Vases and Four of Candlesticks*, and again on another for Labacco, Antonio, *Libro d'A.L. appartenente a L'Architettura*. Both these cataloguing slips also have a note indicating that the items in question are bound in with a copy of Vignola. When the prints were accessioned individually in 1899, the set of friezes and foliage was listed as two separate sets. This could explain why a volume containing two books and

seven sets of prints – nine items in total – was listed on the Old Cataloguing Slip as the trophies, the Vignola architectural treatise and eight others, i.e. ten items in total.

[9] NAL pressmark 87.G.8; see Savage *et al.*, no. 1703, p.897.

[10] NAL pressmark 87.G.9; see Fowler and Baer, p.281.

[11] It is closest in type to Lugt 1157a, but it is not that mark and it is in black, not violet, ink. I am grateful to Mària van Berge-Gerebaud, Director of the Fondation Custodia, Collection Frits Lugt, Paris, for the information that the mark found on the Vignola is absent from the documentation assembled for a projected third volume of Lugt.

[12] For the storage of prints in volumes, as a norm of print-collecting practices, see Griffiths, 1994. For the Solander box, see Roberts and Etherington, p.243. The Solander box was invented by Dr Daniel Charles Solander, a botanist, during his tenure at the British Museum (1773–82).

[13] Records of purchases from this firm held by the Museum's Registry only begin in 1877. An impression of Parsons' business is given by the title of his earliest surviving catalogue preserved in the National Art Library, *Edwin Parsons' List of Fine Art, Scarce, Curious and Miscellaneous Books, Now on Sale for Cash at 45 Brompton Road, S.W. Representing a Portion of 50,000 Volumes*, London, 1882.

[14] These are the four candlesticks, E.2094–2097-1899, which, according to the accessions register, were the same size as all the other folios that make up the volume, at the time they were accessioned. The only possible conclusion that can be drawn from this is that they were cut down to their present size by someone in the Museum some time after they were accessioned.

[15] E.2038-1899.

[16] Tulips in a shield under six-pointed star B, Woodward, *Watermarks*, 1996, no. 125, found on maps dating from 1557 to 1564. See the Watermark Appendix.

[17] Tulips in a shield under six-pointed star A, Woodward, *Watermarks*, 1996, no. 124, found in maps dating from 1542 to 1570. The presence of this pair of very similar watermarks may indicate a stock of paper made using a pair of paper moulds, a standard practice in hand-made paper-making. See also Zonghi, nos 1763 and 1765, where the only two examples of watermarks of this design recorded there are dated 1570 and 1572.

[18] See the Watermark Appendix.

[19] Similar to Woodward *Watermarks*, 1996, nos 28, 29, 30, found on maps dating from 1557 to 1570.

[20] Woodward, 1991, p.236.

[21] Bifolium bearing the impressions of E.2016-1899 and E.2019-1899.

[22] Nicolas Beatrizet, B. XV 17 Copy B, second state.

[23] Ehrle, p.57.

[24] Woodward, 1991, p.244.

[25] Similar to Woodward *Watermarks*, 1996, no. 167, Anchor in double outline with star J, found in a map dating from 1543.

[26] There are fourteen prints of vases but only four prints of candlesticks in the set. It is argued in the catalogue entry for the candlesticks, Catalogue 62, that they were printed from plates originally belonging to Antonio Salamanca, as part of a business agreement that Lafrery had with Salamanca's heir. If this were the case, a set of only four prints might have been too small for Lafrery to publish alongside his own ornamental sets, which contain between thirteen and thirty plates per set. This might explain why Lafrery combined Salamanca's candlesticks with an ornamental set of his own, the vases, to make a set of eighteen prints. The pairing has a logic to it, since both depict three-dimensional objects that were capable – in theory at least – of manufacture in metal.

[27] Bartsch describes a set of plates by Enea Vico, B. XV 452–66, which includes all the numbered plates of foliage in the set of friezes and foliage, B. XV 452–3, 455–66, and one stray plate that is not part of the Lafrery set, B. XV 454.

[28] Enea Vico, B. XV 420–33, Catalogue 68b.

[29] For a more wide-ranging discussion on print collecting in Italy see Bury, 1985.

[30] Parshall, 1982.

[31] Parshall, 1994.

[32] Parshall, 1982, p.139.

[33] Parshall, 1994, p.16.

[34] Parshall, 1982, p.146.

[35] Parshall, 1982, no. 32, pp.171–2.

[36] Parshall, 1982, no. 33, pp.172–4

[37] Parshall, 1982, no. 34, pp.174–5.

[38] Parshall, 1982, no. 31, pp.169–71.

[39] Parshall, 1982, p.181.

[40] Parshall, 1994, p.21.

[41] Scheicher, 1975

[42] Scheicher, p.86

[43] Scheicher, pp.87–8

[44] Letter from Peter Parshall of 4 August 1997.

[45] J. M. González de Zárate, *Real Colección de Estampas de San Lorenzo de El Escorial*, 1992–5 (Abbreviated to E. = Escorial, in 'frequently cited sources' within the Bibliography).

[46] See M. P. McDonald.

[47] McDonald, p.21.

[48] These overlaps can be recognized by the references with the abbreviation 'E.' for Escorial in the literature on the sets in the Lafrery Volume.

[49] McDonald, p.18.

[50] García, p.93, quoted in McDonald, p.22.

[51] McDonald, pp.22–3.

[52] McDonald, p.24.

[53] McDonald, p.30.

[54] McDonald, p.30.

[55] McDonald, p.33.

[56] Collijn.

[57] Collijn, p.V.

[58] Collijn, p.XII.

[59] For a full discussion of this, see Snodin and Howard, Chapter 1, Ornament and the Printed Image, pp.18–62.

[60] In the course of a very helpful correspondence about the use of ornament prints, Peter Parshall has indicated that he sees this issue in a similar light.

[61] Parshall, 1982, p.182.

[62] Collinson, p.3.

[63] Hajós, 1958.

[64] Parshall, 1982, p.142.

[65] Hajós, p.151.

[66] Hajós, p.152.

[67] Hajós, p.153.

[68] Hajós, p.153.

[69] Parshall, 1982, p.183.

[70] Parshall, 1982, p.183.

[71] Hajós, p.153.

[72] Parshall, 1982, pp.145–6.

[73] Antonio Salamanca was based in Campo dei Fiori (Landau and Parshall, p.303). For a sense of this location see Partridge, chapter 1.

[74] See Shoemaker and Broun, pp.194–203; and Landau and Parshall, pp.120–46.

[75] See Höper.

[76] E.g. *Judith Giving the Head of Holofernes to Her Servant* (B. XV 1) and *Leda and the Swan in a Landscape* (B. XV 26).

[77] E.g. *The Annunciation with Kneeling Angel* (B. XV 2), *The Entombment of Christ* (B. XV 7), *The Lamentation before the Tomb* (B. XV 8) and *Tarquinius and Lucretia* (B. XV 15).

[78] E.g. *Lucretia Preparing to Kill Herself* (B. XV 17), *Mars and Venus* (B. XV 21, 27) and *Old Woman Spinning* (B. XV 39).

[79] E.g. *Sacrifice* (B. XV 38) and *Punishment of the Courtesan Who Had Mocked Virgil* (B. XV 46).

[80] Bolaffi, vol. XI, pp.322–3.

[81] Landau and Parshall, p.303.

[82] Landau and Parshall (p.303) raise the possibility that there were in fact two Antonio Salamancas, distinguishable by the style of lettering used to engrave their names on the plates they published. They identify 'an extended version normally engraved in beautiful Roman lettering' with Antonio Salamanca (c. 1500–62) and 'a contracted *Ant. Sal. exc.* in italics' as possibly belonging to a younger son or nephew, of the same name, active 1567. They point out that the younger man would have acquired his plates from his distinguished namesake. To complicate matters further, the only prints in this catalogue with the name Antonio Salamanca in Roman lettering give the name in an abbreviated form. It occurs in this form on a set of ten trophies (Catalogue 50a–d) and a single candlestick (Catalogue 62a, pl. 5). It seems possible that Salamanca commissioned the trophies, which were copied by the publisher Antonio Lafrery around 1550–3 (see note to Catalogue 62). All the other prints in this catalogue bearing the name Antonio Salamanca – and they are numerous – are lettered in the contracted italic style. Even if this style does indicate a second Antonio Salamanca, all the plates lettered with this name are listed in the catalogue under the first Antonio Salamanca, since the assumption is made that he would originally have owned the plate.

[83] Gombrich, p.X.

[84] M. de Jong and I. de Groot, *Ornamentprenten in het Rijksprentenkabinet I, 15de & 16de eeuw*, 's-Gravenhage, 1988, p.12. For a masterly exposition of this process in action in art and design in Elizabethan and Jacobean England, see Wells-Cole.

[85] Late sixteenth-century Spanish ewer and basin, W.L. Hildburgh Bequest, M.380 and A-1956.

[86] I am indebted to Hilary Young for this observation.

[87] Byrne, 1981, p.72.

[88] Clifford, p.287.

[89] Catalogue 69e, pl. 4, 6.

[90] A striking contemporary example of this was given by the twenty-five-year retrospective of the British fashion designer Paul Smith, held at the Design Museum in London in 1995; see Jones.

[91] B. XIV, 245.

[92] Shoemaker and Broun, p.25 and note 14, with reference to A. Oberheide *Der Einfluss Marcantonio Raimondis auf die nordische Kunst des 16. Jahrhunderts*, Dissertation, Hamburg, 1933.

[93] Accession number, 1-1869.

[94] Hughes, pp.113–15, where the V&A tabletop is also illustrated.

[95] Lambert, p.17.

[96] See *Victorian Church Art*, pp.62–3.

[97] It remains to be seen if this physical separation will be upheld in the long term. A description of recent changes in the storage of prints at the British Museum states, 'Back at Bloomsbury we have released whole runs of cases and the print collection will now be arranged like the drawings, in a single sequence organized chronologically by school. We can at last abolish the multiplicity of series made to suit the interests of our predecessors, such as ornament prints or woodcuts printed in colour, which today serve only to confuse.' S. O'Connell in *The Friends of Prints and Drawings Newsletter*, British Museum, London, no. 4, 1997.

[98] Fuhring, 1995, p.124.

[99] The second, 1981 edition of this work, cited in the Bibliography simply as Berliner, has been used in the catalogue entries because it contains certain images not present in the first edition. However, see the review by Fuhring, 1981, for reservations about the later edition.

[100] See R. Dunn and A. Burton, 'The Victoria and Albert Museum: An Illustrated Chronology' and 'The Victoria

and Albert Museum: A Summary Time Line', in Baker and Richardson (eds), pp.49–75, 76–9, and White, p.4.

[101] *First Report of the Department of Practical Art*, London, 1853, p.292.

[102] *First Report of the Department of Practical Art*, p.295.

[103] J.C. Robinson, *Introductory Addresses on the Science and Art Department and the South Kensington Museum, No. 5: On the Museum of Art*, London, 1858, pp.15–16.

[104] *Fifteenth Report of the Science and Art Department of the Committee of Council on Education*, London, 1868, p.240.

[105] See 'Obituary of Robert Henry Soden Smith' in *The Academy*, 5 July 1890, p.16.

[106] Typewritten manuscript in the National Art Library, pressmark VA. 1908.0001.

[107] Minutes and Memos, pp.262–3.

[108] Minutes and Memos, p.265.

[109] A. Loos, p.100.

[110] Laver, p.87. The sale took place on 7 and 8 May 1923; see Acquisition Histories for prints acquired.

[111] Pope-Hennessy, 1992, p.175.

[112] Jervis, p.12.

[113] M. Snodin and M. Howard, p.24.

[114] M. Snodin and M. Howard, p.23.

How to Use the Catalogue: Contents and Coverage

There are a great many more Renaissance ornament prints and drawings than one expects, and trying to impose any kind of order serves only to demonstrate that it cannot be done definitively or to complete satisfaction.[1]

The aim of this catalogue is to make available, to as wide an audience as possible, information about the sixteenth-century Italian ornament prints in the Victoria and Albert Museum's Department of Prints, Drawings and Paintings. The envisaged readership includes anyone interested in ornament prints or prints in general; art historians specializing in the Renaissance; and historians and curators interested in sixteenth-century and nineteenth-century Renaissance Revival decorative arts. If this catalogue encourages others to study these prints and to think and write about them, it will have fulfilled one of its most fundamental purposes. In addition to its appeal to specialist and scholarly audiences, it is hoped that it may be of value to practising designers, for whose nineteenth-century counterparts the collection was assembled.

This is the catalogue of a particular collection, not a *catalogue raisonné*. References to prints in other collections are introduced when they help to explain the nature of

prints that are in the V&A's collection. The prints themselves are available for viewing, on request, in the Museum's Print Room. In order to be included in this catalogue, a print must first be the type of image that past generations of print cataloguers might reasonably classify as an ornament print, as discussed in the Introduction. It must then either have been published during the sixteenth century in the geographical region now known as Italy or be a copy, or a copy in reverse, produced at any period, and in any country, of an ornament print published in Italy during the sixteenth century. These copies and reversed copies give some indication of the popularity and demand for the sixteenth-century Italian prints on which they are based.

This is the first attempt to publish a part of the V&A's collection of ornament prints in detail and is also the first English-language catalogue of a museum collection of ornament prints of a particular school. Because of this, the reader should guard against the temptation to view this catalogue as defining the canon of sixteenth-century Italian ornament prints. This collection makes no claims for completeness, being dependent upon what the Museum has been able to acquire by purchase, bequest

and gift. Yet the breadth and depth of the Museum's holdings in this area make it a valid starting point for a study of the subject. The catalogue represents a body of primary information about sixteenth-century Italian prints, derived from the prints themselves.

Having had an energetic acquisition policy in the second half of the nineteenth century, the Museum was able to add to its holdings much now very scarce material, including for example what may be a unique impression.[2] The importance of these nineteenth-century acquisitions lies not only in the images themselves, but in the presence of sets of prints that retain their sixteenth-century groupings – the Lafrery Volume being the most notable example of this. Hence a cataloguing structure had to be devised to recognize and accommodate this, without attempting to oversimplify complex matters or explain away unresolved problems.

In this catalogue all versions of an image are considered with the same degree of attention accorded to what, in the *oeuvre* catalogue of an individual engraver, would be the prime version.

THE CATALOGUE: ORGANIZATION

The tradition that has grown since the late nineteenth century is to catalogue ornament prints by name of the designer (if his name is not known, by name of the engraver or the publisher). The prime argument for this approach, that differs from the larger field of the 'old master prints' where cataloguing is done by engraver, is the recognition of the primary role of the designer as opposed to the role of the engraver. The problem with numerous Italian sixteenth-century prints is simply that one does not have sufficient names to make the traditional approach work.[3]

The approach used in the organization of this catalogue of ornament prints is close to that of the sixteenth-century curator/librarian Samuel Quicchelberg (see Introduction). The prints are organized according to the visual content of the image, rather than by the name of the designer or engraver. This has been done to make the catalogue as easy as possible to use for those who do not have any previous knowledge in this field. For example, a decorative arts curator searching for a possible design source will find material of a similar kind grouped together. In the first instance the prints are organized under one of two headings: Pure Ornament and Applied Ornament. These categories are then subdi-

vided into the headings shown on the contents page.[4]

Within each heading, the arrangement of the catalogue numbers is chronological. The position of a single print, or set, within the chronology is dependent upon the date when it was first published, which may be earlier than the date of the impressions in the V&A collection. When a print has been assigned an approximate date (e.g. 1530–5), it is placed in the chronology in a position corresponding to the start of the approximate date-span (i.e. 1530 in the example given).

In so far as the prints present in the V&A's collection allow, the hope is that a sense will be conveyed of the development, over the course of the century, of a particular motif, such as vases. One result of this approach is to throw more light on how competition between engravers, and publishers, may have been a motivating factor for the production of some of these sets of prints. An index of names also enables the catalogue to be used in the conventional way.

This catalogue follows the model of the 1939 catalogue of the ornament print collection at the Kunstbibliothek in Berlin,[5] in that descriptions of related prints, early and late impressions, proofs and reissues, copies and copies in reverse, are grouped together within a single catalogue number, subdivided into parts. Then, like the 1988 catalogue of the fifteenth- and sixteenth-century ornament prints at the Rijksmuseum in Amsterdam,[6] it also uses modern standards of print cataloguing to provide a detailed description of individual prints.

The V&A's collection is particularly rich in groupings of prints comparable to those in Berlin.

CATALOGUE ENTRY FORMAT

Each catalogue entry is constructed as follows, although in some cases not all of the headings are applicable (for example, when the prints are unsigned):

- Engraver, designer, publisher (when known), with dates of birth and death or when active

- Title or description of the print

- Whether it is a reissue, a copy or a reversed copy of another print

- Country and (where known) place of publication

- Known or estimated date of impression, followed by earliest date of publication (if different)

- Signature or monogram of the print-maker engraved or etched onto the plate (the actual words or letters in italics)

- Date engraved or etched onto the plate (in italics)

- Engraved or etched lettering, other than signature and date (in italics)

- Significant inscriptions in pencil, or pen and ink, added after printing (in italics)

- Stamps or collectors' marks pre-dating entry into the collection (in italics)[7]

- Technique

- Size

- Museum number

- Literature

- Notes.

Titles for prints are taken from English-language reference works such as *The Illustrated Bartsch, Hollstein* or the publications of A.M. Hind. If no standard title exists, then a descriptive title is given.

The dating is arrived at by combining all available evidence: dating on the print itself, dates of activity of the engraver and publisher, and dating given in the scholarly literature. The dating refers to the date of this particular impression, which may be (and often is) later than the date that forms part of the printed image. Allocating dates to all the images, however approximately (e.g. last quarter of the sixteenth century), is a requirement of the computerized Collection Information System soon to be installed in the Museum, to facilitate searches where 'date' is one of the search criteria.

The lettering is transcribed exactly as it appears.[8] Omissions, such as erased lettering, and any explanatory remarks are placed within square brackets. Size is given in centimetres (height before width), and describes the plate mark, unless the print has been trimmed, in which case the expression 'Cut to...' is used.

LITERATURE

The extensive literature on ornament prints breaks down into three main types. There are surveys of the subject, most of which were originally published on the Continent at the end of the nineteenth or the beginning of the twentieth century; catalogues of permanent collec-

tions of ornament prints published by continental museums; and publications produced in recent decades to accompany temporary exhibitions of ornament prints. A small, but vitally important, additional category for the purposes of this study are two examples of publications describing, in detail, one sixteenth- and one early seventeenth-century collection containing ornament prints.[9] All these types of literature are publicly available only in major specialist art libraries. In the face of a vast array of literature, decisions had to made about which to refer to, without weighing the reader down with too much repetitive material.

The catalogue of the Berlin Kunstbibliothek ornament print collection (referred to as 'Berlin') has long been recognized as the fundamental reference tool for the study of ornament prints by nature of the size and range of that collection, but its drawbacks are: condensed descriptions of sets, a relatively small number of illustrations and the loss of some items as a result of the Second World War, although these losses have in part been compensated for by post-war acquisitions (details of which are as yet unpublished). The much more recent catalogue of the fifteenth- and sixteenth-century ornament prints in Amsterdam uses modern standards of cataloguing to provide a plate-by-plate description, in Dutch, of every set, and at least one print from every set is illustrated. These two permanent collection catalogues are the principal reference works used, and all of the entries here have been systematically checked against the actual prints in those two collections and against the holdings of the British Museum Print Room.

The expanded 1981 edition of R. Berliner, *Ornamentale Vorlageblätter des 15. bis 19. Jahrhunderts* (Leipzig, 1925–6), by R. Berliner and G. Egger, has been preferred because it contains fifteen prints in this catalogue that were not present in the earlier edition and because it is more readily obtainable. It is referred to simply as 'Berliner'.[10]

All the other works listed in the Bibliography under 'frequently cited sources' have also been cross-referenced to the catalogue entries, and the exemplary index of the first ten volumes of *Print Quarterly* has also been trawled. Other works in the remainder of the Bibliography have been mentioned, where appropriate. Where alternatives exist, preference has been given to literature in English. References to multi-volume works (e.g. Bartsch) take the form of volume number, followed by the catalogue number of the engraver under discussion, but not the page number.

NOTES

In the case of the sets that make up the Lafrery Volume, and in one or two other instances, the accompanying notes can run to the length of short essays. While this is a departure from the usual format of a permanent collection catalogue, the reasoning behind the structure of the catalogue entry frequently depends upon the existence of versions of the images not in the Lafrery Volume. In three cases (Catalogue 33a–e, 50a–m and 62a–d), the catalogue entries incorporate radical proposals for a revised understanding of these sets. It seems therefore essential to lay all the evidence and arguments before readers so that they can make up their own minds. The evidence can take the following forms: internal evidence of the individual sets making up the Lafrery Volume; a comparison between sets in the Lafrery Volume and other versions of the same images; comparison between Lafrery Volume sets; or cumulative evidence derived from considering the Lafrery Volume as a whole. This opportunity for what one might call a 'holistic' approach to print studies, which the Lafrery Volume affords, has the potential to yield new insights into sets of prints that have previously been studied from other perspectives.

TYPES OF CATALOGUE ENTRY

Besides the usual questions that occupy any compiler of a print catalogue – such as authorship, technique, size, date, etc. – this catalogue has created additional concerns, arising from the nature of the V&A's collection. First, which prints in this collection belong together in pairs or in sets?[11] Second, if there exist in this collection prints of the same image by more than one engraver, which of them is the original and which the copies? Third, if there exist in the collection impressions from the same plate issued at different dates, in what order did they appear? Finally, within certain broad subject headings (e.g. vases), in what order over the course of the sixteenth century did prints by various print-makers appear?

Each catalogue entry falls into one of four types:

1. A single sixteenth-century Italian ornament print, present in the V&A collection in only one version (e.g. Catalogue 21).

2. A set of sixteenth-century Italian ornament prints present in the collection in only one version (e.g. Catalogue 57). The set is first described as a whole, then the individual plates that make up the set are described in greater detail.

3. A single sixteenth-century Italian ornament print present in the collection in more than one version. A lower-case alphabetical suffix (a, b, c, d, etc.) is added to the main catalogue number to distinguish the versions (e.g. Catalogue 61a–g).

4. A set of prints present in the collection in more than one version. Again a lower-case alphabetical suffix is added to the set description of every version of the set, within a single catalogue number (e.g. Catalogue 33a–e). The sets are each described collectively, then the plates are described individually in greater detail, with every version of each plate being described, before passing on to the next plate. In the plate descriptions, the versions are differentiated by using the appropriate lower-case alphabetical suffix (a, b, c, d, etc.). For a set present in several versions, it is frequently the case that not every version contains all the plates in the set, or even that every version of a set originally contained the same number of plates.

CATALOGUE ENTRY FOR A SINGLE PRINT, OR A SET OF PRINTS PRESENT IN SEVERAL VERSIONS

When a single print or a set of prints is present in the collection in several versions, the versions are sorted into three categories:

I First issue, and reissues, of the original plate or plates.

II Copies in the same direction, of the original plate or plates, and reissues of these copies.

III Reversed copies of the original plate or plates and reissues of these copies.

This sorting has been done so that any other impression of the prints described in this catalogue can be compared to the V&A's holdings, and its exact relationship to them can be pinpointed.

Copies and reversed copies have been separated from each other, because this is one of the first distinctions made when sorting through a large number of versions of the same image. The decision to approach the collection in this way had an unforeseen benefit. If a bipartite division between original and copy (both direct and reversed) is adopted, there is much less likelihood that occasion will arise to question whether the so-called original truly is the original. With a tripartite arrangement of original, direct copy and reversed copy, the relationships between the three types of image are thrown into much greater

relief and it becomes much easier to contemplate the possibility that things may not be what they initially seemed. This is in effect what happened with Catalogue 33a–e and 50a–m.

Only the wording of a catalogue entry that uses the vocabulary 'reissue', 'copy' and 'reversed copy', and *not* the suffixes themselves, should be taken as an indication of the relationship between different versions. For example, version 'a' is only the earliest version in the V&A's collection, which need not be the earliest produced. When such an instance occurs, reference is then made, under version 'a', to the earliest known version.

Within any catalogue entry all the versions in each of the categories are arranged in chronological order, by date of their first publication, *within* the category. As a set of copies may pre-date the reissue of the original plates, it is of fundamental importance to understanding how this catalogue works to grasp that the chronological order applies only *within* each category and *not* across all three.

For each catalogue entry, a diagram has been provided giving an overview of all the prints described in that entry. The relationship between a, b, c, d, etc. in any catalogue entry is indicated by the headings dividing the set descriptions.

Catalogue 62

Plate No.	1	2	3	4	5
62a	☐	☐	☐	☐	☐
62b	☐	☐	☐	☐	
62c	☐	☐	☐	☐	
62d	☐				

In this example sets 62a and 62b are the original plates, with 62b being a reissue of 62a, while 62c and 62d are reversed copies by two separate engravers.

In a few cases neat arrangement has been stretched to breaking point by the nature of ornament prints. Two sets of architectural details (Catalogue 55a and 56), issued by two publishers each active in Rome in the sixteenth century, have overlapping contents. To describe the overlapping plates published by the later publisher, Nicolas van Aelst, as reissues – while strictly true – would split the van Aelst set over two separate catalogue

entries. For this reason the two sets have been kept distinct, with the overlap indicated in the accompanying notes. Sometimes a single set contains impressions of more than one type, as in the set of vase prints published by Antonio Lafrery (Catalogue 68b), which are twelve original plates and two reversed copies. Respecting the integrity of these hybrid sixteenth-century sets seemed of paramount importance, so that where necessary a descriptive heading such as 'Original Plates and Reversed Copy Plates' has had to be adopted. This is ungainly but at least it is accurate. In the case of Catalogue 50a–m, where a publisher copied the original plates but then extended the set, these are described as additional plates, which were themselves in turn copied.

Repetition of information within a single catalogue entry has been avoided, so that once the dates of an engraver, designer or publisher, or the measurements of a platemark, have been given, they are not repeated when describing reissues of the same plate. Once the lettering on a plate has been transcribed, only additions and reductions in the lettering are described explicitly for subsequent reissues of the plate, unless this would lead to ambiguity. Multiple impressions in the V&A collection of the same print are simply referred to by quoting their museum numbers. Where multiple impressions exist, it is the first one to be listed and described that is illustrated.

ORDER OF DESCRIBING THE PLATES IN A SET

The principles used to decide the order in which the plates in a set are described are listed below. If case (i) does not apply, then the set is tested against case (ii), and so on through to case (v).

(i) According to numbers or letters, which are part of the printed image.

(ii) According to numbers or letters that are known to have been added to the plates at a later date.

(iii) According to an order that emerges from the study of the prints themselves.

(iv) According to an order that exists in published literature on the prints.

(v) According to the order in which they were accessioned.

The description of sets of ornament prints presents a special set of challenges. In many cases the number and nature of prints in a set in this collection agree with the

standard description of them in the scholarly literature. In a few instances the holdings of the V&A enable improvements to be made to the existing literature. The most notable example of this is the Lafrery Volume.

A NOTE ON MUSEUM NUMBERS

Museum numbers identify individual impressions of prints in the V&A collection and are unique and unchanging. They fall into two main types:

1. The museum number of a print acquired before 1885 takes the form of a number, with or without a numerical or alphabetical suffix. Examples of three of these, arranged in chronological order of acquisition, are 12831, 21642.16 and 24434.A. Only the first part of the number, before any decimal point, is significant when arranging them in order of acquisition. In a very few cases, pre-1885 museum numbers can have both an alphabetical and a numerical suffix (e.g. 15647.A.10). Two or more sequential museum numbers of this type are expressed by listing the first and last numbers in the sequence divided by a dash. Thus 12831–12834 signifies the four museum numbers 12831, 12832, 12833 and 12834.

2. For acquisitions dating from 1885 onwards, a museum number takes the form E.181-1885. This stands for the 181st item acquired in the year 1885. Two or more sequential museum numbers are indicated by a dash between the highest and the lowest number. Thus E.262–265-1885 means E.262-1885, E.263-1885, E.264-1885 and E.265-1885. Occasionally a single number of this kind was given an alphabetical and numerical suffix (e.g. E.1184.D.1-1887).

A very few museum numbers correspond to items coming from a particular bequest, such as Dyce 1059, from the bequest of the Reverend Alexander Dyce (1798–1869).

In a running list of non-sequential museum numbers, the convention is to arrange them chronologically by date of acquisition, divided by commas.

WHAT IS NOT INCLUDED

This catalogue does not include volumes of ornament in the National Art Library at the V&A. In 1997 the National Art Library was awarded a grant by the Heritage Lottery Fund, enabling it to create the world's largest database dedicated to art and design literature. On completion of the five-year project, researchers working anywhere in the world will have free access via the Internet to more than one million records listing the National Art Library's holdings.[12]

Prints designed by Italian artists, but published for the first time outside Italy,[13] are excluded, as are prints by Italian engravers active outside Italy. Portraits with named sitters have been excluded,[14] with the exception of two sets of prints where the framing devices are printed from plates separate from those used for the portraits; here it is the frames and not the portraits that are catalogued (Catalogue 6 and 7).

Narrative prints with elaborate ornamental borders have been omitted,[15] on the grounds that it is the narrative element and not the ornament that surrounds it which is their main subject. Also excluded are maps, plans and representations of gardens and entire buildings; prints of theatrical events such as masques; and solitary title pages not related to any other prints in the collection.[16]

After careful consideration the work of the French engraver Jacques Androuet Ducerceau (?1510–84) has also been omitted, on the grounds that it would be wrong to describe even part of it as simply copies of sixteenth-century Italian prints. While many of his prints of vases and grotesques undoubtedly use sixteenth-century Italian ornament prints as their starting point, he also drew inspiration from Netherlandish prints, for example by Cornelis Bos (c. 1510–56). From these diverse sources he then synthesized his own vision of the grotesque, making alterations of scale and proportion to his sources that constitute a new act of creation.[17] To include here Ducerceau's specifically Italian-inspired images, which form part of larger sets, would be perverse. Instead, a full description of the Museum's holdings of his prints must wait until they can be seen in the context of a catalogue of all the Museum's sixteenth-century French ornament prints.

Notes

[1] Byrne, 1981, p.11.

[2] Catalogue 65.

[3] P. Fuhring, written communication 2 November 1997.

[4] Archduke Ferdinand of Tyrol's collection, discussed in the Introduction, also contained moresques (sometimes also referred to as arabesques). These are intertwining and interlacing foliate designs. For Italian examples by

Enea Vico and Monogrammist F, of which there are none in this collection, see Byrne, nos 14 and 15.

[5] Listed in the Bibliography as Berlin. The core of this collection, formerly known as the library of the Kunstgewerbemuseum (Museum of Applied Art), was acquired in 1879 from the French architect, Hippolyte Destailleur; see Fischer, p.8.

[6] M. de Jong and I. de Groot, *Ornamentprenten in het Rijksprentenkabinet I, 15de & 16de eeuw*, 's-Gravenhage, 1988. Entries from this work are cited in the catalogue entries with the abbreviation 'A' for Amsterdam.

[7] Collection marks added since entering this collection, corresponding to Lugt 31, 153b, 667a, 1957, 1958 and 2503, are not described.

[8] For guidance on the interpretation of abbreviations, see Cappelli.

[9] Catalogue of the Escorial Collection listed in the Bibliography under the abbreviation 'E'. Collijn.

[10] However, see the review of the new edition, Fuhring, 1987, for criticism of the changes introduced in the new edition, and a concordance between the two sets of plate numbers.

[11] For a discussion of the issue of sets, see Goddard and Ritchkoff.

[12] These holdings include, for example, a quantity of lace pattern books of the type described in Lotz, 1963.

[13] For example, twenty-three plates of strapwork cartouches in the collection on blue paper (14357.1-23),

dating from 1553, designed by the otherwise obscure Florentine painter Benedetto Battini. These are traditionally included in the Italian section of ornament print catalogues. They have been omitted from this catalogue on the grounds that they were published in Antwerp; see Riggs, 1977, p.311, no. 1.

[14] Examples of this type in the collection include Enea Vico, *Petrarch's Laura* (B. XV 237), E.990-1885, *Cardinal Pietro Bembo* (B. XV 242), 26332, and *Laura Terracina* (B. XV 248), 13745. For a portrait of the sixteenth-century Italian print-publisher, Antonio Salamanca, which shows the sitter above a strapwork cartouche bearing his name, and surrounded by putti, herms, masks, volutes, a festoon, a tassel-fringed curtain, and bead and reel moulding, by way of ornament, see Landau and Parshall, p.302, fig. 314. For portraiture in sixteenth-century Italian books, see Zappella.

[15] An example in the collection is the set by Giulio Bonasone, *Amore Sdegni et Gielosie di Givnone* (B. XV,113–134), Berlin 542, S. Massari, *Giulio Bonasone*, Rome, 1983, nos 194–215, E.1184.D.1–22-1887.

[16] This is in line with the decisions taken by the authors of the Amsterdam fifteenth- and sixteenth-century ornament print catalogue. See also A.F. Johnson, *A Catalogue of Italian Engraved Title-pages in the Sixteenth Century*, Supplement to the Bibliographical Society's Publications, no. 11, Oxford, 1936.

[17] See Wagner, pp.123–83. The omitted prints by Ducerceau relate to Catalogue 33, 66 and 68 in this volume.

PURE ORNAMENT

ALPHABETS

Catalogue 1

Plate No. | A B C D E F G H I K L M N O P Q R S T V X Y Z

SET DESCRIPTION

Original plates and reissues

1 Andrea MARELLI (active c. 1560–70), engraver. Plates (23) from the second part of *Il Perfetto Scrittore* by Giovanni Francesco CRESCI. Each plate depicts an interlaced letter surrounded by a strapwork border. Italian, Rome, 1570. Plates F, G, H, I, K, M, P, R, S, T and X signed variously with Marelli's name or monogram.
Engravings
E.2301–2323-1910

Lit: Guilmard, p.293, no. 38; Collijn, 97; Berlin, 5187.

NOTES: These prints are in a modern museum binding, which retains the bookplate of the author and collector A.D. Berard, died 1873 (Lugt, 75). In the process of binding, the letters H and N have become transposed. The listing below follows the alphabetical order. Both figures in plate E are derived from a print by Heinrich Aldegraver (1502–55/61), Ornament with Mask and Grotesque Figures, of 1549 (B. VIII, 445).

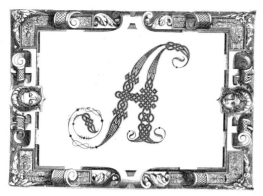

Cat. 1 pl. A

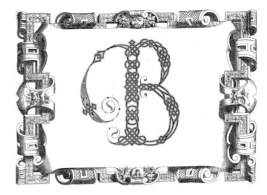

Cat. 1 pl. B

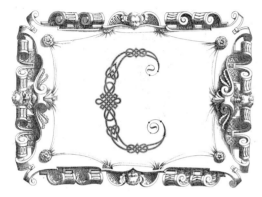

Cat. 1 pl. C

Cat. 1 pl. D

Cat. 1 pl. E

Cat. 1 pl. F

Cat. 1 pl. G

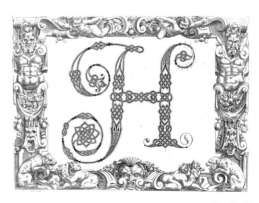

Cat. 1 pl. H

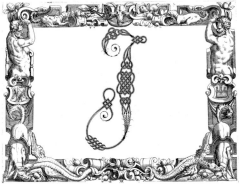

Cat. 1 pl. I

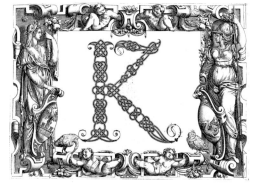

Cat. 1 pl. K

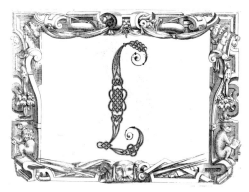

Cat. 1 pl. L

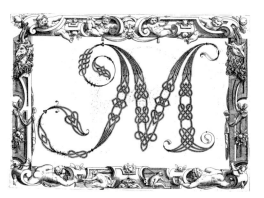

Cat. 1 pl. M

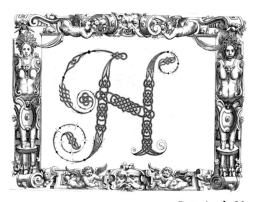

Cat. 1 pl. N

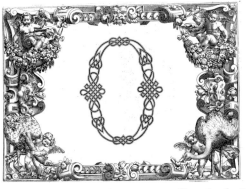

Cat. 1 pl. O

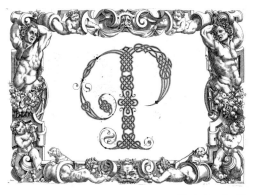

Cat. 1 pl. P

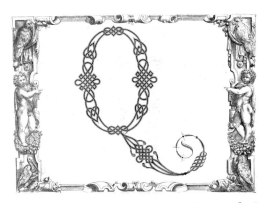

Cat. 1 pl. Q

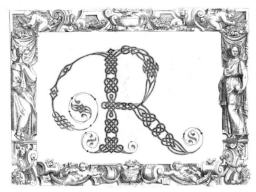

Cat. 1 pl. R

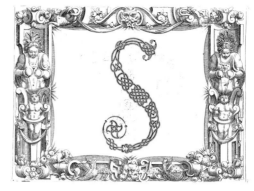

Cat. 1 pl. S

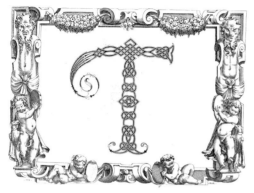

Cat. 1 pl. T

Cat. 1 pl. V

Cat. 1 pl. X

Cat. 1 pl. Y

Cat. 1 pl. Z

Catalogue 1: PLATE DESCRIPTIONS

Plate A

Letter A in a strapwork border with a female mask at either side. Cut to 15.5 x 21.8 cm
E.2301-1910

Plate B

Letter B in a strapwork border with a male grotesque mask at either side and a child's mask amidst fruit and foliage at the top and bottom. Cut to 15.4 x 21.6 cm
E.2302-1910

Plate C

Letter C in a strapwork border with a male grotesque mask at either side and a cherub head in a shell at the top and bottom. Cut to 15.9 x 21.5 cm
E.2303-1910

Plate D

Letter D in a strapwork border with a winged nereid on the left and a winged triton on the right. Cut to 15.2 x 21.3 cm
E.2304-1910

Plate E

Letter E in a strapwork border with a male satyr in a shell on the left and a veiled figure with satyr legs in a shell on the right. Cut to 15.2 x 21.2 cm
E.2305-1910

Plate F

Letter F in a strapwork border with putti, on either side a woman suckling a child, and with a unicorn in the bottom left and a stag in the bottom right corners. Signed in monogram *AM*. Cut to 15.1 x 21.5 cm
E.2306-1910

Plate G

Letter G in a strapwork border with a standing female figure with dividers, set-square and flaming torch on the left, and a winged figure blowing a trumpet on the right. Signed in monogram *AM*. Cut to 16.6 x 22.3 cm
E.2307-1910

Plate H

Letter H in a strapwork border with a satyr-herm on each side, and with a putto holding a cat baiting a dog in each lower corner. Signed in monogram *AM*. Cut to 15.2 x 21.3 cm
E.2313-1910

Plate I

Letter I in a strapwork border containing a male nude half-figure supporting a scroll on either side, with a bucranium [animal skull] at the top flanked by a hound on either side. Signed in monogram *AM*. Cut to 16.1 x 21.6 cm
E.2309-1910

Plate K

Letter K in a strapwork border with a standing female figure with an olive crown holding a shield, with a coat of arms on the left and, on the right, Minerva. Signed *AND. MAR.* Cut to 15.3 x 21.2 cm
E.2310-1910

Plate L

Letter L in a strapwork border with a female head on each side on an S-scroll support, above a monkey. Cut to 15.2 x 21 cm
E.2311-1910

Plate M

Letter M in a strapwork border with a goat's head on each side, with putti at the top and two monkeys at the bottom. Signed *ANDREA*. 15.4 x 21.2 cm
E.2312-1910

Plate N

Letter N in a strapwork border with a female herm on either side, with an elaborate head-dress and goat's legs. Cut to 15.6 x 21.2 cm
E.2308-1910

Plate O

Letter O in a strapwork border with a putto seated on a swag in each top corner, and a putto with an ostrich in each lower corner. Cut to 15.7 x 21.2 cm
E.2314-1910

Plate P

Letter P in a strapwork border with a naked male half-figure on each side, and a putto with a bunch of grapes in each lower corner. Signed *.AND./MARELLI.* Cut to 15.4 x 21.3 cm
E.2315-1910

Plate Q

Letter Q in a strapwork border with a standing, pointing putto and various birds on either side. Cut to 15.5 x 21.5 cm
E.2316-1910

Plate R

Letter R in a strapwork border containing a male standing figure on the left and a female standing figure holding a sphere on the right, and with a vase flanked by squirrels and putti at the top. Signed in monogram *AM.* 15.7 x 21.6 cm
E.2317-1910

Plate S

Letter S in a strapwork border containing on each side a female figure squirting milk from both breasts into the mouth of a putto below. Signed in monogram *AM.* Cut to 15.5 x 21.3 cm
E.2318-1910

Plate T

Letter T in a strapwork border containing a male herm above a tambourine-playing putto. Signed *.AND./.MAR.* Cut to 15.2 x 21 cm
E.2319-1910

Plate V

Letter V in a strapwork border containing, on either side, a female half-figure bearing a vase, above a putto blowing a trumpet and riding a goose. Cut to 15.6 x 21.3 cm
E.2320-1910

Plate X

Letter X in a strapwork border containing a satyr-herm on each side. At the top two reclining putti, and at the bottom, in each corner, a seated putto. Signed in monogram *AM.* Cut to 15.5 x 21.2 cm
E.2321-1910

Plate Y

Letter Y in a strapwork border containing on each side a naked male herm with arms upraised, above a putto playing with a rabbit. Cut to 16.4 x 21.7 cm
E.2322-1910

Plate Z

Letter Z in a strapwork border with the head of a winged putto on either side. 15.7 x 21.7 cm
E.2323-1910

Catalogue 2

Plate No.	A	B	C	D	E	F	G	H	I	L	M	N	O	P	Q	R	S	T	V	Z
2a	☐				☐	☐	☐	☐	☐	☐	☐					☐	☐		☐	
2b	☐	☐	☐	☐	☐		☐	☐	☐	☐	☐	☐	☐	☐	☐	☐	☐	☐	☐	☐
2c						☐								☐						

SET DESCRIPTIONS

Original plates and reissues

2a I. PAULINI (active c. 1570), engraver. Plates (11) from a set of twenty letters of the alphabet showing mythological scenes relating to figures with the corresponding initial, within borders of strapwork. Letters A, E, F, G, H, I, L, M, R, S and V. Italian, c. 1570. Lettered variously *Con Priuilegio*.
Engravings
15647.A.2, 6–12, 17, 18, 20

Lit: Guilmard, p.293, no. 40.

2b I. PAULINI, engraver. Plates (19). Reissues of Catalogue 2a. Plates A, B, C, D, E, G, H, I, L, M, N, O, P, Q, R, S, T, V and Z. Italian, 1570s. Lettered variously *Con Priuilegio* and with titles added.
15647.A.3–5, 13–16, 19, 21 and 27964. 1–5, 7–13, 15–20

Lit: Berlin, 5279; A. 615.1–5 and A. 615.7–20.

Copy plates

2c ANONYMOUS, engraver. Teodoro SPECIE (active late 16th century), publisher. Copy plates (2) after Catalogue 2b, plates F and P. Italian, late 16th century.
Engravings
27964.6 and 14

Lit: Fuhring, 1989, note 615; Fuhring, 1990, no. 1067.

NOTES: The impressions 27964. 1–20 are stamped with an unidentified ornament print collector's mark (Lugt, 2342), perhaps F. Soleil of the Banque de France. The impressions 27964. 1–3, 5, 7–13, 15, 16–19 are partially pricked for transfer. The letter P in 15647.A.14 is indented for transfer. The impressions 15647.A.2–21 are bound together in a modern binding. All of the impressions in Catalogue 2a and two of the impressions in Catalogue 2b, namely 15647.A.3 and 4, appear to be on the same paper, have all been trimmed, and exhibit the same signs of insect damage in the bottom left corner. This suggests that at some date impressions with and without the additional titles were being printed and bound together. A set in Stockholm (Collijn, 120) carries the titles but lacks the engraver's name on the first plate.

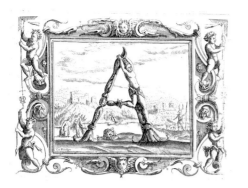

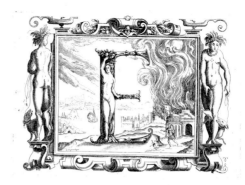

Cat. 2a pl. A

Cat. 2a pl. E

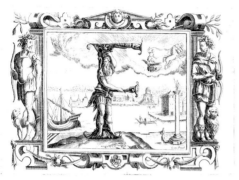

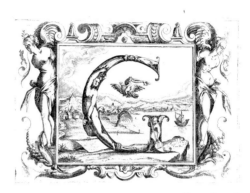

Cat. 2a pl. F

Cat. 2a pl. G

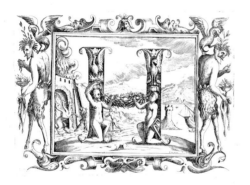

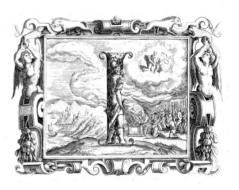

Cat. 2a pl. H

Cat. 2a pl. I

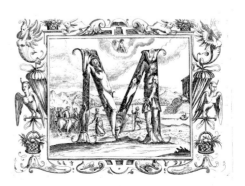

Cat. 2a pl. L

Cat. 2a pl. M

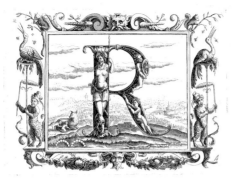

Cat. 2a pl. R

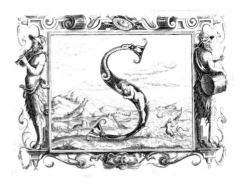

Cat. 2a pl. S

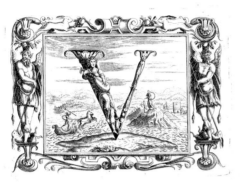

Cat. 2a pl. V

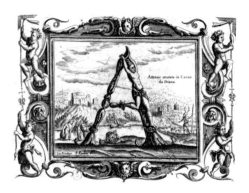

Cat. 2b pl. A

Cat. 2b pl. B

Cat. 2b pl. C

Cat. 2b pl. D

Cat. 2b pl. E

Cat. 2b pl. G

Cat. 2b pl. H

Cat. 2b pl. I

Cat. 2b pl. L

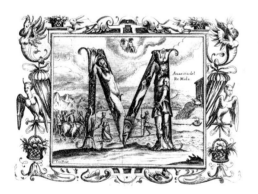

Cat. 2b pl. M

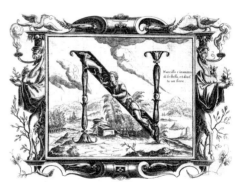

Cat. 2b pl. N

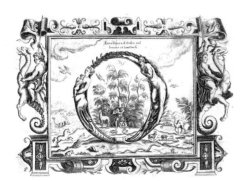

Cat. 2b pl. O

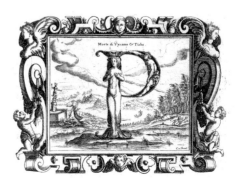

Cat. 2b pl. P

Cat. 2b pl. Q

Cat. 2b pl. R

Cat. 2b pl. S

Cat. 2b pl. T

Cat. 2b pl. V

Cat. 2b pl. Z

Cat. 2c pl. F

Cat. 2c pl. P

Catalogue 2: PLATE DESCRIPTIONS

Plate A

(a) Letter A with Actaeon turned into a stag by Diana. Lettered *Con Priuilegio*. Cut to 11.2 x 15.2 cm
15647.A.2

(b) Impression (A.615.1). Signed *.I. Paulini. F.* Lettered additionally *Ateone mutato in Ceruo da Diana*. Cut to 10.8 x 15.2 cm
27964.1

Plate B

(b) Letter B with Pentheus, and Bacchus on a triumphal car (A.615.2). Lettered *Penteo.* and *Bacco Trionfante*. 10.3 x 15.3 cm
15647.A.3

(b) Another impression.
27964.2

Plate C

(b) Letter C with Cadmus and his wife turned into serpents (A.615.3). Lettered *Cadmo mutato in Serpente con la moglie*. 11.4 x 15.8 cm
15647.A.4

(b) Another impression.
27964.3

Plate D

(b) Letter D with Daedelus and the fall of Icarus (A.615.4). Lettered *Cum Priuil./Dedalo./Icaro.* 10.8 x 15.2 cm
15647.A.5

(b) Another impression.
27964.4

Plate E

(a) Letter E with Aeneas rescuing his father Anchises from burning Troy. Lettered *Con priuilegio*. 10.9 x 15.6 cm
15647.A.6

(b) Impression (A.615.5). Lettered additionally *Enea che porta Anchise suo padre sulle spalle*. 10.9 x 15.6 cm
27964.5

Plate F

(a) Letter F with Phaethon in his chariot. Lettered *Cum Priuil.* 11 x 15.8 cm
15647.A.7

(c) Impression. Lettered additionally *Fetonte guida il carro del sole*. Cut to 11.2 x 15.4 cm
27964.6

Plate G

(a) Letter G with the rape of Ganymede. Lettered *Cum Pri.* 10.8 x 15.3 cm
15647.A.8

(b) Impression (A.615.7). Lettered additionally *Ganimede rapito da Gioue*. 10.8 x 15.5 cm
27964.7

Plate H

(a) Letter H with Hercules encountering Cerberus. Lettered *Con priu.* 10.9 x 15.1 cm
15647.A.9

(b) Impression (A.615.8). Lettered additionally *Hercole entrando nel'inferno Amazza Cerbero*. 10.8 x 15.2 cm
27964.8

Plate I

(a) Letter I with Iphigenia rescued from sacrifice. Lettered *Con pri.* 10.8 x 15.3 cm
15647.A.10

(b) Impression (A.615.9). Lettered additionally *Ifigenia. condotta al Sagrificio*. 10.8 x 15.3 cm
27964.9

Plate L

(a) Letter L with Lycaon turned into a wolf. Lettered *Con Priuil.* 10.9 x 16 cm
15647.A.11

(b) Impression (A.615.10). Lettered additionally *Licaone: mutato in: Lupo*. 11 x 15.9 cm
27964.10

Plate M

(a) Letter M with King Midas. Lettered *Cum Priuil.*
10.5 x 15 cm
15647.A.12

(b) Impression (A.615.11). Lettered additionally *Auaritia del Re Mida.* Cut to 10.6 x 14.9 cm
27964.11

Plate N

(b) Letter N with Narcissus admiring his own reflection (A.615.12). Lettered *Con priuil.* and *Narciso s'inamora di se stesso, et diue: ta un fiore.* 10.9 x 15.8 cm
15647.A.13

(b) Another impression.
27964.12

Plate O

(b) Letter O with Orpheus playing his lyre (A.615.13). Lettered *Con priu.* and *Eccellenza d'Orfeo nel sonare et lametarsi.* 10.8 x 16 cm
15647.A.14

(b) Another impression.
27964.13

Plate P

(b) Letter P with the death of Pyramus and Thisbe (A.615.14). Lettered *Con Priuil.* and *Morte di Pyramo et Tisbe.* 10.7 x 15.7 cm
15647.A.15

(c) Impression. Lettered *Morte di Pyramo e Tisbe.* Cut to 11 x 15.4 cm
27964.14

Plate Q

(b) Letter Q with Quintus Curtius (A.615.15). Lettered *Con priuil.* and *Quinto Curtio.* 10.6 x 14.9 cm
15647.A.16

(b) Another impression.
27964.15

Plate R

(a) Letter R with Romulus and Remus. Lettered *Con priuil.* 11 x 15.5 cm
15647.A.17

(b) Impression (A.615.16). Lettered additionally *Romolo et Remo primi fondatori di Roma.*
27964.16

Plate S

(a) Letter S with a Siren. Lettered *Cum Priuil.*
11 x 15.3 cm
15647.A.18

(b) Impression (A.615.17). Lettered additionally *Serena.*
11.0 x 15.3 cm
27964.17

Plate T

(b) Letter T with Theseus and the Minotaur (A.615.18). Lettered *Con Priuilegio.* and *Teseo uince il Minotauro et inganna Arianna.* 10.5 x 15 cm
15647.A.19

(b) Another impression.
27964.18

Plate V

(a) Letter V with Venus, Cupid and Pluto. Lettered *Con Pri.* 11.1 x 15.6 cm
15647.A.20

(b) Impression (A.615.20). Lettered additionally *Plutone./Venere et Cupido.* Cut to 11.3 x 15.5 cm
27964.19

Plate Z

(b) Letter Z with Zaratani (A.615.20). Lettered *Con priuilegio.* and *Zaratani.* 10.8 x 15.3 cm
15647.A.21

(b) Another impression.
27964.20

FRAMES AND CARTOUCHES

Catalogue 3

Plate No.

PLATE DESCRIPTION

Original plates and reissues

3 Enea VICO (1523–67), engraver. Emblem of Enea Vico. An ostrich with a banderole around its neck in an oval cartouche flanked by terminal figures supporting another cartouche. Italian, mid-16th century. Signed *AENEAE VICI*. Lettered *TENTANDA VIA EST*.
Engraving. Cut to 11.4 x 7.5 cm
E.2466-1912

Lit: B. XV, 35.

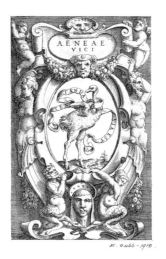

Cat. 3

Catalogue 4

Plate No.

PLATE DESCRIPTION

Original plates and reissues

4 Andrea SCHIAVONE (c. 1510–63), engraver. Plate from a suite of 21 plates representing miscellanous subjects grouped together by Bartsch (B. XVI, 13–33). Bust of a young woman seen in profile turned to the left, in an oval niche, in the middle of an architectural decoration enriched by many figures, including at the top a seated putto entwined with a snake. Italian, mid-16th century. Signed *Andrea Schiaon f.*
Etching. 17.9 x 12.7 cm
20024.A

Lit: B. XVI, 13; Guilmard, p.283, no. 23; Berliner, 380.

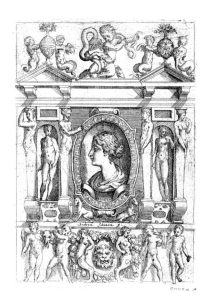

Cat. 4

Catalogue 5

Plate No. | 1 | 2 | 3 | 4 | 5 | 6 | 7 | 8 | 9 | 10 | 11 | 12 | 13

SET DESCRIPTION

Copy plates

5 ANONYMOUS, engraver. Hans VREDEMAN DE VRIES (1527–?1606), designer. Antonio LAFRERY (1512–77), publisher. Plates (13), on seven sheets, of strapwork cartouches. Copies of *Variarum Protractionum (vulgò Compartimenta vocant)...* 1555, H. XLVII, nos 14–26, without the classical Latin texts. Italian, c. 1573. Numbered *1* to *13*.
Engravings
E.2026–2038-1899

Lit: Brown, 86, as Hans Vredeman de Vries; H. XLVII, nos 14–26, copy 1; Miller.

NOTES: Catalogue 5 forms part of the Lafrery Volume (see Introduction) and corresponds to the entry *Libro di diuersi compartimenti* in Lafrery's stocklist of c. 1573 (Ehrle, p.59).

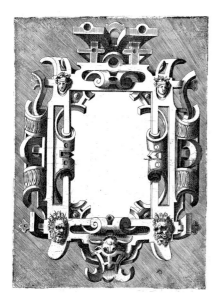

Cat. 5 pl. 1

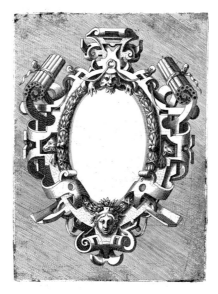

Cat. 5 pl. 2

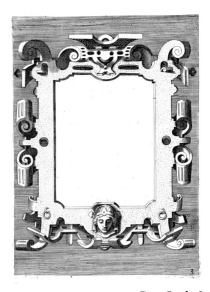

Cat. 5 pl. 3

Catalogue 6: PLATE DESCRIPTIONS

Plate 1

Title page, border of strapwork with two vases and two swags of fruit. The plate for the framing border signed in monogram .C.G.F. The central medallion printed from a separate plate lettered *NATTVRRALLI. E. VERRI RETRAtti. D. TVTI. LI. SIGNIORI DE. TVRRCHI. IN VENETIA ALL. INSEGNA. DEL LEONE.* and dated *1591*. Cut to 20.4 x 15.5 cm
21412.1

Other impressions (4) enclosing medallion portraits of various Sultans.
21412.2, 21412.4, 21412.5, 21412.8

Plate 2

Border of strapwork with two bunches of fruit, enclosing a medallion printed from a separate plate representing Sultan Suleyman. Lettered .C.G.F. Cut to 20.4 x 15.5 cm
21412.3

Other impressions (2) enclosing medallion portraits of various Sultans.
21412.6, 21412.7

Catalogue 7

SET DESCRIPTION

Original plates and reissues

7 ANONYMOUS engraver. Plates (2) of strapwork borders designed to enclose portraits printed from separate plates. Issued with a set of portraits of Sultans of Turkey and Kings of Spain. Italian, after 1591.
Engravings
E.820–829-1927

NOTES: These plates are probably replacements for borders composed of similar elements by Camillo Graffico, Catalogue 6, as five of the portraits are common to both sets.

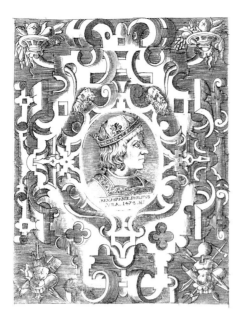

Cat. 7 pl. 1

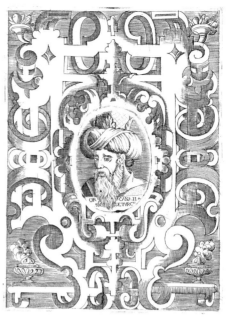

Cat. 7 pl. 2

Catalogue 7: PLATE DESCRIPTIONS

Plate 1

Border of strapwork with two cornucopiae and two trophies enclosing a portrait of Philip VII (sic) printed from a separate plate. 20.7 x 15.9 cm

E.820-1927

Other impressions (3) enclosing portraits of Sultans of Turkey and Kings of Spain.

E.821-1927, E.825-1927, E.826-1927

Plate 2

Border of strapwork with two smoking urns enclosing a portrait of Sultan Orcana printed from a separate plate. 21.2 x 15.9 cm

E.822-1927

Other impressions (5) enclosing portraits of Sultans of Turkey.

E.823-1927, E.824-1927, E.827-1927, E.828-1927, E.829-1927

Bartsch then lists a plate, three friezes with ornamental foliage (B. XV, 454), not present in the Lafrery Volume. (A cut-down impression of this plate is in the V&A's collection, Catalogue 13.) Bartsch then follows this with a description of the remainder of the set (B. XV, 455–66), pointing out that the earliest impressions are unnumbered. Because Bartsch noted pairs of plates numbered IIII, V and VI, he surmised that one of each of these pairs ought to be numbered I, II and III, since every suite he inspected lacked plates so numbered. The continuous numbering of all seventeen plates in the Lafrery Volume indicates that this reasoning was not correct.

Plate II lower is a reversed copy of a print by Giovanni Antonio da Brescia (B. XIII, 19; Faietti and Scaglietti Kelescian, III, 1, p.330). The print by Giovanni Antonio da Brescia is itself a copy of a print attributed to Amico Aspertini (Faietti and Scaglietti Kelescian, I, 2, pp.326–7), dating from the end of the second decade of the 16th century. Berliner suggests a date of c. 1545 for the original publication of plate III upper. Plate IX of Catalogue 9b is copied in reverse as plate 11 of Catalogue 16. As Catalogue 16 is dated 1561, this indicates that Catalogue 9b, plate IX must date from before this time.

Impressions of ten of the plates in Catalogue 9b but before the addition of the Roman numerals are in the Escorial collection. These plates, E. IX, 35.(4446) and E. IX, 37.1-9(4448–54,4456–7) correspond to plates III upper, IIII lower, V upper, VI upper and lower, VII–IX, XI and XII in the set described here.

The order of the plate descriptions below follows the numbering on the impressions in the Lafrery Volume, rather than that given in Bartsch.

Cat. 9a pl. III(*l***)**

Cat. 9b pl. I

Cat. 9b pl. II(*u***)**

Cat. 9b pl. II(*l***)**

Cat. 9b pl. III(*u*)

Cat. 9b pl. III(*l*)

Cat. 9b pl. IIII(*u*)

Cat. 9b pl. IIII(*l*)

Cat. 9b pl. V(*u*)

Cat. 9b pl. V(*l*)

Cat. 9b pl. VI(*u*)

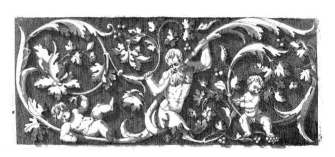

Cat. 9b pl. VI(*l*)

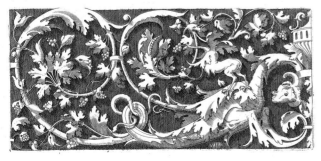

Cat. 9b pl. VII

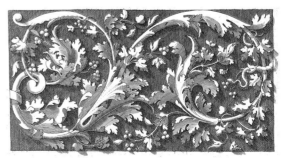

Cat. 9b pl. VIII

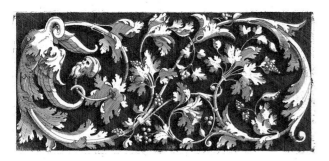

Cat. 9b pl. IX

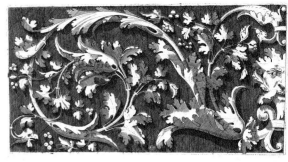

Cat. 9b pl. X

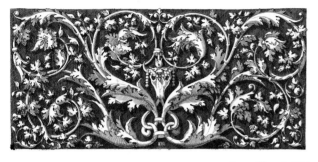

Cat. 9b pl. XI

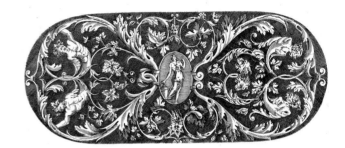

Cat. 9b pl. XII

Catalogue 9: PLATE DESCRIPTIONS

Plate I

(b) Eight children dancing to a bagpipe (B. XV, 38). Signed in monogram *CER* and dated *M.D.LXX*. Lettered *Romae Ant: Lafreri*. Numbered *I*. 10.3 x 31.1 cm
E.2098-1899

Plate II upper

(b) Ten children dancing to a bagpipe (B. XV, 37). Lettered *VBI EST ADOLOCENTIA IBI EST GAVDIVM SINE MALICIA*. Numbered *II*. 10.5 x 19.7 cm
E.2099-1899

Plate II lower

(b) Children dancing to the beat of a drum (B. XV, 36). Lettered *ADOLOSCENTIA ET VOLVPTAS VANA SVNT*. Numbered *II*. 11 x 20.9 cm
E. 2100-1899

Plate III upper

(b) Frieze with scrolling foliage, a siren and four children. Reissue of B. XV, 453 numbered (Berlin, 536; Berliner, 364). Signed *E.V*. Numbered *III*. 8.3 x 21 cm
E.2101-1899

Plate III lower

(a) Frieze with scrolling foliage and two chimerical animals (B. XV, 452; Berliner, 232). Signed in monogram *F*. Lettered *S.P.Q.R*. Cut to 6.2 x 19.5 cm
E.2529-1929

(b) Impression. Numbered *III*. 7.6 x 22.3 cm
E.2102-1899

Plate IIII upper

(b) Ornamental foliage with a mask, from the mouth of which issue two dolphins. Numbered *IIII* (B. XV, 456). 10.7 x 21.4 cm
E.2103-1899

Plate IIII lower

(b) Ornamental foliage with the head of a dolphin, bottom left. Numbered *IIII* (B. XV, 455). 9.1. x 23.1 cm
E.2104-1899

Plate V upper

(b) Ornamental foliage with a cornucopia. Numbered *V* (B. XV, 457; A. 651.1). 10 x 26.1 cm
E.2105-1899

Plate V lower

(b) Ornamental foliage with a nude man looking upward. Numbered *V* (B. XV, 458). 9.7 x 24.5 cm
E.2106-1899

Plate VI upper

(b) Ornamental foliage with a mask and a bowl of fruit. Numbered *VI* (B. XV, 459). 10.2 x 24.3 cm
E.2107-1899

Plate VI lower

(b) Ornamental foliage with an old man and two children. Numbered *VI* (B. XV, 460). 10.3 x 24.9 cm
E.2108-1899

Plate VII

(b) Ornamental foliage with a chimerical ram. Numbered *VII* (B. XV, 461; Berliner 365). 10.7 x 23.6 cm
E.2109-1899

Plate VIII

(b) Ornamental foliage with scattered berries. Numbered *VIII* (B. XV, 462; A. 651.2). 14.6 x 28.1 cm
E.2110-1899

Plate IX

(b) Ornamental foliage with the head of a man in a turban. Numbered *IX* (B. XV, 463). 13.7 x 30.7 cm
E.2111-1899

Plate X

(b) Ornamental foliage with the left half of a mask. Numbered *X* (B. XV, 464). 16.3 x 31.3 cm
E.2112-1899

Plate XI

(b) Ornamental foliage with the skull of a bull. Numbered *XI* (B. XV, 465; Berliner 366). 15.2 x 32.9 cm
E.2113-1899

Plate XII

(b) Ornamental foliage with a medallion of a woman with a covered urn. Numbered *XII* (B. XV, 466). 13.8 x 32.6 cm
E.2114-1899

Catalogue 10

Plate No.

PLATE DESCRIPTION

Original plates and reissues

10 Agostino VENEZIANO (c. 1490–c. 1540), engraver. Antonio SALA-MANCA (c. 1500–62), publisher. Frieze with Eros and a siren. Italian, Rome, 1530. Signed in monogram *A.V.* Dated *1530.* Lettered *Ant. Sal. exc.* Engraving. Cut to 10.4 x 24.9 cm
16743

Lit: B. XIV, 539; Guilmard, p.285, no 16; Berlin, 526 (2); Berliner, 246; A. 643; Fuhring, 1989, no. 643; E. VIII, 49.(3212).

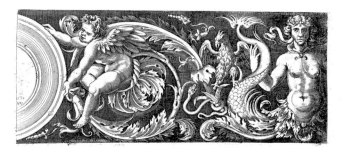

Cat. 10

Catalogue 11

Plate No.

PLATE DESCRIPTION

Original plates and reissues

11 Monogrammist D.A. (active c. 1535), engraver. Plate depicting two bound male figures with plant stems issuing from their mouths, on which perch birds, plucking grapes from baskets. On the head of each man, a putto tying a ribbon. Italian, c. 1535. Signed in monogram *D.A.* with ears of corn. Engraving. Cut to 8.4 x 21 cm
E.1469-1923

Lit: Berliner, 270.

NOTES: Berliner points out that the copper plate had four circular rivets at the corners, hatched to match the plate.

Cat. 11

Catalogue 12

Plate No.

PLATE DESCRIPTION

Original plates and reissues

12 Giulio BONASONE (active c. 1531–74), engraver. Francesco PARMI-GIANINO (1503–40), designer. Ornamental frieze with a winged centaur lighting a torch at an altar. Italian, early 1540s.
Engraving. Cut to 13.2 x 29.6 cm
29460.10

Lit: B. XV, 353; Guilmard, p.288, no. 20; Berliner, 370; Byrne, 56; Massari, 7a.

NOTES: This engraving is after a lost drawing by Parmigianino, a copy of which is in the Louvre (Popham, vol. 1, p.237, no. 26).

Cat. 12

Catalogue 13

Plate No.

PLATE DESCRIPTION

Original plates and reissues

13 Enea VICO (1523–67), engraver. Antonio SALAMANCA (c. 1500–62), publisher. Two friezes with ornamental foliage, lacking a third upper frieze. This impression shows the middle frieze with a bird and a mask seen in profile, and the lower frieze with a grotesque figure with a female head and a foliate tail. A reissue of B. XV, 454. Italian, mid-16th century. Signed in monogram *E.V.* Lettered *Ant. Sal. exc.*
Engraving. Cut to 13.9 x 23.6 cm
16793

Lit: B. XV, 454; Berlin, 536; Berliner, 363; E. IX, 36.(4447).

NOTES: Bartsch records that the three panels are engraved on the same plate, but were intended to be separated. The impression of this print in Berlin lacks Salamanca's name.

Cat. 13

Catalogue 14

Plate No. | 1 | 2

SET DESCRIPTION

Original plates and reissues

14 ANONYMOUS, engraver. Plates (2) of friezes of scrolling foliage with putti, animals and figures. Italian, mid-16th century.
Engravings
17429, E.46-1888

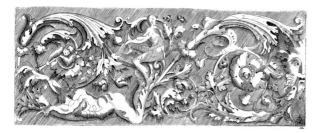

Cat. 14 pl. 1

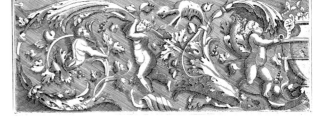

Cat. 14 pl. 2

Catalogue 14: PLATE DESCRIPTIONS

Plate 1

A frieze of scrolling foliage with a mask on the right, a recumbent nude male figure on the left and a putto with a trumpet. 10.7 x 27.4 cm
17429

Plate 2

A frieze with a half-satyr facing to the right, one putto facing to the left and a second putto facing to the right towards a half-vase. 10.4 x 27.4 cm
E.46-1888

Catalogue 15

Plate No.

PLATE DESCRIPTION

Original plates and reissues

15 ANONYMOUS, engraver. Foliage with a figure seen from the rear on a half-horse. On the far right, a bird. Italian, mid-16th century.
Engraving. Cut to 10.9 x 36.2 cm
17003

NOTES: An impression of this print from the Liechtenstein collection is in the Metropolitan Museum of Art, New York, accession no. 53.600.65. The composition bears some similarities (although without the shaded background) to a print that Hind catalogues as Giovanni Antonio da Brescia, Ornamental Panel with a Mermaid (Hind V, no. 54).

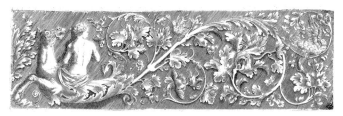

Cat. 15

Catalogue 16

Plate No. | 1 9 11 16

SET DESCRIPTION

Original plates, copy and reversed copy plates

16 Giovanni Battista PITTONI, the Elder (c. 1520–83), engraver. Nicolò VALEGIO (active 1561–98), publisher. Plates (4) including title plate, from a set of sixteen plates of scrolling foliage with figures, putti and grotesque animals. Plate 9 is a copy of Berliner, 274; plate 11 is a reversed copy of Enea Vico, B. XV, 463, Catalogue 9b, pl. IX. Italian, Venice, 1561.
Engravings
27441.A, 27441.B, 29976.5, E.1389-1897, E.1395-1897

Lit: Guilmard, p.291, no. 31; Berlin, 546; A. 618.

NOTES: Bellini, 1995, records a father and son, Nicolò and Giovanni Giacomo Valegio, who were printers and publishers active in Venice from at least 1566. This set of prints indicates that Nicolò was active before this date. The plates are described in order of the Amsterdam catalogue, with the plate not in the Amsterdam collection placed at the end. Some of the plates in Amsterdam, but not present here, are upright panels rather than friezes.

Cat. 16 pl. 1

Cat. 16 pl. 9

Cat. 16 pl. 11

Cat. 16 pl. 16

Catalogue 16: PLATE DESCRIPTIONS

Plate 1

Title plate. Two winged half-women flank a central cartouche (A. 618.1). Signed in monogram *.B.P.P.V.F.* Dated *1561*. Lettered *Al molto magco et Eccellte. sr. alessandro Fedrici nobile Triuigiano rarissi. D. di leggi — Baptista pitoni incenzo Nicolau Valegn formis. CON GRATIA .E.T. PRIVILEGIO DI.VENETIA. PE ANI .XV.* Cut to 12.8 x 26.8 cm

E.1395-1897

Plate 9

Foliage with a male half-figure and grotesque animals (A. 618.9). Signed in monogram *BPV*. Cut to 11.8 x 27.8 cm

29976.5

Another impression.

27441.A

Plate 11

Foliage with grapes and a bearded head (A. 618.11). Lettered *cum priuilegio*. Cut to 12.9 x 28.3 cm

27441.B

Plate 16

Foliage including three putti [not in A.]. Signed in monogram *B.P.V.F.* Cut to 13.4 x 26.2 cm

E.1389-1897

Catalogue 17

Plate No.

PLATE DESCRIPTION

Original plates and reissues

17 ANONYMOUS, engraver. Antonio LAFRERY (1512–77), publisher. Two friezes of scrolling foliage. Italian, 1561. Dated *M.D.LXI.* Lettered *Sic Romae Visunter intercolumniorum folia, mira diligentia ex antigrapho antiquo quod hodie in aedibus Andreae, quondam Card. à Valle, integro marmore conspicitur, desumpta; quibus, lector, interea tibi frui licebit dum ex eodem promptuario et hijs similia, atq etiam maiora propediem paramus. formis Ant. Lafr. Sequam. Romae.* Engraving. 29.2 x 44.5 cm

E.3624-1906

Other impressions (2).

13249.1-2, 17001 [fragment]

Lit: Hülsen, 142; Berlin, 547; Brown, 1.

NOTES: The first of these impressions is a plate in a copy of the *Speculum Romanae Magnificentiae*. The two friezes would be continuous if the left edge of the top frieze were joined to the right edge of the lower frieze.

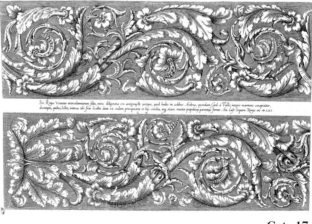

Cat. 17

Catalogue 18

Plate No.

PLATE DESCRIPTION

Copy plates

18 ANONYMOUS, engraver. Antonio LAFRERY (1512–77), publisher. Bas-relief with three Cupids, one carrying a trident, the others a large shell. Copy of Marco DENTE (active 1515–d. 1527). B. XIV, 242; Berlin, 524(1). Italian, third quarter of the 16th century. Dated *M.D.X.VIIII*. Lettered *OPVS. HOC. ANTIQVV. SCVLP. REPERITVR. RAVENAE. IN. AED. DIVI. VITALIS.* Engraving. 19.3 x 36 cm
28193

Another impression.
E.3672-1906 [bound into a copy of *Speculum Romanae Magnificentae*]

Lit: Guilmard, p.285, no. 14; Hülsen, 73; E. IV, 8.1a (1260) as Marco Dente.

NOTES: The engraving by Marco Dente, of which this is a copy, is dated 1519. It is after a fragment of an antique frieze preserved in S. Vitale, Ravenna, known as the Throne of Neptune. See Bober and Rubinstein, no. 52A, and Brown University, no. 38.

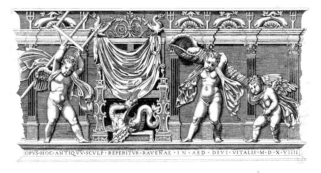

Cat. 18

GROTESQUES

Catalogue 19

Plate No.

PLATE DESCRIPTION

Original plates and reissues

19 Possibly by Peregrino da CESENA (active 1490–1510), engraver. Panel of ornament with a winged chimera. Below the shield, the lower part of an animal. Italian, 1490–1510. Signed in monogram *P*.
Engraving. 8.2 x 2.4 cm
21118

Lit: Hind, 1936, no. 263; Berliner, 238; A. 596.

NOTES: Hind calls this print 'in the manner of Peregrino'.

Cat. 19

Catalogue 20

Plate No. | 1 2 3 4 5 6 7 8 9 10 11 12

SET DESCRIPTION

Original plates and reissues

20 Giovanni Pietro da BIRAGO (Master of the Sforza Book of Hours) (active 1470s–1513) and Giovanni Antonio da BRESCIA (active late 1490s–first quarter of 16th century), engravers. Giovanni Pietro da BIRAGO, designer. Plates (12) of ornamental panels, of which nine (B. XIII, 21–3, 26, 28–32) were engraved by Giovanni Pietro da Birago and three (B. XIII, 24, 25, 27) by Giovanni Antonio da Brescia. Italian, c. 1505–7. Plate 4 signed in monogram *Z.A.*
Engravings
22701.1–2, E.631-1890, E.2211–2222-1920

Lit: B. XIII, 21–32 as Zoan Andrea; Jessen, 26–9; Hind V, no. 10 (1–12) as Master of the Sforza Book of Hours; Berlin, 522; Berliner, 184–7; Washington, 102–13; Brown, 48a, b & c; Byrne, 76–87; Jean-Richard, 137–8; A. 585.

NOTES: Bartsch attributed the whole set to an engraver called Zoan Andrea. He did this on the basis of an identification first made in 1802 (see Martineau (ed.), p.58), that the initials *ZA* appearing on the fourth plate stood for an engraver with this name.

According to the Washington catalogue, Kristeller was the first to associate this set with the illuminator, the so-called Master of the Sforza Book of Hours, who was responsible for most of the miniatures in the illuminated manuscript *The Sforza Book of Hours* (British Library, Add MS 34294). Kristeller also put forward the view that only three of the prints, the signed plate 4 (B. XIII, 24) and two others, plates 5 and 7 (B. XIII, 25 and 27), were engraved in the manner of Zoan Andrea, and suggested that the remainder of the set was engraved by the Master of the Sforza Book of Hours himself. Kristeller attempted to identify the Master of the Sforza Book of Hours as the illuminator Fra Antonio da Monza, an identification rejected by Hind.

In 1956, the Master of the Sforza Book of Hours was securely identified as being Giovanni Pietro da Birago (see Evans, 1992, p.9). The twelve engraved panels 'recall his borders in the frontispieces of the London and Warsaw *Sforziadae* and the Sforza Hours, as well as their ultimate source, Giovanni Antonio Amadeo's richly decorated pilasters at the Colleoni Chapel in Bergamo and the Certosa in Pavia. For Amadeo, see J. Pope-Hennessy, 1958, pp.91–8 and 337–9' (Evans, 1995, p.533). See also Kren (ed.), pp.107–12, and Evans, 1987.

Evans (1995, p.523) points out that Birago was active in Brescia from 1471

to 1474, but also suggests (p.533) that the arrival of Giovanni Antonio da Brescia in Milan in the late 1490s may have encouraged Birago to try his hand at print-making.

Suzanne Boorsch, writing in Martineau (ed.), pp.57–61, has argued that the monogram *ZA,* which had previously been thought to belong to an engraver called Zoan Andrea – who was believed by some to be one and the same person as the painter Zoan Andrea active in Mantua in the 1470s – was in fact the monogram used by the engraver Giovanni Antonio da Brescia, on some of his works dating from before 1508.

In the Washington catalogue a dating of c. 1505–15 is put forward for the set of twelve ornamental panels. Accepting Boorsch's thesis that Giovanni Antonio da Brescia abandoned the use of the monogram *ZA* no later that 1507 (Martineau (ed.), p.60), then the dating of the twelve ornamental panels, presumably engraved at the same time as each other, and one of which is signed *ZA*, must be adjusted accordingly to no later than 1507.

Hind states that the shape of one corner of the plate, and the dimensions, show that plates 10 and 11 were engraved on either side of one piece of copper.

The Washington catalogue points out the correspondence between plate 6 in the set of twelve ornamental panels here and the left-hand pilaster in a print of a pair of pilasters by 'Zoan Andrea' (Hind V, 25 A and B).

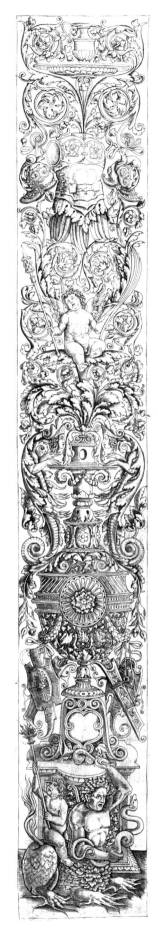

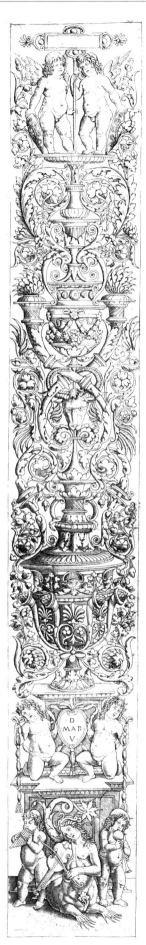

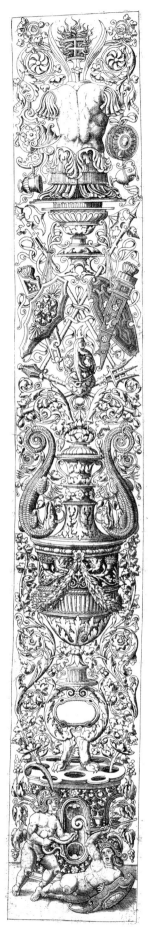

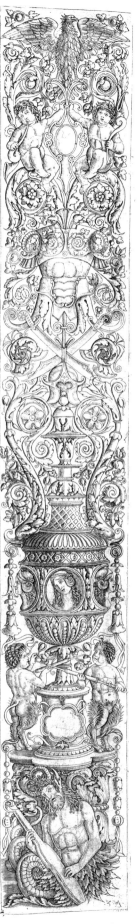

Cat. 20 pl. 1 Cat. 20 pl. 2 Cat. 20 pl. 3 Cat. 20 pl. 4

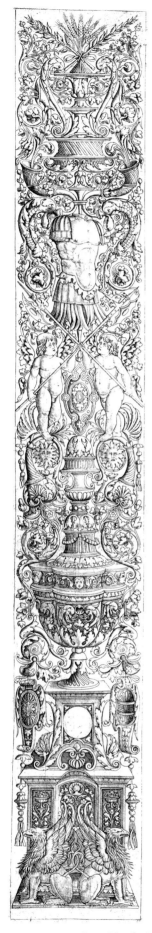

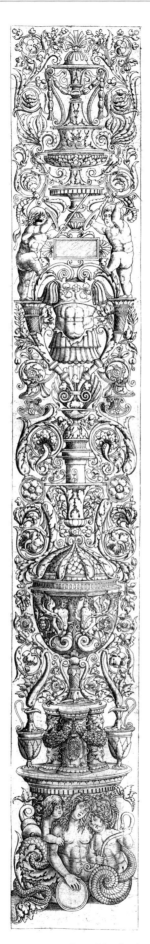

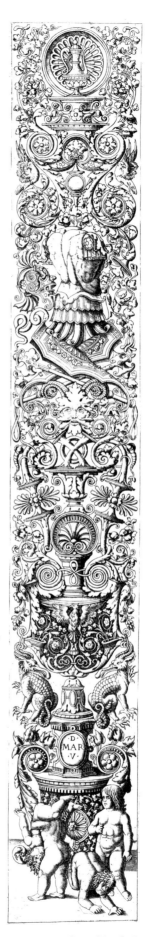

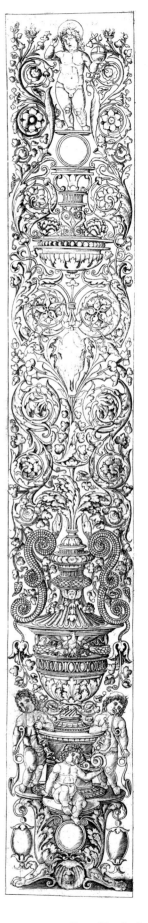

Cat. 20 pl. 5 Cat. 20 pl. 6 Cat. 20 pl. 7 Cat. 20 pl. 8

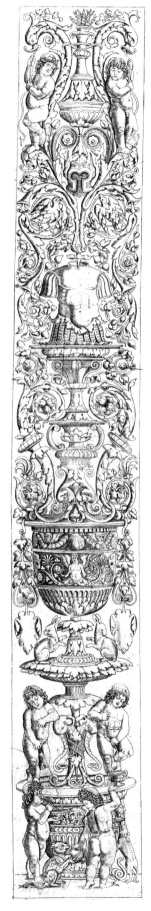

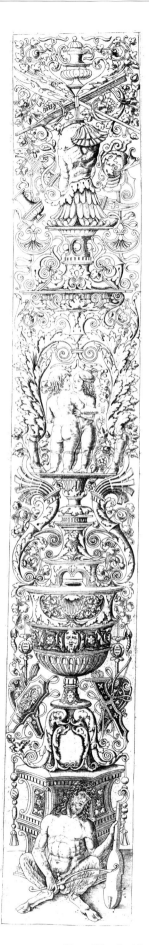

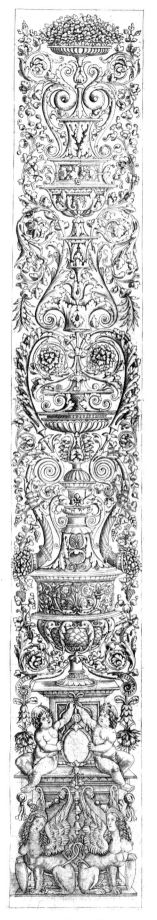

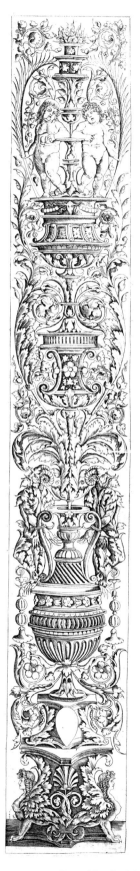

Cat. 20 pl. 9 Cat. 20 pl. 10 Cat. 20 pl. 11 Cat. 20 pl. 12

Catalogue 20: PLATE DESCRIPTIONS

Plate 1

Ornamental panel with a triton ridden by a child (B. XIII, 21). 53.4 x 9.1 cm
E.2211-1920

Plate 2

Ornamental panel with a nereid, and two children playing musical instruments (B. XIII, 22). Lettered .D..MAR..V. 55 x 8.8 cm
E.2212-1920

Plate 3

Ornamental panel with two children wearing helmets (B. XIII, 23). 54.1 x 8.8 cm
E.2213-1920

Plate 4

Ornamental panel with a triton and two infant satyrs (B. XIII, 24). Signed in monogram .Z.A. 53 x 8.3 cm
E.2214-1920

Another impression.
E.631-1890

Another impression [top half only].
22701.2

Plate 5

Ornamental panel with griffins and two Cupids crossing halberds (B. XIII, 25). 54.2 x 8.9 cm
E.2215-1920

Plate 6

Ornamental panel with a nereid ridden by two children (B. XIII, 26). 54.1 x 8.8 cm
E.2216-1920

Plate 7

Ornamental panel with four children playing (B. XIII, 27). Lettered .D..MAR..V. 53.4 x 8.5 cm
E.2217-1920

Plate 8

Ornamental panel with three children blowing horns. (B. XIII, 28; Berliner, 184). 52.2 x 8.3 cm
E.2218-1920

Plate 9

Ornamental panel with four children with a cat and a dog (B. XIII, 29; Berliner, 185). 53.5 x 8.8 cm
E.2219-1920

Plate 10

Ornamental panel with a satyr holding a violin (B. XIII, 30; Berliner, 186). 53.6 x 8.6 cm
E.2220-1920

Plate 11

Ornamental panel with two sphinxes supporting shields (B. XIII, 31; Berliner, 187). 53.6 x 8.7 cm
E.2221-1920

Plate 12

Ornamental panel with two sphinxes and two children holding palms (B. XIII, 32). 49.8 x 8.4 cm
E.2222-1920

Another impression. Cut.
22701.1

Catalogue 21

Plate No.

PLATE DESCRIPTION

Original plates and reissues

21 Giovanni Antonio da BRESCIA (active 1490s–first quarter of 16th century), engraver. Amico ASPERTINI (1473/5–1552), attributed to, designer. Upright ornamental panel with grotesque figures. Under a canopy, a child lies on his back between an old man on the right and a woman on the left. A female figure playing a lute is in the centre at the top, above Pegasus between two goats. Italian, 1515–20.
Engraving. 28 x 17.1 cm
E.463-1911

Lit: B. XIII, 68, as Anonymous; Hind V, 46; Berliner, 208; Jean-Richard, 139; A. 586; Faietti and Scaglietti Kelescian, pp.337–9.

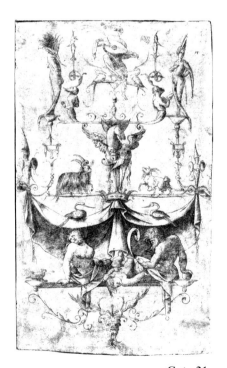

Cat. 21

Catalogue 23

Plate No.

PLATE DESCRIPTION

Original plates and reissues

23 Agostino VENEZIANO (c. 1490–c. 1540), engraver. Ornamental panel with at the bottom two satyrs, in the middle two sphinxes and in the middle at the top the head and front legs of an ox. Italian, c. 1520.
Engraving. Cut to 23.6 x 18.8 cm
E.1076-1922

Lit: B. XIV. 559; Guilmard. p.285. no. 16; Berlin. 526(1); Berliner. 242; A. 647; Fuhring, 1989, no. 647; E. VIII, 55.(3229).

NOTES: The impressions described by Bartsch and in the Amsterdam and Escorial collections are from a later edition issued by Antonio Salamanca.

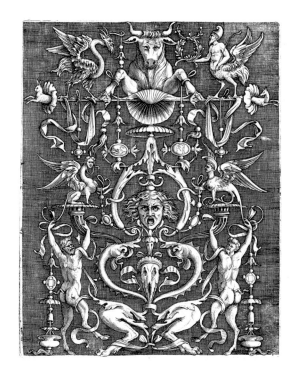

Cat. 23

Catalogue 24

Plate No.

PLATE DESCRIPTION

Reversed copy plates

24 ANONYMOUS, engraver. Half of an ornamental panel. In the centre a mask surmounted by the bust of a woman with butterfly wings, and below a sphinx seated by a vase placed on an altar. Reversed copy of Agostino VENEZIANO (c. 1490–c. 1540). B. XIV, 563; Berlin 526(1), Berliner, 243. Italian, c. 1520.
Engraving. Cut to 32.9 x 12 cm
27723.5

Cat. 24

Catalogue 25

SET DESCRIPTION

Original plates and reissues

25 ANONYMOUS, etchers. Plates (6) of panels of grotesque ornament. Italian, 1520–30. Plates 1 and 2 inscribed in ink *NR*.
Etchings
19026–19029, 20307.1, 28795.E

Lit: Berliner, 225–9.

NOTES: This set is one of the most intriguing in the whole collection. Berliner groups together the first five plates described here, although the repertoire of elements in plate 3 (musical instruments, a ram's head, lions' heads with rings in their mouths, and bearded male figures, seated back-to-back) is strikingly different from plates 1, 2, 4 and 5. It is clear from the stamps and museum numbers that appear on the five illustrations in both the 1925–6 and 1981 editions of Berliner that these depict the impressions in this collection. Examination of these impressions has revealed that the monograms on the first two plates are not etched with the rest of the plate, but inscribed in ink, and so could have been added at any time after the plates were printed. This casts doubt over the attribution of these first two plates to Nicoletto da Modena. Comparison of these two plates with engravings securely attributed to Nicoletto da Modena, such as Catalogue 22a and b, does not point to them being by the same hand. Neither edition of Berliner discusses the sixth plate described here, which shares a number of elements with at least three others in the set. For example, plate 6 has a vertically shaded central area, comparable to the two similar shaded areas in plate 1. Plate 6 shares with plate 1 a version of the winged female figure, the shading of areas inside the ends of scrolling tendrils and the motif of a veiled female mask. Plate 6 also includes a pair of prancing goats, such as those in plate 2. The shaded horizontal platform on which the goats in plate 6 are standing is reminiscent of a similar element in plate 4, as both have an arched central portion, which is smooth on the lower edge and scalloped on the upper.

All six plates are close to each other in size, although plate 3 is slightly narrower than the others. Plates 1, 2, 4 and 5 entered the Museum's collection at the same time. Examination of the papers on which all six images are printed has shown that all except plate 3 are printed on paper carrying a watermark of a stag, with a four-petalled flower protruding from its back (see the Watermark Appendix). The paper used for plate 3 is not watermarked. If these prints are truly a set (putting aside for a moment the grounds for doubting the inclusion of plate 3), then there would appear to be as many as five different hands at work. Even without the added monograms, plates 1 and 2 would seem to be a pair, but the remaining four plates – while they

have some shared elements – show a considerable divergence, both in composition and mastery of the etching technique. Berliner dates the first five plates to 1520–30. If this dating is correct, this is close to the time of the earliest Italian etchings by Marcantonio Raimondi, such as *A Woman Tearing Her Hair*, c. 1520–5 (Reed and Wallace, no. 1) and further undermines the possibility that the first two plates are by Nicoletto da Modena, who is known to have been active only until 1522 (see Zucker).

The repertoire of elements seen in these prints, and the in-filling of the ends of scrolls with parallel shading, are shared by some of the grotesque prints of Domenico del Barbiere (see Zerner, 1969, DB 12–22).

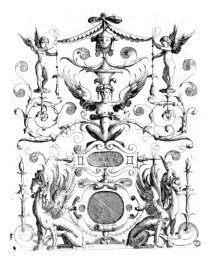

Cat. 25 pl. 1

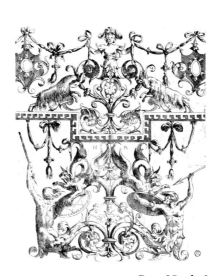

Cat. 25 pl. 2

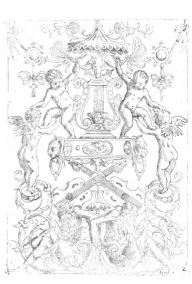

Cat. 25 pl. 3

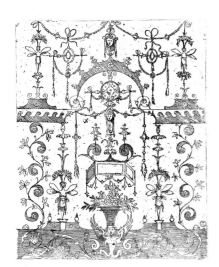

Cat. 25 pl. 4

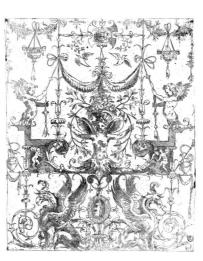

Cat. 25 pl. 5

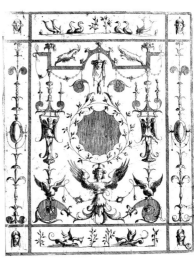

Cat. 25 pl. 6

Catalogue 25: PLATE DESCRIPTIONS

Plate 1

Panel of grotesque ornament. At the centre a sphinx with outstretched wings above two shaded cartouches (Berliner, 225). Inscribed in ink *NR*. Cut to 24 x 19.6 cm

19026

Plate 2

Panel of grotesque ornament. Two tritons with shields and spears combating monsters below two fighting goats (Berliner, 226). Inscribed in ink *NR*. Cut to 23.1 x 19 cm

19027

Plate 3

Panel of grotesque ornament. Two seated bearded men. Above, a pair of crossed viols, two cupids, and two putti on either side of a lyre (Berliner, 227). Cut to 24.2 x 18.5 cm

28795.E

Plate 4

Panel of grotesque ornament. At the centre a sphinx supports a basket of fruit. At the far sides tendrils of foliage climb up to support hatched Vitruvian scrolls. At the top a female mask (Berliner, 228). Cut to 23.6 x 19.5 cm

19028

Plate 5

Panel of grotesque ornament. At the base two griffins flanking an oval with a standing female figure. Above, a winged female whose body ends in foliage supports a basket of fruit. On either side putti with tails hold ribbons attached to a canopy (Berliner, 229). Cut to 23.8 x 19.8 cm

19029

Plate 6

Panel of grotesque ornament. In the centre a shaded cartouche surrounded by a wreath of leaves; above, a female head with a head-dress, flanked by two fighting goats. Below, a winged female half-figure. A shaded framework margin containing swans and dolphins at the top and dragons at the bottom. Cut to 24.5 x 19.6 cm

20307.1

Catalogue 26

Plate No.

PLATE DESCRIPTION

Original plates and reissues

26 Agostino VENEZIANO (c. 1490–c. 1540), engraver. Ornamental panel, in the centre of which is a medallion showing two slaves sitting back-to-back below a trophy; above, in a shield, a satyr milking a goat; below, in a cartouche, six warriors are shown in combat. Italian, 1521. Signed in monogram *.A..V.* and dated *.1521.*
Engraving. Cut to 26.2 x 11.3 cm
E.637-1890

Lit: B. XIV, 560; Guilmard, p.285, no. 16; Jessen, 39; Berlin, 526 (1); Berliner, 245; Jean-Richard, 150.

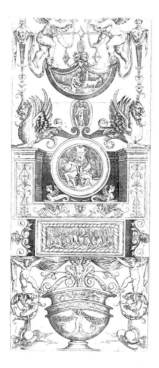

Cat. 26

Catalogue 27

Plate No.

PLATE DESCRIPTION

Original plates and reissues

27 Agostino VENEZIANO (c. 1490–c. 1540), engraver. Antonio SALA-MANCA (c. 1500–62), publisher. Ornamental panel showing alternative schemes in the right and left halves. At the bottom, a satyr on the right and a triton on the left, blowing horns. Halfway down on the left a satyr seizing a dog; on the right a cupid pouring water from a pot. Italian, second quarter of the 16th century.
Signed in monogram *.V.A.* Lettered *Ant. Sal. exc.*
Engraving. Cut to 26.5 x 14.5 cm
16792

Lit: B. XIV, 561; Guilmard, p.285, no. 16; Jessen, 36; Berlin, 526(1); Berliner, 244; Byrne, 61; A. 648; Fuhring, 1989, no. 648.

NOTES: The plate originally dates from c. 1520. The engraving is partly after the antique, partly after Raphael or Giovanni da Udine, as well as perhaps after the drawings of Perino del Vaga. See Bernini Pezzini *et al.*, p.267, no. 2, and p.848.

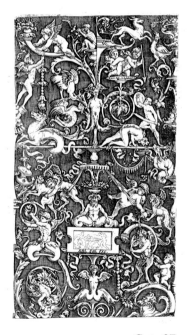

Cat. 27

Catalogue 28

Plate No.	1	2	3	6
28a	☐			
28b	☐	☐	☐	☐

SET DESCRIPTIONS

Original plates and reissues

28a MASTER OF THE DIE (c. 1512–70), engraver. Perino del VAGA (1501–47), designer. Plates (2) from a set of six panels of ornament. Italian, 1528–32.
Engravings
16747, 16748

Lit: B. XV, 80, 85; Guilmard, p.287, no. 18; Berlin, 530; Brown, 60.

28b MASTER OF THE DIE, engraver. Perino del VAGA, designer. Antonio SALAMANCA (c. 1500–62), publisher. Plates (3) from a set of six panels of ornament. Reissues of Catalogue 28a. Italian, Rome, 1532–53.
Engravings
17428, 28706, E.1384-1897

Lit: B. XV, 80–2; Guilmard, p.287, no. 18; Berlin, 530; Berliner, 265, 267, 268; Brown, 60; Byrne, 45; E. VII, 33, 34, 37.(2986, 2987, 2990).

NOTES: Gombrich (p.280) translates the poem beneath plate 3 as:

> Poet and Painter as companions meet
> Because their strivings have a common passion
> As you can see expressed in this sheet
> Adorned with friezes in this skilful fashion.
>
> Of this, Rome can the best examples give,
> Rome towards which all subtle minds are heading
> Whence now from grottoes where no people live
> So much new light on this fine art is spreading.

Bartsch called these prints 'after Raphael', but in 1966 Konrad Oberhuber attributed them to Perino del Vaga on the basis of a drawing for plate 2 in the Uffizi (Oberhuber, pl. 36). The plate numbering follows Bartsch.

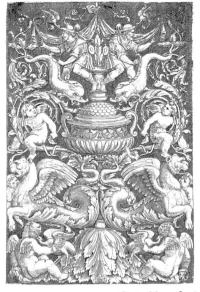

Cat. 28a pl. 1

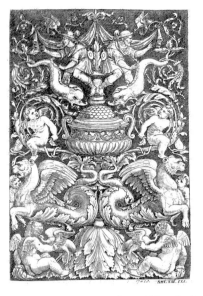

Cat. 28b pl. 1

Cat. 28b pl. 2

Cat. 28b pl. 3

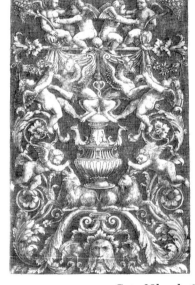

Cat. 28b pl. 6

Catalogue 28: PLATE DESCRIPTIONS

Plate 1

(a) Panel of ornament. Two seated cupids seen from the back. Above them, two winged lions with fish tails. At mid-height, cupids astride scrolling foliage, flanking a vase with, on its lid, two men each with a dolphin at his feet (B. XV, 80; Berliner, 267). Cut to 20.4 x 14 cm
16748

(b) Impression (E. VII, 33.(2986)). Lettered *Ant. sal. exc.*
17428

Plate 2

(b) Panel of ornament. Scrolling foliage, amongst which is a seated cupid holding a weathercock between two eagles. Above is a satyr surprising a nymph (B. XV, 81; Berliner, 268). [Trimmed to remove Salamanca's name and the date.] Cut to 20.5 x 14.9 cm
28706

Plate 3

(b) Panel of ornament. At the bottom, a female nude holding a large vase on her head. The female nude terminates in scrolling foliage, on which six cupids are seated. At the centre top, two seated female figures each holding a snake (B. XV, 82; Berliner, 265; E.VII, 34.(2987)). Dated *1532* and lettered *Ant. Sal. exc* and with eight lines of verse beginning: *Il poeta el pittor Vanno di pare...* Cut to 22.5 x 15 cm
E.1384-1897

Plate 6

(a) Panel of ornament. Scrolling foliage, amongst which at the bottom are two flying cupids, each grasping the horns of a goat. At mid-height, two other flying cupids, hanging from drapery (B. XV, 85; E. VII, 37.(2990)). Cut to 21.6 x 14.5 cm
16747

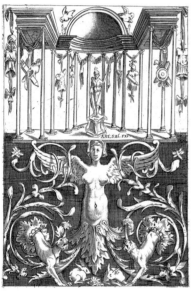

Cat. 29c pl. 3

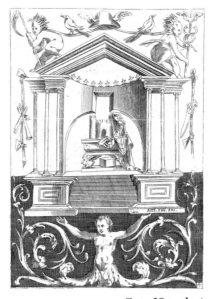

Cat. 29c pl. 4

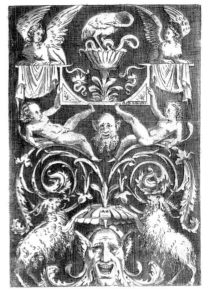

Cat. 29c pl. 5

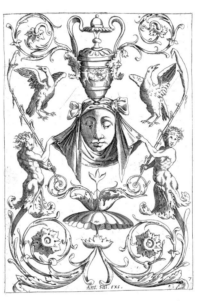

Cat. 29c pl. 6

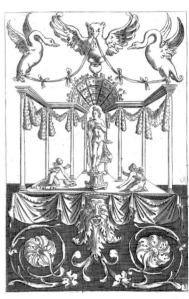

Cat. 29c pl. 7

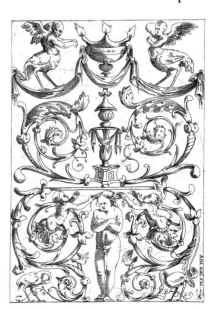

Cat. 29c pl. 8

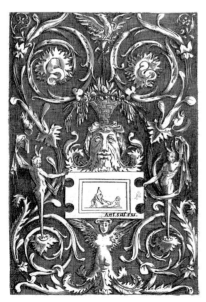

Cat. 29c pl. 9

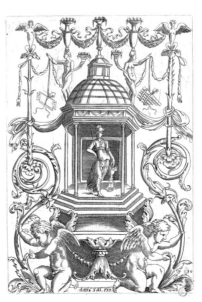

Cat. 29c pl. 10

Cat. 29c pl. 11

Cat. 29c pl. 12

Cat. 29c pl. 13

Cat. 29c pl. 14

Cat. 29c pl. 15

Cat. 29c pl. 16

Cat. 29c pl. 17

Cat. 29c pl. 18

Cat. 29c pl. 19

Cat. 29c pl. 20

Catalogue 29: PLATE DESCRIPTIONS

Plate 1

(c) Ornamental panel. Female figure who terminates in scrolling foliage between two children, one of whom she holds by the ear, the other by the hair (B. XIV, 564-II; state after Berliner, 247; E. VIII,57.1.(3231)). Signed in monogram .A.V. Lettered *Ant. Sal. exc.* Numbered *1*. 19.7 x 14 cm

16725

Plate 2

(c) Ornamental panel. Two young satyrs supporting, on their heads, a small round temple (B. XIV, 565-II; E. VIII,57.2.(3232)). Signed in monogram .A.V. Lettered *Ant. Sal. exc.* Numbered *2*. 20.5 x 14.3 cm

16726

Plate 3

(c) Ornamental panel. At the bottom, a man and a woman who terminate in scrolling foliage; in the middle two resting chimerical quadrupeds, and at the top in the middle a half-length winged siren (B. XIV, 566-II; Hind V, no. 18-II). Signed in monogram .I.F. Lettered *Ant. Sal. ex.* Numbered *3*, and *4* [twice, and partially erased]. 20.1 x 14.2 cm

16788

(c) Another impression.

16727

Plate 4

(c) Ornamental panel. A temple containing a type of sarcophagus. Above, two putti, one holding a scythe and the other the caduceus of Mercury (B. XIV, 567-II; state after Berliner, 248; E. VIII, 57.3.(3233)). Signed in monogram .A V. Lettered *Ant. sal. exc.* Numbered *4*. 20.3 x 14.4 cm

16728

Plate 5

(a) Ornamental panel. At the bottom two rams; in the middle two nude children; at the top two sphinxes (state before B. XIV, 569-I; state before Berliner, 250). Numbered *1*. Cut to 20.6 x 14.1 cm

27724.12

(c) Impression. (B.XIV, 569-II; state after Berliner, 250; E. VIII, 57.5.((3235)). Signed in monogram .A.V. Lettered

Ant. sal. exc. Numbered *5*. Cut to 20.4 x 14.3 cm

13224.A

Plate 6

(c) Ornamental panel. Winged female demi-figure supporting on her head a temple containing a statue of Mars (B. XIV, 568-II; state after Berliner, 249; E. VIII, 57.4.(3234)). Signed in monogram twice, .A.V. and A.V. Lettered *Ant. Sal. exc.* 20.3 x 14.2 cm

16729

(c) Another impression.

26446.1

Plate 7

(c) Ornamental panel. Head of a woman wearing a head-dress held out by two demi-figures at the left and right (B. XIV, 570-II; E. VIII, 57.6.(3236)). Signed in monogram .A.V. Lettered *Ant. sal. exc.* Numbered 7. 20.5 x 14.5 cm

16789

Plate 8

(c) Ornamental panel. A temple with a statue of Diana adored by two kneeling women (B. XIV, 571-II; E. VIII, 57.7.(3237)). Lettered *Ant. Sal. exc.* Numbered *8*. 20.7 x 13.9 cm

16730

(c) Another impression.

16731

Plate 9

(c) Ornamental panel. Mask above a cartouche, on which one child is frightening another with a large hideous mask (B. XIV, 572-II; state after Berliner, 252; E. VIII, 57.8.(3238)). Signed in monogram .A.V. Lettered *Ant. sal. exc.* Numbered 9. 20.2 x 14.2 cm

16732

Plate 10

(c) Ornamental panel. A temple with a figure of Pallas standing beside a sacrificial altar. Below are two kneeling winged putti (B. XIV, 573-II; state after Berliner, 253; E. VIII, 57.9.(3239)). Signed in monogram .A.V. Lettered *Ant. sal. exc.* Numbered *10*. 20.4 x 14.2 cm

16733

Plate 11

(b) Ornamental panel. A nude child with crossed arms, between two other children who hold him by the hair (B. XIV, 574-I; Berliner, 263). Signed in monogram *.A.V.* Numbered *11*. 20.1 x 14.5 cm

26446.2

(c) Impression (B. XIV, 574-II; state after Berliner, 263; E. VIII, 57.10.(3240)). Lettered *Ant. sal. exc.* Numbered *11*.

16734

Plate 12

(a) Ornamental panel. Two female figures carry a large festoon and support a platform on which is a furnace (state before B. XIV, 575; state before Berliner, 251). Numbered *16*. Cut to 20.1 x 14.3 cm

27724.13

(c) Impression (B. XIV, 575-II; state after Berliner, 251; E. VIII, 57.11.(3241)). Signed in monogram *.A.V.* Lettered *Ant. sal. exc.* Numbered *12*. 20 x 14.1 cm

16735

Plate 13

(c) Ornamental panel. Two small circular temples flanking a flaming vase placed on an altar (B. XIV, 576-II; Hind V, no. 19-II; E. VIII, 57. 12.(3242)). Signed in monogram *.I.F.* Lettered *Ant sal. exc.* Numbered *13*. 20.1 x 14.1 cm

16736

Plate 14

(c) Ornamental panel. A temple containing a statue of Ceres holding a sickle in her raised right hand (B. XIV, 577-II; E. VIII, 57.13.(3243)). Signed in monogram *.A V.* Lettered *Ant. S. exc.* Numbered *14*. 20.3 x 14 cm

16745

Plate 15

(c) Ornamental panel. At the bottom two winged horses, at the top two angels seated at the base of a vase (B.XIV, 578-II; E. VIII, 57.14.(3244)). Signed in monogram *.A.V.* Lettered *Ant. Sal. ex.* Numbered *15*. 20.6 x 14.5 cm

16737

(c) Another impression.

26446.3

Plate 16

(b) Ornamental panel. A temple containing a statue of Pomona holding fruit in her right hand and a bill hook in her left hand (B. XIV, 579-I; Berliner, 254). Signed in monogram *.A.V.* Cut to 20.4 x 14.2 cm

26446.4

(c) Impression (B. XIV, 579-II; state after Berliner, 254; E. VIII, 57.15.(3245)). Lettered *Ant. Sal. exc.* 20.2 x 14.3 cm

16738

Plate 17

(c) Ornamental panel. Two women flanking a vase on which is seated a cupid (B. XIV, 580-II; after Berliner, 255; E. VIII, 57.16.(3246)). Signed in monogram *.A.V.* Lettered *Ant. sal. exc.* and *.S.P.Q.R.* Numbered *17*. 20.4 x 14.2 cm

16739

Plate 18

(c) Ornamental panel. Two nude children supporting a cartouche on which is a mask. At the bottom a sphinx and a large dog (B. XIV, 581-II; state after Berliner, 256; E. VIII, 57.17.(3247)). Signed in monogram *.A.V.* Lettered *Ant. Sal. exc.* Numbered *18*. 20.2 x 14.3 cm

16740

Plate 19

(c) Ornamental panel. A statue of Isis placed between two altars (B. XIV, 582-II; E. VIII, 57.18.(3248)). Signed in monogram *.A.V.* Lettered *Ant. Sal. exc.* Numbered *19*. 20.3 x 14.3 cm

16741

Plate 20

(c) Ornamental panel. A head surmounted by a basket of fruit and flowers and, above, three children seated on a large festoon (B. XIV, 583-II; state after Berliner, 257; E. VIII, 57.19.(3249)). Signed in monogram *.A.V.* Lettered *Ant. sal. exc.* Numbered *20*. 20.3 x 14 cm

16742

Catalogue 30

Plate No.

PLATE DESCRIPTION

Original plates and reissues

30 ANONYMOUS (School of Marcantonio RAIMONDI (1488–1534)), engraver. Antonio SALAMANCA (c. 1500–62), publisher. Ornamental panel with scrolling foliage in the form of a reversed 'S'. Reissue of B. XV, p.56, 2. Lettered *Ant. sal. exc.* Italian, c. 1530.
Engraving. 16 x 11.7 cm
16750

Lit: Berlin, 529; Berliner, 264; E. IX, 34.(4445) as Enea Vico.

NOTES: The illustration in Berliner has been printed back to front.

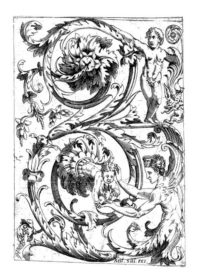

Cat. 30

Catalogue 31

Plate No.

31a ☐
31b ☐

PLATE DESCRIPTIONS

Original plates and reissues

31a ANONYMOUS (School of Marcantonio RAIMONDI (1488–1534)), engraver. Ornamental panel with Venus and Cupid. Italian, c. 1530. Engraving. Cut to 13.4 x 11.4 cm

26216.5

Lit: Berlin, 529.

31b ANONYMOUS (School of Marcantonio RAIMONDI), engraver. Antonio SALAMANCA (c. 1500–62), publisher. Reissue of Catalogue 31a. Italian, c. 1530. Lettered *Ant. Sal. exc.* 13.6 x 11.6 cm

16749

Another impression, cut.

26446.5

Lit: B. XV, p.55, 1; Berliner, 262; E. VIII, 16.(3664).

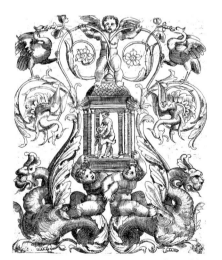

Cat. 31a

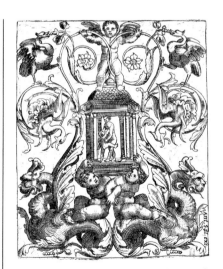

Cat. 31b

Catalogue 32

Plate No.	1	2
32a	☐	
32b	☐	☐

SET DESCRIPTIONS

Original plates and reissues

32a ANONYMOUS, engraver. Ornamental panel with a foliated head. Italian, c. 1535.
Engraving. Cut to 19.9 x 13.9 cm
27725.2

Lit: Berliner, 259.

Copy plate and reversed copy plate

32b Agostino VENEZIANO? (c. 1490–c. 1540) and ANONYMOUS, engraver. Antonio SALAMANCA (c. 1500–62), publisher. Plates (2) of ornamental panels. Plate 1, a reversed copy of Catalogue 32a and reissue of Agostino Veneziano?, B. XIV, 555. Plate 2, a copy of Marco DENTE (active 1515–d. 1527) B. XIV, 557; Berlin, 524(2); Berliner, 241; A. 597. Italian, 1535–53. Each lettered *Ant. Sal. exc.*
Engravings
16794, 16795

Lit: B. XIV, 555, 557; Guilmard, p.285, no. 16; A. 646; E. VIII, 54.(3228).

NOTES: The print copied by Catalogue 32b, pl. 2 (Marco Dente, B. XIV, 557) is signed with the engraver's monogram. Catalogue 32b, pl. 1 and 2 have not been linked together before, but the impressions here exhibit many signs of being a pair. They are on the same paper, they are close in size, subject matter and engraving style, and they share the same publisher. They entered the Museum's collection together. Impressions of Catalogue 32b, pl. 1 exist before the addition of Salamanca's name, and one such is shown in *The Illustrated Bartsch*. The description in Bartsch could apply to either Catalogue 32b, pl. 1, before the addition of Salamanca's name, or Catalogue 32a, pl. 1. They can be distinguished by the direction in which the cluster of leaves at the top in the centre leans, but Bartsch is not specific on this point. As Catalogue 32b, pl. 2 is known to be a copy, and seems to be one of a pair with Catalogue 32b, pl. 1, this might also suggest that Catalogue 32b, pl. 1 is also a copy, since a pair made up of one copy plate and one original plate seems unlikely. This explanation is not entirely satisfactory, however, as it does not explain how one plate in a pair came to be a copy of a print in the same direction, while the other plate in the pair copies another print in reverse.

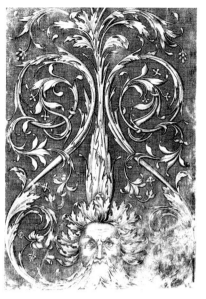

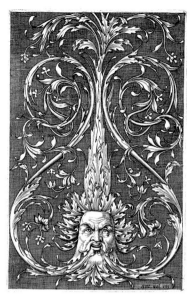

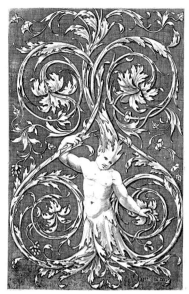

Cat. 32a pl. 1 Cat. 32b pl. 1 Cat. 32b pl. 2

Catalogue 32: PLATE DESCRIPTIONS

Plate 1

(a) A mask at the bottom, from the base of which rises foliage on both sides, which fills the rest of the panel. After an antique design (Berliner, 259). Cut to 20 x 14.1 cm

27725.2

(b) Impression. Reversed copy of Catalogue 32a, pl. 1 (B. XIV, 555; E. VIII, 54.(3228)). Lettered *Ant. Sal. ex.* 21.3 x 14 cm

16795

Plate 2

(b) A child with hair and lower body of scrolling foliage. His raised right arm grasping one of the tendrils. (Copy of B. XIV, 557; E. IV, 22.(1281) under Marco Dente.) Lettered *Ant. Sal. exc.* 21.2 x 14 cm

16794

Catalogue 33

Plate No.	1	2	3	4	5	6	7	8	9	10	11	12	13	14(l)	14(r)	15(l)	15(r)	16(l)	16(r)	17
33a		□																		
33b			□			□						□	□			□	□	□	□	□
33c	□	□	□	□	□	□	□	□	□	□	□	□	□	□	□	□	□	□	□	
33d	□	□	□	□	□	□	□	□	□	□	□	□	□	□	□	□	□	□		□
33e											□									

SET DESCRIPTIONS

Original plates and reissues

33a Enea VICO (1523–67), engraver. Italian, Rome, 1541. Plate of a grotesque, proof before the addition of the publisher's name and the date. Copied in reverse as plate 2 of Catalogue 33d. Italian, Rome, before 1541–2. Engraving

20306.3

Lit: B. XV, 484.

33b Enea VICO, Tomaso BARLACHI (active 1540–50), engravers. Tomaso BARLACHI, publisher. Plates (9) from a set of twenty-three plates of grotesques. Italian, Rome, 1541–2.
Plates 3, 6, 12, 13, 15 (right) and 16 (left) signed in monogram *E.V.* Plates 3, 6 and 12 dated *1541* and lettered with the publisher's name.
Engravings

16771, 16781, 20306.1, 20306.2, 20306.4, E.224-1885, E.225-1885, E.227-1885, E.232-1885, E.233-1885

Lit: B. XV, 468, 470, 471, 473, 480, 481, 483, 487, 488; Guilmard, p.289, no. 24; Berlin, 534; Brown, 84c; A. 655A.

Reversed copy plates

33c ANONYMOUS, engraver. *Leviores et (ut videtur) extemporaneae picturae quas grotteschas vulgo vocant.* A set of 19 plates, including title of grotesques. Plate 1: B. XV, 467, as Enea Vico, and copies of B. XV, 468–72, 474, 475, 477, 478, 480–4, 486–8, 490. Six of the plates engraved in pairs, on three copper plates, cut and mounted separately after printing. Italian, Rome, mid-16th century. Before the numbering added in Catalogue 33d.
Engravings

13181, 16754, 16754.A, 16770, 16772–16780, 16782–16787, 20305, 29755.1-4, 29755.6, 29900, E.222-1885, E.223-1885, E.226-1885, E.228–231-1885, E.234–240-1885

Lit: Jessen, 40–1; Berlin, 533; Berliner, 277–9; Brown, 84a & b; Byrne, 59; A. 655; E. IX, 38.1–16(4458–73) [lacking pl. 2, 6 and 14 left].

33d ANONYMOUS, engraver. Antonio LAFRERY (1512–77), publisher. Plates (19), reissues of Catalogue 33c, including the six paired plates unseparated. The sheets numbered *1–16*. Italian, Rome, c. 1573.
E.2062–2074-1899, E.2075–2077-1899 left and right.

Lit: Miller.

33e ANONYMOUS, engraver. Reversed copy plate after Catalogue 33b, pl. 11. Italian, mid-16th century.
Engraving
29755.5

NOTES: Catalogue 33d forms part of the Lafrery Volume (see Introduction) and corresponds to the entry *Libro de Grottesche* in Lafrery's stocklist of c. 1573 (Ehrle, p.59).

The last three folios of Catalogue 33d in the Lafrery Volume exhibit a curious feature. They each bear the impression of a single copper plate engraved with two grotesques, separated by a blank vertical strip. The three impressions are numbered 14, 15 and 16 at the bottom of the blank strip. Impressions of these 'double subjects' are frequently encountered cut up into their two separate subjects, a process that has hindered a proper understanding of the set.

Fuhring (1990, no. 659) stated that nowhere in the literature does there exist a proper description of this set and proposed that the principal versions of these prints consisted of:

I. An original set of around twenty anonymous plates dating from 1530–40 in states before and after numbering. [These correspond to Catalogue 33c and d.]

II. A set of reversed copies engraved by Enea Vico and Tomaso Barlachi, consisting of twenty-three plates published by Tomaso Barlachi dating from 1541–2. [Ten impressions from this set are Catalogue 33a and b.]

Now that the anonymous set proves to be nineteen images printed from sixteen copper plates published by Lafrery (Catalogue 33d), the situation appears rather to have been:

I. An original set of twenty-three plates engraved by Enea Vico and Tomaso Barlachi and published by Barlachi in 1541–2 [Catalogue 33a and b]

II. A set of anonymous reversed copies, nineteen subjects engraved on sixteen copper plates published by Antonio Lafrery no earlier than 1544, when Lafrery was first active [Catalogue 33c and d].

The evidence that points to this conclusion is cumulative.

Bartsch lists twenty-four grotesques in his catalogue of Enea Vico (B. XV, 467–90). The first of these is the title plate from the anonymous set, Catalogue 33c, pl. 1 (B. XV, 467), which is lettered with a title stating that the series is composed of 'lighter and extemporaneous pictures which are commonly called grotesques, which the ancient Romans used for decorating the dining rooms and other separate places of their houses which have been

variously selected and reduced with great faith and care into one from many vaulted chambers and ancient walls' (Brown University, no. 84). The equivalent plate in the Vico/Barlachi set (B. XV, 479, not in the V&A collection) has no such lettering.

If the plates in the anonymous set had been the originals, this would have meant that when Vico and Barlachi came to copy them, they omitted the lettering that gives the set its title, and that they took three horizontal plates that each carry two compositions (Catalogue 33d, pl. 14, 15 and 16) and instead of copying this arrangement, they turned them into six vertical plates. Instead, what seems to have happened is that the anonymous engraver who was copying the Vico/Barlachi set Catalogue 33b added a title, and engraved six grotesques onto three pieces of copper. This latter procedure would have resulted in a saving of paper and would have halved the time needed to print the same number of subjects. Copying two separate prints onto one piece of copper in this way provides a glimpse of the labour-saving solutions employed by Lafrery's firm, which helped ensure his domination of the market.

In plate 6 of the Vico/Barlachi set Catalogue 33b, the composition runs right up to the platemark along the top edge, whereas in the anonymous set Catalogue 33c and d, the composition is positioned squarely on the copper plate, well inside the platemark. The anonymous engraver was able to calculate the space he needed, because he was working from another image.

Both plate 16 right in the Vico/Barlachi set (B. XV, 469, not in the V&A collection) and the corresponding plate in the Lafrery set, Catalogue 33d plate 16 right, contain a frieze between two lunettes. In the Vico/Barlachi print, the wider of the two lunettes is at the top, but in the Lafrery set it is at the bottom, creating a more balanced overall composition. The way the composition has been neatened up points to the plate in the Lafrery set being the copy.

Between 1544 and 1553, Antonio Lafrery published twenty copies of prints originally published by Antonio Salamanca (Hülsen, p.125). Other examples of Lafrery publishing copies include eight copies of prints by Giorgio Ghisi (Boorsch and Lewis, p.231), the first and last plate in the set of vases in the Lafrery Volume (Catalogue 68b plates I and XIIII), which are reversed copies of vases by Agostino Veneziano, and the entire set of cartouches in the Lafrery Volume (Catalogue 5), which are copies of a set of prints by Hans Vredeman de Vries. Clearly Lafrery's methods of building up his business routinely involved publishing anonymous copies of works by named engravers. Catalogue 33c may be impressions of the anonymous plates sold by Lafrery individually, before he had the idea of collecting them into a numbered set.

The Vico/Barlachi set has a heterogeneous quality in terms of scale and subject matter, and it includes four plates (B. XV, 473, 476, 485 and 489) that are not in the anonymous set. The anonymous set is executed in a more accomplished technique, but this could be accounted for by a competent engraver copying plates executed by someone at the start of his career who was not yet in control of the medium. Vico was eighteen years old in 1541, and Barlachi was his teacher (Byrne, 1981. p.60).

It is clear from *The Illustrated Bartsch* that of the twenty-three plates published by Barlachi (B. XV, 468–90), one is lettered *Tomaso barlachi Faciebat 1542* (B. XV, 473), twenty one arc known in impressions bearing Vico's monogram (B. XV, 468–72, 474–88 and 490) and one is unsigned (B. XV, 489).

Giorgio Vasari refers to Catalogue 33b and d in the chapter on 'Marc'Antonio Bolognese and Other Engravers of Prints' in the 1568 edition of the *Lives of the Painters, Sculptors and Architects* (see note to Catalogue 55).

Since the Vico/Barlachi set is not numbered, for ease of reference the numbering used is that which appears on Catalogue 33d. The impression from the Vico/Barlachi set which is not copied in reverse in the anonymous set published by Lafrery has been assigned a number at the end.

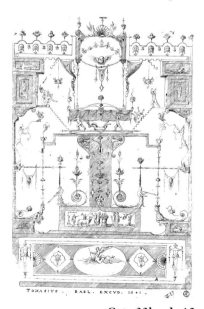

Cat. 33a pl. 2

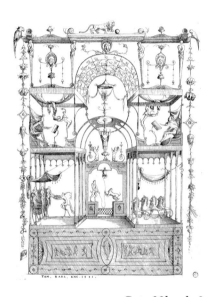

Cat. 33b pl. 3

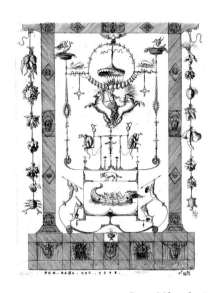

Cat. 33b pl. 6

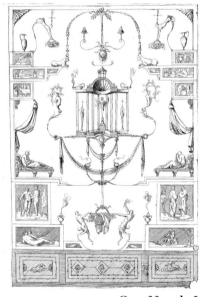

Cat. 33b pl. 12

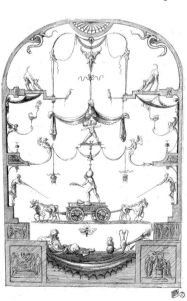

Cat. 33b pl. 13

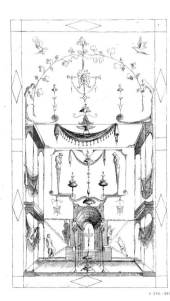

Cat. 33b pl. 14*(r)*

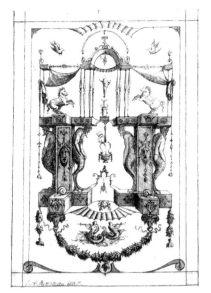

Cat. 33b pl. 15*(l)*

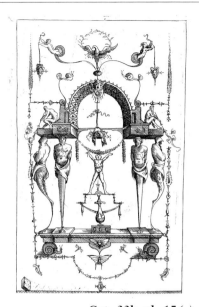

Cat. 33b pl. 15*(r)*

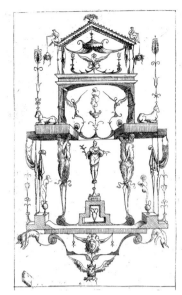

Cat. 33b pl. 16*(l)*

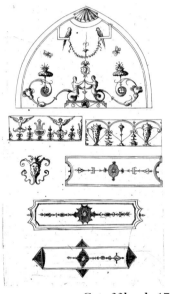

Cat. 33b pl. 17

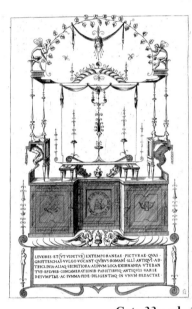

Cat. 33c pl. 1

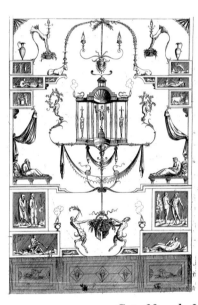

Cat. 33c pl. 2

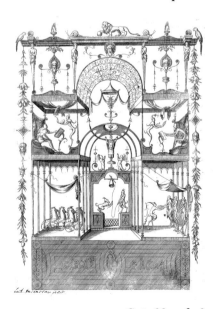

Cat. 33c pl. 3

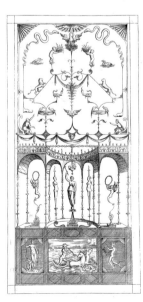

Cat. 33c pl. 4

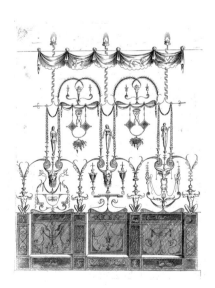

Cat. 33c pl. 5

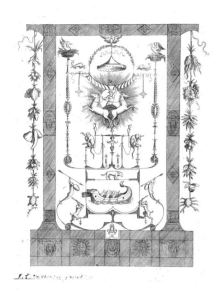

Cat. 33c pl. 6

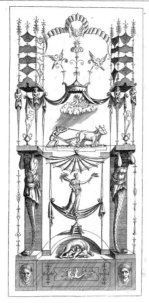

Cat. 33c pl. 7

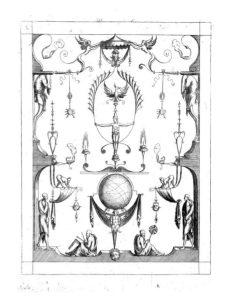

Cat. 33c pl. 8

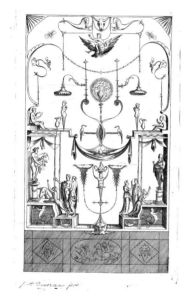

Cat. 33c pl. 9

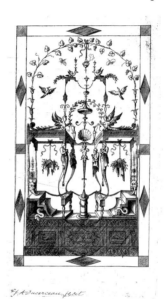

Cat. 33c pl. 10

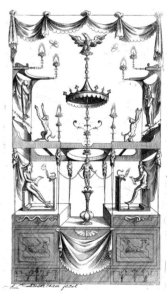

Cat. 33c pl. 11

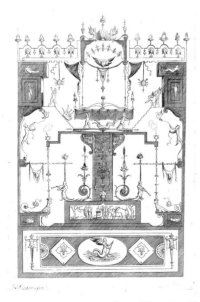

Cat. 33c pl. 12

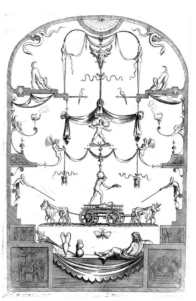

Cat. 33c pl. 13

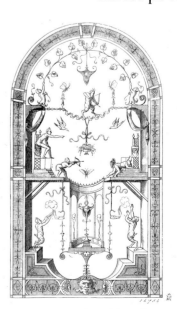

Cat. 33c pl. 14*(1)*

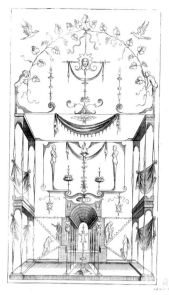

Cat. 33c pl. 14*(r)*

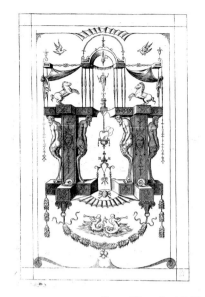

Cat. 33c pl. 15*(l)*

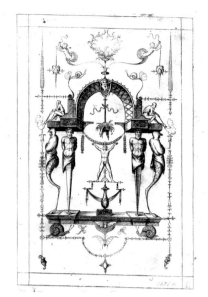

Cat. 33c pl. 15*(r)*

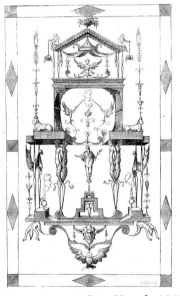

Cat. 33c pl. 16*(l)*

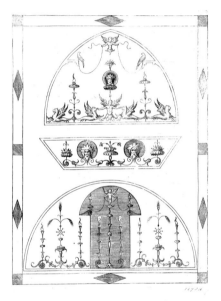

Cat. 33c pl. 16*(r)*

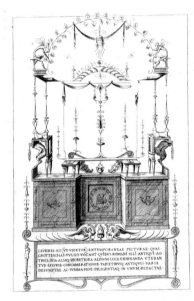

Cat. 33d pl. 1

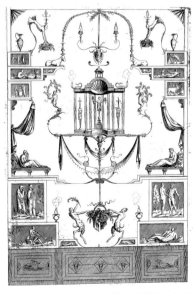

Cat. 33d pl. 2

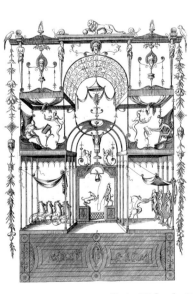

Cat. 33d pl. 3

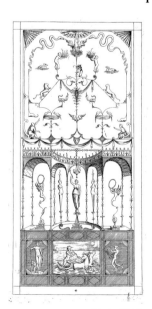

Cat. 33d pl. 4

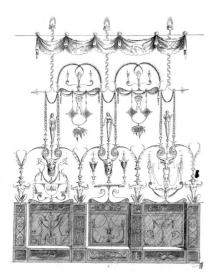

Cat. 33d pl. 5

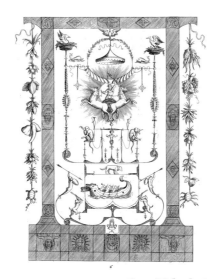

Cat. 33d pl. 6

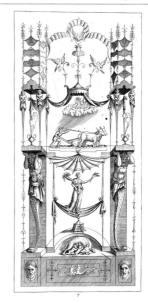

Cat. 33d pl. 7

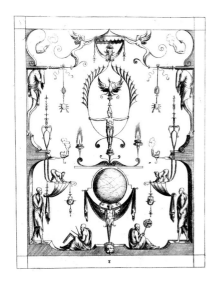

Cat. 33d pl. 8

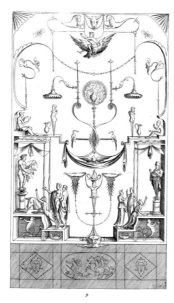

Cat. 33d pl. 9

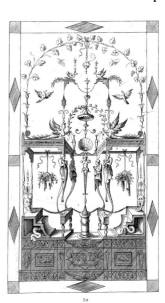

Cat. 33d pl. 10

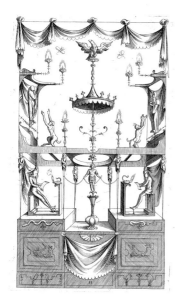

Cat. 33d pl. 11

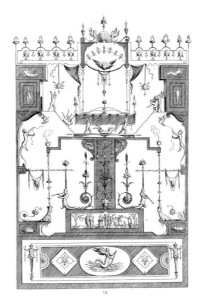

Cat. 33d pl. 12

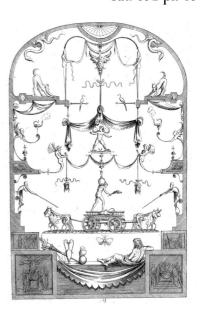

Cat. 33d pl. 13

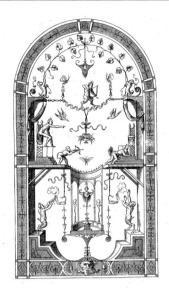

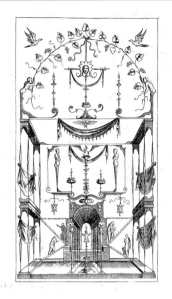

Cat. 33d pl. 14*(l & r)*

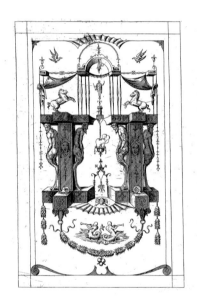

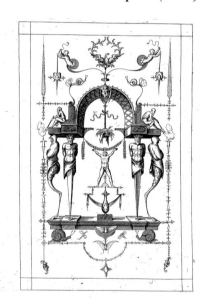

Cat. 33d pl. 15*(l & r)*

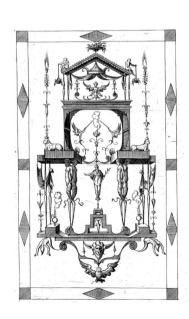

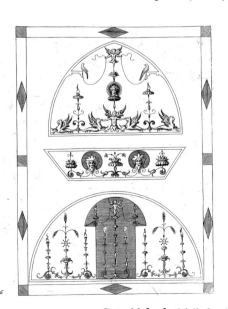

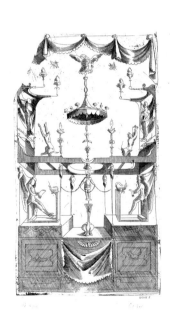

Cat. 33d pl. 16*(l & r)* **Cat. 33e pl. 11**

Catalogue 33: PLATE DESCRIPTIONS

Plate 1

(c) Armoire. A large chest below which is a cartouche lettered *LEVIORES. ET. (VT. VIDETVR). EXTEMPORANEAE. PICTVRAE. QVAS. GROTTESCHAS. VVLGO. VOCANT. QVIBVS. ROMANI. ILLI. ANTIQVI. AD. TRICLINIA. ALIAQ. SECRETIORIA. AEDIVM. LOCA. EXOR-NANDA. VTEBANTVR. EPLVRIB. CONCAMERATIONIB. PARIETIBVSQ. ANTIQVIS. VARIE DESVMPTAE. AC. SVMMA. FIDE. DILIGENTIAQ. IN. VNVM. REDACTAE.* (B. XV, 467). 26.8 x 18.6 cm
16770

(c) Another impression. [Trimmed to remove the lettering.]
E.222-1885

(d) Impression. Numbered *1*. 26.8 x 18.7 cm
E.2062-1899

Plate 2

(a) Panel with two satyrs. At the bottom, two satyrs take herbs from a basket, suspended between them on a ribbon (B. XV, 484). 28.7 x 21.6 cm
20306.3

(c) Impression. 28.6 x 19.5 cm
16779

(c) Another impression.
E.236-1885

(d) Impression. Numbered *2*. 28.6 x 19.5 cm
E.2063-1899

Plate 3

(b) Panel with two satyrs ringing a bell (B. XV, 488). Signed in monogram *E.V.* Dated *1541*. Lettered *TOM. BARL. EXC.* 28.6 x 21.5 cm
20306.4

(b) Another impression.
16781

(c) Impression. 27.9 x 20.2 cm
E.239-1885

(c) Other impressions (2).
16780 [cut], 13181 [damaged]

(d) Impression. Numbered *3*. 28 x 20.5 cm
E.2064-1899

Plate 4

(c) Mercury, Neptune and Venus, at the base, in three compartments. (Reversed copy of B. XV, 477.) 27.6 x 13.8 cm
E.230-1885

(c) Another impression.
16778

(d) Impression. Numbered *4*. 27.5 x 13.7 cm
E.2065-1899

Plate 5

(c) Panel with a wooden wall surmounted by five ornamental arches. (Reversed copy of B. XV, 486.) 27.6 x 20.5 cm
E.237-1885

(c) Other impressions (2).
16773 [damaged], 29755.1 [damaged]

(d) Impression. Numbered *5*. 27.7 x 22.7 cm
E.2066-1899

Plate 6

(b) The sun in a chariot drawn by two horses. Signed in monogram *E.V.* [partially erased]. Lettered *TOM. BARL. EXC. 1541* (B. XV, 468). Cut to 24 x 17.8 cm
16771

(c) Impression. 25.7 x 19.7 cm
E.223-1885

(c) Other impressions (2).
16772, 29900

(d) Impression. Numbered *6*. 25.7 x 19.8 cm
E.2067-1899

Plate 7

(c) Panel with Romulus, Remus and the Capitoline wolf. At the bottom, the figures of Romulus and Remus suckled by the she-wolf and, above, a labourer with two oxen harnessed to his plough. (Reversed copy of B. XV, 490.) 17.2 x 13.7 cm
16775

(c) Other impressions (2).
29755.3, E.240-1885

(d) Impression. Numbered 7. 27.4 x 13.8 cm
E.2068-1899

Plate 8

(c) Isis and two astronomers. At the centre a statue of Isis above a globe. Below are two seated astronomers. (Reversed copy of B. XV, 478.) 25.4 x 19.8 cm
E.231-1885

(d) Impression. Numbered 8. 25.5 x 19.8 cm
E.2069-1899

Plate 9

(c) Ganymede. At the top Ganymede carried by an eagle, and below a peacock displaying its feathers. (Reversed copy of B. XV, 475.) 24.4 x 15.3 cm
E.229-1885

(c) Another impression [cut].
29755.6

(d) Impression. Numbered 9. 25.7 x 15.5 cm
E.2070-1899

Plate 10

(c) Five figures supporting a canopy, the central figure surmounted by a shell. (Reversed copy of B. XV, 472.) 24.5 x 13.2 cm
E.226-1885

(c) Another impression.
16787

(d) Impression. Numbered 10. 24.5 x 13.4 cm
E.2071-1899

Plate 11

(c) A warrior above a candelabrum, two men reading. A man in armour; at either side of him sit two figures, each reading by the light of a lamp. (Reversed copy of B. XV, 474.) 25.8 x 15.5 cm
E.228-1885

(c) Other impressions (2).
16774, 29755.4 [damaged]

(d) Impression. Numbered 11. 25.8 x 15.5 cm
E.2072-1899

(e) Impression. [damaged.] Cut to 25.4 x 14.4 cm
29755.5

Plate 12

(b) Panel with cupids battling satyrs. A cupid beats a satyr, which another cupid is pulling by a rope, attached to the satyr's legs. Signed in monogram E.V. Dated 1541. Lettered TOMASIVS. BARL. EXCVD. (B. XV, 483). Cut to 27.6 x 18.5 cm
20306.2

(c) Impression. 29.2 x 19.9 cm
E.235-1885

(c) Other impressions (2).
16776, 29755.2 [both cut]

(d) Impression. Numbered 12. 29.3 x 20 cm
E.2073-1899

Plate 13

(b) Panel with four bulls pulling a cart. Two pairs of oxen pulling a cart in opposite directions. Signed in monogram E.V. (B. XV, 487). 30.2 x 20.6 cm
20306.1

(c) Impression. 29 x 19.8 cm
E.238-1885

(d) Impression. Numbered 13. 29.2 x 19.8 cm
E.2074-1899

Plate 14 left

(c) Panel of grotesque figures and satyrs. A satyr aims an arrow at the bottom of a crouching figure. (Reversed copy of B. XV, 482.) Cut to 19.2 x 14.5 cm
16786

(c) Other impressions (3).
16777, 20305, E.234-1885

(d) Impression. Numbered *14*. 19.5 x 30.3 cm [whole plate including pl.14 right.]
E.2075-1899 (left)

Plate 14 right

(b) Panel with a candelabrum at an archway. A candelabrum at the entrance to a vaulted pavilion, outside which are staircases, upon which are climbing figures (B. XV, 480). Cut to 19.8 x 14.3 cm
E.232-1885

(c) Impression. Cut to 19.2 x 14 cm
16785

(d) Impression. Numbered *14*. 19.5 x 30.3 cm [whole plate including pl. 14 left]
E.2075-1899 (right)

Plate 15 left

(b) Panel of grotesques. Four fauns that support architraves on which are galloping horses (B. XV, 481). Cut to 16.3 x 11.8 cm
E.233-1885

(c) Impression. Cut to 18.9 x 15 cm
16754.A

(c) Another impression.
16782

(d) Impression. Numbered *15*. 19.5 x 30 cm [whole plate including pl.15 right]
E.2076-1899 (left)

Plate 15 right

(b) A man reaching towards a festoon. A spread-eagled figure stands under a festoon. Signed in monogram *E.V.* [partially erased] (B. XV, 471). Cut to 17.1 x 12.2 cm
E.225-1885

(c) Impression. Cut to 19 x 14.8 cm
16754

(d) Impression. Numbered *15*. 19.5 x 30 cm [whole plate including pl. 15 left]
E.2076-1899 (right)

Plate 16 left

(b) A three-storeyed Chinese house. At the bottom, a statue between two pillars made up of two figures back-to-back. Signed in monogram *E.V.* [partially erased] (B. XV, 470). Cut to 16.3 x 11 cm
E.224-1885

(c) Impression. Cut to 19.1 x 12.9 cm
16783

(d) Impression. Numbered *16*. 19.1 x 28.6 cm [whole plate including pl.16 right]
E.2077-1899 (left)

Plate 16 right

(c) Three small panels. Within a border at the top a pointed lunette; in the centre a section of frieze; at the bottom a semi-circular lunette with a winged putto holding ropes. (Reversed and reorganized copy of B. XV, 469.) Cut to 19.3 x 15.4 cm
16784

(d) Impression. Numbered *16*. 19.1 x 28.6 cm [whole plate including pl. 16 on left]
E.2077-1899 (right)

Plate 17

(b) Panel with two parrots and five small friezes. Five friezes with a pointed lunette above (B. XV, 473). 24.2 x 14 cm
E.227-1885

[The lettering described in Bartsch has been cut out and replaced by a blank paper patch.]

Catalogue 35: PLATE DESCRIPTIONS

Plate 1

Silvanus and a nymph (B. XV, 165; Massari, 75; E. I, 24.(316)). Signed *I. BONASO F*. Inscribed in ink on the front *WE 50*, and on the back *1834 WE 50* [marks of the collection of W. Esdaile (Lugt 2617)]. 20.2 x 15 cm
22553.2

Plate 2

Hercules and Dejanira (B. XV, 166; Massari ,76). Signed *I. BONASO. F*. Inscribed in ink on the front *WE 60*, and on the back *1834 WE 60* [marks of the collection of W. Esdaile (Lugt 2617)]. 20.6 x 15.6 cm
22553.1

For the drawing by Polidoro da Caravaggio for the nymph, see Massari, vol. I, p.69.

'IMPRESAS'

Catalogue 36

Plate No.	1	2	3	4	5	6	7	8	9	10	11	12	13	14	15
36a	□			□			□	□	□	□	□	□	□	□	
36b		□	□	□	□	□			□		□		□		□

SET DESCRIPTIONS

Original plates and reissues

36a Domenico ZENOI (active c. 1560–80), Nicolò NELLI (active 1563–76) and ANONYMOUS, engravers. Girolamo RUSCELLI (1538–after 1592), compiler. Plates (10) including title plate of Book Three from *Le Imprese Illustri Con Espositioni, et Discorsi del Sor. Ieronimo Ruscelli*. Italian, Venice, 1566. Title plate of Book Three lettered with title and dedication. Plates lettered with names and mottoes.
Engravings
E.1602-1923, E.1604-1923, E.1606–1608-1923, E.1610-1923, E.1612-1923, E.1615-1923, E.1617-1923, E.1619-1923

Lit: Guilmard, p.294, no. 43; Berlin, 4512; Mortimer, 449.

36b Giacomo FRANCO (1550–1620) and ANONYMOUS, engravers. Plates (8) and a new title plate to a fourth book and reissues of Catalogue 36a, largely reworked. Italian, Venice, 1584. Lettered with names and mottoes.
Engravings
E.1603-1923, E.1605-1923, E.1609-1923, E.1611-1923, E.1613-1923, E.1614-1923, E.1616-1923, E.1618-1923

Lit: Pasero, p.338, no. IV.

NOTES: An impresa (Italian plural *imprese*) is a pictorial device, often with an accompanying motto or verse, invented for an individual and alluding to character, position or occupation. The plates are described in the order in which they appear in bound copies of the volume. According to Mortimer, 449, there are 135 engravings in the original work, which was continued to a fourth book by Girolamo Ruscelli's nephew, Vincenzo Ruscelli.

Cat. 36a pl. 1

Cat. 36a pl. 4

Cat. 36a pl. 7

Cat. 36a pl. 8

Cat. 36a pl. 9

Cat. 36a pl. 10

Cat. 36a pl. 11

Cat. 36a pl. 12

Cat. 36a pl. 13

Cat. 36a pl. 14

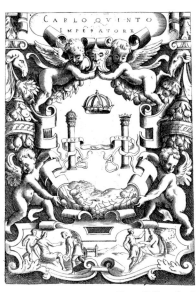

Cat. 36b pl. 2

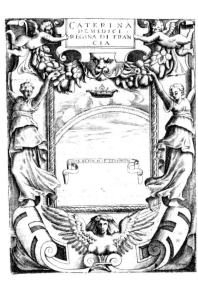

Cat. 36b pl. 3

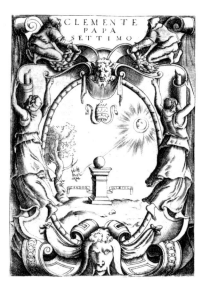

Cat. 36b pl. 4

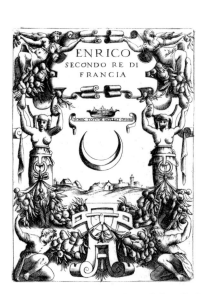

Cat. 36b pl. 5

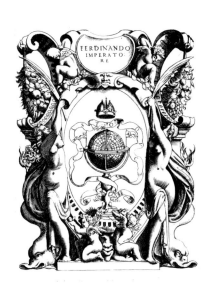

Cat. 36b pl. 6

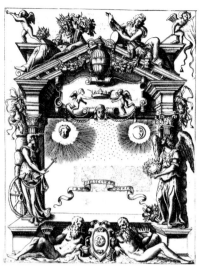
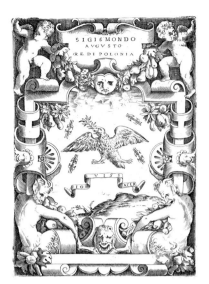

Cat. 36b pl. 9 Cat. 36b pl. 11 Cat. 36b pl. 15

Catalogue 36: PLATE DESCRIPTIONS

Plate 1

(a) Fortune within a border of strapwork, two Cupids and two angels holding a crown. Lettered *CARLO ARCIDVCA D'AVSTRIA* and *AVDACES IVVO*. Cut to 18.4 x 14.8 cm
E.1607-1923

Plate 2

(b) Two columns, surmounted by a crown. A border of four cupids, strapwork, swags and rams' heads. Lettered *CARLO QVINTO IMPERATORE* and *PLVS VLTRA*. 17.4 x 12.7 cm
E.1611-1923

Plate 3

(b) A crown over a rainbow. A border of strapwork, a winged sphinx and two dancing women. Lettered *CATERINA DE MEDICI REGINA DI FRANCIA* and in Greek. 17.4 x 13.2 cm
E.1605-1923

Plate 4

(a) Sun shining on a ball on a pedestal; above, a papal tiara. A border of strapwork with two women and two hooded men. Lettered *CLEMENTE PAPA SETTIMO* and *CANDOR ILLAESVS*. Cut to 17.4 x 12.7 cm
E.1617-1923

(b) Impression.
E.1616-1923

Plate 5

(b) A crown over a crescent moon. A border of strapwork, two female figures, two angels and two boys. Lettered *ENRICO SECONDO RE DI FRANCIA* and *DONEC TOTVM IMPLEAT ORBEM*. 17.8 x 13.1 cm
E.1609-1923

Plate 6

(b) Imperial crown over a globe and an eagle. Border of two nude women, four winged putti, foliage and two dolphins. Lettered *FERDINANDO IMPERATORE* and *CRISTO DVCE*. 18.4 x 13.9 cm
E.1613-1923

Plate 7

(a) Apollo in his chariot. A border of Justice and Temperance, two putti and cupids set in strapwork and foliage. Lettered *IAM IL LVSTRABIT OMNIA*. 18 x 14.2 cm
E.1606-1923

Plate 8

(a) A lion and a hand holding a torch beneath a crown. A border of caryatids, two women, foliage and masks with strapwork. Lettered *CON ESTAS*. 17.3 x 13.7 cm
E.1612-1923

Plate 9

(a) The sun and moon. A border with an angel holding a wreath, standing on a cornucopia, and a woman with a wheel and a sceptre. Above, a pediment with two women and two cupids. Below, two reclining river gods holding crowns. Lettered *IAM FELICITER OMNIA*. Cut to 18.2 x 14.1 cm
E.1619-1923

(b) Impression.
E.1618-1923

Plate 10

(a) Double-headed eagle under a crown. Border with two pediments, the infant Hercules and four tritons. A male and a female herm flanking male and female figures in niches. Below, a frieze of four cupids, two satyrs and a lion mask. Lettered in Greek. Cut to 18.2 x 13.8 cm
E.1608-1923

Plate 11

(a) Eagle bearing a branch in its mouth. A border of two cupids, two satyrs, strapwork and foliage. Lettered *SIGISMONDO AVGVSTO RE DI POLONIA* and *IO VIS ACER*. Cut to 17.5 x 12.8 cm
E.1615-1923

(b) Impression.
E.1614-1923

Plate 12

(a) Four candlesticks with one alight in a strapwork border. Lettered in Arabic. Cut to 18.1 x 13.4 cm
E.1610-1923

Plate 13: title plate to Book 3

(a) Male and female herms with two putti holding swags. Lettered *LE IMPRESE ILLVSTRI CON FIGVRE DI STAMPE DI RAME ET CON ESPOSITIONI DI IERONIMO RVSCELLI* and *AL SERENISSIMO PRINCIPE GVGLIELMO GONZAGA DVCA DI MANT. ET MONFERR* and *LIBRO TERZO*. Cut to 19.2 x 14.2 cm
E.1602-1923

Plate 14

(a) Sacrificial altar. A pedimented border with Temperance and Justice. Two satyrs support a festoon, two cupids and a crown. Lettered in Greek. Cut to 17.4 x 14.7 cm.
E.1604-1923

Plate 15: title plate to Book 4

(b) Fortitude and Temperance stand on either side. Justice and Truth display the Gonzaga arms. Signed *Giacomo Francho Fecit*. Dated *.M.D.L.XXXIIII*. Lettered *LE IMPRESE ILLVSTRI DEL S.or IERONIMO RVSCELLI. AGGIVNTOVI NVOVAM. TE IL QVARTO LIBRO DA VINCENZO RVSCELLI DA VITERBO* and *In venetia appresso Francesco de fraceschi Senesi*. Cut to 19.7 x 14.2 cm
E.1603-1923

Catalogue 37

Plate No.	1	2	3	5	6	7	8	10	12	13	14
	☐	☐	☐	☐	☐	☐	☐	☐	☐	☐	☐

SET DESCRIPTION

Original plates and reissues

37 Bartolomeo da BRESCIA (1506–after 1578), engraver. Plates (11) from a set of 16, each used as the frontispiece to a chapter of *Rime de Gli Academici occulti con de loro imprese et discorsi,* printed by Vincenzo SABBIO, Italian, Brescia, 1568. Each signed *S.B.B.* Each lettered with titles and mottoes. Each with text on the back and some with printers' signatures adjacent to the engraver's monogram.
Engravings
E.1078–1088-1923

Lit: Guilmard, p.294, no. 44.

NOTES: A copy of the book is in the British Library (82.g.23). The plates are numbered here according to the order of the chapters that they illustrate. Each plate includes the armorial bearings of the author of the related chapter.

Cat. 37 pl. 1	Cat. 37 pl. 2	Cat. 37 pl. 3

Cat. 37 pl. 5

Cat. 37 pl. 6

Cat. 37 pl. 7

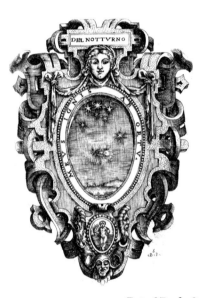

Cat. 37 pl. 8

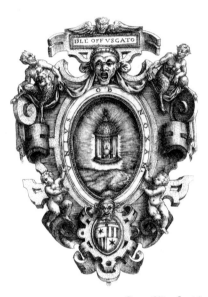

Cat. 37 pl. 10

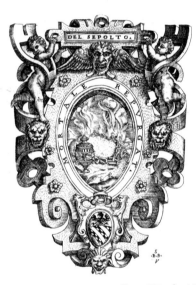

Cat. 37 pl. 12

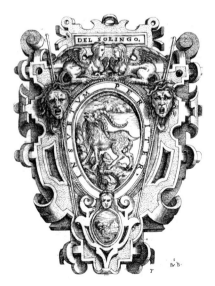

Cat. 37 pl. 13

Cat. 37 pl. 14

Catalogue 37: PLATE DESCRIPTIONS

Plate 1

Strapwork cartouche surmounted by two putti and with female figures supporting a central oval panel, on which a sea-urchin is depicted in a landscape. Signed in monogram *S.B.B.* Lettered *DELL ABSTRVSO.* and *VNDIQUE TVTVS.* Lettered in letterpress *A.* 17.2 x 12.8 cm
E.1085-1923

Plate 2

Strapwork cartouche, surmounted by two putti holding baskets of fruit, with two female demi-figures below; in the central panel a swan in front of a laurel tree. Signed in monogram *S.B.B.* Lettered *DELL' ADOMBRATO* and *NON COME SOGLIO IL FOLGORAR PAVENTO.*
17.4 x 12.8 cm
E.1081-1923

Plate 3

Strapwork cartouche with two armless, winged, female demi-figures; in the central oval panel a bird. Signed in monogram *S.B.B.* Lettered at the top *DELL' ARCANO.* and *TACITVRNIOR.* 17.3 x 12.8 cm
E.1086-1922

Plate 5

Strapwork cartouche with two putti, and two women symbolizing Painting and Geometry. In the central oval a Doric column entwined by a stem of bell-shaped flowers. Lettered *DEL DESIOSO.* and *VT ERIGAR.* Lettered in letterpress *I.* Numbered *2.* 17.4 x 13.2 cm
E.1079-1923

Plate 6

Strapwork cartouche, festoons of fruit and vegetables hanging from two goat masks and, in the central oval, a plough in a field. Lettered at the top *DELL'INCOGNITO.* and on the frame of the central oval *VETERES TELLVRE RECLVDIT.* 17.1 x 13.2 cm
E.1088-1923

Plate 7

Strapwork cartouche, surmounted by two putti and flanked by festoons of fruit and vegetables; in the central oval a chrysalis on a stone plinth. Signed in monogram *S.B.B.* Lettered *DELL'INTRICATO* and, on the frame of the central oval, in Greek APTEROS OU DYNATAI [without wings he is powerless]. Lettered in letterpress *M.* 17.2 x 12.3 cm
E.1080-1923

Plate 8

Strapwork cartouche with a female mask and, in the central oval, the sky with seven stars and a firefly. Signed in monogram *S.B.B.* Lettered *DEL NOTTVRNO* and *MEVS IGNIS AB ORTV.* 17.3 x 12.5 cm
E.1083-1923

Plate 10

Strapwork cartouche, surmounted by two satyrs and supported by two putti; in the central oval an illuminated lantern. Signed in monogram *S.B.B.* Lettered *D'LL'OFFVSCATO* and *VNIVS OB NOXAM.* 17.8 x 12.8 cm
E.1078-1923

Plate 12

Strapwork cartouche with two putti, two lions' masks and, in the central oval, a burning funeral pyre and an urn. Signed in monogram *S.B.B.* Lettered *DEL SEPOLTO.* and *MORTALE REPVRGAT.* Lettered in letterpress *V.*
17.3 x 12.5 cm
E.1082-1923

Plate 13

Strapwork cartouche with two sphinxes, two medusa heads with wands behind and, in the central oval, a mountain goat. Signed in monogram *S.B.B.* Lettered *DEL SOLINGO.* and *INSVETVM PER ITER.* Lettered in letterpress *T.* 17.2 x 12.9 cm
E.1087-1923

Plate 14

Strapwork cartouche; in the central oval a sea-god holding a fish. Signed in monogram *S.B.B.* Lettered *DEL SOMMERSO.* and *QVO FATA TRAHVNT.* Lettered in letterpress *EE.* Numbered *2.* 17.3 x 12.2 cm
E.1084-1923

MASKS

Catalogue 38

1	2	3	4	5	6	7	8	9	10	11	12	13	14	15	16	17	18	19	20	21	22	23	24
☐	☐	☐	☐	☐	☐	☐	☐	☐	☐	☐	☐	☐	☐	☐	☐	☐	☐	☐	☐	☐	☐	☐	☐

SET DESCRIPTION

Original plates and reversed copy plates

38 MONOGRAMMIST IHS (active 1560–72), engraver. Cornelis FLORIS (1514–75), Giulio ROMANO (1492/99–1546) and MONOGRAMMIST IHS, designers. René BOYVIN (c. 1530–98), publisher. Plates (24), including a title plate, of masks. Plates 12, 14–17 and 21 original plates. Plates 1–11, 13, 18–20, 22–4 reversed copies of plates by Frans Huys (c. 1522–c. 1562) after Cornelis Floris (Hedicke X, 12–16, and XI, 1–12). Italian, 1560. Each signed in monogram *IHS*. The title plate dated *MDLX*. The title plate lettered with title and *RENATVS. B.L. FECIT*.
Engravings
28860.1, E.938-1886, E.57.1–24-1896

Lit: Nagler Mon. III, 2602(33); Collijn, 29; Warncke, 446–9; Byrne, 1981, no. 37; A. 78B.

NOTES: The lettering on the title plate *RENATVS B.L. FECIT* has in the past meant that these prints have been attributed to René Boyvin. However, the placing of this lettering in relation to the stippled background on that part of the plate suggests that it was added after the plate had been engraved.

Levron does not list this set in his catalogue of Boyvin's works, or illustrate it, although he does make reference to a little-known set of masks engraved by Boyvin after Angelo Veientano, lettered *Renatus B fecit* and dating from 1560, in the introductory text, p.25. This reference seems to be a misunderstanding of the set here. Robert-Dumesnil (vol. VIII, p.16) cites the correct title of this set but appears never to have seen it.

A set of seventeen masks and a title plate, engraved by Frans Huys after designs by Cornelis Floris, was published in Antwerp in 1555, by Hans Liefrinck. (Hedicke X, 12–16, and XI, 1–12). In the set described here all the Huys plates, including the title plate, are copied in reverse and six new plates, pl. 12, 14, 15, 16, 17 and 21, have been added. Byrne (1981) suggests that the new plates in the set by the Monogrammist IHS were his original invention. One plate at least has another source. I am indebted to Tim Miller for the observation that plate 14 depicts one of the painted masks on the ceiling of the Loggia del Davide in Giuilio Romano's Palazzo del Te in Mantua (see Gombrich *et al.*, pp.364–5).

The plates are described in the order in which the impressions acquired in 1896 were bound. This volume has a binding dating from the end of the nineteenth century.

Cat. 38 pl. 1

Cat. 38 pl. 2

Cat. 38 pl. 3

Cat. 38 pl. 4

Cat. 38 pl. 5

Cat. 38 pl. 6

Cat. 38 pl. 7

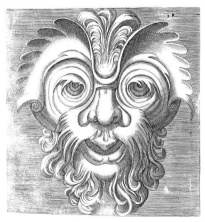

Cat. 38 pl. 8

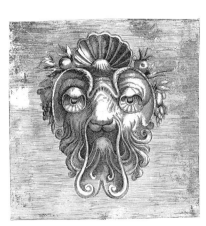

Cat. 38 pl. 9

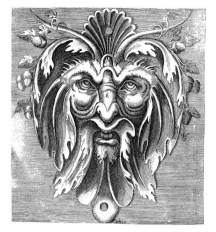

Cat. 38 pl. 10

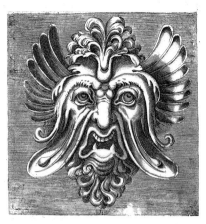

Cat. 38 pl. 11

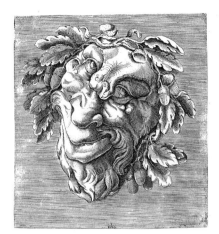

Cat. 38 pl. 12

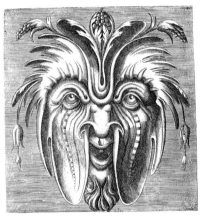

Cat. 38 pl. 13

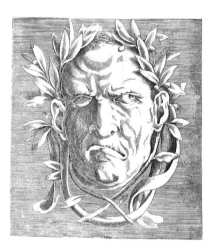

Cat. 38 pl. 14

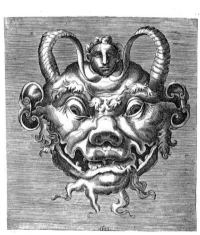

Cat. 38 pl. 15

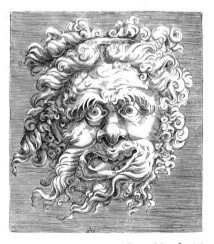

Cat. 38 pl. 16

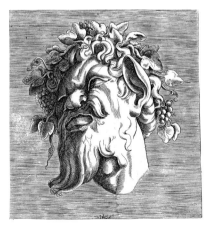

Cat. 38 pl. 17

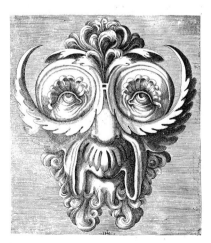

Cat. 38 pl. 18

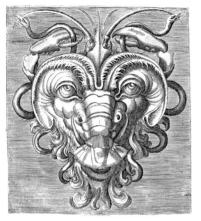

Cat. 38 pl. 19

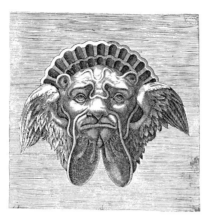

Cat. 38 pl. 20

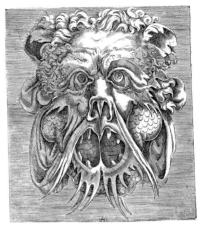

Cat. 38 pl. 21

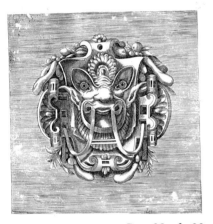

Cat. 38 pl. 22

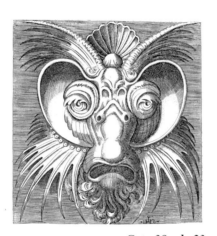

Cat. 38 pl. 23

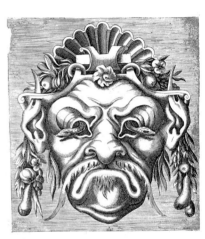

Cat. 38 pl. 24

Catalogue 38: PLATE DESCRIPTIONS

Plate 1: title plate

Title plate of a strapwork cartouche. (Reversed copy of Hedicke X, 1.) Signed in monogram *.IHS.* [cut]. Lettered *RENATVS .B.L. FECIT/LIBRO. DI VARIATE. MASCARE. QVALE. SERVONO. A PITTORI. SCVLTORI. ET. A. HVOMINI. INGENIOSI. MDLX.* Cut to 16 x 14.3 cm

E.57.1-1896

Plate 2

Grotesque mask facing front, with whiskers suspended through holes in the ears. (Reversed copy of Hedicke XI, 1.) Signed in monogram *.IHS.* [cut]. Cut to 16 x 14.4 cm

E.57.2-1896

Plate 3

Grotesque mask facing front, with saucer-like eye sockets and a dimpled chin. (Reversed copy of Hedicke XI, 11.) Signed in monogram .IHS. [cut]. Cut to 16.1 x 14.2 cm
E.57.3-1896

Plate 4

Grotesque mask facing front, with plant fronds growing from the hairline. (Reversed copy of Hedicke XI, 6.) Signed in monogram IHS [cut]. Cut to 15.6 x 14.5 cm
E.57.4-1896

Plate 5

Grotesque mask facing front, with mouth drooping at corners and round seeds sprouting from centre of forehead. (Reversed copy of Hedicke X, 12.) Signed in monogram .IHS. [cut]. Cut to 15.6 x 14.4 cm
E.57.5-1896

Plate 6

Grotesque mask facing front with open mouth and scaly eyebrows. (Reversed copy of Hedicke XI, 12.) Signed in monogram .IHS. [cut]. Cut to 16.1 x 14.4 cm
E.57.6-1896

Plate 7

Grotesque mask facing right. (Reversed copy of Hedicke XI, 4.) Signed in monogram IHS [cut]. Cut to 15.8 x 14.3 cm
E.57.7-1896

Plate 8

Grotesque mask facing front, with beard divided at the chin. (Reversed copy of Hedicke XI, 5.) Signed in monogram .IHS. [erased and cut]. Cut to 15.1 x 14.9 cm
E.57.8-1896

Plate 9

Grotesque mask facing front, with a shell at centre of forehead and fruit around hairline. (Reversed copy of Hedicke XI, 8.) Signed in monogram .IHS. [partially erased]. Cut to 14.8 x 15 cm
E.57.9-1896

Another impression.
28860.1

Plate 10

Grotesque mask facing front, with shell at centre top and acorns and oak leaves around hairline. (Reversed copy of Hedicke X, 13.) Signed in monogram .IHS. [cut]. Cut to 15.1 x 14.4 cm
E.57.10-1896

Another impression [cut].
E.938-1886

Plate 11

Grotesque mask facing front, with flying jowls and open mouth showing teeth. (Reversed copy of Hedicke XI, 2.) Signed in monogram .IHS. [cut]. Cut to 15.3 x 14.7 cm
E.57.11-1896

Plate 12

Grotesque mask, three-quarter face, with distorted features, one eye higher than the other, with a supplementary bridge to the nose, the face surrounded with acorns and oak leaves. [Not in Hedicke.] (Warncke, 446.) Signed in monogram IHS. Cut to 15.2 x 14.4 cm
E.57.12-1896

Plate 13

Grotesque mask facing front, with three seed pods growing from the hairline. (Reversed copy of Hedicke XI, 7.) Signed in monogram IHS [cut]. Cut to 15.4 x 15 cm
E.57.13-1896

Plate 14

Grotesque mask facing front, with crooked mouth, and wreathed round the face with laurel leaves and berries. [Not in Hedicke.] Signed in monogram IHS. Cut to 15.8 x 14.3 cm
E.57.14-1896

Plate 15

Grotesque mask facing front, surmounted by a human male mask flanked by scale-like horns. The ears are formalized into cartouches of C scrolls. [Not in Hedicke.] (Warncke, 449.) Signed in monogram .IHS. Cut to 15.9 x 14.9 cm
E.57.15-1896

Plate 16

Grotesque mask facing front, with its tongue slightly protruding from its mouth, and with corkscrew ringlets held back by a bandeau. [Not in Hedicke.] (Warncke, 448.) Signed in monogram *IHS* [cut]. Cut 14.8 x 13.5 cm
E.57.16-1896

Plate 17

Three-quarter-face mask of a satyr, wreathed with vine leaves and grapes. [Not in Hedicke.] Signed in monogram *IHS* [cut]. Cut to 14.8 x 13.8 cm
E.57.17-1896

Plate 18

Grotesque mask facing front, with fringed pieces curling upwards under the eye sockets. (Reversed copy of Hedicke X, 15.) Signed in monogram *IHS* [cut]. Cut to 15.9 x 14.3 cm
E.57.18-1896

Plate 19

Grotesque mask facing front, with crab claws and snakes protruding from the hairline. (Reversed copy of Hedicke XI, 3.) Signed in monogram *IHS* [cut]. Cut to 15.8 x 14.3 cm
E.57.19-1896

Plate 20

Grotesque mask facing front, with wing-shaped ears. (Reversed copy of Hedicke X, 16.) Signed in monogram *.IHS*. Cut to 14.8 x 14.8 cm
E.57.20-1896

Plate 21

Grotesque mask facing front, with an open mouth divided in two parts, with four teeth in each. Fish-like scales hang in place of his cheeks. [Not in Hedicke.] (Warncke, 447.) Signed in monogram *.IHS*. Cut to 14.9 x 13.5 cm
E.57.21-1896

Plate 22

Grotesque mask facing front, made up of strapwork. (Reversed copy of Hedicke XI, 10.) Signed in monogram *IHS* [cut]. Cut to 15 x 14.8 cm
E.57.22-1896

Plate 23

Grotesque mask facing front, with spiky fronds above and below the eye socket. (Reversed copy of Hedicke XI, 9; A. 78B.) Signed in monogram *IHS* [cut]. Cut to 15.4 x 14.5 cm
E.57.23-1896

Plate 24

Grotesque mask facing front, with snakes protruding from the eye sockets. (Reversed copy of Hedicke X, 14.) Signed in monogram *IHS* [cut]. Cut to 15.8 x 14.6 cm
E.57.24-1896

Catalogue 39

Plate No.	1	2	3	4	5	6	7	8	9	10	11	12	13	14	15	16	17	18	19	20	21	22	23
	☐	☐	☐	☐	☐	☐	☐	☐	☐	☐	☐	☐	☐	☐	☐	☐	☐	☐	☐	☐	☐	☐	☐

SET DESCRIPTION

Original plates and reissues

39 ANONYMOUS, etcher. Antonio LAFRERY (1512–77), publisher. Plates (23) on six sheets, representing twenty-one Antique sculptures of Roman actors' masks, an Antique head of Medusa (pl. 21), and a 16th-century sculpture (pl. 15). Italian, c. 1573. Lettered variously in Latin, with the location or name of the collection where the sculpture could be found. Numbered *1–23*.
Etchings
E.2039–2061-1899

Lit: Berlin, 532; A. 624; E. VII, 85.1–23.(2760–82); Miller.

NOTES: Catalogue 39 forms part of the Lafrery Volume (see Introduction) and corresponds to the entry *Libro de Maschere* in Lafrery's stocklist of c. 1573 (Ehrle, p.59). It is evidence of 16th-century collectors' taste for antiquities and refers to classical examples in contemporary Roman collections, with the exception of pl. 15, which is probably a Renaissance fountain mask executed after the Antique. Pairs of masks corresponding to pl. 3–8 still decorate the Octagonal Court of the Vatican Museums, the now much-altered site of the garden used for the display of Antique sculpture at the beginning of the 16th century, which formed part of the then Belvedere Palace. Some of the prints can be matched with surviving masks in other museum collections (see Pertosa).

In the Berlin catalogue eighteen plates of Roman actors' masks, numbered *21–38,* are listed as a continuation of a set of grotesque masks attributed by Bartsch to Adamo Scultori, after designs by Giulio Romano (B. XV, 108–27; Bellini, 1991, nos 121–40), although these two sets are quite different in character. The set in Berlin was destroyed during the Second World War. The Amsterdam impressions are numbered in the same way as, according to the catalogue, were those in Berlin. The impressions in Amsterdam show signs of having been renumbered. The images absent from the Amsterdam set are pl. 7, 10, 12, 18 and 23 in the listing below.

The impressions in Amsterdam were once part of a larger volume with ornament prints, published in Rome by Giovanni Giacomo de Rossi, printed on uniform sheets of paper and containing masks, friezes and foliage scrolls by, or after, Ludovico Scalzi, Pietro Antonio Priscus and a panel by Marco Dente (A. 597; RP-P-1951-183). [P. Fuhring, written communication, November 1997.] The masks are listed in the de Rossi *Indice* of 1735 as *Maschere antiche di marmo intagliate a bulino libro in 39 ottavi di fogli reale bajocchi 50* (Grelle Iusco, 174).

The larger size of the set in the V&A, and the fact of their being numbered *1–23,* indicates that the V&A set represents an earlier stage in the history of these plates. The set illustrated in the catalogue of the collection at the Escorial appears to contain two impressions of the plate here numbered *21.*

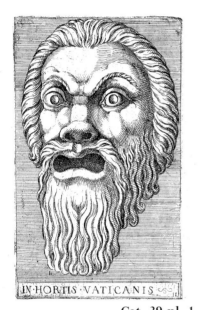

Cat. 39 pl. 1

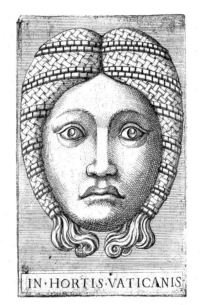

Cat. 39 pl. 2

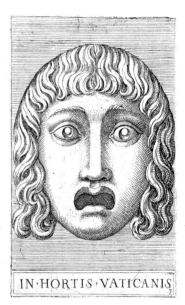

Cat. 39 pl. 3

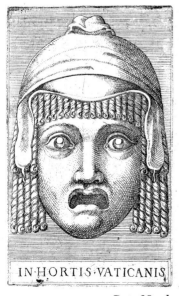

Cat. 39 pl. 4

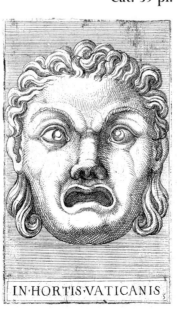

Cat. 39 pl. 5

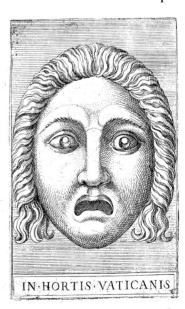

Cat. 39 pl. 6

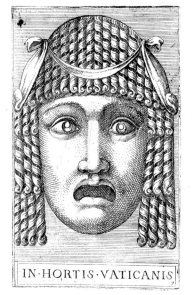

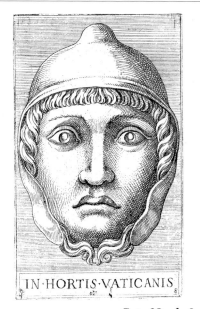

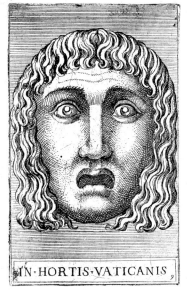

Cat. 39 pl. 7

Cat. 39 pl. 8

Cat. 39 pl. 9

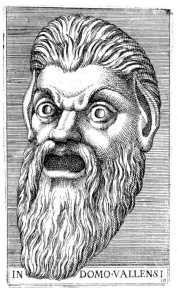

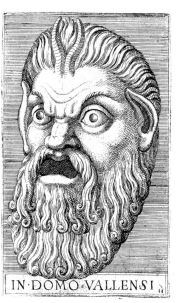

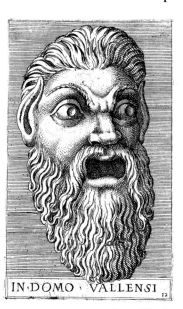

Cat. 39 pl. 10

Cat. 39 pl. 11

Cat. 39 pl. 12

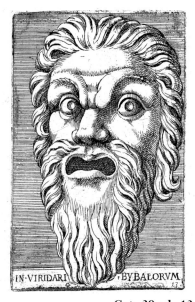

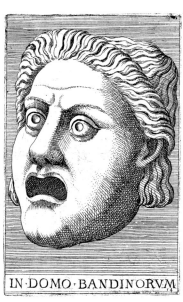

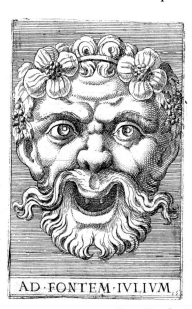

Cat. 39 pl. 13

Cat. 39 pl. 14

Cat. 39 pl. 15

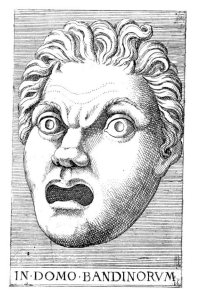

IN·DOMO·BANDINORVM

Cat. 39 pl. 16

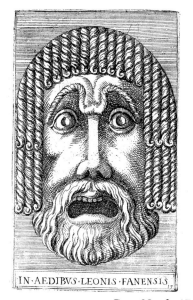

IN·AEDIBVS·LEONIS·FANENSIS

Cat. 39 pl. 17

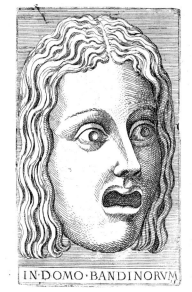

IN·DOMO·BANDINORVM

Cat. 39 pl. 18

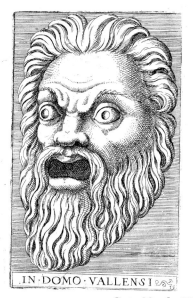

IN·DOMO·VALLENSI

Cat. 39 pl. 19

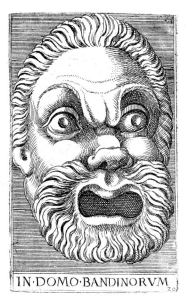

IN·DOMO·BANDINORVM

Cat. 39 pl. 20

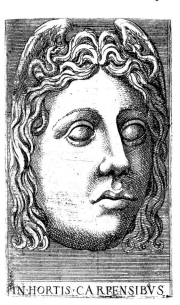

IN·HORTIS·CARPENSIBVS

Cat. 39 pl. 21

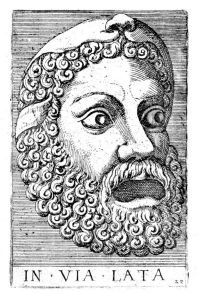

IN·VIA·LATA

Cat. 39 pl. 22

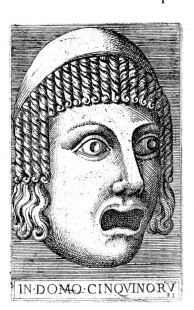

IN·DOMO·CINQVINORV

Cat. 39 pl. 23

Cat. 41a Frontispiece

Cat. 41b Frontispiece

Cat. 41b pl. A

Cat. 41b pl. B

Cat. 41b pl. C

Cat. 41b pl. D

Cat. 41b pl. E

Cat. 41b pl. F

Cat. 41b pl. G

Cat. 41b pl. H

Cat. 41b pl. I

Cat. 41b pl. K

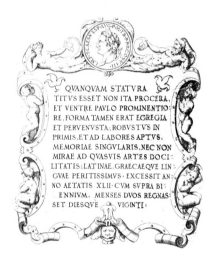

Cat. 41b pl. L

Cat. 41b pl. M

Catalogue 41: PLATE DESCRIPTIONS

Frontispiece

(a) Frontispiece for *Omnium Caesarium*... Second edition of *Le Imagine...de gli Imperatori*. A cartouche flanked by female figures in Antique dress; above, two winged putti, each holding a festoon. Two putti at the bottom supporting a coat of arms (B. XV, 322(II)). Signed *AENEAS VICVS PARM F.* Dated *ANNO MDLIIII.* Lettered on the upper cartouche *OMNIVM CAESARVM VERISSI-MAE IMAGINES EX ANTIQVIS NVMISMATIS DESVMP-TAE...LIBRI PRIMI. EDITIO ALTERA.* 19 x 14.2 cm
E.2464-1912

(b) Impression (B. XV, 322(II), relettered). Dated *MDCXIIII.* Lettered in the upper cartouche *PRIMOR. XII. CAESARVM VERISSIMAE IMAGINES EX ANTIQVIS NVMISMATIB DESVMPTAE...PER AENEA VICV PARMENS./EDITIO TERTIA/superior licentia/ROMAE. Apud Jacobum Mascardum impensis Antonij Caranzanj et Matthaei Greuterj.* 19 x 14.1 cm
E.1841-1923

Plate A

(b) Subtitle for medals of Julius Caesar (B. XV, 323, relettered). Lettered *A* and on a medal *CAESAR IMP,* and with fifteen lines of engraved text beginning *FVISSE TRADITVR...* 16.2 x 13.9 cm
E.1842-1923

Plate B

(b) Subtitle for medals of Augustus (B. XV, 328, relettered). Lettered *B* and on a medal *DIVVS AVGVSTVS,* and with sixteen lines of engraved text beginning *OCTAVIVS EXIMIA FVIT...* 15.4 x 14.2 cm
E.1843-1923

Plate C

(b) Subtitle for medals of Tiberius (B. XV, 341, relettered). Lettered *C* and on a medal *TI. CAESAR AVGVSTI. F. IMPERATOR,* and with fourteen lines of engraved text beginning *AMPLO FVIT TIBERIVS...* 15.9 x 13 cm
E.1844-1923

Plate D

(b) Subtitle for medals of Caligula (B. XV, 346, relettered). Lettered *D* and on a medal *C.CAESAR. AVG. GERMANICVS. PON. M. TR. POT,* and with fifteen lines of engraved text beginning *CAIVS STATVRA FVIT...* 15.6 x 12.9 cm
E.1845-1923

Plate E

(b) Subtitle for medals of Claudius (B. XV, 350, relettered). Lettered *E* and on a medal *TI. CLAVDIVS CAESAR AVG. P. M. TR. P. IMP. P. P.,* and with twelve lines of engraved text beginning *CLAVDIO CVM SVMMA...* 16 x 12.9 cm
E.1846-1923

Plate F

(b) Subtitle for medals of Nero (B. XV, 354, relettered). Lettered *F* and on a medal *NERO CLAVD. CAESARAVG. GER. P.M. TR. P. IMP. P. P,* and with thirteen lines of engraved text beginning *STATVRA FVIT NERO...* 15.7 x 12.4 cm
E.1847-1923

Plate G

(b) Subtitle for medals of Galba (B. XV, 360, relettered). Lettered *G* and on a medal *IMP. SER GALBA AVG.TR. P.,* and with thirteen lines of engraved text beginning *SERGIVS GALBA IVSTAE...* 15.7 x 12.8 cm
E.1848-1923

Plate H

(b) Subtitle for medals of Otho (B. XV, 365, relettered). Lettered *H* and on a medal *IMP. OTHO CAESAR AVG. TR. P.,* and with thirteen lines of engraved text beginning *FVISSE TRADITVR OTHO...* 16.4 x 13.5 cm
E.1849-1923

Plate I

(b) Subtitle for medals of Vitellius (B. XV, 368, relettered). Lettered *I* and on a medal *A. VITELLIVS GERMANICVS. IMP. AVG. P. M. TR. P.,* and with thirteen lines of engraved text beginning *VITELLIO VASTA ERAT...* 15.7 x 14.3 cm
E.1850-1923

Plate K

(b) Subtitle for medals of Vespasian (B. XV, 372, relettered). Lettered *K* and on a medal *DIVVS AVGVSTVS VESPASIANVS,* and with eleven lines of engraved text beginning *VESPASIANVS STATVRA FVIT...* 16.3 x 13.4 cm
E.1851-1923

Plate L

(b) Subtitle for medals of Titus (B. XV, 381, relettered). Lettered *L* and on a medal *IMP. T. CAES. VESP. AVG. P. M. TR. P. P. P. COS. V. III,* and with thirteen lines of engraved text beginning *QVANQVAM STATVRA TITVS ESSET...* 15.7 x 13.2 cm
E.1852-1923

Plate M

(b) Subtitle for medals of Domitian (B. XV, 388, relettered). Lettered *M* and on a medal *IMP. CAES. DOMIT. AVG. GERM. COS. XII. CENS. PER. P. P.,* and with eleven lines of engraved text beginning *DOMITIANVS PROCERITATIS FVIT...* 16 x 14.2 cm
E.1853-1923

Catalogue 42

Plate No.	IX	XIIII	XV	XVIII	XIX	XX	XXII	XXIII	XXIIII	XXVI	XXX	XXXI	XXXIII	XXXV	XXXVI	XXXVII	XLVIII	LII	LIII	LV	LVI	LVII	LVIII	LIX	LXII
42a			☐						☐																
42b	☐	☐		☐	☐	☐	☐	☐	☐	☐	☐	☐	☐	☐	☐	☐	☐	☐	☐	☐	☐	☐	☐	☐	☐
42c					☐																				

SET DESCRIPTIONS

Original plates and reissues

42a Enea VICO (1523–67), engraver. Plates (2) from *Le Imagini delle Donne Auguste*, a suite of sixty-three prints representing medals of the Roman empresses and ladies of the imperial family, set in elaborate frames. Numbered *XV* and *XXIIII*. Italian, Venice, 1557.
Engravings
29291.H, E.1864-1923

Lit: B. XV, 271, 280; Berlin, 4243; E. IX, 29, 13 and 22.(4372 and 4381).

NOTES: Mortimer (no. 532) records another edition of the book from which these prints are drawn, also dating from 1557, but before the addition of the Roman numerals.

42b Enea VICO, engraver. Macé RUETTE (active 1606–19), publisher. Plates (24), reissues of Catalogue 42a, heavily reworked. Each plate lettered with the name of the empress on the medal and with those of her father and mother in ornamental panels. Numbered in Roman numerals.
Italian, published in Paris, 1619.
Engravings
E.1866–1889-1923

Lit: B. XV, 265, 270, 274–6, 278–80, 282, 286–7, 289, 291–3, 304, 308–9, 311–15, 318.

NOTES: The reworking of the plates includes diagonal cross-hatching in the backgrounds. Ruette is recorded as a bookseller in 1606, *Catalogue Chronologique ...*, p.64.

42c Enea VICO, engraver. Macé RUETTE, publisher. Plate, a reissue of Catalogue 42b, pl. XIX, relettered and renumbered. Italian, published in Paris, after 1619.
Engraving
29291.I

Lit: B. XV, 275.

Cat. 42a pl. XV

Cat. 42a pl. XXIIII

Cat. 42b pl. IX

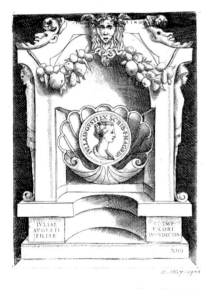

Cat. 42b pl. XIIII

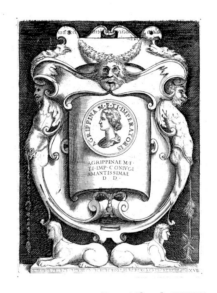

Cat. 42b pl. XVIII

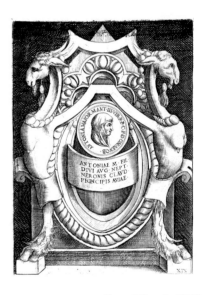

Cat. 42b pl. XIX

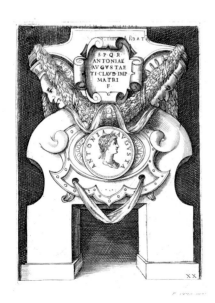

Cat. 42b pl. XX

Cat. 42b pl. XXII

Cat. 42b pl. XXIII

Cat. 42b pl. XXIIII

Cat. 42b pl. XXVI

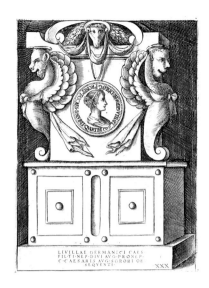

Cat. 42b pl. XXX

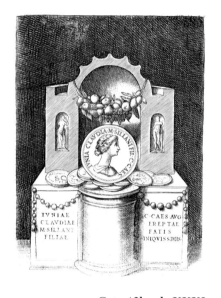

Cat. 42b pl. XXXI

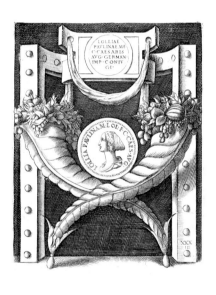

Cat. 42b pl. XXXIII

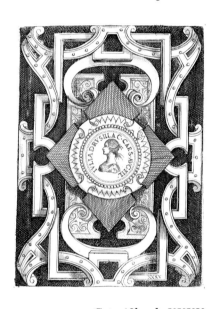

Cat. 42b pl. XXXV

Cat. 42b pl. XXXVI

Cat. 42b pl. XXXVII

Cat. 42b pl. XLVIII

Cat. 42b pl. LII

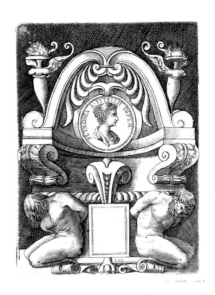

Cat. 42b pl. LIII

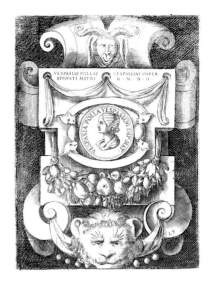

Cat. 42b pl. LV

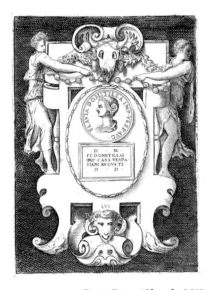

Cat. Cat. 42b pl. LVI

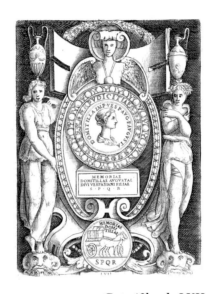

Cat. 42b pl. LVII

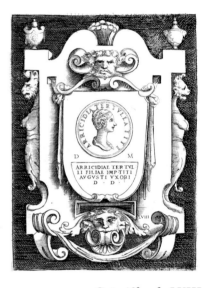

Cat. 42b pl. LVIII

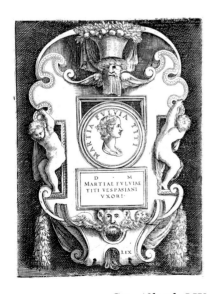

Cat. 42b pl. LIX

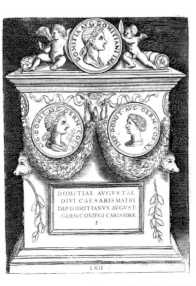

Cat. 42b pl. LXII

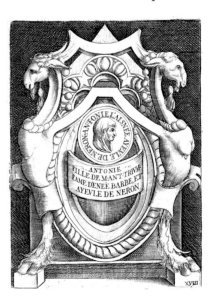

Cat. 42c pl. XIX

Catalogue 42: PLATE DESCRIPTIONS

Plate IX

(b) Actia (B. XV, 265). Lettered on the medal *ACTI-AACT. BALBIET IVLIAE. S. DIVICAES. F. OCT. M.* and below *ACTIAE BALBI FILIAE CAESARIS AVGVST. MATRI.* Numbered *IX*. 15.1 x 11.1 cm
E.1866-1923

Plate XIIII

(b) Julia (B. XV, 270). Lettered on the medal *IVLIA AVGVSTIEX SCRIB. F. M. AGRIP.* and below *IVLIAE AVGVSTI FILIAE TI. IMP. VXORI IMPVDICISS.* Numbered *XIIII*. Cut to 15.2 x 11.4 cm
E.1867-1923

Plate XV

(a) Cartouche without portrait (B. XV, 271; E. IX, 29.13.(4372)). A large scrolled cartouche supported by two standing female figures, with winged putti above and below. Numbered *XV*. Cut to 15.3 x 11.4 cm
E.1864-1923

Plate XVIII

(b) Agrippina (B. XV, 274). Lettered on the medal *AGRIPPINA M. F. TI. IMPERATORIS* and below *AGRIP-PINAE M. F. TI. IMP. CONIVGI AMANTISSIMAE D. D.* Numbered *XVIII*. 15.3 x 11.5 cm
E.1868-1923

Plate XIX

(b) Antonia the Greater (B. XV, 275). Lettered on the medal *ANTONIA MAIOR. M. ANT.III. VIR. R.P.CF.DOM.AENOB* and below *ANTONIAE M. FIL. DIVI AVG.NEPT. NERONIS CLAVD. PRINCIPIS AVIAE.* Numbered *XIX*. Cut to 15.3 x 11.1 cm
E.1869-1923

(c) Impression (reissue of B. XV, 275). Relettered on the medal *ANTONIE L'AISNEE AYEVLE DE NERON* and below, on a cartouche, *ANTONIE FILLE DE M.ANT. TRIVM. FAME D'ENEE BARBE, ET AYEVLE DE NERON.* Renumbered *XVIII*.
29291.I

Plate XX

(b) Antonia Augusta (B. XV, 276). Lettered on the medal *ANTONIA AVGVSTA* and above *S. P. Q. R. ANTONIAE AVGVSTAE TI.CLAVD. IMP. MATRI F.* Numbered *XX*. Cut to 15.8 x 11.4 cm
E.1870-1923

Plate XXII

(b) Livia Drusilla (B. XV, 278). Lettered on the medal *LIVIADRVSIL. DRVSI. F. M. AN. III. VIR. NEP. DRVSI CAES* and below *LIVIAE DRVSILLAE NERONIS CLAVD. DRV SEGERM. IMP.FIL.DIVAE AVGVS TAE NEP.DRVSI CAESARIS CONIVGI.* Numbered *XXII*. Cut to 15.2 x 11.2 cm
E.1871-1923

Plate XXIII

(b) Cartouche without portrait (B. XV, 279). At the bottom a winged cherub and a putto flanking a vase [lettering erased]. Numbered *XXIII*. Cut to 15.4 x 11.4 cm
E.1872-1923

Plate XXIIII

(a) Agrippina (B. XV, 280; E. IX, 29.22.(4381)). Lettered on the medal *AGRIPPINA. M. F. MAT. C.CAESARIS AVGVSTI* and below *AGRIPPINAE M. F. AVGVSTAE DIVI AVG. NEPTIS. VXORIS GERMANICI CAESARIS. MATRIS C. CAESARIS AVG. GERMANICI PRINCIPIS MEMORIAE.* Numbered *XXIIII*. 15.6 x 11.4 cm
29291.H

(b) Impression.
E.1873-1923

Plate XXVI

(b) Julia Agrippina and the Godess of Fertility (B. XV, 282). Lettered twice on the medals *AGRIPPINAE AVGVSTAE* and below *IVLIAE AGRIP PINAE AVGVSTAE GERMANICI CAESARIS F.TI. NEP DIVI AVG. PRON C. CAESARIS. AVG. SORO RI. MATRI NERONIS PRIN CIPIS. TI CLAVDIVS CAES IMP.AVG. GERM. NEPT ET CONIVGI CA RISSIMAE. F.* Numbered *XXVI*. Cut to 14.9 x 11.2 cm
E.1875-1923

Plate XXX

(b) Livilla Germanica (B. XV, 286). Lettered on the medal *LIVILLA GERM. FIL. DIVI AVG. PRONEPT. C. CAES. S. MVINIT. QVARTINI COS* and below *LIVILLAE GERMANICI CAES. FIL. TI. NEP.DIVI AVG. PRONEP. C. CAESARIS AVG. SORORI OB: SEQVENTI.* Numbered *XXX.* Cut to 15.1 x 11.3 cm
E.1876-1923

Plate XXXI

(b) Junia Claudia (B. XV, 287). Lettered on the medal *IVNIA CLAVDIA. M. SILIANI FIL. C. CAES* and below *IVNIAE CLAVDIAE M. SILLANI FILIAE C. CAES. AVG. EREPTAE FATIS INIQVISSIMIS.* Numbered *XXXI.* 15.3 x 11.5 cm
E.1877-1923

Plate XXXIII

(b) Lollia Paulina (B. XV, 289). Lettered on the medal *LOLLIA PAVLINAM. LOL. F. C. CAES. AVG.* and above *LOLLIAE PAVLINAE M. F. C. CAESARIS AVG. GERMAN. IMP. CONIV GI.* Numbered *XXXIII.* Cut to 15.1 x 11.3 cm
E.1878-1923

Plate XXXV

(b) Julia Drusilla (B. XV, 291). Lettered on the medal *IVLIA DRVSILLA C. CAES AVG. FIL.* Numbered *XXXV.* Cut to 14.7 x 10.9 cm
E.1874-1923

Plate XXXVI

(b) Aemilia Lepida (B. XV, 292). Lettered on the medal *AEMILIA LEPIDA DIVI AVG. PRCNEP. TI. CLAVD.* and below *D M AEMILIAE LE PIDAE L. PAVLI FIL. DIVI AVG. PRON. TI. CLAVD CONIVGI.* Numbered *XXXVI.* Cut to 15.4 x 11.3 cm
E.1879-1923

Plate XXXVII

(b) Livia Medulina (B. XV, 293). Lettered on the medal *LIVIA MEDVLINA TI CLAVDI,* above *LIVIAE MEDVLINAE CAMILLAE* and below *TI CLAVDII CONIVGI NOBILISSIME.* Numbered *XXXVII.* Cut to 15.3 x 11.3 cm
E.1880-1923

Plate XLVIII

(b) Statilia Messalina (B. XV, 304). Lettered on the medal *STATILIA MESSALINA STATILII TAVRI ABNEP. NER. IMP.* and above *STATILIAE MES SALINAE TAVRI ABN. NERONIS CLAVD. AVG. CONIV.GI.* Numbered *XLVIII.* Cut to 15.3 x 11.5 cm
E.1881-1923

Plate LII

(b) Sextillia (B. XV, 308). The upper medal lettered *SEXTILIA. A. VITELLII. IMP. AVG. GERM. P. M. TR. P. MATER;* the lower medal lettered *MAT. AVG. MAT. SEN. MAT.PATR. S. C.* Numbered *LII.* Cut to 15 x 11.4 cm
E.1882-1923

Plate LIII

(b) Petronia (B. XV, 309). Lettered on the medal *PETRONIA A. VITELLII IMPER.* Numbered *LIII.* Cut to 15.2 x 11.3 cm
E.1883-1923

Plate LV

(b) Vespasia (B. XV, 311). Lettered on the medal *VESPASIA POLLA VESPASIANI IMP. MAT.* and above *VESPASIAE POLLAE VESPASIANI IMPER. AVGVSTI MATRI B. M. D. D.* Numbered *LV.* Cut to 15.5 x 11.5 cm
E.1884-1923

Plate LVI

(b) Flavia Domitilla (B. XV, 312). Lettered on the medal *FLAVIA DOMITILIA IMP. VESP. AVG.* and below *D. M. FL. DOMITILLAE IMP. CAES. VESPA. SIANI AVGVSTI. D. D.* Numbered *LVI.* Cut to 15.3 x 11.2 cm
E.1885-1923

Plate LVII

(b) Domitilla (B. XV, 313). Lettered on the upper medal *DOMITILLA IMP. VESP. AVG. F. AVGVSTA* and on the lower medal *MEMORIAE DOMITILLAE SPQR,* and between *MEMORIAE DOMITILLAE AVGVSTAE DIVI VESPASIANI FILLIAE S. P. Q. R.* Numbered *LVII.* Cut to 15.3 x 11.5 cm
E.1886-1923

Plate LVIII

(b) Arricidia Tertulla (B. XV, 314). Lettered on the medal *ARRICIDIA TERTVLLA TITI* and below *D. M. ARRICIDIAE TER TVL LI FILIAE IMP. TITI AVGVSTI VXORI D. D.* Numbered *LVIII*. Cut to 15.3 x 11.3 cm

E.1887-1923

Plate LIX

(b) Marcia Fulvia (B. XV, 315). Lettered on the medal *MARTIA FVLVIA TITI* and below *D. M. MARTIAE FVLVIAE TITI VESPASIANI VXORI*. Numbered *LIX*. Cut to 15.1 x 11.5 cm

E.1888-1923

Plate LXII

(b) Domitia (B. XV, 318). Lettered on the medals *DOMITIA AVG. DOMITIANI IMP.* and *AVG. DOMIT. AVG. GERM. COS. V.* and *IMP. DOMIT. AVG. GERM. COS. XI.,* and below *DOMITIAE AVGVSTAE DIVI CAESARIS MATRI IMP. DOMITIANVS AVGVST. GERM.CONIVGI CARISSIMAE F.* Numbered *LXII*. Cut to 15.4 x 11.4 cm

E.1889-1923

Catalogue 47

Plate No.

PLATE DESCRIPTION

Original plates and reissues

47 Diana SCULTORI (c. 1547–1612), engraver. Battista di PIETRA SANTA, designer. Orazio PACIFICO (active c. 1580–1637), publisher. Scrolls of foliage with a snail, bird and two insects against a dotted background. Reissue of Bellini 1991, 33, I. Italian, Rome, late 16th century, first published 1577. Signed *DIANA MANTVANA IN CIDEBAT ROMAE*. Dated *1577*. Lettered *BATTISTA DI PIETRA SANTA DALL ANTICHO*/*Horatius PaciFicus Formis*. Engraving. Cut to 40.4 x 28.2 cm

E.1127-1930

Lit: Passavant VI, no. 58; Bellini, 1991, 33, II.

NOTES: The first state of this print lacks Orazio Pacifico's name.

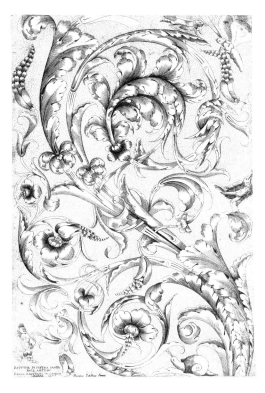

Cat. 47

Catalogue 48

Plate No.	I	2	3	4	5	6
48a	☐					
48b		☐	☐	☐	☐	
48c					☐	

SET DESCRIPTIONS

Original plates and reissues

48a Cesare DOMENICHI (active c. 1600), engraver. Ludovico SCALZI (16th century), designer. Plate from a set of fourteen representing panels of foliage. Italian, 1599.
Engraving
29291.G

Lit: Berlin, 552; A. 634.8; Fuhring, 1989, no. 634.

NOTES: Berlin gives the dates 1607, 1610, 1611 as appearing on other plates in this set. Six other plates from the set are in the volume in Stockholm put together at the start of the 17th century (Collijn, 123).

48b Cesare DOMENICHI, engraver. Ludovico SCALZI, designer. Giovanni Giacomo de ROSSI (active 1638–84), publisher. Plates (4) of scrolls from a set of fourteen. Reissues of Catalogue 48a. Italian, Rome, 1638–84.
Engravings
28800.A–D

Lit: Berlin, 552; A. 634.A.2–3.

NOTES: The set is listed in the de Rossi *Indice* of 1735 as *Fogliami diversi, invenzione, e intaglio di Ludovico Scalzi, libro in 14 fogli reali bajocchi 70* (Grelle Iusco, 320).

Copy plates

48c ANONYMOUS, engraver. Ludovico SCALZI, designer. Plate of a scroll. Copy of Catalogue 48a. Italian, 17th century.
Engraving
28800.E

Lit: A. 634.B.

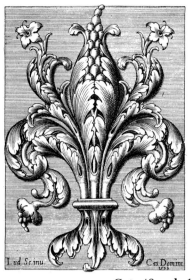

Cat. 48a pl. 1

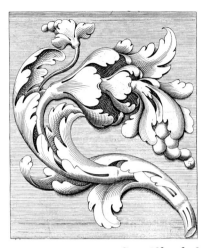

Cat. 48b pl. 2

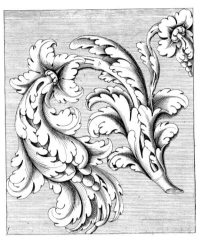

Cat. 48b pl. 3

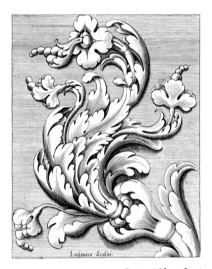

Cat. 48b pl. 4

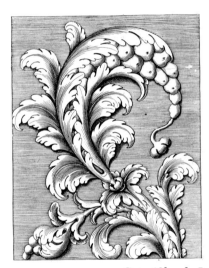

Cat. 48b pl. 5

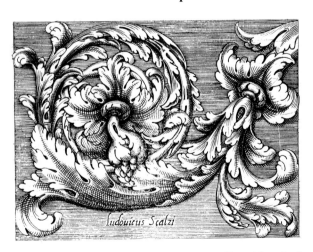

Cat. 48c pl. 6

Catalogue 48: PLATE DESCRIPTIONS

Plate 1

(a) A fleur-de-lis (A.634.8). Signed *Caes. Dom. Inc.* Dated *1599*. Lettered *Lud. Sc. inv*. 13.2 x 9.7 cm
29291.G

Plate 2

(b) A cut tendril bending upwards to the right (A. 634.A.2 left). Cut to 13.6 x 11.6 cm
28800.A

Plate 3

(b) A cut tendril bending downwards to the left (A.634.A.2 right). Cut to 13.5 x 11.5 cm
28800.B

Plate 4

(b) A tendril with a flower opening at the top (A. 634.A.3 left). Lettered *Lodovico Scalzi*. Cut to 14.6 x 11.7 cm
28800.C

Plate 5

(b) A split pod springing from a tendril (A.634.A.3 right). Cut to 14.6 x 11.8 cm
28800.D

Plate 6

(c) A scroll issuing from the top right corner (A. 634.B). Lettered *Ludovicus Scalzi*. 9.3 x 12.4 cm
28800.E

TROPHIES

Catalogue 49

Plate No.

PLATE DESCRIPTION

Original plates and reissues

49 Giovanni Antonio da BRESCIA (active late 1490s–first quarter 16th century), engraver. Trophies on a chariot. At the base four wheels support a platform, on which stand two candelabra and a ball flanking the central structure; on this, further up, a pile of helmets is flanked by banners interlaced with musical horns. Italian, 1505. Signed in monogram *.Z.A.* and dated *1505.s.* Lettered *DIV.FELIX*.
Engraving. Cut to 34.4 x 13.3 cm
26611

Lit: Guilmard, p.282, no. 6; Jessen, 30; Berliner, 193, Hind V, no. 26, as Zoan Andrea; Jean-Richard, 136; TIB 25, 2509.038, as Zoan Andrea.

NOTES: Suzanne Boorsch, writing in Martineau (ed., pp.57–61), has argued that the monogram ZA seen here, which had previously been thought to belong to a print-maker called Zoan Andrea – who was believed by some to be one and the same person as the painter Zoan Andrea, active in Mantua in the 1470s – was in fact the monogram used by the print-maker Giovanni Antonio da Brescia on some of his works dating from before 1508. David Landau concurred with this argument (see Martineau (ed.), p.53). The bottom left corner of this impression is missing. A patch has been inserted and the missing portion added in pen and ink.

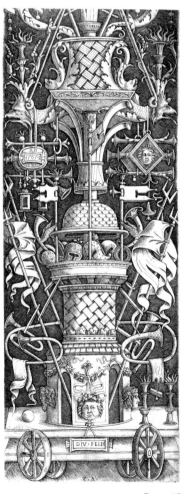

Cat. 49

Catalogue 50

Plate No.	Title	1	2	3	4	5	6	7	8	9	10	11	12	13	14	15	16	17	18
50a															☐	☐			
50b														☐					
50c											☐								
50d										☐	☐	☐	☐	☐	☐	☐	☐	☐	☐
50e													☐						
50f		☐	☐	☐	☐	☐	☐	☐	☐	☐	☐	☐	☐	☐					
50g	☐	☐	☐	☐	☐	☐	☐	☐	☐	☐	☐			☐	☐	☐			
50h		☐	☐	☐	☐	☐	☐		☐	☐	☐	☐	☐	☐	☐	☐			
50i														☐					
50j		☐	☐		☐														
50k							☐		☐					☐					
50l		☐		☐		☐													
50m										☐									

SET DESCRIPTIONS

Salamanca plates and reissues

50a ANONYMOUS, engraver. Polidoro da CARAVAGGIO (1499–1543?), designer. Antonio SALAMANCA (c. 1500–62), publisher. Plates (2) from a set of ten military trophies. Plates 14 and 15 in the listing below. Plate 15 numbered *10* (see below for an explanation of the numbering system). Italian, Rome, second quarter of the 16th century. Both lettered *ANT.SAL.EXC.*
Engravings
17307, 20303.3

50b ANONYMOUS, engraver. Polidoro da CARAVAGGIO, designer. Orazio PACIFICO (active c. 1580–1637), publisher. Plate from a set of ten military trophies. Plate 13 in the listing below. Italian, Rome, c. 1580. Lettered with the names of the publishers Antonio Salamanca and Orazio Pacifico.
Engraving
20303.4

Lit: Guilmard, p.289, no. 24.

50c ANONYMOUS, engraver. Polidoro da CARAVAGGIO, designer Giovanni Battista de ROSSI (1601–78), publisher. Plate from a set of ten military trophies. Plate 10 in the listing below. Italian, Rome, 1640–78. Lettered with the names of the publishers Antonio Salamanca, Orazio Pacifico and Giovanni Battista de Rossi. Numbered *1*.

Engraving
20303.2

Lit: Guilmard, p.289, no. 24.

50d ANONYMOUS, engraver. Polidoro da CARAVAGGIO, designer. Carlo LOSI (active 1773–88), publisher. Plates (10) from a set of ten military trophies. Plates 9–18 in the listing below. Italian, Rome, 1773. Each lettered *ANT.SAL.EXC.* Plates 11, 13, 17 and 18 lettered with the name of the publisher Orazio Pacifico. Plate 10 dated *1773* and lettered *Presso Carlo Losi in Rome.* Numbered *1* and *17–25.*
Engravings
24496.1, 24496.17–25

Lafrery plates and reissues

50e Enea VICO (1523–67), engraver. Polidoro da CARAVAGGIO, designer. Antonio LAFRERY (1512–77), publisher. Plate from a set of sixteen military trophies. Reversed copy of a plate originally published by Antonio Salamanca. Subsequently numbered as plate 12 in Catalogue 50f. Italian, before 1553. Lettered *ANT.LAFRERI.*
Engraving
17311

Lit: B. XV, 445.

50f Enea VICO (1523–67), engraver. Polidoro da CARAVAGGIO, designer. Antonio LAFRERY, publisher. Plates (16) from a set of sixteen military trophies. Plates 9–16, reversed copies of eight plates originally published by Antonio Salamanca. Italian, Rome, c. 1573, first published 1553. Plate 1 dated *1553*, plates 15 and 16 dated *1550*. Plates 1, 9, 12, 14, 15 and 16 lettered once with Lafrery's name. Plates 10, 11 and 13 lettered twice with Lafrery's name. Numbered *1–16.*
Engravings 16809–16816, 17301–17304, 17313, 19019–19025, 20302.1–15, 25016.136, E.2078–2093-1899

Lit: B. XV, 434–49; Guilmard, p.289, no. 24; Jessen 42–3; Berlin, 540(1); Berliner, 369; E. IX, 33.1–16.(4429–44); Miller.

50g Enea VICO and ANONYMOUS, engravers. Polidoro da CARAVAGGIO, designer. Petrus de NOBILIBUS (active 1574–86), publisher. Plates (16) including new title plate of military trophies. Reissues of Catalogue 50f, plates 1–11, 13–16. Italian, Rome, 1586. The title page dated *M.D.L.XXXVI* and lettered *LIBRO DE DIVERSI TROPHEI DI POLIDORO CAVATI DA GL'ANTICHI...* Each plate lettered *Petri de Nobilibus Formis.* Numbered *1–11* and *13–16.*
17300, 17305, 17308–17309, 25016.134–135, 28457, 29522.A.1–15

Lit: Berlin, 540(1).

50h Enea VICO, engraver. Polidoro da CARAVAGGIO, designer. Carlo LOSI (active 1773–88), publisher. Plates (15) of military trophies. Reissues of Catalogue 50f, plates 1–7 and 9–16. Italian, Rome, 1773. The lettering *Petri de Nobilibus Formis* present in Catalogue 50g largely erased. Numbered *1–7* and *10–16.*
24496.2–16

Copies and reversed copies

50i ANONYMOUS, engraver. Polidoro da CARAVAGGIO, designer. Plate of a military trophy. Copy of Catalogue 50d, plate 13. Italian, second half of 16th century.
Engraving
14070

50j René BOYVIN (c. 1530–98), engraver. Polidoro da CARAVAGGIO, designer. Pierre MARIETTE, II (active 1655–91), publisher, Paris. Plates (3) from a set of seven military trophies. Reversed copies of Catalogue 50f, plates 1, 2 and 4. French, Paris, 1655–91, first published 1575–6.
Engravings
17299, 20303.1, E.2029-1908

Lit: R-D, 153, 154 ,156; Berlin, 540(3); Levron, 105, 106, 108.

50k ANONYMOUS, engraver. Polidoro da CARAVAGGIO, designer. Giovanni ORLANDI (active 1590–1640), publisher. Plate (3) of military trophies. Copies of Catalogue 50f, plates 7, 9 and 14. Italian, Rome, 1602. Plates 7 and 9 lettered *Ioannes Orlandi formis romae*. Copy of plate 7 numbered *14*.
Engravings
17306, 17310, E.1410-1897

Lit: Berlin, 540(2).

50l ANONYMOUS, etcher. Polidoro da CARAVAGGIO, designer. Plate (3) of military trophies. Copies of Catalogue 50f, plates 1, 3 and 6, with a decorative border added. Possibly French, 17th century.
Etchings
E.1407–1409-1897

50m ANONYMOUS, engraver. Polidoro da CARAVAGGIO, designer. Plate of a military trophy. Copy after Catalogue 50f, plate 10. Possibly French, 17th century.
Etching
E.389-1911

NOTES: The impressions of Catalogue 50f with museum numbers E.2078–2093-1899 form part of the Lafrery Volume (see Introduction) and correspond to the entry *Libro de Trofei cauati da dissegni di Polidoro, ad imitatione de gli Antichi* in Lafrery's stocklist of c. 1573 (Ehrle, p.59).

A different arrangement has been adopted for this catalogue entry, in order to maintain the separate integrity of the sets published by Antonio Salamanca and Antonio Lafrery, even though it will be argued that one is partially dependent on the other. Salamanca's set consisted of ten plates and Lafrery's of sixteen; each set included eight plates present in the other in reverse. The entire Salamanca set is represented in the V&A collection only in a reissue dating from 1773 (Catalogue 50d). The Lafrery set is Catalogue 50f. Bartsch knew only the set published by Lafrery, which he attributed to Enea Vico (B. XV, 434–49). Since only one impression from the Salamanca set in the collection

retains its original numbering (Catalogue 50a), the listing has been arranged according to the numbering, plates 1–16, on the Lafrery set, Catalogue 50f. The plates common to both sets are numbered in the Lafrery set 9–16. The two plates in the Salamanca set, not in the Lafrery set, are listed at the end, and assigned plate numbers 17 and 18.

The sets were issued at a crucial period in the relationship between Salamanca and Lafrery, since in a contract dated 20 December 1553 they effectively merged their businesses, each agreeing to make impressions from their respective stock of plates available to the other (Ehrle, p.35, only known from a later document of 1563).

It is argued here that Lafrery's plates 9–16 are reversed copies of the corresponding plates in Salamanca's set. The respective practices of the two publishers suggests that this was likely to be the case: Salamanca very rarely published copies of other publishers' plates (Landau and Parshall, p.303), whereas Lafrery frequently did, including between 1544 and 1553 twenty of Salamanca's, of Roman antiquities and monuments (Hülsen, p.125). Hülsen (p.126) noted the absence of any engravings published by Salamanca from 1550 to 1553 and deduced that he was losing out in competition with Lafrery. The agreement between them may have been an attempt by Salamanca to stop his profits being siphoned off by Lafrery's copies.

This circumstantial evidence is reinforced by the evidence of the Lafrery plates themselves. The design of plates 10, 11 and 13 in the Lafrery set, showing single trophies, is different from that of the rest of the plates in the Lafrery set, which each depict two trophies suspended on ribbons. Plates 10, 11 and 13 also have different lettering from the rest of the set. Having been lettered once with Lafrery's name in large capitals, each plate has had this lettering partially erased, and each plate has then been lettered a second time with Lafrery's name, in smaller, neater, letters corresponding to the other lettered plates in the set, plates 1, 9, 12, 14, 15 and 16. Plate 1 is dated 1553 and plates 15 and 16 are dated 1550.

The curious distribution of the lettering and the dating on the Lafrery set suggests that it went through two intermediate stages before arriving at its final form. After Salamanca's set was published, Lafrery seems to have had his engravers copy in reverse three plates from it showing single trophies. These became Lafrery plates 10, 11 and 13 in the set's final form, but would not have had this numbering – or possibly any numbering – on them at this early stage. They were lettered with Lafrery's name in large capitals. Once these three reversed copies proved successful, Lafrery appears to have had five more of Salamanca's plates copied in reverse. These became Lafrery plates 9, 12, 14, 15 and 16 in the set's final form. There is a single impression in the collection of one of these without a number (Catalogue 50e, pl. 12), indicating that an intermediate, unnumbered stage existed in the history of Lafrery's set. The erasure of the large lettering on Lafrery plates 10, 11 and 13 and its replacement by smaller, neater lettering can be explained by the five new plates, which represent double rather than single trophies, not having sufficient space on them to continue the style and position of the lettering used on the single trophy plates. To make the new set of eight Lafrery plates look uniform, the original lettering on what eventually became plates 10, 11 and 13 in the Lafrery set was removed. This stage in the evolution is likely to have taken place in 1550, the

date on what eventually became plates 15 and 16 of the Lafrery set. Finally the Lafrery set took the form it has in the Lafrery Volume, when eight new plates were added and all the plates were numbered. This is likely to have happened in 1553, the date on what became plate 1. Plates 1–8 do not correspond exactly to any in the Salamanca set, but in one instance there is a clear debt. The left half of plate 3 of the Lafrery set is a modified reversed copy of one of the Salamanca plates not copied in its entirety (Catalogue 50d, pl.18). Plates 1–8 in the Lafrery set have a monotonous, repetitive quality in their design, absent from the rest of the set. They form a distinct subgroup within the whole set.

The attribution of the designs for these trophies to Polidoro originates with the title given to the set published by Antonio Lafrery in his stocklist of c. 1573. When the publisher Petrus de Nobilibus acquired fifteen out of the sixteen copper plates from the Lafrery set, Catalogue 50g, he seems to have taken Lafrery's stocklist entry and turned it into an additional title plate. Support for the attribution to Polidoro comes from the detail of an anonymous copy drawing, now in the Louvre (Ravelli, p.260, no. 386) thought to be after a lost Polidoro façade decoration. It shows a trophy made up of elements similar to those seen in the prints, suspended from a ring by a ribbon with fluttering ends.

It is clear from a volume in the collection (24496.1–25, Catalogue 50d and h) that by 1773 the Roman print-publisher, Carlo Losi, owned all ten of the plates originally published by Salamanca, and all except plate 8 of the Lafrery set. In his combined set of twenty-five plates he used Lafrery's plates 2–7 and 9–16 in their original positions. He moved Lafrery's plate 1 into the position that should have been held by the missing plate 8 and distributed Salamanca's plates in positions 1 and 17–25. This accounts for the numbering on these impressions.

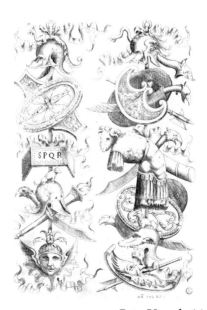

Cat. 50a pl. 14

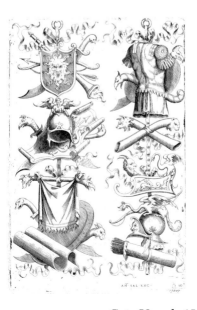

Cat. 50a pl. 15

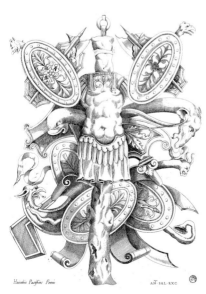

Cat. 50b pl. 13

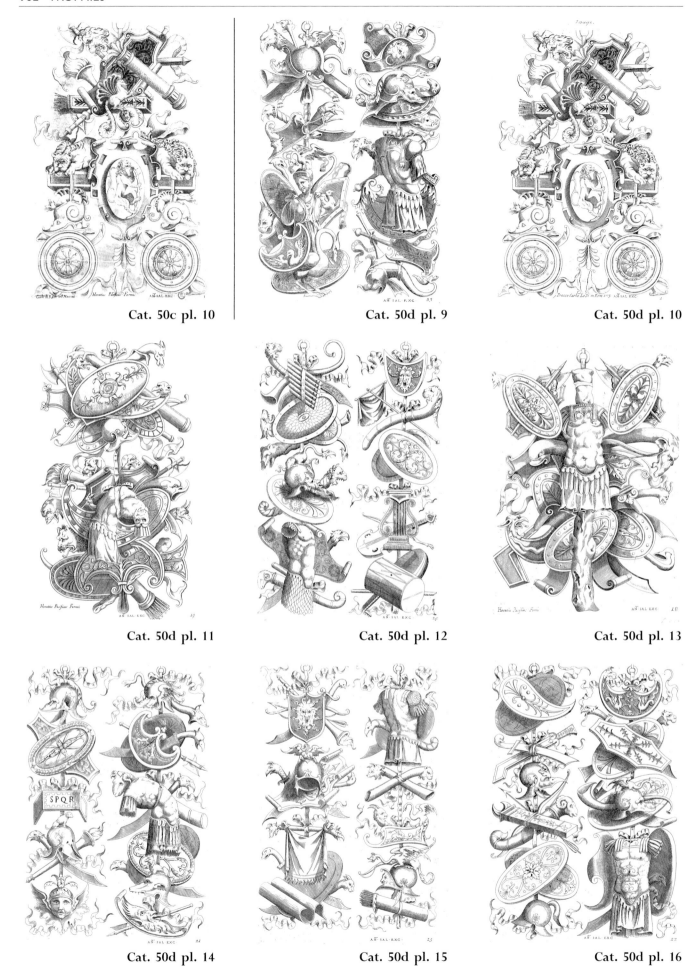

Cat. 50c pl. 10

Cat. 50d pl. 9

Cat. 50d pl. 10

Cat. 50d pl. 11

Cat. 50d pl. 12

Cat. 50d pl. 13

Cat. 50d pl. 14

Cat. 50d pl. 15

Cat. 50d pl. 16

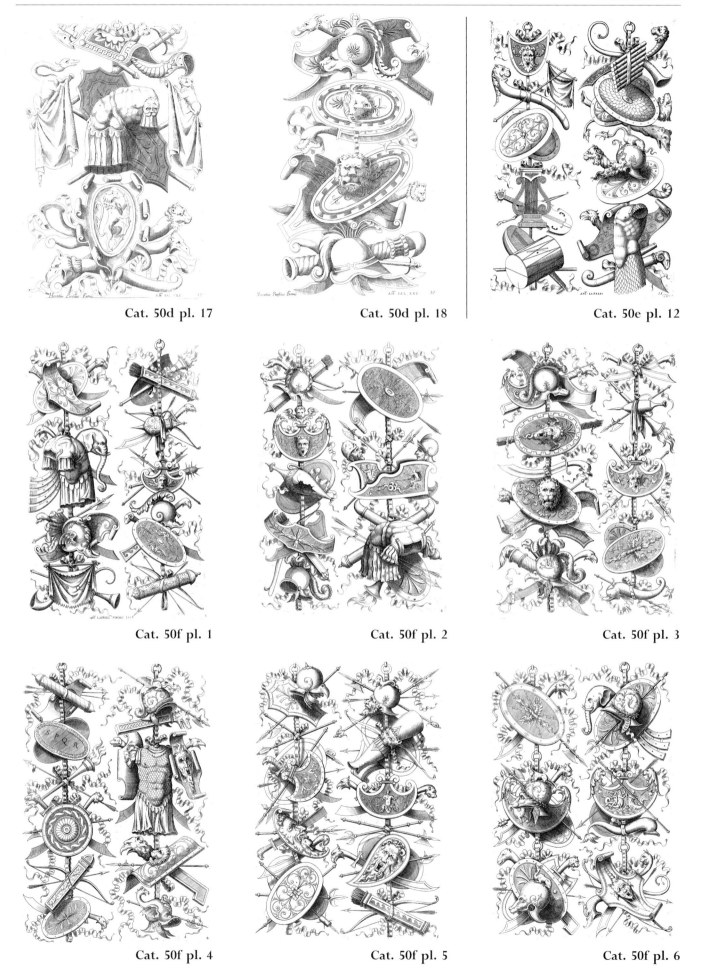

Cat. 50d pl. 17

Cat. 50d pl. 18

Cat. 50e pl. 12

Cat. 50f pl. 1

Cat. 50f pl. 2

Cat. 50f pl. 3

Cat. 50f pl. 4

Cat. 50f pl. 5

Cat. 50f pl. 6

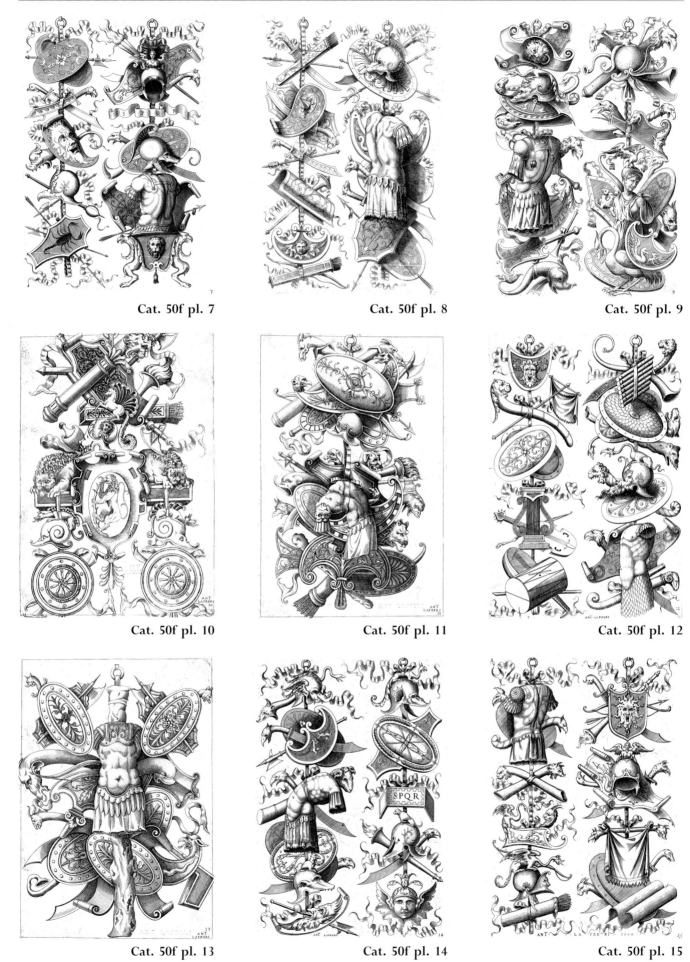

Cat. 50f pl. 7

Cat. 50f pl. 8

Cat. 50f pl. 9

Cat. 50f pl. 10

Cat. 50f pl. 11

Cat. 50f pl. 12

Cat. 50f pl. 13

Cat. 50f pl. 14

Cat. 50f pl. 15

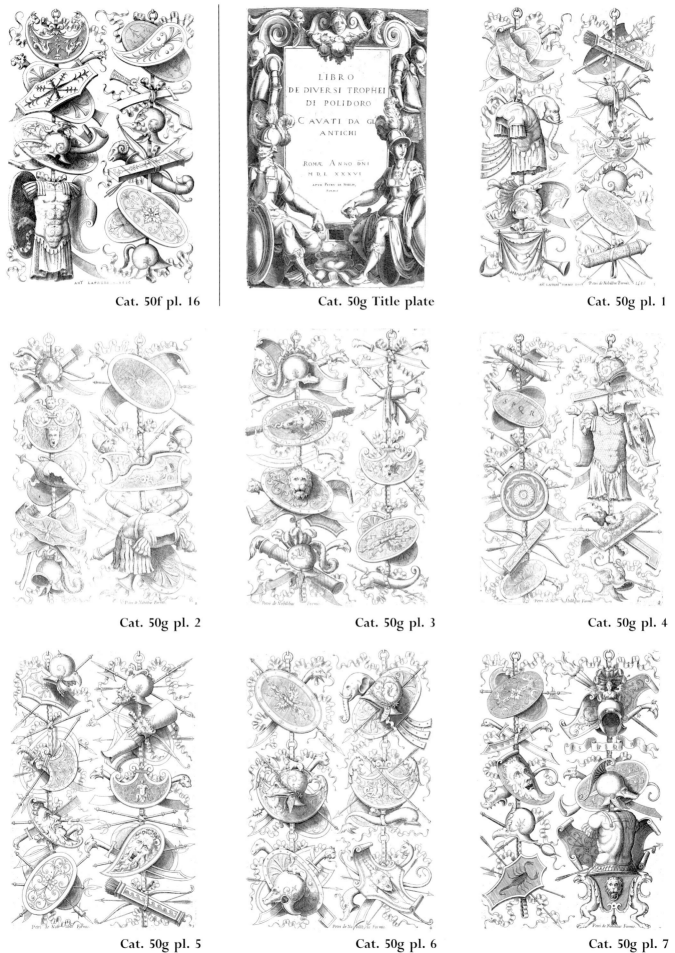

Cat. 50f pl. 16

Cat. 50g Title plate

Cat. 50g pl. 1

Cat. 50g pl. 2

Cat. 50g pl. 3

Cat. 50g pl. 4

Cat. 50g pl. 5

Cat. 50g pl. 6

Cat. 50g pl. 7

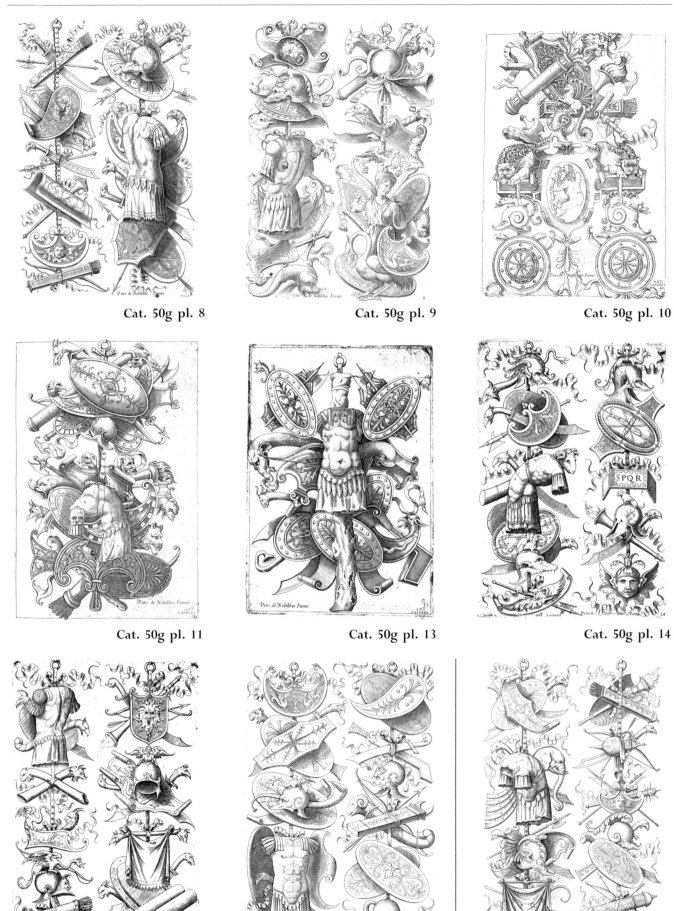

Cat. 50g pl. 8

Cat. 50g pl. 9

Cat. 50g pl. 10

Cat. 50g pl. 11

Cat. 50g pl. 13

Cat. 50g pl. 14

Cat. 50g pl. 15

Cat. 50g pl. 16

Cat. 50h pl. 1

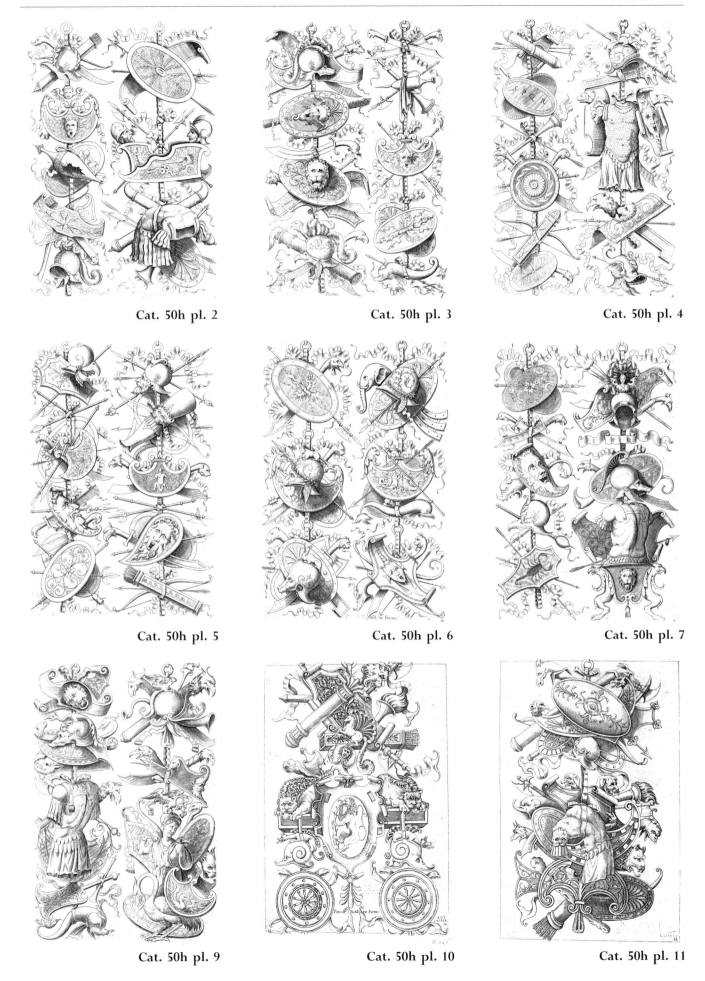

Cat. 50h pl. 2

Cat. 50h pl. 3

Cat. 50h pl. 4

Cat. 50h pl. 5

Cat. 50h pl. 6

Cat. 50h pl. 7

Cat. 50h pl. 9

Cat. 50h pl. 10

Cat. 50h pl. 11

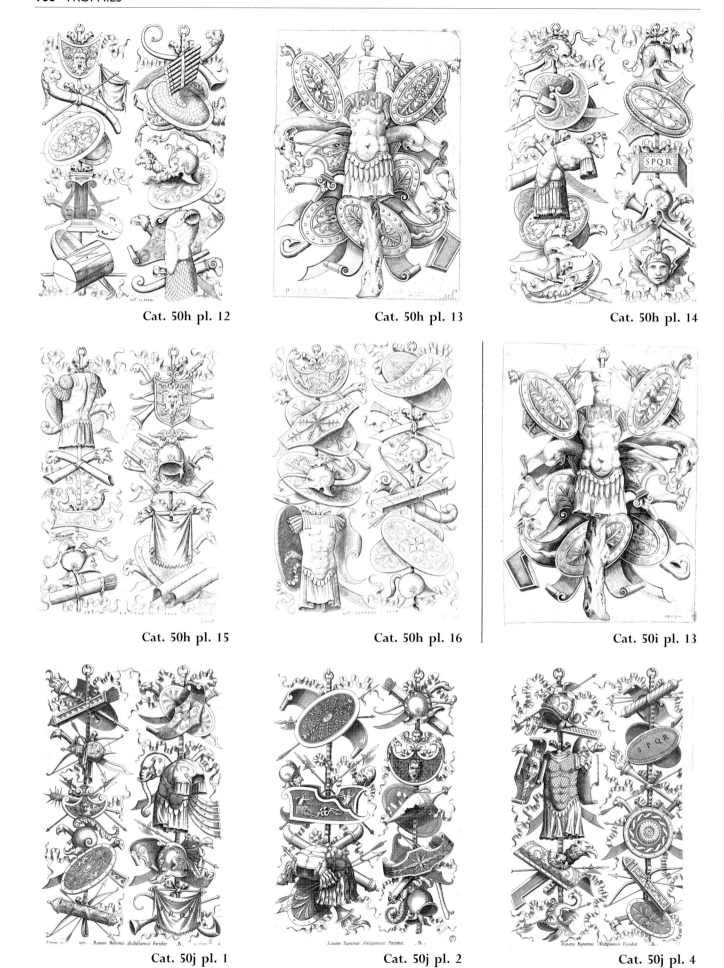

Cat. 50h pl. 12

Cat. 50h pl. 13

Cat. 50h pl. 14

Cat. 50h pl. 15

Cat. 50h pl. 16

Cat. 50i pl. 13

Cat. 50j pl. 1

Cat. 50j pl. 2

Cat. 50j pl. 4

Cat. 50k pl. 7

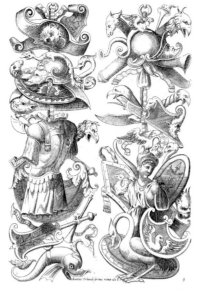

Cat. 50k pl. 9

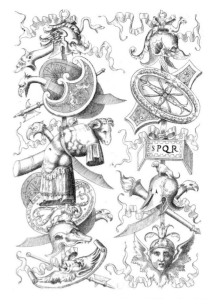

Cat. 50k pl. 14

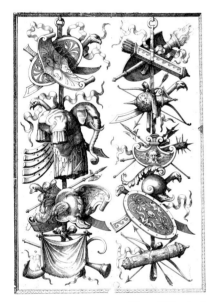

Cat. 50l pl. 1

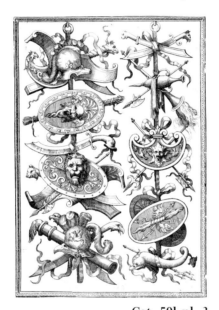

Cat. 50l pl. 3

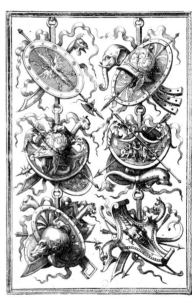

Cat. 50l pl. 6

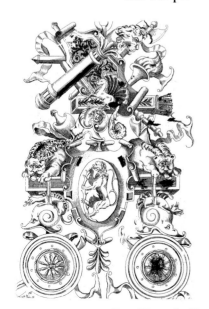

Cat. 50m pl. 10

Catalogue 50: PLATE DESCRIPTIONS

Title plate

(g) Title flanked by two seated warriors. Lettered *LIBRO DE DIVERSI TROPHEI DI POLIDORO CAVATI DA GL'ANTICHI* and *ROMAE ANNO DNI M.D.L.XXXVI/APVD PETRV DE NOBILIB, FORMIS.*
Engraving. 25.5 x 17.1 cm
29522.A.1

Plate 1

(f) Trophies with body armour and the head of an elephant (B. XV, 434; E. IX, 33.1(4429)). Dated *1553*. Lettered *ANT. LAFRERII FORMIS*. Numbered *1*. 25.7 x 17.3 cm
E.2078-1899

(f) Other impressions (2).
16809, 20302.1

(g) Impression. Dated *1553* and additionally *1585*. Lettered *ANT. LAFRERII FORMIS* and additionally *Petri de Nobilibus Formis*. Numbered *1*.
29522.A.2

(g) Another impression. Numbered in ink *12* over the engraved plate number.
17308

(h) Impression with the number *1*, and the additional date and lettering described under (g) largely erased.
24496.8

(j) Impression. Signed in monogram *.RB.* and *Renatus Boyuinus Andegauensis Faciebat* (R-D, 153; Levron, 105). Dated *1575*. Lettered *P. Marette ex*. Numbered *1*. Cut to 25.3 x 17.2 cm
17299

(l) Impression. Cut to 25.8 x 18.3 cm
E.1408-1897

Plate 2

(f) Trophies with a broken vase (B. XV, 435; E. IX,33.2.(4430)). Numbered *2*. 24.8 x 17.6 cm
E.2079-1899

(f) Other impressions (2).
16810, 20302.2

(g) Impression. Lettered *Petri de Nobilibus Formis*. Numbered *2*.
17300

(g) Another impression.
29522.A.13

(h) Impression, with the lettering described under (g) largely erased. Numbered *2*.
24496.2

(j) Impression (R-D, 154; Levron, 106). Signed in monogram *.RB.* and *Renatus Boyuinus Andegauensis Faciebat*. 25.3 x 17.2 cm
20303.1

Plate 3

(f) Trophies with a lion's head on a shield (B. XV, 436; E. IX, 33.3.(4431)). Numbered *3*. 24.9 x 17 cm
E.2080-1899

(f) Other impressions (3).
17301, 19019, 20302.3

(g) Impression. Lettered *Petri de Nobilibus Formis*. Numbered *3*.
25016.134

(g) Another impression.
29522.A.3

(h) Impression. Lettered [partially erased: Petri de Nobilibus] *Formis*. Numbered *3*.
24496.3

(l) Impression. Cut to 25.4 x 18.1 cm
E.1409-1897

Plate 4

(f) Trophies. The right-hand group includes a cuirass [close-fitting body armour] flanked by two shields. Lettered *SPQR*. (B. XV, 437; E. IX,33.4.(4432)). Numbered *4*. 25 x 17.6 cm
E.2081-1899

(f) Other impressions (3).
17302, 19020, 20302.4

(g) Impression. Lettered *Petri de Nobilibus Formis*. Numbered *4*.
25016.135

(g) Another impression.
29522.A.4

(h) Impression, the lettering described under (g) largely erased. Numbered *4*.
24496.4

(j) Impression (R-D, 156; Levron, 108). Signed in monogram *.RB.* and *Renatus Boyuinus Andegauensis Faciebat.* Cut to 25.2 x 15.9 cm
E.2029 1908

Plate 5

(f) Trophies with a helmeted warrior at the top on the right, above leg armour and a bow (B. XV, 438; E. IX, 33. 5(4433)). Numbered *5.* 24.1 x 16.5 cm
E.2082-1899

(f) Other impressions (3).
17303, 19023, 20302.5

(g) Impression. Lettered *Petri de Nobilibus Formis.* Numbered *5.*
29522.A.14

(h) Impression. The lettering described under (g) largely erased. Numbered *5.*
24496.5

Plate 6

(f) Six shields, one with an elephant. In the middle, on the right, a shield decorated with a battle between tritons (B. XV, 439; E. IX.33.6.(4434)). Numbered 6. 23.9 x 16.5 cm
E.2083-1899

(f) Other impressions (3).
17304, 19021, 20302.6

(g) Impression. Lettered *Petri de Nobilibus Formis.* Numbered 6.
29522.A.15

(h) Impression. Lettered [partially erased: Petri de No]*bilibus Formis.* Numbered 6.
24496.6

(l) Impression. 25.3 x 17.4 cm
E.1407-1897

Plate 7

(f) Six shields, one with a kind of crayfish (B. XV, 440; E. IX.33.7.(4435)). Numbered 7. 25.2 x 17.3 cm
E.2084-1899

(f) Other impressions (2).
20302.7, 25016.136

(g) Impression. Lettered *Petri de Nobilibus Formis.* Numbered 7.
28457

(g) Another impression.
29522.A.9

(h) Impression with the lettering described under (g) erased. Numbered 7.
24496.7

(k) Impression. Dated *1602.* Lettered *Ioannes Orlandi formis romae.* Numbered *14.* 24.7 x 16.7 cm
17310

Plate 8

(f) Trophies with a cuirass seen from behind, suspended against four shields, two sabres and two arrows (B. XV, 441; E. IX, 33.8.(4436)). Numbered *8.* 25.5 x 16.9 cm
E.2085-1899

(f) Other impressions (2).
16811, 20302.8

(g) Impression. Lettered *Petri de Nobilibus Formis.* Numbered *8.*
17305

(g) Another impression.
29522.A.10

Plate 9

(d) Trophies including a helmeted woman and, below her, a chimerical bird with the neck of a swan and the wings of an eagle. Lettered *ANT. SAL. EXC.* Numbered *23.* 25.6 x 17 cm
24496.23

(f) Impression (B. XV, 442; E. IX, 33.9.(4437)). Lettered *ANT LAFRERII* [erased]. Numbered *9.* 25.1 x 16.9 cm
E.2086-1899

(f) Other impressions (2).
16812, 20302.9

(g) Impression. Lettered *Petri de Nobilibus Formis.* Numbered *9.*
29522.A.5

(h) Impression, the lettering described under (g) largely erased and the plate number partially removed.
24496.9

(k) Impression. Dated *1602.* Lettered *Ioannes Orlandi formis romae.* Numbered *9.* 24.7 x 16.6 cm
17306

Plate 10

(c) Ornamental panel with rampant lion on an oval cartouche. The rampant lion facing right. Lettered *ANT. SAL. EXC./Horatius Pacificus Formis* and *Giob. de Rossi in P. Navona*. Numbered *1*. 23.2 x 15.2 cm
20303.2

(d) Impression. Dated *1773*. Lettered *ANT. SAL. EXC./Presso Carlo Losi in Rome*. Numbered *1*. 23.3 x 15.5 cm
24496.1

(f) Impression (B. XV, 443; Berliner, 369; E. IX, 33.10.(4438)). Lettered twice, *ANT LAFRERI* [once partially erased] and numbered *10*. 23 x 16.4 cm
E.2087-1899

(f) Other impressions (2).
19022, 20302.10

(g) Impression. Lettered twice, *ANT LAFRERI* [once partially erased] and *Petri de Nobilibus Formis*. Numbered *10*.
29522.A.6

(h) Impression. Lettered twice, *ANT LAFRERI* [once partially erased] and *Petri de Nobilibus Formis*. Numbered *10*.
24496.10

(m) Impression. 22.3 x 15.5 cm
E.389-1911

Plate 11

(d) Trophy with breastplate leaning towards the right. Lettered *ANT.SAL. EXC./Horatius Pacificus Formis*. Numbered *19*. 24.6 x 16.3 cm
24496.19

(f) Trophy with breastplate leaning towards the left (B. XV, 444; E. IX, 33.11.(4439)). Lettered twice *ANT LAFRERI* [once partially erased]. Numbered *11*. 25.1 x 17.1 cm
E.2088-1899

(f) Other impressions (3).
17313, 19024, 20302.11

(g) Impression. Lettered twice, *ANT LAFRERI* [once partially erased] and *Petri de Nobilibus Formis*. Numbered *11*. Cut to 25.3 x 17.4 cm
29522.A.8

(h) Impression. Lettered twice, *ANT LAFRERI* [once partially erased] and *Petri de Nobilibus Formis*. [largely erased]. Numbered *11*. 25.1 x 17.1 cm
24496.11

Plate 12

(d) Two trophies including musical instruments. The right-hand group of trophies includes a lyre and a viol, below which are a drum and a lute. Lettered *ANT. SAL. EXC.* and numbered *24*. 25.2 x 17.3 cm
24496.24

(e) Two trophies including musical instruments. The left-hand group of trophies includes a lyre and a viol, below which are a drum and a lute. Lettered *ANT. LAFRERI*. Inscribed in ink *15*.
17311

(f) Impression (B. XV, 445; E. IX, 33.12.(4440)). Lettered *ANT. LAFRERI*. Numbered *12*. 25 x 17.5 cm
E.2089-1899

(f) Other impressions (2).
19025, 20302.12

(h) Impressions. Lettered *ANT. LAFRERI* and [partially erased: Petri de Nobilibus] *Formis*. Numbered *12*. 25.2 x 17.5 cm
24496.12

Plate 13

(b) Trophy with a cuirass on the trunk of a tree. Lettered *ANT. SAL. EXC./Horatiu Pacificus Formis*. 22.2 x 15.9 cm
20303.4

(d) Impression. Lettered *ANT. SAL. EXC./Horatiu Pacificus Formis*. Numbered *18*.
24496.18

(f) Impression (B. XV, 446; E. IX, 33.13.(4441)). Lettered twice, *ANT LAFRERI* [once partially erased]. Numbered *13*. 23 x 16.4 cm
E.2090-1899

(f) Other impressions (2).
16813, 20302.13

(g) Impression. Lettered twice, *ANT LAFRERI* [once partially erased] and *Petri de Nobilibus Formis*. Numbered *13*.
17309

(h) Impression. Lettered twice *ANT LAFRERI* [once partially erased] and *Petri de Nobilibus Formis* [largely erased]. Numbered *13*.
24496.13

(i) Impression. Cut to 22.7 x 16 cm
14070

Plate 14

(a) Two trophies with, on the right, a cuirass bent over. Lettered *ANT. SAL. EXC.* and *SPQR*. Numbered *6*. Cut to 25.2 x 17.3 cm
20303.3

(d) Impression. Lettered *ANT. SAL. EXC.* and *SPQR*. Numbered *21*. 25.3 x 17.2 cm
24496.21

(f) Two trophies with, on the left, a cuirass bent over (B. XV, 447; E. IX, 33.14. (4442)). Lettered *ANT LAFRERI* and *SPQR*. Numbered *14*. 24.9 x 17.5 cm
E.2091-1899

(f) Other impressions (2).
16814, 20302.14

(g) Impression. Lettered *ANT LAFRERI* and additionally *Petri de Nobilibus Formis*. Numbered *14*.
29522.A.11

(h) Impression, with the additional lettering described at (g) largely erased. Numbered *14*.
24496.14

(k) Impression. Cut to 24.5 x 17.4 cm.
E.1410-1897

Plate 15

(a) Two trophies with a cuirass at upper right, seen from the back. At the bottom, on the left, an unfurled paper. Lettered *ANT. SAL. EXC.* Numbered *10*. Cut to 24.8 x 16.2 cm
17307

(d) Impression. Lettered *ANT. SAL. EXC.* Numbered *25*. 24.6 x 16.3 cm
24496.25

(f) Two trophies with a cuirass at upper left, seen from the back. At the bottom, on the right, an unfurled paper (B. XV, 448; E. IX, 33.15.(4443)). Dated *1550*. Lettered *ANT. LAFRERI.* Numbered *15*. 23.9 x 16.4 cm
E.2092-1899

(f) Another impression.
16815

(g) Impression. Dated *1550*. Lettered *ANT. LAFRERI.* and additionally *Petri de Nobilibus Formis*. Numbered *15*.
29522.A.7

(h) Impression. Dated *1550*. Lettered *ANT. LAFRERI* and with the additional lettering described at (g) largely erased. Numbered *15*.
24496.15

Plate 16

(d) Two trophies with a cuirass at lower right. The left-hand group includes a bow, an arrow, a quiver and a sheathed sword with a ram's head hilt. Lettered *ANT. SAL. EXC.* Numbered *22*. 23.8 x 16.9 cm
24496.22

(f) Two trophies with a cuirass at lower left. The right-hand group includes a bow, an arrow, a quiver and a sheathed sword with a ram's head hilt (B. XV, 449; E. IX, 33.16.(4444)). Dated *1550*. Lettered *ANT. LAFRERI*. Numbered *16*. 23.9 x 16.9 cm
E.2093-1899

(f) Other impressions (2).
16816, 20302.15

(g) Impression. Dated *1550* and additionally *1585*. Lettered *ANT LAFRERI.* and additionally *Petri de Nobilibus Formis*. Numbered *16*.
29522.A.12

(h) Impression, with the additional date and lettering described at (g) largely erased. Numbered *16*.
24496.16

Plate 17

(d) A trophy suspended on a ribbon. A cuirass twisted in front of a shield flanked by standards. Below is a shield bearing a rampant lion before swords and a trumpet. Lettered *ANT. SAL. EXC.* and *Horatius Pacificus Formis*. Numbered *17*. 24.4 x 16.3 cm
24496.17

Plate 18

(d) A trophy suspended on a ribbon. Shields, helmets and weapons and, in the centre, a lion's mask. Lettered *ANT. SAL. EXC.* and *Horatius Pacificus Formis*. Numbered *20*. 24.6 x 16.6 cm
24496.20

Catalogue 51

Plate No.	1	2
51a		☐
51b	☐	☐
51c		☐

SET DESCRIPTIONS

Original plates and reissues

51a ANONYMOUS, engraver. Antonio LAFRERY (1512–77), publisher. One of the trophies of Marius. Italian, mid-16th century.
Engraving
E.3794-1906

51b ANONYMOUS, engraver. Antonio LAFRERY, publisher. Plates (2) of the trophies of Marius. Reissues of Catalogue 52a. Italian, third quarter of the 16th century. Each lettered with title.
Engravings
24486.1–2, E.3629,3630-1906, E.3793-1906

Lit: Hülsen, 27, 28.

NOTES: The impressions acquired in 1906 are bound into copies of the *Speculum Romanae Magnificentae*. These two plates correspond to the entry 'Trofei di Mario in doi parti' in Lafrery's stocklist of c. 1573 (Ehrle, p.55).

Copy plate

51c ANONYMOUS, etcher. Trophy. Copy plate after Catalogue 51a pl. 2, lacking the background. English, 18th century. Lettered with title.
Etching
25016.139

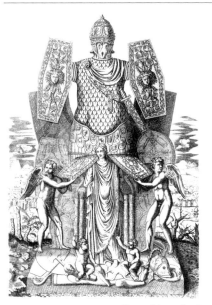

Cat. 51a pl. 2

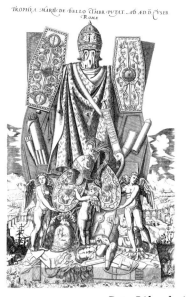

Cat. 51b pl. 1

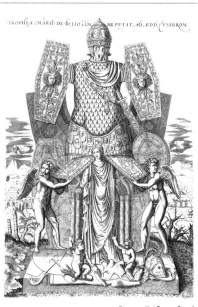

Cat. 51b pl. 2

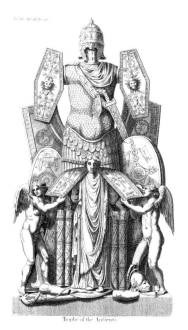

Cat. 51c pl. 2

Catalogue 51: PLATE DESCRIPTIONS

Plate 1

(b) One of the trophies of Marius. Two winged youths and a putto holding shields (Hülsen, 27). Lettered *TROPHEA MARII DE BELLO CYMBR. PVTAT. AD AED. D. EVSEB. ROMAE.* 38 x 23.8 cm
E.3630-1906

(b) Other impressions (2).
24886.1, E.3793-1906

Plate 2

(a) A trophy. A draped woman flanked by two putti holding shields beneath a cuirass flanked by medusa-head shields. The right-hand shield pricked in outline. 38 x 26.9 cm
E.3794-1906

(b) Impression (Hülsen, 28). Lettered *TROPHEA MARII DE BELLO CYM BR. PVTAT. AD AED.D. EUSEB. ROM.* 38.1 x 26.8 cm
E.3629-1906

(b) Another impression.
24486.2

(c) Impression. Lettered *Trophy of the Antients* (sic) and *Vol. XI. Part II Page 37.* 31.5 x 18.4 cm
25016.139

APPLIED ORNAMENT

ARCHITECTURAL DETAILS

Catalogue 52

Plate No. | 1 2 3 5 7 9 10 11 12 13

SET DESCRIPTION

Original plates and reissues

52 Agostino VENEZIANO (c. 1490–c. 1540), Monogrammist G.A. with the CALTROP (active 1538–c. 1560) and ANONYMOUS, engravers after Sebastiano SERLIO (1475–1544), designer. Antonio SALAMANCA (c. 1500–62), publisher. Plates (10) representing the Doric, Ionic and Corinthian orders of architecture. Italian, 1531–53. Plates 1, 2, 3, 5, 7, 9, 10 and 11 signed in monogram *A.V.* and dated *1536*. The unnumbered plate, here numbered pl. 12, signed in monogram *G.A.* with a caltrop. All lettered variously with the name of the publisher.
Engravings
16799–16805, 26458.1–10

Lit: Pl. 1–3, 5, 7, 9, 10, 11: B. XIV, 525A-II–527A-II and B. XIV, 529-II–533A-II; A. 641.1–4 and A. 641.6–9; E. VIII, 47.1, 2, 4–7.(3204, 3205, 3207–10). Pl. 12 and 13: Passavant VI, 27, 35; Nagler Mon II, 2679, no. 16; E. I, 16.(16) and E. I, 7.(7) as Giovanni Agucchi.

NOTES: A caltrop is a four-spiked iron ball thrown on the ground to impede cavalry horses. In 1528 Agostino Veneziano engraved nine plates, each of a base, a capital or an entablature of the Doric, Ionic and Cornthian orders. They are described by Bartsch, XIV, nos 525–33, and illustrated in *The Illustrated Bartsch*, although unfortunately the image of Bartsch, XIV, 525 is printed upside down and back to front. According to Dinsmoor (p.65), these prints, which carry the initials *S.B.*, as well as those of Agostino Veneziano, are based on designs by Sebastiano Serlio. In 1536 Agostino Veneziano copied his own nine plates, and these copy plates were subsequently acquired by Antonio Salamanca, who added his name to them. In *The Illustrated Bartsch* seven of these copies are illustrated in impressions before the addition of Salamanca's name (B. XIV, 525A-I to B. XIV, 528A-I, and B. XIV, 530A-I to B. XIV, 532A-I) and the remaining two (B. XIV, 529A-II, 533A-II) after the addition of his name.

Passavant lists the Monogrammist G.A. with the Caltrop under the French version of his name, 'Le Maitre au Chausse-Trappé'. He is identified by the catalogue of the Escorial collection as Giovanni Agucchi.

The ten images in this collection consist of eight out of the nine Salamanca reissues of Veneziano's copies of 1536, one plate signed by the Monogrammist G.A. with the Caltrop and one unsigned plate. The prints in this collection with museum numbers 26458.1–10 are ten copper plates printed on five sheets of paper, two to a sheet – that is, 26458.1 and 2 together, 26458.2 and 3 together, etc. The sheets measure on average 36.5 by 23 centimetres.

See Dinsmoor, and Brown University no.12 for discussions of the relationship between Veneziano's engravings and 15th- and 16th-century architectural treatises.

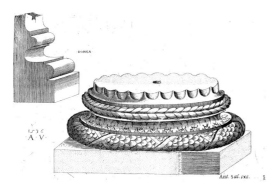

Cat. 52 pl. 1

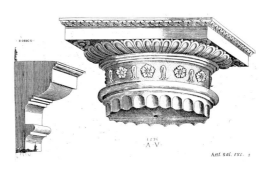

Cat. 52 pl. 2

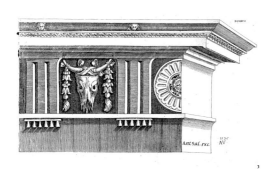

Cat. 52 pl. 3

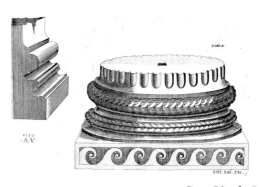

Cat. 52 pl. 5

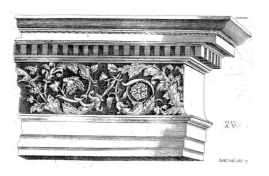

Cat. 52 pl. 7

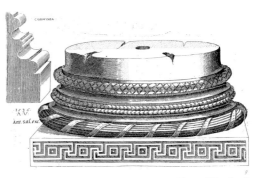

Cat. 52 pl. 9

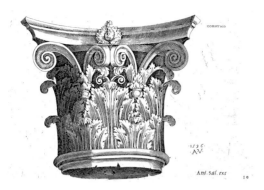

Cat. 52 pl. 10

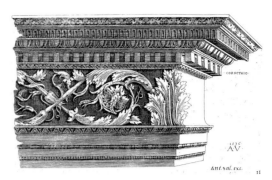

Cat. 52 pl. 11

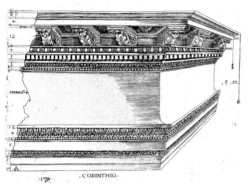

Cat. 52 pl. 12

Cat. 52 pl. 13

Catalogue 52: PLATE DESCRIPTIONS

Plate 1

Doric base and profile (B. XIV, 526A-II; A. 641.1; E. VIII, 47.2.(3205)). Signed in monogram .A.V. and dated *1536*. Lettered .DORICA./Ant. sal. exc. Numbered *1*. 12.4 x 18.9 cm
26458.4

Another impression.
16799

Plate 2

Doric capital and profile (B. XIV, 525A-II; A. 641.2; E. VIII, 47.1.(3204)). Signed in monogram .A.V. and dated *1536*. Lettered .DORICO./Ant.sal. exc. Numbered *2*. 11.9 x 18.3 cm
26458.1

Plate 3

Doric entablature (B. XIV, 527A-II; A.641.3). Signed in monogram .A.V. and dated .*1536*. Lettered DORICO/Ant. Sal. exc. Numbered *3*. 12.7 x 19.2 cm
26458.5

Another impression.
16800

Plate 5

Ionic base and profile (B. XIV, 529A-II; A. 641.4; E. VIII, 47. 4.(3207)). Signed in monogram .A.V. and dated *1536*. Lettered IONICA.[N reversed]/Ant. sal. exc. Numbered *5*. 12.1 x 18.8 cm
26458.3

Another impression.
16801

Plate 7

Ionic entablature (B. XIV, 530A-II; A. 641.6). Signed in monogram .*A.V.* and dated .*1536.* Lettered .*IONICO.*/*Ant. sal. exc.* Numbered 7. 12.5 x 19.3 cm
26458.7

Another impression.
16802

Plate 9

Corinthian base and profile (B. XIV, 532A-II; A. 641.7; E. VIII, 47.6. (3209)). Signed in monogram .*A.V.* and dated .*1536.* Lettered *CORINTHIA.*[N reversed]/*Ant. sal. exc.* Numbered 9. 12.2 x 19 cm
26458.9

Another impression.
16803

Plate 10

Corinthian capital (B. XIV, 531A-II; A. 641.8; E. VIII, 47.5.(3208)). Signed in monogram .*A.V.* and dated .*1536.* Lettered *CORINTHIO*[N reversed]/*Ant.Sal.exc.* Numbered *10.* 12.2 x 18.8 cm
26458.2

Plate 11

Corinthian entablature (B. XIV, 533A-II; A. 641.9; E. VIII, 47.7.(3210)). Signed in monogram .*A.V.* and dated .*1536.* Lettered .*CORINTHIO.*[N reversed]/*Ant. sal. exc.* Numbered *11.* 12.5 x 19.6 cm
26458.6

Another impression.
16804

Plate 12

Corinthian entablature (Passavant, 35; Nagler Mon II, 2679, no. 16; E. I, 16.(16)). Signed in monogram .*G.A.* with a caltrop. Lettered with dimensions and .*CORINTHIO.*/*Ant. Sal. exc.* 15.4 x 18.1 cm
26458.8

Plate 13

Base (Passavant 27; E. I, 7.(7)). Lettered *Ant. Sal exc.* 12.5 x 19.8 cm
26458.10

Another impression.
16805

Catalogue 53

Plate No. | 1 | 2
☐ ☐

SET DESCRIPTION

Original plates and reissues

53 MASTER of the DIE (c. 1512–70), engraver. Cuttings (2), from a single plate of fifteen examples of whole or half-capitals, showing the left halves of two ornamented capitals. Italian, mid-16th century.
Engravings
13075.1-2

Lit: Passavant VI, 88; E. VII, 38.(2991).

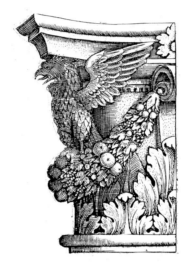 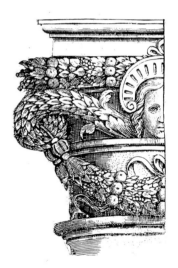

Cat. 53 pl. 1 **Cat. 53 pl. 2**

Catalogue 53: PLATE DESCRIPTIONS

Plate 1

Left half of a capital with a festoon of fruit, and an eagle forming the volute. Cut to 8 x 5.6 cm
13075.1

Plate 2

Left half of a capital with a festoon of fruit, the volute formed from a festoon of laurel and the rosette replaced by a female head. Cut to 8 x 5.3 cm
13075.2

Catalogue 54

Plate No.

PLATE DESCRIPTION

Original plates and reissues

54 Nicolas BEATRIZET (1515–after 1565), engraver. Antonio LAFRERY (1512–77), publisher. Salomonic column. Italian, mid-16th century. Lettered *Ant. Lafrerij, Roma.*
Engraving. 45.5 x 28.3 cm
E.3805-1906

Other impressions (3).
27470.8 [trimmed], E.3605-1906, E.3729-1906

Lit: Hülsen, 142; Berlin, 3917; McGinniss, 324; E. I, 49.(227).

NOTES: This plate is described in Lafrery's stocklist of c. 1573 as *Colonna santa condotta dal tempio di Salomone insieme con molte altre colonne poste in San Pietro* (Ehrle, 55). The impressions with 1906 accession numbers are bound into three separate copies of the *Speculum Romanae Magnificentae* in the V&A collection.

Cat. 54

Catalogue 55

Plate No.	1	2	3	4	5	6	7	8	9	10	11	12	13	14	15	16	17	18	19	20	21	22	23	24	25	26	27	28	29	30
55a	□	□	□	□	□	□	□	□	□	□	□	□	□	□	□	□	□	□	□	□	□	□	□	□	□	□	□	□	□	□
55b																				□										

SET DESCRIPTIONS

Original plates and reissues

55a Monogrammist PS (active 1535–7), Monogrammist G.A. with the CALTROP (active 1538–c. 1560) and ANONYMOUS, engravers. Antonio LAFRERY (1512–77) publisher. Plates (30) on fifteen sheets of cornices, capitals and bases of Antique buildings in Rome. Italian, c. 1573.
Plates 5–12, 14 and 19 signed in monogram *PS* and dated *1535* or *1537*. Plates 13, 15, 18, 20–30 signed in monogram *.G.A.* with a caltrop. Plates 1 and 2 lettered with dimensions and location. Plates 5–12, 14 and 19 lettered with the name of the order, dimensions and the name or location in Rome of the building from which the detail is taken. Plates 13, 15, 18, 20–30 lettered with the name of the order and dimensions. Numbered in ink *1–30*.
Engravings, except pl. 11 and 19, which are etchings.
E.1982–2011-1899

Lit: G.A.: Nagler Mon II, 2679, nos 2–5, 10, 11, 13 and 14; E. I, 6, 13, 14–15, 18–21, 23–7.(6, 13, 14–15, 18–21, 23–7) as Giovanni Agucchi. PS: Nagler Mon IV, 3268, nos 6–17; Passavant IV, nos 26, 30, 32–4; Brown, 62, 64, 66–8; E. VIII, 1.1, 3–10 (3496, 3498–3505), as Jacques Prévost; Miller.

Reversed copy plates

55b Monogrammist S.S., engraver. Plate of a Corinthian base. Reversed copy of Catalogue 55a, plate 20. Italian, 1544. Signed in monogram *.S. S.* Lettered with the name of the order and the dimensions.
Engraving
16806

Lit: Nagler Mon V, no. 299; Brown, 79b as Sebastiano Serlio; E. VIII, 2.(3980) as Sebastiano Serlio.

NOTES: Catalogue 55a forms part of the Lafrery Volume (see Introduction) and corresponds to the entry *Libri di Cornice Capitelli et Basi cauato dalle uestigie de gli Antichi, quale giornalmente si trouano in Roma* in Lafrery's stocklist of c. 1573 (Ehrle, p.59). It is made up of thirty copper plates printed on fifteen sheets, two plates to a sheet, in the order of the inscribed plate numbers, which may be in a 16th-century hand. The first twelve plates are cornices or entablatures. This is specified in the individual plate descriptions, but in the rest of this note this group of plates is referred to as the cornices, just as Lafrery describes them in his catalogue. The next seven plates are capitals, and the last eleven plates are bases.

The set has many puzzling features. Ten of the plates, namely eight of the cornices (plates 5–12) and two of the capitals (plates 14 and 19), are signed by the Monogrammist PS. These ten plates all carry lettering specifying that it is the Corinthian order that is being depicted and giving the location in Rome where the architectural fragment depicted could be viewed, or was discovered. One of them (plate 14) is dated 1535, the others are dated 1537, the year in which Sebastiano Serlio published the fourth book, but the first to appear, of his *Regole generali di architettura*, describing the orders. Another fourteen plates in the set, namely three of the capitals (plates 13, 15 and 18) and all eleven of the bases (plate 20–30) are signed by the Monogrammist G.A. with the Caltrop. The lettering on these specifies that they depict the Composite, Corinthian or Ionic order, but does not specify the location of the building or fragment, and none of them is dated. The remaining six plates, namely four of the cornices (plates 1–4) and two of the capitals (plates 16 and 17), are unsigned, undated and do not specify the location. The absence of any plates of the Doric order seems perplexing. Two of the plates by the Monogrammist PS (plates 11 and 19) are etched, while the other twenty-eight plates in the set – including the other eight plates by the same print-maker – are engraved.

The units of measurement used in these plates are not consistent. The anonymous plate 1 specifies the Florentine *braccio*, equivalent to 58.36 cm. The measurements in plate 9 by the Monogrammist PS are given in *braccio* divided into *minuti*. All the other plates by the Monogrammist PS (plates 5–8, 10–22, 14 and 19) are calibrated in *palmi* divided into *oncie*, or *oncie* and *minuti*. Sixty *minuti* equal twelve *oncie* or one Roman *palmo*. A Roman *palmo* measures 22.34 cm and there are two and a half *palmi* in a Roman *braccio*, which measures 55.85 cm. Two of the plates by the Monogrammist G.A. with the Caltrop (plates 13, 19) introduce yet a third unit of measurement, the *piede*. This seems to indicate that the prints are based on drawings by more than one draughtsman, since such a person working directly from the architecture itself would surely have had his own preferred measuring system. (For a table detailing the sizes of these units of measurement, and their relationship to one another, see Frommel, vol. I, p.179.)

The disparity between the various groups of plates that make up this set strongly suggests that they were not produced together as part of a carefully thought-out programme, but rather that they are the result of a merging by Lafrery of plates he acquired from a number of sources, perhaps combined with some judicious additions of new unsigned plates. Lafrery, it must be remembered, only became active as a publisher around 1544.

It seems probable that the plates by one or other of the Monogrammist PS or the Monogrammist G.A. with the Caltrop might be the core around which the set was created, since the coincidence of the coming together of a set of mostly Corinthian cornices with a set of mostly Corinthian bases seems implausible. Which has priority remains unclear.

According to Brown (p.72), the Monogrammist G.A. with the Caltrop was active 1538–c. 1560. The date of this engraver commencing activity, based on a dated view of Naples (Nagler VI, no. 4) does not rule out the possibility that the Monogrammist G.A. with the Caltrop may have been active before then and that his undated plates pre-date those of the Monogrammist PS.

Giorgio Vasari refers to this set in the 1568 chapter on 'Marc'Antonio Bolognese and Other Engravers of Prints' in the 1568 edition of the *Lives of the Painters, Sculptors and Architects*:

> But I must not be silent about the above-mentioned Antonio Lanferri and Tommaso Barlachi, for they, as well as others, have employed many young men to engrave plates after original drawings by the hands of a vast number of masters, insomuch that it is better to say nothing of these works, lest it should become wearisome. And in this manner have been published, among other plates, grotesques, ancient temples, cornices, bases, capitals and many other suchlike things, with all their measurements. [Vasari, p.94.]

It is now impossible to compare Catalogue 55a to three sets in Berlin (Berlin, 3902, 3903 and 3905) of similar subjects, by the same engravers, in sets of nineteen, eleven and thirty plates respectively, since these sets were among the prints in that collection destroyed during the Second World War. The cornices, capitals and bases are the only instance where Lafrery refers in his stocklist to *Libri*, books, in the plural, as opposed to *Book of various frames*, *Book of masks*, etc., although there is always the possibility that this is a 16th-century printer's error. A larger set of thirty-five plates made up of the thirty plates here and five additional subjects (three by the Monogrammist G.A. with the Caltrop, one by the Monogrammist PS, and one unsigned) is in the British Museum, Department of Prints and Drawings (168* b.3). For the plates common to both the V&A and British Museum sets, the pairing of plates on individual folios is identical. The plates in the British Museum are now in a binding probably dating from just before 1904 (the year of accessioning), but inscribed numbers running from 79 to 92 at the top of each folio show that, in the past, they have been bound together, preceded by at least seventy-eight other items.

Dinsmoor (pp.72–3) points out that Catalogue 55b is a copy of a plate by the Monogrammist G.A. with the Caltrop and that another plate (not in the V&A collection), also signed S.S., is a copy of a plate by the Monogrammist PS, Catalogue 55a, pl. 19. Dinsmoor (note 86), following earlier authorities, attributed the two plates signed S.S. to Sebastiano Serlio. Zerner, 1988 (p.283) has rejected this attribution, arguing that in 1544 Serlio is unlikely to have made direct copies of two earlier plates by other engravers, adding banderoles with the name of the Corinthian order, since the capital in the plate not in the V&A collection shows the Composite order – the very order that Serlio had been the first person to describe in 1537. This may explain why plate 19 of Catalogue 55a, originally etched in 1537, is lettered *Corinthio*, meaning the Corinthian order, when to a present-day architectural historian it appears to show a Composite capital. In addition, if the two existing plates by the Monogrammist S.S. were both engraved in 1544, this would seem to indicate that the two plates by the Monogrammist G.A. with the Caltrop and the Monogrammist PS, which they copy, might also have been together by this date. This points to the possibility of a much earlier grouping of architectural details by these two print-makers than the impressions in the Lafrery Volume dating from c. 1573.

See Catalogue 56 for the reissuing of sixteen of these thirty plates by a later

publisher. Dinsmoor (p.73) also believed that Catalogue 55a, pl. 20 is a copy of Catalogue 56, pl. 14. The catalogue of the Escorial collection identifies the monogrammist G.A. with the Caltrop as Giovanni Agucchi and the monogrammist PS as Jacques Prévost, a French etcher, engraver and painter active in France 1546–7. Henri Zerner, writing in *The French Renaissance in Prints* (p.226), has supported earlier authors in rejecting the identification of the monogrammist PS with Prévost 'since the two groups of prints are dissimilar in technique and there is no particular stylistic link'. Zerner does believe, however, that it is possible that the monogrammist PS was a Frenchman active in Rome. Marianne Grivel in *The Dictionary of Art* (vol. 25, p.570) notes that 'Michel de Marolles writing in 1666 [*Catalogue des livres d'estampes et de figures en tailles douce*, Paris] thought that this [the monogram PS] referred to a certain Perjeconter, otherwise unknown.'

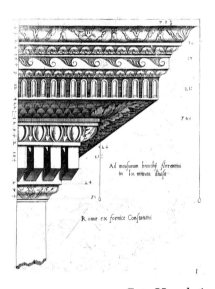

Cat. 55a pl. 1

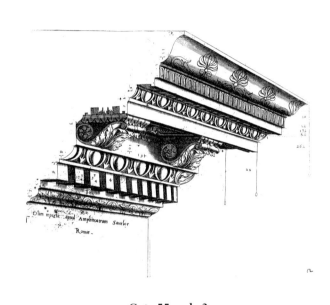

Cat. 55a pl. 2

Cat. 55a pl. 3

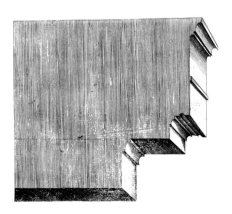

Cat. 55a pl. 4

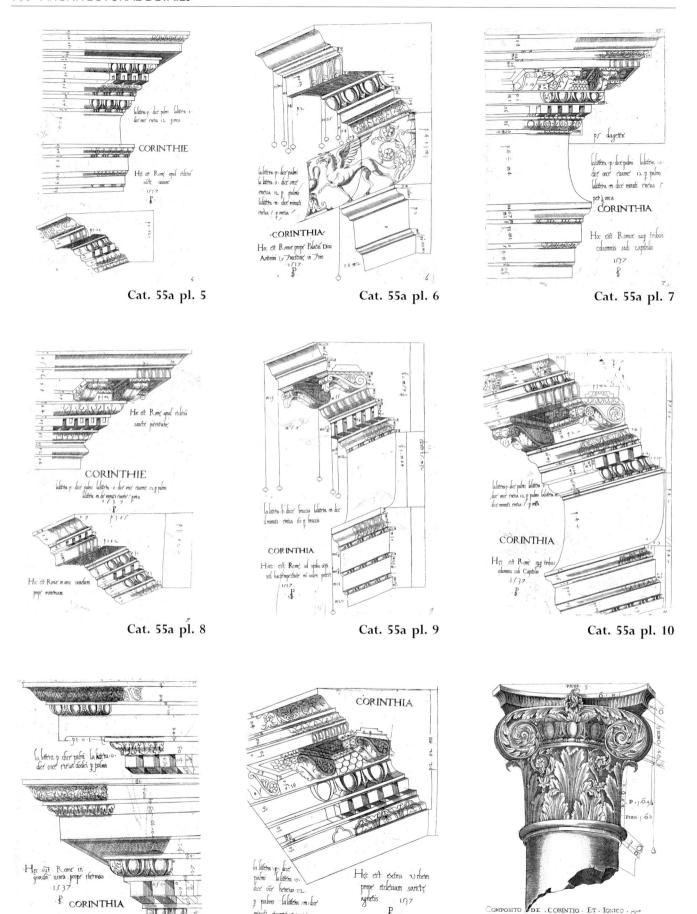

Cat. 55a pl. 5

Cat. 55a pl. 6

Cat. 55a pl. 7

Cat. 55a pl. 8

Cat. 55a pl. 9

Cat. 55a pl. 10

Cat. 55a pl. 11

Cat. 55a pl. 12

Cat. 55a pl. 13

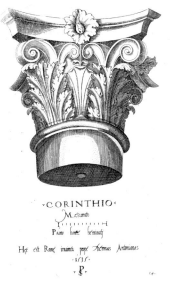

· CORINTHIO ·

· IONICO ·

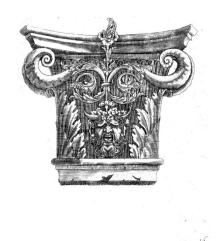

Cat. 55a pl. 14

Cat. 55a pl. 15

Cat. 55a pl. 16

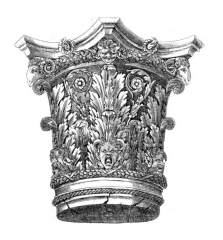

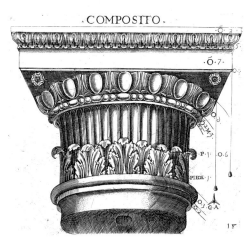

· COMPOSITO ·

Cat. 55a pl. 17

Cat. 55a pl. 18

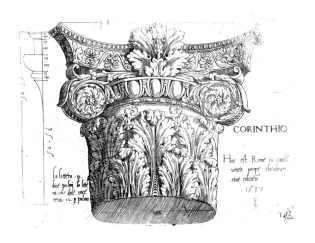

CORINTHIO

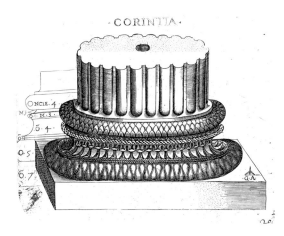

· CORINTIA ·

Cat. 55a pl. 19

Cat. 55a pl. 20

Plate 6

(a) Corinthian entablature (E. VIII, 1.6.(3501)). Numbered in ink 6. Signed in monogram *.PS.* and dated *1537*. Lettered with dimensions and *CORINTHIA/Hoc est Romae prope Palatiu Diui Antionini & Faustine in Foro,/la littera .p. dice palmi la littera .o. dice once eneua 12 p. palmo la littera .m. dice minuti eneua .5. p onecia.* 20.3 x 14.3 cm
E.1987-1899

Plate 7

(a) Corinthian entablature (E. VIII, 1.5.(3500)). Numbered in ink 7. Signed in monogram *PS* and dated *1537*. Lettered with dimensions and *CORINTHIA/Hoc est Romae sup tribus columeris sub capitolio/la littera .p. dice palmi la littera .o. dice once eneua 12 p palmo la littera .m. dice minuti eneua 5 per onca.* 17.5 x 12.8 cm
E.1988-1899

Plate 8

(a) Two Corinthian cornices (E. VIII,1.7.(3502)). Numbered in ink 8. Signed in monogram *.PS.* and dated *1537*. Lettered with dimensions and *CORINTHIE/Hoc est Rome apud ecclesia sancte potentiane/Hoc est Romae in arcu cameliani prope minervam/la littera .p. dice palmi la littera .o. dice once euanne 12 p palmo la littera .m. die minuti euanne .5. ponca.* 21.2 x 13.6 cm
E.1989-1899

Plate 9

(a) Corinthian entablature (E. VIII, 1.8.(3503)). Signed in monogram *.PS.* and dated *1537*. Lettered with dimensions and *CORINTHIA/Haec est Rome ad spolia .xpi. sed hac tempestate no uideri potest.* Lettered *La littera .b. dice braccia la littera.m. dice d minuta eneua 60 p braccio.* Numbered in ink 9. 20.5 x 14.4 cm
E.1990-1899

Plate 10

(a) Corinthian entablature (E. VIII,1.10.(3505)). Signed in monogram *.PS.* and dated *1537*. Lettered with dimensions and *CORINTHIA/Hec est Rome sup tribus columnis sub Capitolio ./la littera .p. dice palmi la littera .o. dice once eneua 12 p palmo la littera .m. dice minuti eneua .5. ponca.* Numbered in ink *10*. 21.8 x 16 cm
E.1991-1899

Plate 11

(a) Two Corinthian cornices (E. VIII, 1.3.(3498)). Numbered in ink *11*. Signed in monogram *.PS.* and dated *1537*. Lettered with dimensions and *CORINTHIA/Hec sut Rome in guada uinea prope thermas ./la littera .p. dice palmi la littera .o. dice once eneua dodici p palmo.* 15.8 x 12.2 cm
E.1992-1899

Plate 12

(a) Corinthian cornice (E. VIII, 1.4.(3499)). Numbered in ink *12*. Signed in monogram *PS* and dated *1537*. Lettered with dimensions and *CORINTHIA/Hec est extra urbem prope ecclesiam sancte agnetis/la littera .p. dice palmi la littera .o. dice oce heneua .12. p palmo la littera .m. dice minuti euanne .5. p onca.* 15.7 x 12.3 cm
E.1993-1899

Plate 13

(a) Composite capital (Nagler, 11; E. I, 19.(19)). Numbered in ink *13*. Signed in monogram *.G.A.* with a caltrop. Lettered with dimensions and *COMPOS-ITO.DE.CORINTIO.ET.IONICO.* 21.9 x 14.3 cm
E.1994-1899

Plate 14

(a) Corinthian capital (E. VIII, 1.1.(3946)). Numbered in ink *14*. Signed in monogram *.PS.* and dated *1535*. Lettered with dimensions and *. CORINTHIO. Mesurato/Palmo honec heminuti/Hec est Rome inuinea prope Thermas Antonianas.* 22 x 13.9 cm
E.1995-1899

Plate 15

(a) Ionic capital (E. I, 18.(18)). Numbered in ink *15*. Signed in monogram *.G.A.* with a caltrop. Lettered with dimensions and *.IONICO.* 13.7 x 15 cm
E.1996-1899

Plate 16

(a) Pilaster capital with a bearded mask (E. I, 6.(6)). Numbered in ink *16*. 16.5 x 15.4 cm
E.1997-1899

Plate 17

(a) Capital with rams' heads and masks (Nagler, 10; Passavant, 26). Numbered in ink *17*. 16.7 x 15.3 cm
E.1998-1899

Plate 18

(a) Composite capital (Nagler, 14; Passavant, 33; E. I, 14.(14)). Numbered in ink *18*. Signed in monogram *.G.A.* with a caltrop. Lettered with dimensions and *.COMPOSITO*. 13.6 x 15 cm

E.1999-1899

Plate 19

(a) Corinthian capital. Numbered in ink *19*. Signed in monogram *PS* and dated *1537*. Lettered with dimensions and *CORINTHIO/Hoc est Rome in guada uinea prope theatrum siue coliseu/la littera .p. dice palmi la littera .o. dice once neua .12. p palmo*. 12.8 x 18.1 cm

E.2000-1899

Plate 20

(a) Corinthian base (E. I, 21.(21)). Numbered in ink *20*. Signed in monogram *.G.A.* with a caltrop. Lettered with dimensions and *CORINTIA*. 12.8 x 16 cm

E.2001-1899

(b) Impression (E. VIII, 2.(3980)). Signed in monogram *.S.S.* Lettered with dimensions and *.CORINTIA*. Cut to 13.1 x 18.7 cm

16806

Plate 21

(a) Corinthian base (Nagler, 5; Passavant, 34; E. I, 15.(15)). Numbered in ink *21*. Signed in monogram *.G.A.* with a caltrop. Lettered with dimensions and *.CORINTIA*. 12.4 x 16.6 cm

E.2002-1899

Plate 22

(a) Corinthian base. Numbered in ink *22*. Signed in monogram *.G.A.* with a caltrop. Lettered with dimensions and *.CORINTIA*. 12.4 x 17.8 cm

E.2003-1899

Plate 23

(a) Corinthian base (Nagler, 4; E. I 23.(23)). Numbered in ink *23*. Signed in monogram *.G.A.* with a caltrop. Lettered with dimensions and *.CORINTA*. 13 x 17.6 cm

E.2004-1899

Plate 24

(a) Ionic base (? Nagler 13; E. I, 20.(20)). Numbered in ink *24*. Signed in monogram *G.A.* with a caltrop. Lettered with dimensions and *IONICA* [N reversed]. 13 x 18.4 cm

E.2005-1899

Plate 25

(a) Corinthian base. Numbered in ink *25*. Signed in monogram *.G.A.* with a caltrop. Lettered with dimensions and *CORINTIA* [N reversed]. 13 x 18.5 cm

E.2006-1899

Plate 26

(a) Corinthian base (E. I, 26.(26)). Numbered in ink *26*. Signed in monogram *.G.A.* with a caltrop. Lettered with dimensions and *CORINTIA* [N reversed]. 12.8 x 15.4 cm

E.2007-1899

Plate 27

(a) Corinthian base (E. I, 24.(24)). Numbered in ink *27*. Signed in monogram *.G.A.* with a caltrop. Lettered with dimensions and *.CORINTIA*. 12.9 x 15.3 cm

E.2008-1899

Plate 28

(a) Corinthian base (Nagler, 2; E. I, 25.(25)). Numbered in ink *28*. Signed in monogram *.G.A.* with a caltrop. Lettered with dimensions and *CORINTIA*. 12.5 x 17.8 cm

E.2009-1899

Plate 29

(a) Corinthian base (Passavant, 30; E. I, 27.(27)). Numbered in ink *29*. Signed in monogram *.G.A.* with a caltrop. Lettered with dimensions and *.CORITIA*. 12.3 x 16.6 cm

E.2010-1899

Plate 30

(a) Corinthian base (Nagler, 3; Passavant, 32; E. I, 13.(13)). Numbered in ink *30*. Signed in monogram *.G.A.* with a caltrop. Lettered with dimensions and *.CORINTIA*. 13.1 x 17.6 cm

E.2011-1899

Pla

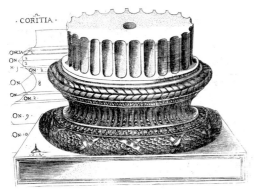

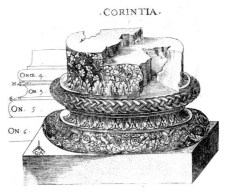

Cat. 56 pl. 20

Cat. 56 pl. 21

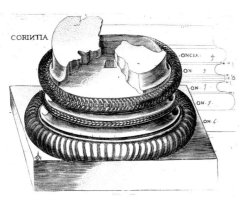

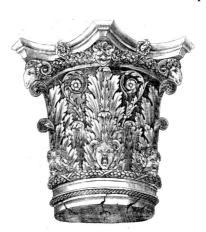

Cat. 56 pl. 22

Cat. 56 pl. 23

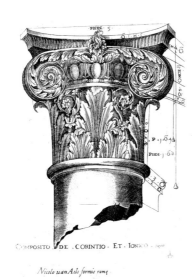

Cat. 56 pl. 24

Catalogue 56: PLATE DESCRIPTIONS

Plate 1

Capital and base (Nagler Mon II, 2679, no. 9; Passavant, 28; E. I, 9.(9) capital only). Signed in monogram .G.P. with a caltrop. Lettered *Ant. sal. exc./.BASA IN.* [N reversed] *ROMA. SOTTO CAPITOLIO.*
30.1 x 21.4 cm
25511.1

Plate 2

Section through a Doric building (Nagler Mon II, 2679, no. 18; Passavant, 36; E. I, 17.(17)). Signed in monogram .G.A. with a caltrop. Lettered *.DORICO ./Ant. Sal. exc.* 21.4 x 14 cm
25511.2

Plate 3

Capital with acanthus leaves and masks. Signed in monogram .G.P. with a caltrop. Lettered *Ant. sala. exc.*
18 x 15.3 cm
25511.3

Plate 4

Capital with egg and dart ornament and acanthus leaves. The name of Petrus de Nobilibus partially erased.
13.4 x 17.6 cm
25511.4

Plate 5

Doric capital (E. I, 28.(28)). Signed in monogram .G.A. with a caltrop. Lettered with dimensions and *DORICO.* The name of Petrus de Nobilibus partially erased.
12.2 x 15.7 cm
25511.5

Plate 6

Ionic base (? Nagler, 13; E. I, 20.(20)). Signed in monogram G.A. with a caltrop. Lettered with dimensions and *IONICA* [N reversed]. The name of Petrus de Nobilibus partially erased. 13.2 x 18.4 cm
25511.6

Plate 7

Pilaster capital with a bearded mask (E. I, 6.(6)).
15.3 x 15.2 cm
25511.7

Plate 8

Ionic capital (Nagler Mon II, 2679, no.12; Passavant, 29; E. I, 10.(10)). Signed in monogram .G.A. with a caltrop. Lettered with dimensions and *.IONICO.* The name of Petrus de Nobilibus partially erased. 11.9 x 18 cm
25511.8

Plate 9

Ionic capital (E. I, 18.(18)). Signed in monogram .G.A. with a caltrop. Lettered with dimensions and *.IONICO.*
13.8 x 14.3 cm
25511.9

Plate 10

Ionic base (E. I, 22.(22)). Signed in monogram .G.A. with a caltrop. Lettered with dimensions and *.IONICA.*
11.9 x 17.9 cm
25511.10

Plate 11

Composite capital (Nagler Mon II, 2679, no. 14; Passavant, 33; E. I, 14.(14)). Signed in monogram .G.A. with a caltrop. Lettered with dimensions and *.COMPOSITO.* The name of Petrus de Nobilibus partially erased.
13.9 x 14.9 cm
25511.11

Plate 12

Corinthian base (E. I, 24.(24)). Signed in monogram .G.A. with a caltrop. Lettered with dimensions and *.CORINTIA.* 13.1 x 15.2 cm
25511.12

Plate 13

Corinthian base (Nagler Mon II, 2679, no. 2; E. I, 25.(25)). Signed in monogram .G.A. with a caltrop. Lettered with dimensions and *CORINTIA.* The name of Petrus de Nobilibus partially erased. 12.6 x 17.8 cm
25511.13

Plate 14

Corinthian base (E.V III,1.2.(3497)). Signed in monogram *PS*. Dated *1537*. Lettered with dimensions and *CORINTHIA/Haec.est Romae in domo. Marchionnjs de baldassinis.* and *Tuttj linumeri dichono deta eneua 12 p palmo.* The name of Petrus de Nobilibus partially erased. 11.2 x 16.3 cm

25511.14

Plate 15

Corinthian base (Brown University, 63; E. I, 21.(21)). Signed in monogram *.G.A.* with a caltrop. Lettered with dimensions and *CORINTIA.* The name of Petrus de Nobilibus partially erased. 12.7 x 15.9 cm

25511.15

Plate 16

Corinthian base (E. I, 26.(26)). Signed in monogram *.G.A.* with a caltrop. Lettered with dimensions and *CORINTIA* [N reversed]. 13 x 15 cm

25511.16

Plate 17

Corinthian base. Signed in monogram *.G.A.* with a caltrop. Lettered with dimensions and *.CORINTIA.* 12.5 x 17.3 cm

25511.17

Plate 18

Corinthian base (Nagler Mon II, 2679, no. 5; Passavant, 34; E. I, 15.(15)). Signed in monogram *.G.A.* with a caltrop. Lettered with dimensions and *.CORINTIA.* The name of Petrus de Nobilibus partially erased. 12.5 x 16.4 cm

25511.18

Plate 19

Corinthian base (Nagler Mon II, 2679, no. 4; E. I, 23.(23)). Signed in monogram *.G.A.* with a caltrop. Lettered with dimensions and *.CORINTA.* The name of Petrus de Nobilibus partially erased. 13.1 x 17.4 cm

25511.19

Plate 20

Corinthian base (Passavant, 30; E. I, 27.(27)). Signed in monogram *.G.A.* with a caltrop. Lettered with dimensions and *.CORITIA.* 12.6 x 16.5 cm

25511.20

Plate 21

Corinthian base (Nagler Mon II, 2679, no. 3; Passavant, 32; E. I, 13.(13)). Signed in monogram *.G.A.* with a caltrop. Lettered with dimensions and *.CORINTIA.* 13.2 x 17.5 cm

25511.21

Plate 22

Corinthian base. Signed in monogram *.G.A.* with a caltrop. Lettered with dimensions and *CORINTIA* [N reversed]. 13.2 x 18.4 cm

25511.22

Plate 23

Capital with rams' heads and masks (Nagler Mon II, 2679, no. 10; Passavant, 26). 16.9 x 15.3 cm

25511.23

Plate 24

Composite capital (Nagler Mon II, 2679, no. 11; E. I, 19.(19)). Signed in monogram *.G.A.* with a caltrop. Lettered with dimensions and *COMPOSITO.DE.CORIN-TIO.ET.IONICO/Nicolo van Aels formis rome.* 22 x 15.3 cm

25511.24

ARMS AND ARMOUR

Catalogue 57

Plate No.	1	2	3	4	5	6	7	8	9	10	11	12
	☐	☐	☐	☐	☐	☐	☐	☐	☐	☐	☐	☐

SET DESCRIPTION

Original plates and reissues

57 ANONYMOUS, engraver. Drawings by workshop of Jacopo STRADA (1507–88) or Ottavio STRADA (1550–1612). Giulio ROMANO (1492/9–1546), designer. Plates (12) representing characters from *Orlando Furioso* by Ludovico Ariosto (1474–1533). Each shown in profile and wearing an ornamental helmet. Italian, mid-17th century, first published second half of 16th century. Each lettered with the name of the character above a quotation. Etching and engraving

26803.1–12

NOTES: Two volumes of helmet drawings by the workshop of Jacopo or Ottavio Strada survive, one in the Österreichische Nationalbibliothek, Vienna, and the other in the Nationalmuseum, Stockholm. The volume in Stockholm is inscribed in ink *Casques d'apres Jules Romain* (see Vienna, no. VI, 44, and Rangström, no. 102). Plate 11 of the set of prints is a copy in reverse of one of the drawings in Vienna. The subject matter of these prints is also similar to sixteen drawings of men in helmets and armour (E.1772–1787-1929) in the volume of drawings by Filippo Orso (active 1554) in the V&A (see Ward-Jackson, no. 212). All except plate 4, which is a close helmet, show examples of a type of helmet known as a burgonet. For illustrations of surviving Italian burgonets of this period, see Laking, vol. IV.

These prints are each on sheets measuring 41.4 x 28.2 cm. They are stitched together and once formed part of a leather-spined volume, traces of which still remain. Plates 8, 9 and 11 carry a watermark similar to Boorsch and Lewis, p.220, no. 34, found on prints published by Giovanni Giacomo De Rossi (active 1638–84).

While the illustrated editions of *Orlando Furioso* have been the subject of special studies on at least two occasions (see Hofer, and Bellocchi and Fava), these engravings would seem to be unrecorded.

The plates are described in the order of their accession.

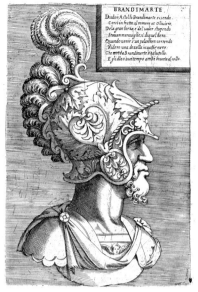

BRANDIMARTE

Cat. 57 pl. 1

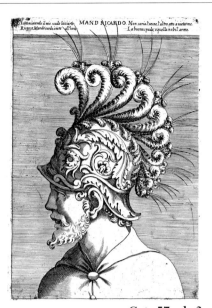

MANDRICARDO

Cat. 57 pl. 2

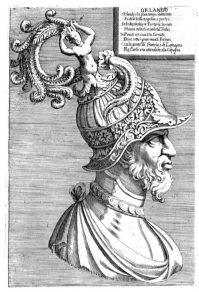

ORLANDO

Cat. 57 pl. 3

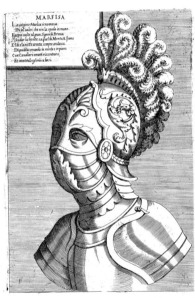

MARFISA

Cat. 57 pl. 4

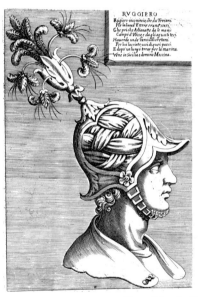

RVGGIERO

Cat. 57 pl. 5

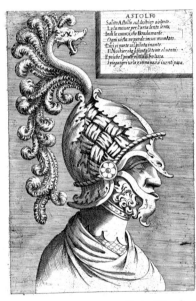

ASTOLFO

Cat. 57 pl. 6

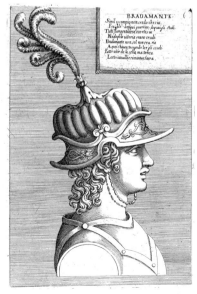

BRADAMANTE

Cat. 57 pl. 7

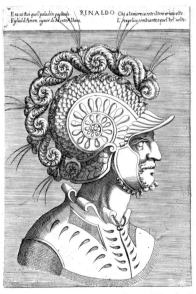

RINALDO

Cat. 57 pl. 8

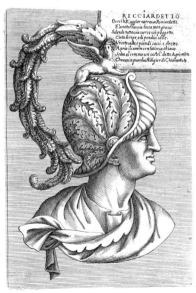

RICCIARDETTO

Cat. 57 pl. 9

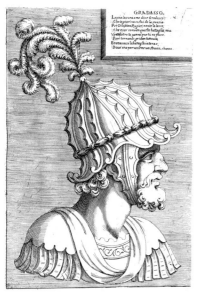

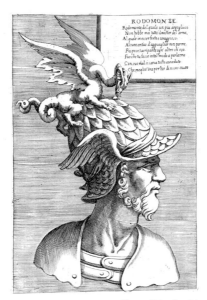

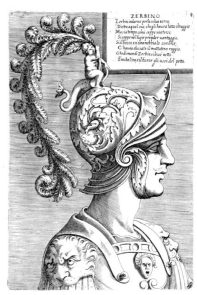

Cat. 57 pl. 10 Cat. 57 pl. 11 Cat. 57 pl. 12

Catalogue 57: PLATE DESCRIPTIONS

Plate 1

Bust of Brandimarte. Lettered *BRANDIMARTE* with eight lines of verse. 19.9 x 13.5 cm

26803.1

Plate 2

Bust of Mandricardo. Lettered *MANDRICARDO* with four lines of verse. 19.8 x 13.8 cm

26803.2

Plate 3

Bust of Orlando. Lettered *ORLANDO* with eight lines of verse. 19.8 x 13.7 cm

26803.3

Plate 4

Bust of Marfisa. Lettered *MARFISA* with eight lines of verse. 19.8 x 13.6 cm

26803.4

Plate 5

Bust of Ruggiero. Lettered *RUGGIERO* with eight lines of verse. 20 x 13.8 cm

26803.5

Plate 6

Bust of Astolfo. Lettered *ASTOLFO* with eight lines of verse. 19.8 x 13.5 cm

26803.6

Plate 7

Bust of Bradamante. Lettered *BRADAMANTE* with eight lines of verse. 19.8 x 13.7 cm

26803.7

Plate 8

Bust of Rinaldo. Lettered *RINALDO* with four lines of verse. 19.9 x 13.8 cm

26803.8

Plate 9

Bust of Ricciardetto. Lettered *RICCIARDETTO* with eight lines of verse. 19.7 x 13.6 cm

26803.9

Plate 10

Bust of Gradasso. Lettered *GRADASSO* with eight lines of verse. 19.8 x 13.6 cm

26803.10

Plate 11

Bust of Rodomonte. Lettered *RODOMONTE* with eight lines of verse.
19.8 x 13.6 cm
26803.11

Plate 12

Bust of Zerbino. Lettered *ZERBINO* with eight lines of verse. 19.7 x 13.6 cm
26803.12

FANS

Catalogue 58

Plate No.	
58a	☐
58b	☐

PLATE DESCRIPTIONS

Original plates and reissues

58a Agostino CARRACCI (1557–1602), designer and engraver. Headpiece in the form of a fan decorated with a head of Diana and a landscape, with a satyr spying on two nymphs bathing in a stream. At the bottom right, three other subjects in ovals, a bust of Minerva, Minerva and Neptune and the Three Graces. Italian, c. 1589–95.
Signed *Agust. Carazza Inu. e fe.* Stamped with the mark of the collection of John Tetlow, died before 1840 (Lugt 2868).
Engraving. Cut to 35.6 x 24.9 cm [the oval with the Three Graces cut away].
30000.C

(a) Another impression. [Two ovals cut away and the remaining one repositioned on a backing sheet.]
27380

Lit: B. XVIII, 260; Guilmard, p.295, no. 51; Berlin, 550(1); DeGrazia Bohlin, 193-II.

Copy plates

58b ANONYMOUS, lithographer. A fan. Copy after Catalogue 58a, omitting the extra ovals. British? 19th century.
Lithograph. Size of sheet 32.8 x 26.1 cm
24163

NOTES: The first state of the Carracci engraving is before the lettering. DeGrazia Bohlin illustrates a preparatory drawing by the artist, in an English private collection.

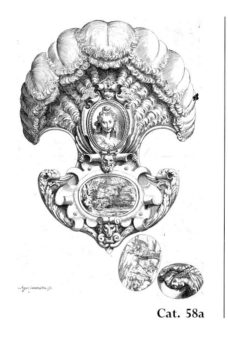

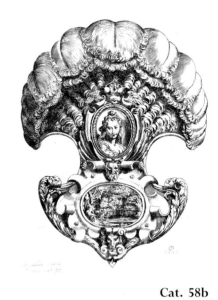

Cat. 58a

Cat. 58b

GLASS

Catalogue 59

Plate No. | 1 4 5 6 7 9 14 16 17 18 20 23 28 34 39 40 43 44 54 55 60 63 67 68 70 73 74 77 78 79 80

SET DESCRIPTION

Original plates and reissues

59 Monogrammist CAP (late 16th century), engraver. Plates (31) of glass drinking vessels from a set of eighty. Numbered, some partially erased or cut off. Some with dotted lines explaining the design. Italian, late 16th century. All except plate 70 signed in monogram *CAP*.
Etchings. Cut to or within borderlines, some with corners cut.
21642.1–24, E.1160–1168-1923

Lit: Guilmard, p.302, no. 81; Berlin, 1038.

NOTES: Nagler Mon I, 2242 associated this monogram with Polidoro da Caravaggio (1499–1543?) and his followers. No preparatory drawings by Polidoro survive for this set, and the attribution of this set to Polidoro is rejected in the Berlin catalogue. The set of eighty plates in Berlin was among those prints in that collection destroyed during the Second World War. Seventy-six out of the set of eighty plates are in the British Museum, Department of Prints and Drawings, Sloane 2.A.A*.a.72.1–76. The plates absent from that collection are numbers 73–6. For illustrations of examples of this type of Renaissance glass, see Heikamp.

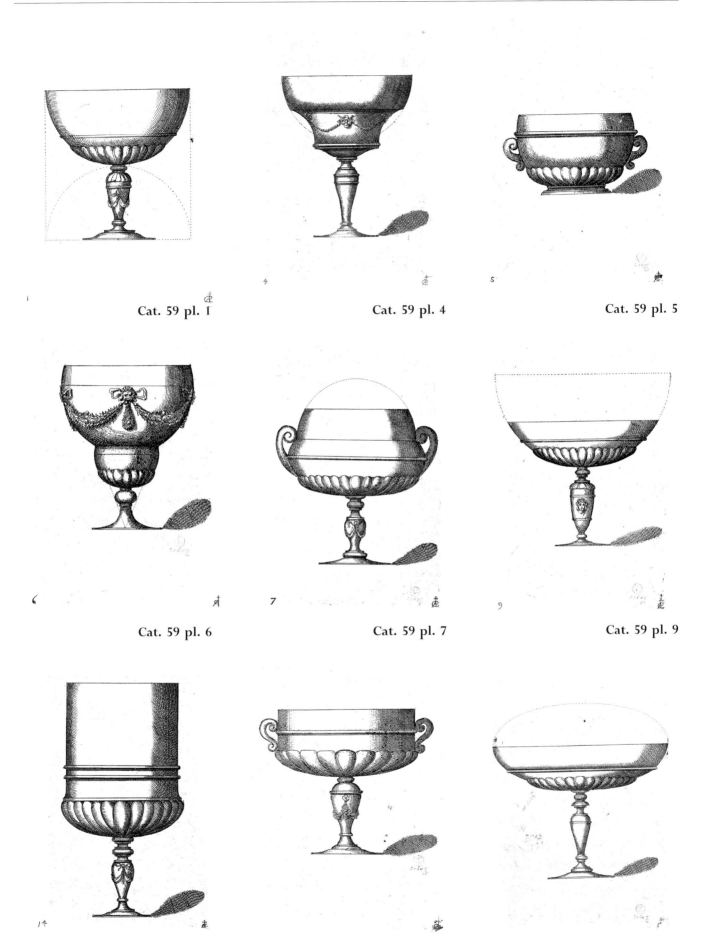

Cat. 59 pl. 1 Cat. 59 pl. 4 Cat. 59 pl. 5

Cat. 59 pl. 6 Cat. 59 pl. 7 Cat. 59 pl. 9

Cat. 59 pl. 14 Cat. 59 pl. 16 Cat. 59 pl. 17

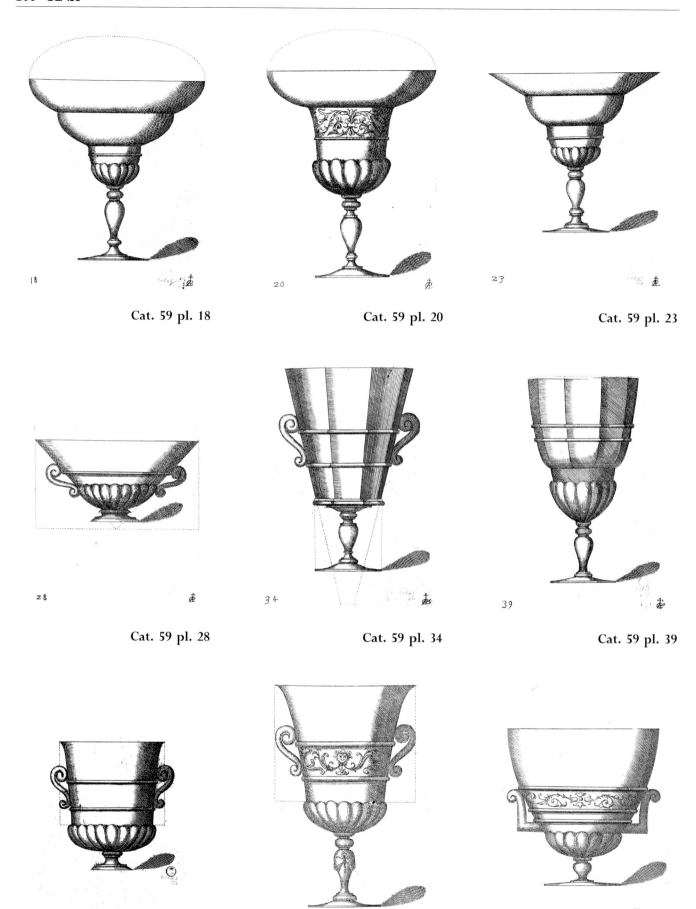

Cat. 59 pl. 18

Cat. 59 pl. 20

Cat. 59 pl. 23

Cat. 59 pl. 28

Cat. 59 pl. 34

Cat. 59 pl. 39

Cat. 59 pl. 40

Cat. 59 pl. 43

Cat. 59 pl. 44

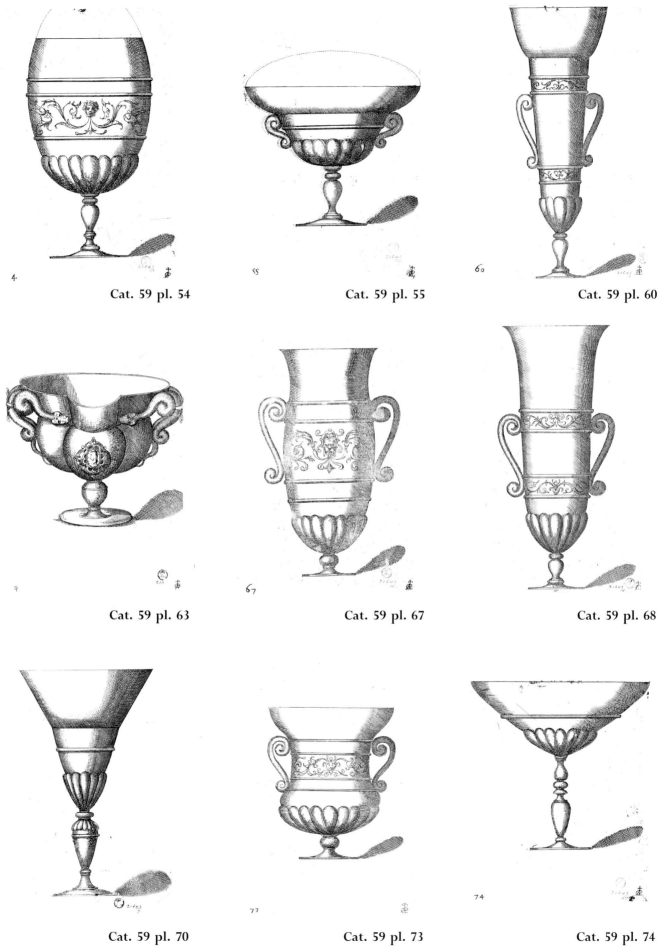

Cat. 59 pl. 54

Cat. 59 pl. 55

Cat. 59 pl. 60

Cat. 59 pl. 63

Cat. 59 pl. 67

Cat. 59 pl. 68

Cat. 59 pl. 70

Cat. 59 pl. 73

Cat. 59 pl. 74

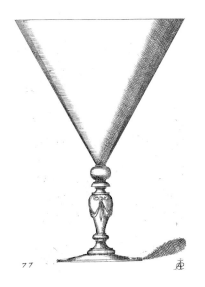

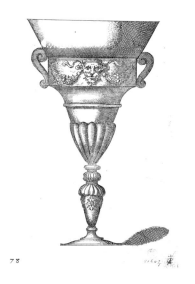

Cat. 59 pl. 77 Cat. 59 pl. 78 Cat. 59 pl. 79

Cat. 59 pl. 80

Catalogue 59: PLATE DESCRIPTIONS

Plate 1

A semi-circular goblet with gadrooning [a series of convex curves] around the base of the bowl and the top of the inverted baluster stem, which is hung with swags. Signed in monogram *CAP* and numbered *1*. Cut to 15.8 x 10.7 cm

E.1160-1923

Plate 4

A goblet with swags suspended from rosettes on the bowl. The inverted baluster stem ringed three times. Signed in monogrammed *CAP* and numbered *4*. Cut to 15.4 x 10.6 cm

E.1161-1923

Plate 5

A cup on a base with two scroll-shaped handles and gadrooning around the base of the bowl. Signed in monogram *CAP* and numbered *5*. Cut to 16 x 10.8 cm

21642.21

Plate 6

A goblet with a bowl in two parts, the upper with swags hanging from a mask, the lower smaller and gadrooned, on a stem with a knop [a swelling formed in glass-blowing]. Signed in monogram *CAP* and numbered *6*. Cut to 15.9 x 10.6 cm

21642.11

Plate 7

A goblet narrowing at the top, with two scroll-shaped handles and gadrooning around the base of the bowl on an inverted baluster stem hung with swags. Signed in monogram *CAP* and numbered 7. Cut to 15.9 x 10.8 cm

21642.8

Plate 9

A tazza [saucer-shaped cup mounted on a foot] gadrooning around the base of the bowl on an inverted baluster stem decorated with a female mask. Signed in monogram *CAP* and numbered *9*. Cut to 15.8 x 10.6 cm.

21642.22

Plate 14

A straight-sided goblet, ringed twice, with gadrooning around the base of the bowl, the inverted baluster stem hung with swags. Signed in monogram *CAP* and numbered *14*. Cut to 15.6 x 10.6 cm

E.1162-1923

Plate 16

A straight-sided goblet ringed once and with gadrooning around the base of the bowl, two scroll-shaped handles and an inverted baluster stem hung with festoons hanging from a flower. Signed in monogram *CAP* and numbered *?16* [torn]. Cut to 16 x 10.8 cm

21642.15

Plate 17

A tazza, ringed once, and with gadrooning around the base of the bowl on an inverted baluster stem. Signed in monogram *CAP* [torn] and numbered *?17* [torn]. Cut to 15.8 x 10.8 cm

21642.2

Plate 18

A goblet with gadrooning around the base of the bowl above a knop and an inverted baluster stem. Signed in monogram *CAP* and numbered *18*. Cut to 16.2 x 10.8 cm

21642.9

Plate 20

A goblet, ringed once and with a band of foliated ornament and gadrooning around the base of the bowl on an inverted baluster stem. Signed in monogram *CAP* and numbered *20*. Cut to 15.8 x 10.5 cm

E.1163-1923

Another impression. The monogram torn.

21642.4

Plate 23

A goblet with gadrooning around the base of the bowl on an inverted baluster stem. Signed in monogram *CAP* and numbered *23*. Cut to 15.9 x 10.7 cm

21642.24

Plate 28

A wide-mouthed, straight-sided cup with two scroll-shaped handles on a low foot. Signed in monogram *CAP* and numbered *28*. Cut to 15.2 x 10.1 cm
E.1164-1923

Plate 34

A bucket shaped, faceted goblet with two scroll-shaped handles on an inverted baluster stem. Signed in monogram *CAP* and numbered *34*. Cut to 15.7 x 10.6 cm
21642.20

Plate 39

A faceted goblet, ringed twice and with gadrooning around the base of the bowl. Signed in monogram *CAP* and numbered *39*. Cut to 16 x 10.6 cm
21642.17

Plate 40

A deep squat cup, ringed twice, with gadrooning around the base of the bowl on a low foot, with two scroll-shaped handles. Signed in monogram *CAP* and numbered *40*. Cut to 15.6 x 10.7 cm
21642.16

Plate 43

A goblet, decorated with a band of foliated ornament, with an animal mask in the centre, ringed twice, gadrooning around the base of the bowl, two scroll-shaped handles and an inverted baluster stem hung with festoons. Signed in monogram *CAP* and numbered [4]*3*. Cut to 16 x 10.8 cm
21642.5

Plate 44

A short-stemmed goblet with two square handles terminating in scrolls. Decorated with a band of foliated ornament and gadrooning around the base of the bowl. Signed in monogram *CAP* and numbered *44*. Cut to 16 x 10.8 cm
21642.18

Plate 54

An ovoid goblet, ringed three times, decorated with a band of foliated ornament with a mask at the centre, and with gadrooning around the base of the bowl on an inverted baluster stem. Signed in monogram *CAP* and numbered [5]*4*. Cut to 16 x 10.8 cm
21642.13

Plate 55

A goblet with two scroll-shaped handles, gadrooning around the base of the bowl on a double knop above an inverted baluster stem. Signed in monogram *CAP* and numbered *55* [torn]. Cut to 16.1 x 10.7 cm
21642.19

Plate 60

A tall goblet with two scroll-shaped handles, two bands of foliated ornament, with gadrooning around the base of the bowl, on an inverted baluster stem. Signed in monogram *CAP* and numbered *60*. Cut to 15.9 x 10.8 cm
21642.6

Plate 63

A tri-lobed goblet with two handles in the form of snakes. The front of the bowl set with a jewel. Numbered in pencil *63*. Signed in monogram *CAP* and numbered [6]*3*. Cut to 15.8 x 10.8 cm
21642.3

Plate 67

A short-stemmed, two-handled goblet, decorated with a wide band of foliated ornament, with an animal mask in the centre and two rings above and below, and with two scroll-shaped handles. Signed in monogram *CAP* and numbered *67*. Cut to 16 x 10.9 cm
21642.12

Plate 68

A tall goblet with two bands of foliated ornament, gadrooning around the base of the bowl, two scroll-shaped handles and a gently flaring lip, on an inverted baluster stem. Signed in monogram *CAP* and numbered *68* [torn]. Cut to 16 x 10.8 cm
21642.14

Plate 70

A goblet with gadrooning on the base of the bowl and top of the inverted baluster stem. Cut to 15.8 x 10.6 cm
21642.7

Plate 73

A cup narrowing in the middle, with a band of foliated ornament, gadrooning around the base of the bowl and two scroll-shaped handles, the foot surmounted by a knop. Signed in monogram *CAP* and numbered *73*. Cut to 15.9 x 10.8 cm
E.1165-1923

Another impression.
21642.23

Plate 74

A tazza with gadrooning around the base of the bowl, with a tall stem of double baluster and knop form. Signed in monogram *CAP* and numbered *74*. Cut to 12.9 x 10.8 cm
21642.10

Plate 77

A conical goblet with a knop and inverted baluster stem hung with swags. Signed in monogram *CAP* and numbered *77*. Cut to 15.8 x 10.5 cm
E.1166-1923

Plate 78

A goblet with two handles attached to a straight-sided band of ornament consisting of a festoon hung from an animal mask, and with gadrooning around the base of the bowl. On the inverted baluster stem is a rosette. Signed in monogram *CAP* and numbered *78*. Cut to 16.1 x 10.8 cm
21642.1

Plate 79

A goblet ringed once with gadrooning around the base of the bowl. The inverted baluster stem hung with festoons. Signed in monogram *CAP* and numbered *79*. Cut to 15.3 x 10.5 cm
E.1167-1923

Plate 80

A tall goblet decorated with a band of satyr heads, two rings above and below. Signed in monogram *CAP* and numbered *80*. Cut to 15.7 x 10.7 cm
E.1168-1923

61c Marcantonio RAIMONDI, engraver. RAPHAEL, designer. Antonio LAFRERY (1512–77), publisher. A censer. Reissue of Catalogue 61a with the whole plate reworked, bound into a volume of the *Speculum Romanae Magnificentae*. Italian, Rome, third quarter of the 16th century.
Lettered *Ant. Sal exc.*
E.3847-1906

NOTES: See Fuhring, 1989, no. 622, for yet later reissues of this plate.

Copy plates

61d ANONYMOUS, engraver. RAPHAEL, designer. A censer. Copy of Catalogue 61a without the tablet. Italian, 1520–50. Inscribed in ink *R*.
Engraving 30.4 x 16.4 cm
Dyce 1060

Lit: B. XIV, 489A; Berlin, 1120; Fuhring, 1989, no. 622, copy 2.

Reversed copy plates

61e Marco DENTE (active 1515–d. 1527), engraver. RAPHAEL, designer. A censer. Reversed copy of Catalogue 61a. Proof impression before the addition of the monogram. Italian, 1520–7.
Engraving. 31.1 x 14.9 cm
12977

NOTES: This image is significantly different from Catalogue 61a. There is a void between the head-dress of the figure on the left and the central column in this print, which is not present in Catalogue 61a. It is conceivable that this print by Marco Dente is the original and the Marcantonio Raimondi the copy. If this were to be the case, the festoon of leaves on the column in Catalogue 61a (absent in Catalogue 61e) could have been added to enliven what would otherwise be a visually uninteresting area at the centre of the composition, created by bringing the left-hand figure into the same spatial relationship with the column as the one on the right.

61f Marco DENTE, engraver. RAPHAEL, designer. A censer. Reversed copy of Catalogue 61a. Reissue of Catalogue 61e with the addition of the monogram. Italian, 1520–7. Signed in monogram *SR*.
Engraving. Cut to 30.5 x 14.2 cm
29459.8

Lit: B. XIV, 490; Fuhring, 1989, no. 622, copy 3.

NOTES: See Fuhring, 1989, no. 622, for later reissues of this plate.

61g ANONYMOUS, etcher. RAPHAEL, designer. A perfume-burner. French, 18th century(?). Reversed copy of Catalogue 61a.
Etching. Cut to 30 x 16.8 cm
29463

Cat. 61a

Cat. 61b

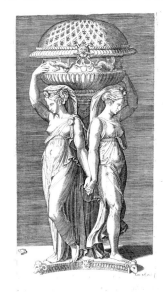

Cat. 61c

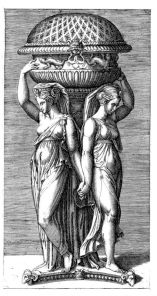

Cat. 61d

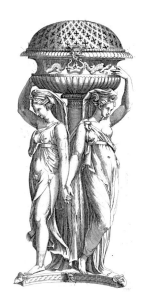

Cat. 61e

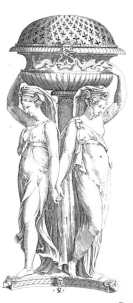

Cat. 61f

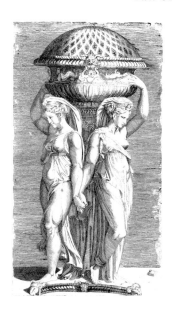

Cat. 61g

Catalogue 62

Plate No.	1	2	3	4	5
62a	☐	☐	☐	☐	☐
62b	☐	☐	☐	☐	
62c	☐	☐	☐	☐	
62d	☐				

SET DESCRIPTION

Original plates and reissues

62a ANONYMOUS, engraver. Antonio SALAMANCA (c. 1500–62), publisher. Plates (5) of candlesticks. Italian, Rome, 1552. Plate 1 dated *M.D.LII.* [Plate 5] lettered with Salamanca's name. Numbered *1–4*.
Engravings
14987, 19014–19018, 20024, 20309, 26819, 29468.3, E.2403–2404-1913

Lit: Berlin, 1126; Berliner, 368; A. 652.1–4, A. 664.1; TIB 30, 491-4-Copy; E. IX, 39.1–4 (4474–77)

62b ANONYMOUS, engraver. Antonio LAFRERY (1512–77), publisher. Plates (4) of candlesticks. Reissues of Catalogue 62a. Italian, Rome, c. 1573. Numbered *1–3*.
Engravings
E.2094–2097-1899

Lit: Miller.

Reversed copy plates

62c Enea VICO (1523–67). Plates (4) of candlesticks. Reversed copies after Catalogue 62a, plates 1–4. Italian, Rome, 1552–67.
Engravings
14887, 14986, 17347–17348, 29460.12

Lit: Guilmard, p.289, no. 24; Jessen, 44–5; Berlin, 1126; TIB 30, 491–4.

62d Georg Christoph EIMMART (1638–1705), engraver. A candlestick. Plate from J. von Sandrart, *Teutsche Academie der Edlen Bau- Bild- und Mahlerey-Künste*, 3 vols, Nuremburg, 1675–9. Reversed copy after Catalogue 63a pl. 1. German, 1675–9. With added lettering in verse, and letterpress on the back.
Engravings
13640.2, E.1527.A.117-1885

Lit: Fuhring, 1989, no. 650.

NOTES: Bartsch describes two sets. A set of four plates numbered at the bottom right, and lit from the left, he calls the originals by Enea Vico; and another set of the same compositions in reverse, lit from the right, he calls copies, without specifying whether or not this second set is numbered. The corresponding volume of *The Illustrated Bartsch* illustrates four prints lit from the left but without visible numbers as the originals, and four prints of the same compositions in reverse, lit from the right, three of which are numbered bottom right, as the copies. The unnumbered print in this second set exists in the V&A collection, in an impression also numbered bottom right. Research towards this catalogue has failed to uncover any impressions of the four images illustrated in *The Illustrated Bartsch* as the originals by Vico, i.e. those lit from the left, which are numbered.

The Amsterdam catalogue (A. 652) lists under Vico, as designer, the images shown in *The Illustrated Bartsch* as the copies. In reviewing the Amsterdam catalogue, Peter Fuhring (Fuhring, 1989) doubts that the designs are by Vico and goes on to say, 'The quality of the engraving in the set of numbered plates by Vico is so far inferior to those of the anonymous master that, contrary to Bartsch, I think the latter should be seen as the original set and the former as the copies.'

This catalogue follows Fuhring, in opposition to Bartsch, in believing that the set lit from the right should be seen as the originals, and the set lit from the left as the copies. As Bartsch says, the numbered plates are the originals, and as it is these that are lit from the right perhaps Bartsch accidentally transposed either the presence of the numbering or the direction of the lighting in the two sets.

Plate 1 in the set makes use of the caryatids that support the perfume burner engraved by Marcantonio Raimondi (see Catalogue 61a).

Fuhring, following Guilmard, also linked the four prints lit from the right in Amsterdam (A. 652) to two other prints of candlesticks listed separately in the Amsterdam catalogue (A. 664.1–2). One of these additional plates (A. 664.1) is also in the V&A's collection (19015), having been acquired as part of a group 19014–19018. These five prints are on the same paper in the same style of engraving and, to a greater or lesser extent, exhibit a type of horizontal shading carried out in a way that creates an optical effect of a vertical line flanking one or both sides of the candlestick in each print, a feature absent in the set lit from the left.

Catalogue 62b forms part of the Lafrery Volume (see Introduction) and corresponds to the second part of the entry *Libro de uasi et candelieri* in Lafrery's stocklist of 1573 (Ehrle, p.59). They are very tired impressions compared to the freshness of all the other images in the Lafrery Volume. They have been trimmed of their margins since entering the museum. When they were accessioned in 1899, they are recorded in the manuscript *Register of Engravings* as measuring 15.25 by 10.75 inches (38.8 x 27.4 cm) – i.e. the same size as all the other folios that make up the volume. The one plate lettered with Antonio Salamanca's name in the set, Catalogue 62a, establishes that he is the publisher of the other four subjects. It is these four subjects that turn up in the Lafrery Volume. In 1553 Lafrery and Salamanca effectively merged their businesses, giving each access to impressions from

the other's stock of plates (Ehrle, p.13). The original contract is lost and can be reconstructed only from later documents. Salamanca died in 1562 and in a contract of 28 September 1563, Antonio Lafrery and Antonio Salamanca's son, Francesco, agreed to end the partnership (Ehrle, pp.13–14). However, in a new contract dated 11 October 1563, Francesco Salamanca agreed that for a period of ten years he would sell Antonio Lafrery as many '*fogli reali* prints well and appropriately printed' (Ehrle, p.38, line 126 ff.) as he might need. The tired impressions in the Lafrery Volume certainly could not be described as 'well and appropriately printed', but this contract indicates that even as late as 1573 Antonio Lafrery would have at his disposal impressions of Salamanca plates.

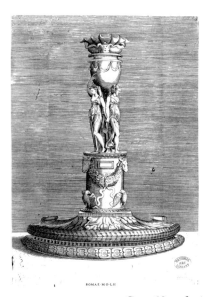

Cat. 62a pl. 1

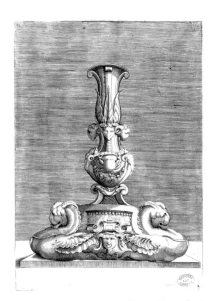

Cat. 62a pl. 2

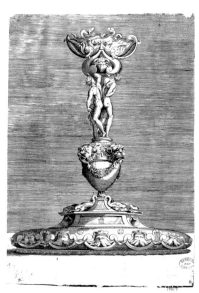

Cat. 62a pl. 3

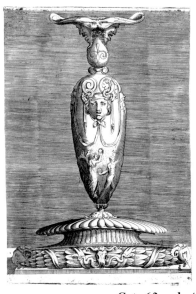

Cat. 62a pl. 4

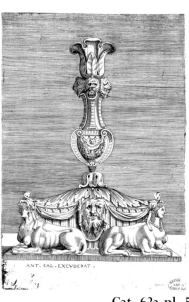

Cat. 62a pl. 5

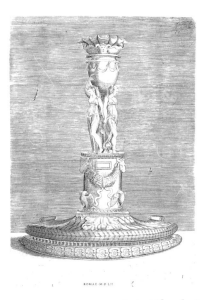

Cat. 62b pl. 1

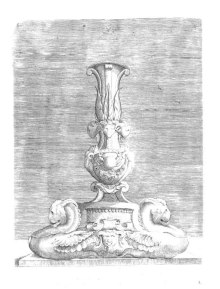

Cat. 62b pl. 2

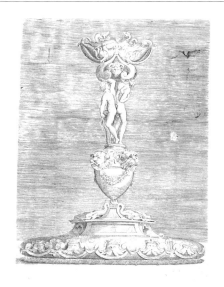

Cat. 62b pl. 3

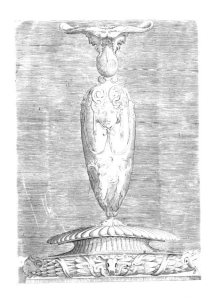

Cat. 62b pl. 4

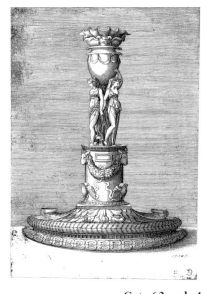

Cat. 62c pl. 1

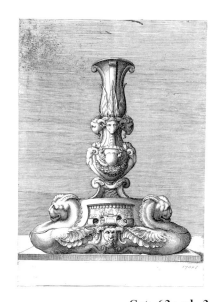

Cat. 62c pl. 2

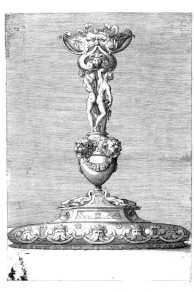

Cat. 62c pl. 3

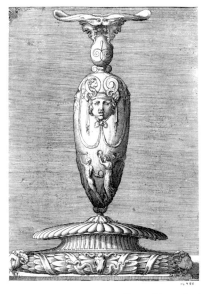

Cat. 62c pl. 4

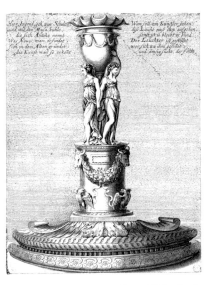

Cat. 62d pl. 1

Catalogue 62: PLATE DESCRIPTIONS

Plate 1

(a) Candlestick with two caryatids (B. XV, 491 Copy; A. 652.1; E. IX, 39.1.(4474)). Lettered *ROMAE . M.D. LII* and numbered *1*. Cut to 24.9 x 17.8 cm
19014

(a) Other impressions (2).
20024, E.2403-1913

(b) Impression.
E.2094-1899

(c) Impression (B. XV, 491). Cut to 24.9 x 17.8 cm
17347

(c) Another impression.
29460.12

(d) Impression with additional lettering in verse: *Hier, Iugend, geh zur Schule...* Cut to 20.9 x 16.3 cm
13640.2

(d) Another impression.
E.1527.A.117-1885

Plate 2

(a) Candlestick with a crayfish and two chimerical animals (B. XV, 492 Copy; A. 652.2; E. IX, 39.2.(4475)). Numbered *2*. 24.9 x 18.1 cm
19016

(a) Other impressions (2).
20309, 26819

(b) Impression.
E.2095-1899

(c) Impression (B. XV, 492). 24.9 x 17.8 cm
17348

Plate 3

(a) Candlestick with two men supporting a mask (B. XV, 493 Copy; A. 652.3; E. IX, 39.3.(4476)). Numbered *3*. Cut to 25.3 x 18.2 cm
19017

(a) Other impressions (2).
14987, E.2404-1913

(b) Impression.
E.2096-1899

(c) Impression (B. XV, 493). Cut to 25.4 x 18 cm
14887

Plate 4

(a) Candlestick with a faun and a bacchante. The candleholder supported by two bearded masks (B. XV, 494 Copy; A. 652.4; E. IX.39.4.(4477)). Numbered *4*. Cut to 25.5 x 17.7 cm
19018

(a) Another impression. Numbered in ink over the plate number, *16,* and in the lower left-hand corner *XVI.*
29468.3

(b) Impression.
E.2097-1899

(c) Impression (B. XV, 494). 24.8 x 18.2 cm
14986

Plate 5

(a) Candlestick with two sphinxes, and the candleholder in the form of a flower (A. 664.1). Lettered *ANT. SAL. EXCUDEBAT.* 24.9 x 17 cm
19015

Catalogue 63

Plate No.	1	2
63a	☐	☐
63b	☐	☐
63c	☐	☐
63d	☐	☐

SET DESCRIPTIONS

Original plates and reissues

63a Cherubino ALBERTI (1553–1615), engraver. Francesco SALVIATI (1510–63), designer. Plates (2) each of two knives with elaborately modelled handles featuring human, animal and grotesque figures. Italian, 1583. Both plates signed twice on the blades *CA* and lettered with the papal privilege.
Engravings
27974, 29458.23, 29458.24, E.1722-1979

Lit: B. XVII, 171–2; Guilmard, p.294, no. 47; Berlin, 1131; Berliner, 371–2; A. 633; Fuhring, 1989, no. 633; Monbeig Goguel, 109.

NOTES: Ewart Witcombe (p.167, chart B) has shown that the copper plates for these two prints were amongst those inherited by Cherubino Alberti's daughter Caterina. Bartsch refers to impressions before the addition of the papal privilege. The design on the knife on the right in Catalogue 63a, pl. 2, 29458.23, is pricked for transfer.

Reversed copy plates

63b Aegidius SADELER (1570–1629), engraver and publisher. Francesco SALVIATI, designer. Plates (2) of knives. Reversed copies of Catalogue 63a. Prague, 1605. Each lettered *Fra[n]c. Salviat. In.* and *CUM PRIVIL . S.C.M.tis.* Numbered *11* and *12*.
Engravings
12831, 12886, 22728.1, E.836-1916

Lit: Berlin, 1131; Collijn, 122; H. XXI, 387–8–I; A. 633A.

NOTES: According to the Amsterdam catalogue (A. 633A), these impressions are numbered 11 and 12 because Aegidius Sadeler published them along with a set of ten reversed copies of vases by Cherubino Alberti after Polidoro da Caravaggio (see Catalogue 69c). A combined set of this type is in the volume of ornament prints assembled at the beginning of the 17th century, which is now in Stockholm (see Collijn, no. 39, p.33).

63c Aegidius SADELER, engraver. Francesco SALVIATI, designer. Marcus SADELER (1614–60), publisher. Plates (2) of knives. Reversed copies of Catalogue 63a. Reissues of Catalogue 63b. Prague, mid-17th century. With

additional lettering *Marco Sadeler excudit.*

22728.2, 24334.A and B, 25016.7

Lit: H. XXI, 387–8-II; A. 633B.

63d Aegidius SADELER, engraver. Francesco SALVIATI, designer. Plates (2) of knives. Reversed copies of Catalogue 63a. Reissues of Catalogue 63c, with Marcus Sadeler's name removed. Late 17th century.

25079, 26925, 27899.1, 27899.2, 29458.45, E.15-1923

NOTES: Catalogue 63b, c and d are the first, second and third states of this pair of prints.

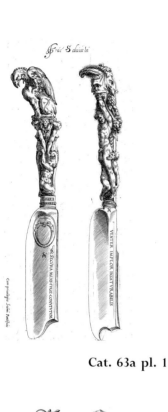

Cat. 63a pl. 1

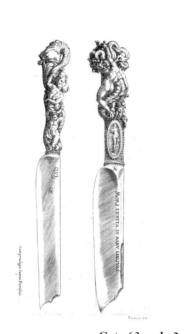

Cat. 63a pl. 2

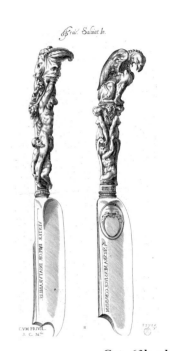

Cat. 63b pl. 1

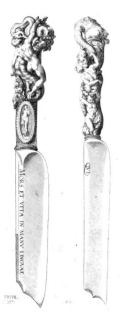

Cat. 63b pl. 2

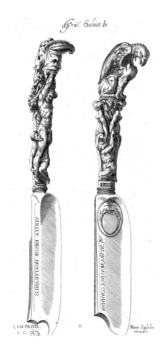

Cat. 63c pl. 1

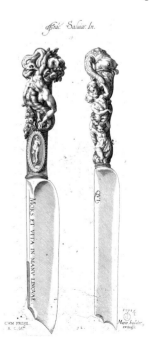

Cat. 63c pl. 2

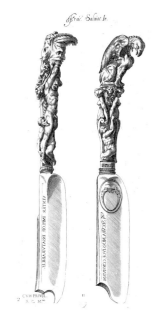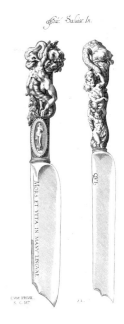

Cat. 63d pl. 1 **Cat. 63d pl. 2**

Catalogue 63: PLATE DESCRIPTIONS

Plate 1

(a) Ornamental knives. On the knife handle on the left, a kneeling man, his arms raised to one of two female terminal figures standing back-to-back above and behind him. They are surmounted by a griffin facing left. On the knife handle on the right, the flaying of Marsyas surmounted by a Janus-like head (B. XVII, 171). Signed in monogram twice .C.A and dated *1583*. Lettered *Frac Salviat. In/Cum priuilegio Sumi Pontificis/SECVRA. MENS.IVGE. CONVIVIVM /VENTER IMPLOR INSATVRA-BILIS*. 25 x 11.8 cm
29458.24

(a) Another impression [cut].
27974

(b) Impression. Dated on the handle of the knife on the right *1605*. Lettered *Frac. Salviat. In. /CVM PRIVIL. S.C.M.tis*. Lettered in reverse *SECVRA. MENS. IVGE.CONVIVIVM./VENTER IMPLOR INSATVRABILIS.* Numbered *11*. 25.2 x 11.7 cm
22728.1

(b) Another impression [cut].
12886

(c) Impression, with additional lettering *Marco Sadeler excudit*.
25016.7

(c) Another impression. Numbered *18* [cut].
24334.A

(d) Impression. 25.1 x 11.8 cm
25079

(d) Other impressions (4)
26925, 27899.1, 29458.45, E.15-1923

Plate 2

(a) Ornamental knives. On the knife handle on the left, a child raising his hands to the waist of a woman, who is being kissed by a monster with a human head on a snake-like neck rising from a female torso. On the knife handle on the right, a standing female figure in a cartouche, surmounted by a man struggling with a grotesque serpent (B. XVII, 172). Signed in monogram twice .C.A. Lettered *Cum priuilegio Summi Pontificis/QVI/MORS ET VITA IN MANV LINGVAE.* 25.2 x 11.5 cm
29458.23

(a) Another impression.
E.1722-1979

(b) Impression. Lettered *PRIVIL. S.C.M.tis./QVI/MORS ET VITA IN MANV LINGVAE*. Numbered *12*. Cut to 22.4 x 9.4 cm
12831

(b) Another impression [trimmed].

E.836-1916

(c) Impression with additional lettering *Marco Sadeler excudit*. [damaged and cut].

22728.2

(c) Another impression with the plate number partially removed.

24334.B

(d) Impression.

27899.2

TAPESTRIES

Catalogue 64

Plate No. | 1 | 3
64a
64b

SET DESCRIPTIONS

Original plates and reissues

64a MASTER of the DIE (c. 1512–70), engraver. RAPHAEL (1483–1520), designer. Giovanni ORLANDI (active 1590–1640), publisher. Plate from a set of four designs for tapestries, known as the *giochi di putti*. Reissue of B. XV, 34. Italian, Rome, 1602. Signed, dated and lettered.
Engraving
E.4316-1919

Lit: B. XV, 34; Guilmard, p.287, no. 18; Bernini Pezzini *et al.*, p.138, no. 3b; E. VII, 22.3. (2937).

64b MASTER of the DIE, engraver. RAPHAEL, designer. Giovanni Giacomo de ROSSI (active 1638–84), publisher. Plate from a set of four designs for tapestries, known as the *giochi di putti*. Reissue of B. XV, 32. Reissue of Catalogue 64a. Italian, Rome, 1655. Signed, dated and lettered.
Engraving
E.1156-1926

Lit: Guilmard, p.287, no. 18; Bernini Pezzini *et al.*, p.137, no. 1d; Byrne, 1981, no. 44; Jean-Richard, 151; E. VII, 22.1. (2935).

NOTES: These prints originally date from 1532. They relate to tapestries from a set commisioned by Leo X (whose lion insignia is seen in plate 1), intended for the Sala di Constantino in the Vatican. Vasari attributed the designs to Giovanni da Udine and there also exist a number of later drawings for the series by Tommaso Vincidor (including one in the Victoria and Albert

Museum, see Ward-Jackson, p.415). The four engravings are however included in the catalogue *Raphael Invenit* (Bernini Pezzini *et al.*, p.138).

Bartsch (B. XV, 32–5) describes all four prints in the set as bearing Antonio Lafrery's name but mentions rare impressions without lettering. The Lafrery impressions correspond to the entry *Quattro festoni di Raf.* in Lafrery's stocklist of c. 1573 (Ehrle, p.57). The above impressions represent later reissues of the plates by two subsequent publishers, Giovanni Orlandi and Giovanni Giacomo de Rossi.

They are mentioned in a manuscript inventory of the de Rossi publishing firm in 1653. By 1735 they were listed amongst the prints after Raphael in the de Rossi *Indice* and had been linked to a fifth plate as '*Scherzi di putti con festoni, e diversi animali negli arazzi piccoli delle Camere Vaticane, intagliati a bulino da Giulio Bonasoni[sic], libro in 5. mezzi fogli reale per traverso bajocchi 30*' (see Grelle Iusco, pp.276–7, 465). The fifth plate may have been another scene of playing putti, this time without a festoon by the Master of the Die, since it is also known in a state published by Giovanni Orlandi and dated 1602 (B. XV, 30; Bernini Pezzini *et al.*, p.138, no. 5).

The impressions in the Escorial catalogue are from the edition published by Antonio Lafrery.

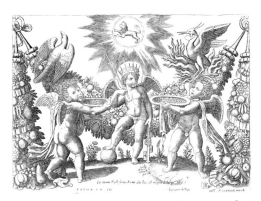

Cat. 64a pl. 3

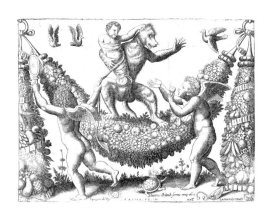

Cat. 64b pl. 1

Catalogue 64: PLATE DESCRIPTIONS

Plate 1

(b) Two putti presenting cups full of gold to the god of Riches (B. XV, 32). Signed in monogram *B* on a die. Dated *1655*. Lettered *RAPHA .VR. IN./ANT LAFRERII. FORMIS/Gio: Iacomo Rossi formis Romae alla Pace all insegna di Parigi* [over erased lettering]/ *Tapezzerie del Papa.* 21 x 28.5 cm

E.1156-1926

Plate 3

(a) Two putti mocking a monkey (B. XV, 34). Signed in monogram *B* on a die. Dated *1602*. Lettered *.RAPHA .VR. IN./ANT LAFRERII. FORMIS/Ioannes Orlandi formis rome./Tapezzerie del Papa.* 20.8 x 28.3 cm

E.4316-1919

VASES AND EWERS

Catalogue 65

Plate No.

PLATE DESCRIPTION

Original plates and reissues

65 Giovanni Antonio da BRESCIA? (active 1490s–first quarter of 16th century), engraver. Vase and tripod. Italian, c. 1515.
Engraving. 12.1 x 14.1 cm
E.2232-1920

Lit: Hind V, no. 65; TIB 2511.064.

NOTES: Hind placed this print under Giovanni Antonio da Brescia's name 'for convenience, rather than through conviction'. He lists two known impressions, noting that the other impression, in Hamburg, lacks the tripod.

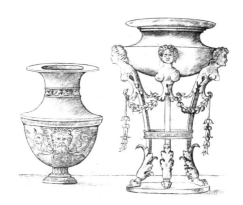

Cat. 65

Catalogue 66

Plate No.	1	2	3	4	7	8	9	10	11	12
66a	☐	☐	☐	☐	☐	☐	☐	☐	☐	☐
66b			☐					☐		
66c			☐							

SET DESCRIPTIONS

Original plates and reissues

66a Agostino VENEZIANO (c. 1490–c. 1540), engraver. Antonio SALA-MANCA (c. 1500–62), publisher. Plates (10) from a set of twelve vases. Reissues of B. XIV, 541–4-I and 547–52-I. Italian, 1531–3. Each signed in monogram, and lettered with the publisher's name and the title.
Engravings
16837–16846

Lit: B. XIV, 541–4-II, 547–52-II; Guilmard, p.285, no. 16; Jessen, 35; Berlin, 1121; A. 644.A; Fuhring, 1989, no. 644; E. VIII, 51.1–4, 7–12.(3214–17, 3220–5).

NOTES: Bartsch describes a state of these prints before the addition of Salamanca's name, and impressions of this type for all, except B. XIV, 543, are shown in *The Illustrated Bartsch*.

Reversed copies

66b ANONYMOUS, engraver. Plates (2) of vases. Reversed copies of B. XIV, 543 and 550, Catalogue 66a, pl. 3 and 10. Italian, mid-16th century. Both lettered with title.
Engravings
29456.48, 29470.7

66c Georg Christoph EIMMART (1638–1705), engraver. Plate of a vase from J. von Sandrart's *Teutsche Academie der Edlen Bau-Bild-und Mahlerey-Künste*, 3 vols, Nuremburg, 1675–9. Reversed copy after Catalogue 66a, pl.3. Lettered with four lines of verse, beginning *Götter, so die blinden...* German, 1675–9.
Engravings
13640.1, E.1527.A.116-1885

Lit: Fuhring, 1989, no. 650.

NOTES: The plate numbering follows the order in Bartsch's, omitting those images of which the V&A collection has no impression.

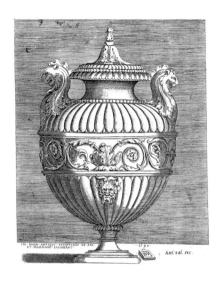

Cat. 66a pl. 1

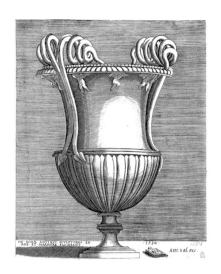

Cat. 66a pl. 2

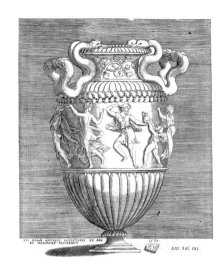

Cat. 66a pl. 3

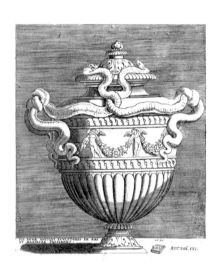

Cat. 66a pl. 4

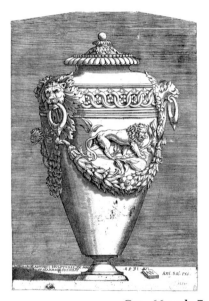

Cat. 66a pl. 7

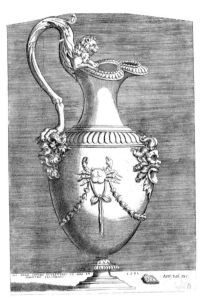

Cat. 66a pl. 8

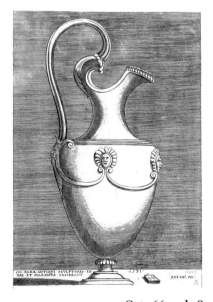

Cat. 66a pl. 9

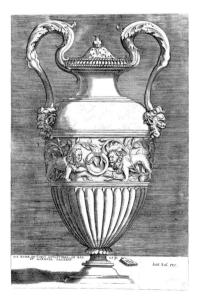

Cat. 66a pl. 10

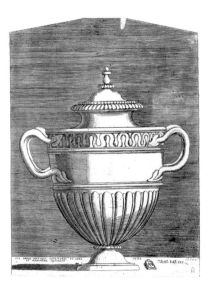

Cat. 66a pl. 11

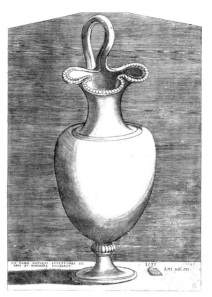

Cat. 66a pl. 12

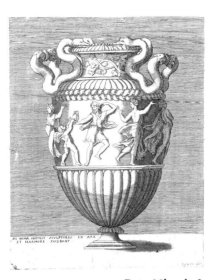

Cat. 66b pl. 3

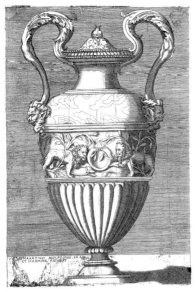

Cat. 66b pl. 10

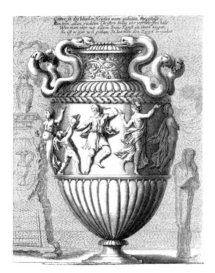

Cat. 66c pl. 3

Catalogue 66: PLATE DESCRIPTIONS

Plate 1

(a) Vase with two lions' heads; on the body a frieze of scrolling foliage with a male mask below (B. XIV, 541-II; E. VIII, 51.1.(3214)). Signed in monogram .*A.V.* and dated .*1530*. Lettered *Ant. sal. exc./SIC. ROMAE. ANTIQVI. SCVLPTORES. EX. AERE. ET. MARMORE. FACIEBANT.* Cut to 21.4 x 16.9 cm

16837

Plate 2

(a) Vase with two handles, in the form of coils and with winged putti at regular intervals below the rim (B. XIV, 542-II; E. VIII, 51.3.(3216)). Signed in monogram .*A.V.* and dated .*15.30*. Lettered *Ant. sal. exc./SIC. ROMAE. ANTIQVI. SCVLPTORES. EX. AERE. ET. MARMORE. FACIEBANT.* Cut to 20 x 16.7 cm

16838

Plate 3

(a) Vase with two handles, each formed by two serpents whose tails are joined by foliage; on the body four dancing figures and a winged cupid (B. XIV 543-II; E. VIII, 51.2.(3215)). Signed in monogram *.A.V.* and dated *1530*. Lettered *Ant. sal. exc./SIC. ROMAE. ANTIQVI. SCVLPTORES. EX. AERE. ET. MARMORE. FACIEBANT.* Cut to 20.2 x 17.1 cm

16839

(b) Impression. Lettered *SIC. ROMAE. ANTIQVI. SCVLP-TORES. EX. AERE ET MARMORE FACEBANT.* Cut to 21.8 x 17.4 cm

29456.48

(c) Impression with additional pictorial background and German letterpress on the back. Lettered *Götter, so die blinden...* 19.7 x 16 cm

13640.1.

(c) Another impression.

E.1527.A.116-1885

Plate 4

(a) Vase with two handles, each formed by two inter-twined serpents; on the body two winged putti supporting festoons of foliage (B. XIV. 544-II; E. VIII, 51.4.(3217)). Signed in monogram *.A.V.* and dated *1530*. Lettered *Ant. sal. exc./SIC. ROMAE. ANTIQVI. SCVLPTORES. EX. AERE. ET. MARMORE. FACIEBANT.* Cut to 23.3 x 17.2 cm

16840

Plate 7

(a) Vase with two rings held in lions' mouths as handles; on the body a lion standing on laurel branches above a large festoon of foliage (B. XIV, 547-II; E. VIII, 51.7.(3220)). Signed in monogram *.A.V.* and dated *.1531*. Lettered *Ant. Sal. exc./SIC. ROMAE. ANTIQVI. SCVLPTORES. EX. AERE ET MARMORE FACIEBAT.* Cut to 25 x 17.3 cm. [The top of the plate angled at each side.]

16841

Plate 8

(a) Ewer with one handle on the left; at the top of the handle a lion's head and, at the bottom, a mask; on the body a crab supporting festoons (B. XIV, 548-II; E. VIII, 51.8.(3221)). Signed in monogram *.A.V.* and dated *.1531*. Lettered *Ant. sal. exc./SIC. ROMAE. ANTIQVI. SCVLPTORES. EX. AERE. ET. MARMORE. FACIEBANT.* Cut to 25.3 x 16.9 cm. [The top of the plate angled at each side.]

16842

Plate 9

(a) Ewer with one handle on the left; on the body three masks (B. XIV, 549-II; E. VIII, 51.9. (3222)). Signed in monogram *.A.V.* and dated *.1531*. Lettered *Ant. sal. exc./SIC. ROMAE. ANTIQVI. SCVLPTORES. EX. AERE. ET. MARMORE. FACIEBANT.* Cut to 25.9 x 18.5 cm

16843

Plate 10

(a) Vase with two handles; on the body a ring between two lions (B. XIV, 550-II; E. VIII, 51.10.(3223)). Signed in monogram *AV* and dated *1531*. Lettered *Ant. sal. exc./SIC. ROMAE. ANTIQVI. SCVLPTORES EX. AERE ET. MARMORE. FACIEBAT.* Cut to 26.8 x 18.1 cm

16844

(b) Impression. Lettered *SIC ROMAE. ANTIQVI. SCVLP-TORES. EX. AERE ET. MARMORE. FACIEBAT.* Cut to 26.1 x 18.4 cm

29470.7

Plate 11

(a) Vase with a lid and two handles, each with spade-shaped terminals (B. XIV, 551-II; E. VIII, 51.11.(3224)). Signed in monogram *.A.V* and dated *.1531*. Lettered *Ant. sal. exc/SIC. ROMAE. ANTIQVI. SCVLTORES. EX. AERE.ET. MARMORE. FACIEBAT.* Cut to 23 x 17.6 cm. [The top of the plate angled at each side.]

16845

Plate 12

(a) Ewer with one handle hidden by the body (B. XIV, 552-II; E. VIII, 51.12.(3225)). Signed in monogram *.A.V.* and dated *1531*. Lettered *Ant. sal. exc./SIC. ROMAE. ANTIQVI. SCVLPTORES. EX. AERE. ET. MARMORE. FACIEBANT.* Cut to 23.7 x 17.3 cm. [The top of the plate angled at each side.]

16846

Catalogue 67

Plate No.	1	2	3	4	5	6	7	8
67a	□	□	□	□	□	□		
67b							□	□

SET DESCRIPTIONS

Original plates and reissues

67a Leonardo da UDINE (active 1539–44), engraver. Polidoro da CARAVAGGIO (1499–1543?) and ANONYMOUS, designers. Plates (6) from a set of eleven vases decorated with masks, swags, putti, gadrooning and figured scenes. Italian, Rome, 1539–44. Plates 1, 2 and 3 signed in monogram. Each dated and lettered with title.
Engravings
14889, 19031–19033, 26051–26052, 28263.72, 28612.A

Lit: Nagler Mon IV, no. 1399; Berlin, 1124; Berliner, 367.

Reversed copy plates

67b ANONYMOUS, engraver. Polidoro da CARAVAGGIO and ANONYMOUS, designers. Plates (2) of vases, reversed copies of Catalogue 67a. Italian, mid-16th century.
Engravings
13222, 19030, 19034, 23178

Lit: A. 661; Fuhring, 1989, no. 638; E. IX, 32.1.(4425) as Enea Vico.

NOTES: The Berlin catalogue compares these prints to the vases of Agostino Veneziano, Catalogue 66a. Berliner (1981, p.53, no. 367) attributes plate 4 to Enea Vico. The set of eleven prints in Berlin was amongst those prints in that collection which were destroyed in the Second World War. There are three plates – here numbered 5, 6 and 7 – inspired by Polidoro da Caravaggio's painted grisaille vases on the façade of the Palazzo Milesi, Rome, illustrated in Maccari (pl. 37). For another series of designs inspired by the same source, see Catalogue 69b by Cherubino Alberti.

The plates that are signed with the monogram LV are described first and numbered in date order. The plates bearing the same inscription without a monogram are then described in date order. The unlettered reversed copy plates come last.

An impression of plate 3, without the engraver's monogram, is in the Escorial collection listed under Enea Vico, E. IX, 32.4.(4428).

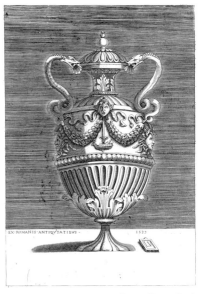

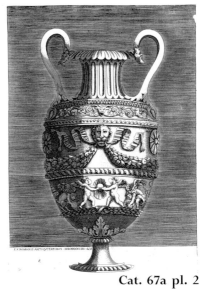

Cat. 67a pl. 2

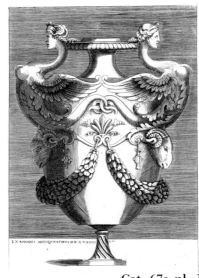

Cat. 67a pl. 3

Cat. 67a pl. 1

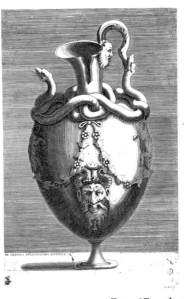

Cat. 67a pl. 4

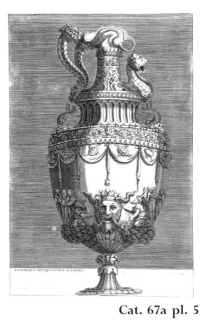

Cat. 67a pl. 5

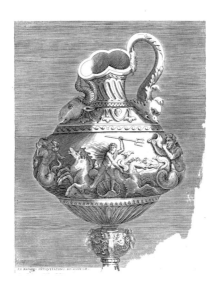

Cat. 67a pl. 6

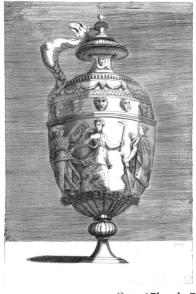

Cat. 67b pl. 7

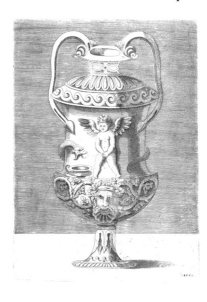

Cat. 67b pl. 8

Catalogue 67: PLATE DESCRIPTIONS

Plate 1

(a) Vase with two snake handles, and festoons, masks and fluting on the body. Signed in monogram *LV* and dated *1539*. Lettered *EX. ROMANIS. ANTIQVITATIBVS.* Cut to 25.3 x 17.9 cm

19032

Plate 2

(a) Vase with two handles; on the body a lion's mask, festoons and winged putti. Signed in monogram *L.V.* Dated *.M.D. XXXXIIII.* Lettered *EX ROMANIS ANTIQVI-TATIBVS.* 26.7 x 18.5 cm

28612.A

Other impressions (2).

26051 [damaged], 28263.72

Plate 3

(a) Vase with two sphinx handles, festoons and rams' heads on the body. Signed in monogram. *L.V.* Dated *.M.D. XXXXIIII.* Lettered *EX ROMANIS ANTIQVITATIBVS.* Cut to 27 x 19 cm

19033

Plate 4

(a) A ewer with a snake handle, and a satyr's mask and a festoon of flowers on the body (Berliner, 367). Dated *M.D.XXXXII.* Lettered *EX ROMANIS ANTIOVITATIBVS.* Cut to 26.7 x 17.3 cm

14889

Plate 5

(a) A ewer with a double cornucopia handle, and on the body festoons with a satyr mask and a figure scene. Dated *MD XXXXII.* Lettered *EX ROMANIS ANTIQVITATI-BVS.* Cut to 26.4 x 17.8 cm

19031

Plate 6

(a) A ewer with a dolphin handle. A sea battle with Neptune and tritons on the body. Dated *MD.XXXXIIII.* Lettered *EX ROMANIS ANTIQVITATIBVS.* Cut to 23 x 18.2 cm

26052

Plate 7

(b) A ewer with a griffin handle, and on the body masks and a scene with three figures (E. IX, 32.1. (4425)). 26.7 x 18.4 cm

19034

Plate 8

(b) A vase with handles terminating in leaf shapes; on the body a snake and a winged putto urinating into a basin (A. 661). 25 x 18.4 cm

13222

Other impressions (2).

19030, 23178

Catalogue 68

Plate No.	I	II	III	IIII	V	VI	VII	VIII	VIIII	X	XI	XII	XIII	XIIII
68a		☐	☐	☐		☐	☐	☐	☐	☐	☐	☐	☐	
68b	☐	☐	☐	☐	☐	☐	☐	☐	☐	☐	☐	☐	☐	☐
68c				☐									☐	
68d		☐			☐									
68e			☐		☐	☐						☐		

SET DESCRIPTIONS

Original plates and reissues

68a Enea VICO (1523–67), engraver. Plates (11) of vases. Plates subsequently numbered *II–IIII* and *VI–XIII* in Catalogue 68b. Italian, 1543.
Engravings
16847–16857, E.829-1888

Lit: B. XV, 421–2, 424–7, 429–33; Berlin, 1125; Byrne, 123; Jean-Richard, 152; A. 650; Fuhring, 1989, no. 650.

Original plates and reversed copy plates

68b Enea VICO and ANONYMOUS, engravers. Antonio LAFRERY (1512–77), publisher. Plates (14) of vases. Reissue of Catalogue 68a numbered and with two additional plates (plates I and XIIII), reversed copies of Agostino Veneziano, B. XIV, 547, and 546. Italian, c. 1573, first published mid-16th century. Plates III and X signed in monogram *E.V.* Plates II, IV–IX, XIII signed in monogram *AEV* on a tablet. Plates II–XIII dated *M.D. XXXXIII*. Plates I and XIIII lettered *SIC ROMAE ANTIQVI SCVLPTORES EX AERE ET MARMORE FACIEBANT*. Plates II–XIII lettered *ROMAE AB ANTIQVO REPERTVM*. Numbered *I –XIIII*.
Engravings
17243–17244, 25928.C, 26773, 29470.8, E.1527.A.94-1885, E.598-1888, E.825–826-1888, E.830–831-1888, E.2012–2025-1899

Lit: B. XV, 420–33; Guilmard, p.289, no. 24; Berlin, 1125; A .650; Miller.

68c Enea VICO, engraver. Plates (2) of vases. Reissues of Catalogue 68b, pl. IIII and XIII, B. XV, 430, 433, with additional numbering. Italian, late 16th century.
E.824-1888, E.827-1888

68d Enea VICO, engraver. Plates (2) of vases. Reissue of Catalogue 68b, pl. II and V, B. XV, 421, 423. Italian, late 16th century. The plates reduced, removing the Roman numerals.
28860.30, E.828-1888

Reversed copy plates

68e ANONYMOUS, engraver. Plates (4) of vases. Reversed copies after Catalogue 68a, pl. III, V, VI, XII. Italian, second half of the 16th century. Engravings
16858, 16859, E.1527.A.93-1885, E.832-1888

Lit: Ferrara and Bertelà, 605, 607, 609; Fuhring, 1989, no. 650.

NOTES: The impressions of Catalogue 68b numbered E.2012–2025-1899 form part of the Lafrery Volume (see Introduction) and correspond to the first part of the entry *Libro de uasi et candelieri* in Lafrery's stocklist of c. 1573 (Ehrle, p.59). The order of the description of the plates given below follows the numbering on these impressions, rather than that given in Bartsch.

Plates I and XIIII of Catalogue 68b are unsigned, reversed copies (including the lettering) of Agostino Veneziano, B. XIV, 547, 546. The two Agostino Veneziano plates are part of a set of twelve, B. XIV, 541–52 (see Catalogue 66a). (An impression of B. XIV, 547 is in the V&A collection, Catalogue 66a, plate 7, museum number 16841, but no impression of B. XIV, 546.)

Catalogue 68b is thus made up of twelve plates of vases signed in monogram by Enea Vico, sandwiched between unsigned, reversed copies of vases by Agostino Veneziano. Given the status of plates I and XIIII as reversed copies and the style of their engraving, it seems probable that they are not by Enea Vico. The copy plates at the beginning and end of the set might lead the unwary purchaser into thinking that they were in fact buying the Agostino Veneziano set.

Fuhring (1989, no. 650) points out that the unnumbered edition Catalogue 68a precedes the numbered edition.

A skinned area of Catalogue 68a, pl. III, museum number 16848, has been patched with a small piece of an impression of Catalogue 68b, pl. VIIII, incorporating both cross-hatching and the numbers *XIII* from the end of the date.

An edition of Catalogue 68b published by Petrus de Nobilibus is in the Escorial collection, E. IX, 31.1–14.(4411–24).

See T.L. Rebanks writing in Holman (no. 12A, B and C) for a discussion of plates 4, 11 and 13 of Catalogue 68b. She points out that this and earlier sets of vase prints, such as Catalogue 66a and Catalogue 67a, combine elements of genuine antique vases with other features invented by the print-makers and draws a parallel between this practice and the restoration of antique sculpture carried out during the Renaissance. Plate III Catalogue 68b seems to borrow parts of the handle, the crab and the horned satyr's mask transposed from the bottom to the top of the handle from Catalogue 66a, pl. 8.

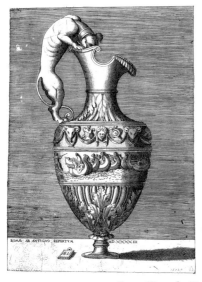

Cat. 68a pl. II

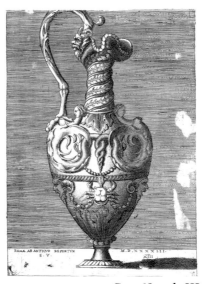

Cat. 68a pl. III

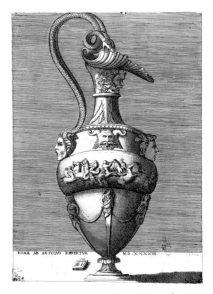

Cat. 68a pl. IIII

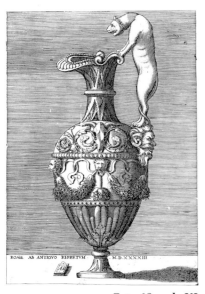

Cat. 68a pl. VI

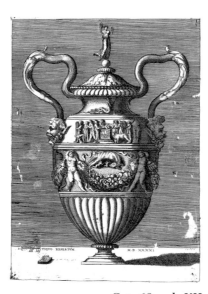

Cat. 68a pl. VII

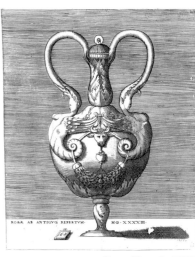

Cat. 68a pl. VIII

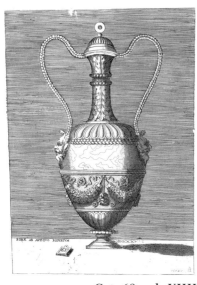

Cat. 68a pl. VIIII

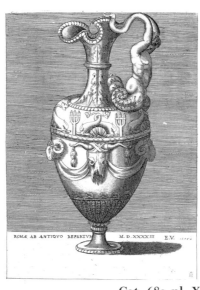

Cat. 68a pl. X

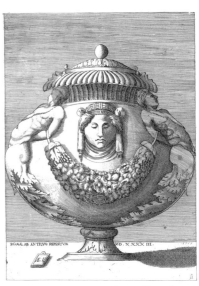

Cat. 68a pl. XI

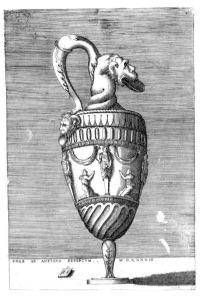

Cat. 68a pl. XII

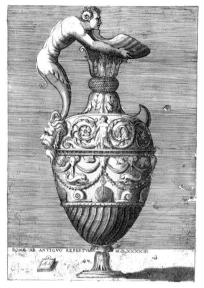

Cat. 68a pl. XIII

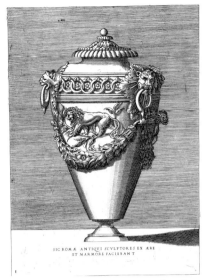

Cat. 68b pl. I

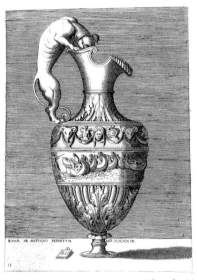

Cat. 68b pl. II

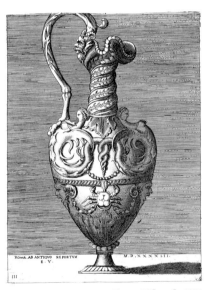

Cat. 68b pl. III

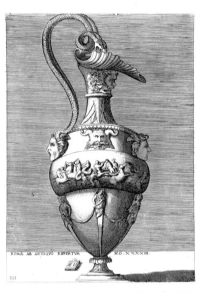

Cat. 68b pl. IIII

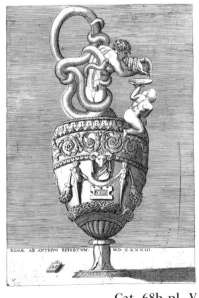

Cat. 68b pl. V

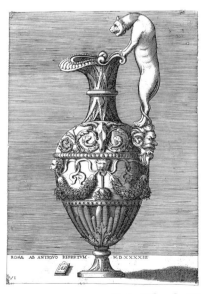

Cat. 68b pl. VI

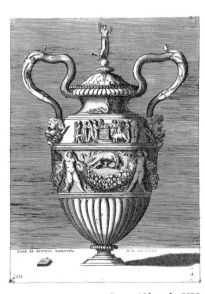

Cat. 68b pl. VII

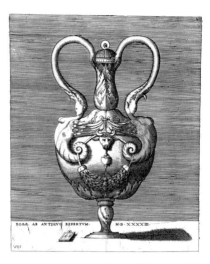

Cat. 68b pl. VIII

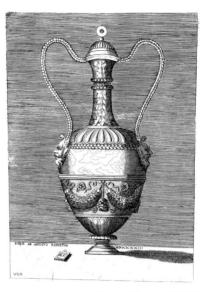

Cat. 68b pl. VIIII

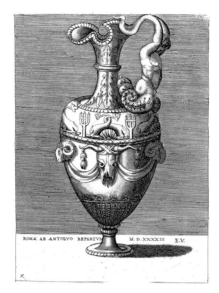

Cat. 68b pl. X

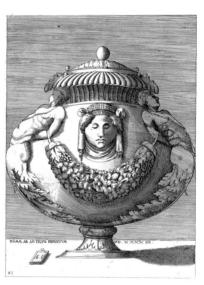

Cat. 68b pl. XI

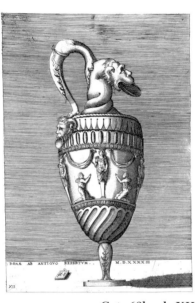

Cat. 68b pl. XII

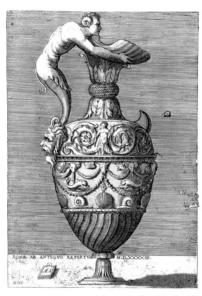

Cat. 68b pl. XIII

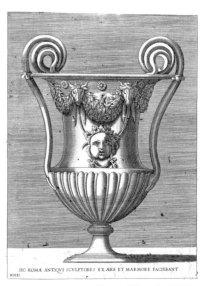

Cat. 68b pl. XIIII

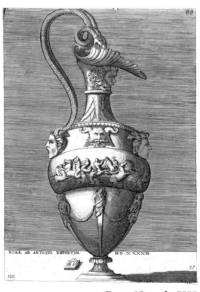

Cat. 68c pl. IIII

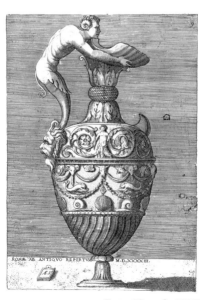

Cat. 68c pl. XIII

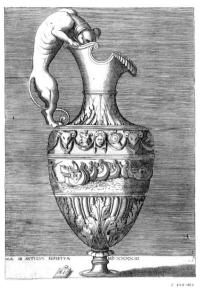

Cat. 68d pl. II

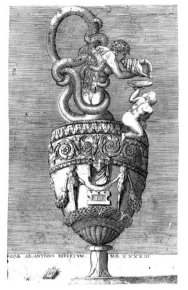

Cat. 68d pl. V

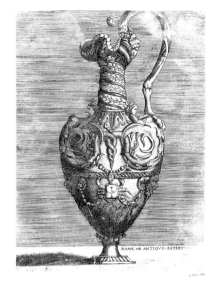

Cat. 68e pl. III

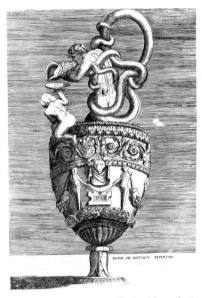

Cat. 68e pl. V

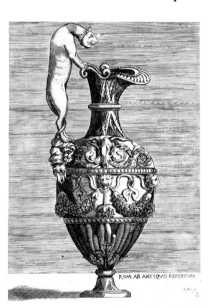

Cat. 68e pl. VI

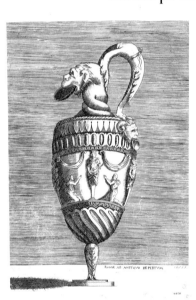

Cat. 68e pl. XII

Catalogue 68: PLATE DESCRIPTIONS

Plate I

(b) Vase with lions' heads, each with a ring in its mouth; on the body a lion facing left above a festoon (B. XV, 420). Lettered *SIC ROMAE ANTIQVI SCVLP-TORES EX AERE ET MARMORE FACIEBANT*. Numbered *I*. 28.5 x 20.8 cm
E.2012-1899

(b) Another impression [cut and damaged].
29470.8

Plate II

(a) Ewer with a handle in the shape of a dog; on the body a flotilla (B. XV, 421). Signed in monogram *AE.V.* Dated *M.D.XXXXIII*. Lettered *ROMAE AB ANTIQVO REPERTVM*. Cut to 26.5 x 19.7 cm
16847

(b) Impression. Numbered *II*. 27.1 x 19.8 cm
E.2013-1899

(d) Impression. Cut to 24.5 x 17.9 cm
E.828-1888

Plate III

(a) Ewer with a handle in the shape of an eagle's talons; on the body of the ewer, a crab (B. XV, 422). Signed in monogram *E.V.* Dated *M.D.XXXXIII*. Lettered *ROMAE AB ANTIQVO REPERTVM*. 24.2 x 18.2 cm
16848

(b) Impression. Numbered *III*. 24.3 x 18.1 cm
E.2014-1899

(b) Another impression.
E.598-1888

(e) Impression (Ferrara and Bertelà, 605). Lettered *ROMAE AB ANTIQVO. REPERTVM*. Cut to 23.7 x 17.9 cm
E.832-1888

Plate IIII

(a) Ewer with a bas-relief; on the body a scene with mounted tritons and sirens (B. XV, 430). Signed in monogram *AEV*. Dated *M.D.XXXXIII*. Lettered *ROMAE AB ANTIQVO REPERTVM*. Cut to 26.5 x 19.4 cm
16854

(b) Impression. Numbered *IIII*. 26.7 x 20 cm
E.2015-1899

(c) Impression. Also numbered *75* and *88*.

E.824-1888

Plate V

(b) Ewer with a man entwined by snakes blowing a conch; in front of him a child holding a bowl (B. XV, 423). Signed in monogram *AE.V.* Dated *M.D.XXXXIII*. Lettered *ROMAE AB ANTIQVO REPERTVM*. Numbered *V*. 28.3 x 19.5 cm
E.2016-1899

(b) Other impressions [cut].
E.825-1888

(d) Impression. Cut to 27.1 x 16.9 cm
28860.30

(e) Impression (Ferrara and Bertelà, 607). Lettered *ROMAE AB ANTIQVO REPERTVM*. Cut to 27 x 18.4 cm
E.1527.A.93-1885

Plate VI

(a) Ewer with a handle on the right in the shape of a panther standing on his hind legs (B. XV, 424). Signed in monogram *AE.V.* Dated *M.D.XXXXIII*. Lettered *ROMAE AB ANTIQVO REPERTVM*. Cut to 25.7 x 18.9 cm.
16849

(b) Impression. Numbered *VI*. 26.2 x 19.1 cm
E.2017-1899

(e) Impression (Ferrara and Bertelà, 609). Lettered *ROME AB ANTIQVO REPERTVM*. Cut to 25.1 x 17.9 cm
16859

Plate VII

(a) Vase with a pagan sacrifice and the Capitoline wolf (B. XV, 431). Signed in monogram *AE.V.* Dated *M.D.XXXXIII*. Lettered *ROMAE. AB. ANTIQVO. REPERTUM*. Cut to 27.1 x 20.5 cm [damaged]
16855

(b) Impression. Numbered *VII*. 27.3 x 20.5 cm
E.2018-1899

Plate VIII

(a) Vase with the head of a bull and two handles (B. XV, 425). Signed in monogram *AE.V.* Dated *M.D.XXXXIII*. Lettered *ROMAE AB ANTIQVO REPERTVM*. Cut to 24.8 x 20.4 cm
16850

(b) Impression. Numbered *VIII*. 28.4 x 20.7 cm
E.2019-1899

(b) Another impression [cut].
E.831-1888

Plate VIIII

(a) Vase with two grotesque masks from which rise the handles in the form of braided hair (B. XV, 426). Signed in monogram *AE.V.* Dated *M.D.XXXXIII*. Lettered *ROMAE AB ANTIQVO REPERTVM*. Cut to 26.5 x 18.9 cm.
16851

(b) Impression. Numbered *VIIII*. 27.1 x 20 cm
E.2020-1899

(b) Another impression [cut].
E.830-1888

Plate X

(a) Ewer with a figure, scrolling foliage and dolphins. The handle formed by a man terminating in scrolling foliage; on the body, dolphins interspersed with tridents (B. XV, 432). Signed in monogram *E.V.* Dated *M.D.XXXXIII.* Lettered *ROMAE AB ANTIQVO REPERTVM.* Cut to 24 x 18 cm
16856

(b) Impression. Numbered *X*. 24.2 x 18.2 cm
E.2021-1899

(b) Another impression [damaged].
26773

Plate XI

(a) Vase with figures, scrolling foliage and festoons; on the body, two male figures terminating in scrolling foliage. Attached to the arms of each is the end of a festoon, above which is a woman's head (B. XV, 429). Signed in monogram *AE.V.* Dated *M.D.XXXXIII.* Lettered *ROMAE AB ANTIQVO REPERTVM.* Cut to 26.2 x 19.5 cm
16853

(b) Impression. Numbered *XI*. 26.7 x 20 cm
E.2022-1899

(b) Other impressions (2).
25928.C, E.826-1888

Plate XII

(a) Ewer with a grotesque head holding a bowl in its mouth; on the body two praying figures adoring a caryatid (B. XV, 427). Signed in monogram *AE.V.* Dated *M.D.XXXXIII.* Lettered *ROMAE AB ANTIQVO REPERTVM.* Cut to 28.3 x 19.8 cm
16852

(a) Another impression.
E.829-1888

(b) Impression. Numbered *XII*. 28.5 x 19.8 cm
E.2023-1899

(b) Other impressions (2).
17243, E.1527.A.94-1885

(e) Impression. Lettered *ROMAE AB ANTIQVO REPERTVM.* Cut to 27.1 x 18.1 cm
16858

Plate XIII

(a) Ewer with a satyr holding a large conch; on the body a siren terminating in scrolling foliage and some festoons interspersed with dolphins (B. XV, 433). Signed in monogram *AE.V.* Dated *M.D.XXXXIII.* Lettered *ROMAE AB ANTIQVO REPERTVM.* Cut to 26.3 x 18.7 cm
16857

(b) Impression. Numbered *XIII*. 26.4 x 18.8 cm
E.2024-1899

(b) Another impression.
17244

(c) Impression. Numbered [7]9 and with the numbers *XIII* and *75* partially erased.
E.827-1888

Plate XIIII

(b) Vase with the heads of bulls and Bacchus (B. XV, 428). Lettered *SIC ROMAE ANTIQVI SCVLPTORES EX AERE ET MARMORE FACIEBANT.* Numbered *XIIII.* 27.4 x 20.5 cm
E.2025-1899

Catalogue 69

Plate No.	Title 1	2	3	4	5	6	7	8	9	10
69a	☐									
69b	☐	☐	☐	☐	☐	☐	☐	☐	☐	☐
69c	☐									
69d	☐	☐		☐	☐	☐	☐	☐	☐	☐
69e	☐	☐	☐	☐	☐		☐	☐	☐	☐
69f	☐	☐	☐	☐	☐	☐	☐	☐	☐	☐
69g		☐	☐		☐	☐	☐	☐	☐	☐

SET DESCRIPTIONS

Original plates and reissues

69a Cherubino ALBERTI (1553–1615), engraver. Polidoro da CARAVAGGIO (1499–1534?), designer. Title plate from a set of ten vases. Italian, Rome, 1582. Lettered with the engraver's name, title, dedication and date. Numbered *I*.
Engraving
17202

Lit: Guilmard, p.294, no. 47; Berlin, 1130; A. 589.1.

69b Cherubino ALBERTI, engraver. Polidoro da CARAVAGGIO, designer. Heirs of Cherubino ALBERTI, publishers. Plates (10) including title plate of a set of vases. Reissues of Catalogue 69a. Italian, Rome, 1628. Title plate lettered with new dedication, new date and name of publishers. Other plates lettered *POLYDORUS DE CARAVAGIO I* (or *IN*) *ROMAE* and signed variously by Alberti and numbered.
13633.11, 17203, 24488, 24792.1–3, 27736.1–8, E.1527.A.75-1885, E.1527.A.76-1885, E.1527.A.78-1885, E.833.A–C-1888, E.833.E-1888, E.833.G–J-1888

Lit: B. XVII, 161–70; A. 589A; Fuhring, 1989, no. 589.

Reversed copy plates

69c ANONYMOUS, engraver. Polidoro da CARAVAGGIO, designer. A vase. Reversed copy of Catalogue 69b, pl. 1. Italian, late 16th century. Lettered with title [cut].
20576.13

Lit: Berliner, 398; Fuhring, 1989, no. 589.

69d Aegidius SADELER (1570–1629), engraver. Polidoro da CARAVAGGIO, designer. Plates (9) including the title plate from a set of ten vases. Reversed copies of Catalogue 69a, pl. 1–2 and 4–10. Prague, 1605. Lettered *POLYDORVS DE CARAVAGIO IN* and on the base *ROMAE, CVM PRIVIL S.C.Mtis.*
13633.1 and 2, 13633.4–10, 28263.68, E.1527.A.81-1885, E.1527.A.82-1885

Lit: Collijn, 39; H. XXI 377–86-I; A. 589.B.

69e Aegidius SADELER, engraver. Polidoro da CARAVAGGIO, designer. Marcus SADELER (1614–60), publisher. Plates (9) including the title plate from a set of ten vases. Reversed copies of Catalogue 69b, plates 1–6 and 8–10. Reissues of Catalogue 69d, with Marcus Sadeler's name added. Prague, mid-17th century.
17204, 20576.1–8, E.833.D-1888, E.833.F-1888

Lit: H. XXI 377–86-II; A. 589.C.

69f Aegidius SADELER, engraver. Polidoro da CARAVAGGIO, designer. Jean François DAUMONT (active c. 1740–75), publisher. Plates (10) including title plate of vases. Reversed copies of Catalogue 69b, plates 1–10. Reissues of Catalogue 69e, with the lettering and numbering mostly removed. Paris, 1740–75. All, except the title plate, unlettered. The title plate numbered.
17267, 20576.9–12, 20576.14–19, 22571.3

Lit: Fuhring, 1989, no. 589A.

69g ANONYMOUS, engraver. Polidoro da CARAVAGGIO, designer. Samuel SYMPSON (active before 1751), publisher. Plates (8) from a set of ten. Reversed copies of Catalogue 69b, plates 2–3 and 5–10. British, London. Second quarter of the 18th century. All, except plate 8, lettered with Sympson's name.
13633.3, 16577–16582, 17205–17206, 28263.67, E.1527.A.77-1885, E.1527.A.79–80-1885

Lit: A. 589.D.

NOTES: Derived from the grisaille façade decoration of the Palazzo Milesi, Rome, designed by Polidoro da Caravaggio (illustrated Maccari, pl. 37 and Clifford, p.285). Ewart Witcombe (p.162) has shown that Alberti's heirs and the inheritors of his copper plates were his three married daughters, Dionora, Francesca and Caterina. Witcombe also demonstrates that the ten vase plates were part of a larger group of thirty-four Alberti plates reprinted in 1628, and that the copper plates for four of the vases (B. XVII, 163, 164, 169, 170, pl. 3, 4, 9 and 10) survive in the Istituto Nazionale per la Grafica, Rome. See Fuhring (1989, no. 589) for an earlier state of Catalogue 69a. For another suite of vases partly derived from the same source, see Catalogue Nos. 67a and b, by Leonardo da Udine. The complete compositions incorporating vases were engraved by Giovanni Battista Galestruzzi in 1660 (see Amsterdam, 588, and Fuhring, 1989, no. 588).

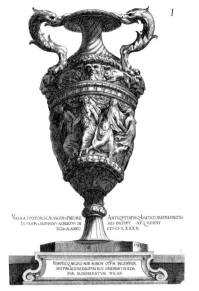

Cat. 69a pl. 1

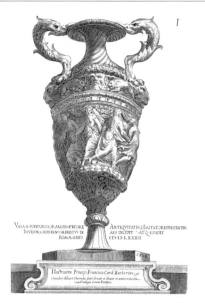

Cat. 69b pl. 1

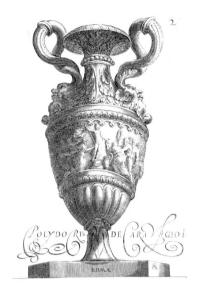

Cat. 69b pl. 2

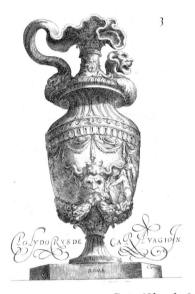

Cat. 69b pl. 3

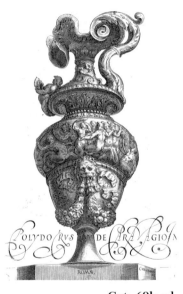

Cat. 69b pl. 4

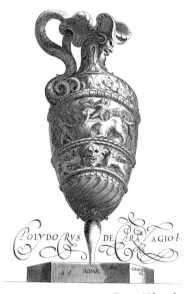

Cat. 69b pl. 5

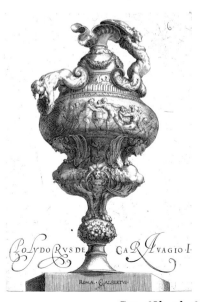

Cat. 69b pl. 6

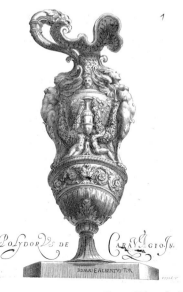

Cat. 69b pl. 7

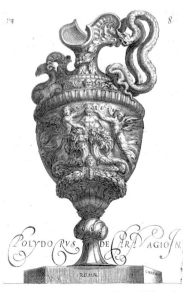

Cat. 69b pl. 8

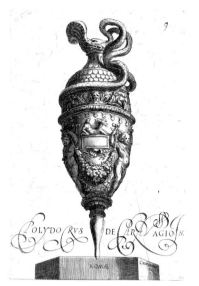

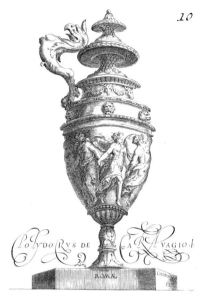

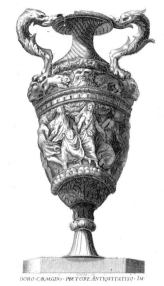

Cat. 69b pl. 9

Cat. 69b pl. 10

Cat. 69c pl. 1

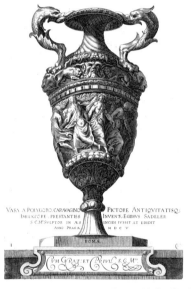

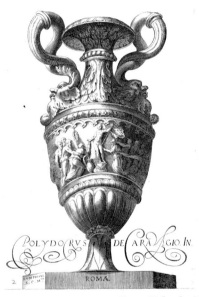

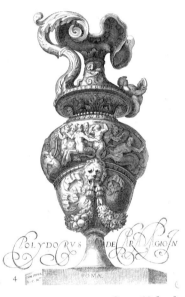

Cat. 69d pl. 1

Cat. 69d pl. 2

Cat. 69d pl. 4

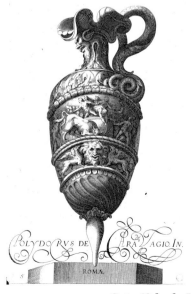

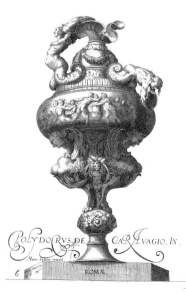

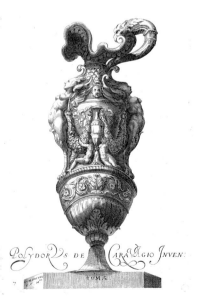

Cat. 69d pl. 5

Cat. 69d pl. 6

Cat. 69d pl. 7

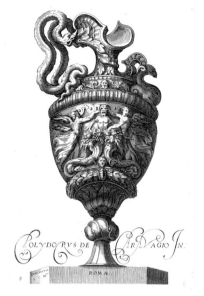

Cat. 69d pl. 8

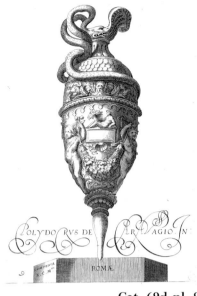

Cat. 69d pl. 9

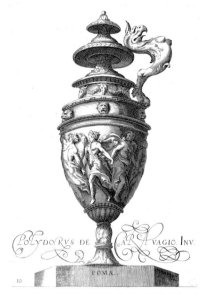

Cat. 69d pl. 10

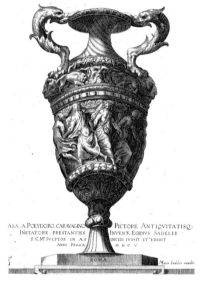

Cat. 69e pl. 1

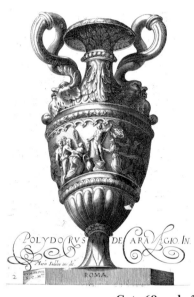

Cat. 69e pl. 2

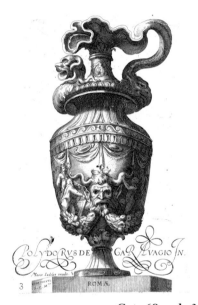

Cat. 69e pl. 3

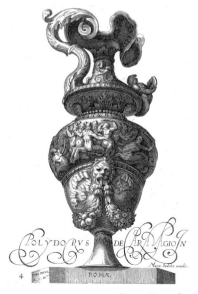

Cat. 69e pl. 4

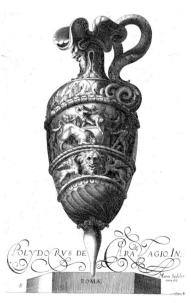

Cat. 69e pl. 5

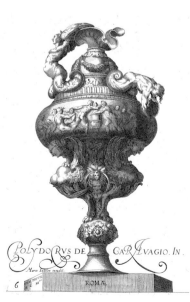

Cat. 69e pl. 6

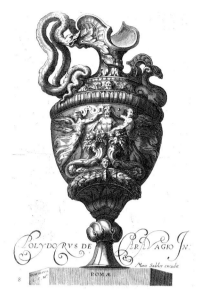

Cat. 69e pl. 8

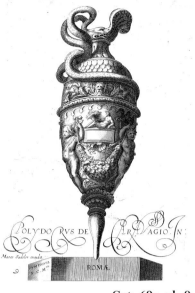

Cat. 69e pl. 9

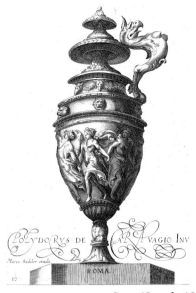

Cat. 69e pl. 10

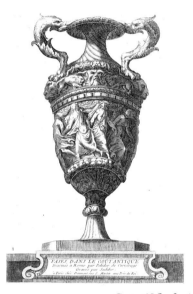

Cat. 69f pl. 1

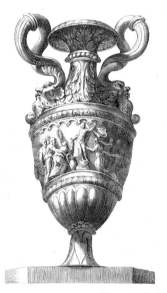

Cat. 69f pl. 2

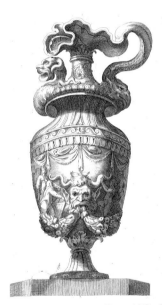

Cat. 69f pl. 3

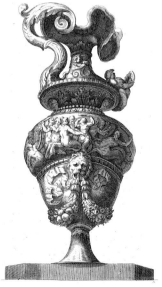

Cat. 69f pl. 4

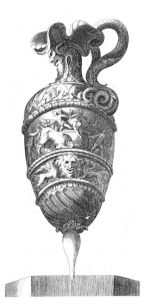

Cat. 69f pl. 5

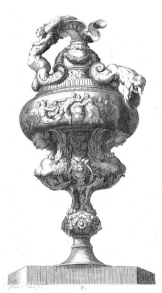

Cat. 69f pl. 6

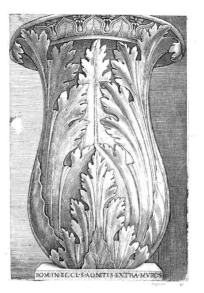

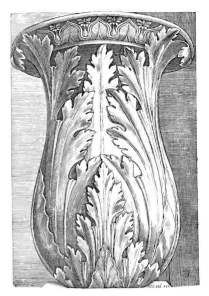

Cat. 70a

Cat. 70b

Catalogue 71

Plate No. | 1 2
☐ ☐

SET DESCRIPTION

Original plates and reissues

71 ANONYMOUS, engraver. Plates (2) of antique altars. Italian, mid-16th century.
Etchings
16798, E.2489-1912

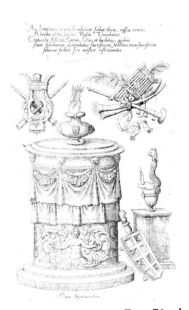

Cat. 71 pl. 1

Cat. 71 pl. 2

Catalogue 71: PLATE DESCRIPTIONS

Plate 1

An antique altar decorated on the front with a figure of Diana of Ephesus and two winged sphinxes. On top of the altar is a pile of fruit and flowers. Above two horns and two branches and to the right, a receptacle on legs containing a knife. Lettered with three lines, beginning *Ara in qua offerebantur frugum*…and *Cornua, quibus Cornicines in Sacris utebantur/Salis receptaculum*. 26.1 x 15.8 cm

16798

Plate 2

An antique altar surmounted by a flaming urn and with two trophies of musical instruments; on the left a lyre; on the right pipes. In the background is a plinth with a lamp. Lettered with five lines, beginning *Ara Litationis in qua Sacrificium*…and, below, *Altare thymiamatum*.
Cut to 24.5 x 15.1 cm

E.2489-1912

ACQUISITION HISTORIES

The following list gives the acquisition histories of the prints in this catalogue compiled in museum-number order. Much of the V&A's Italian ornament print collection was built up before 1906 primarily by purchase from two dealers, E. Parsons – whose premises were close to the Museum on Brompton Road (see Introduction, note 13) – and Robert Jackson. In the early part of the twentieth century the collection was enlarged by purchases from auctions, a number of them overseas, as well as by gifts and bequests. Acquisitions by all these means continue to the present day.

Information concerning the price paid for the prints is also shown. Where prints were acquired as part of a larger group and no breakdown of price was given, the prices have been omitted.

Where (-) is inserted, the acquisition registers yield no relevant information. P = Purchase; B = Bequest; G = Gift; n/a = not applicable

Museum Numbers	P/B/G	Source	Date of Acquisition	Price
12831	P	J. H. Burn	16.6.1859	-
12886	-	-	-	-
12977	-	-	-	-
13075.1-2	-	-	-	-
13181	-	-	-	-
13222	-	-	-	-
13224.A	-	-	-	-
13249.1-2	-	-	-	-
13633.1-11	-	-	-	-
13640.1-2	-	-	-	-
14070	-	-	-	-
14887		Transfer from Art Museum	-	-
14889		"		
14891		"		-
14986-7	-	-	-	-
15647.A.2 -21	P	Heussner and Lauser	23.7.1875	£3.8.0
16577-82	-	-	-	-
16725-45	P	F. Bonsfield	28.10.1857	-
16747-50	"	"	"	-
16752	"	"	"	-
16754	"	"	"	-
16754.A	"	"	"	-
16770-89	"	"	"	-
16792-96	"	"	"	-
16798-818	"	"	"	-
16837-59	"	"	"	-
17001	"	Evans	18.11.1857	-
17003	"	"	"	-
17202-6	"	Evans	18.12.1857	-
17243-4	"	"	"	-
17267	"	"	"	-
17299-311	"	"	"	-
17313	"	"	"	-
17347-8	"	"	"	-
17428-9	"	"	"	-
19014-34	P	Evans and Son	1858	-
20024	P	H. Fawcett	3.9.1862	-
20024.A	"	"	"	-

Museum Numbers	P/B/G	Source	Date of Acquisition	Price
20302.1-15		Transfer from Art Museum	-	-
20305		"		
20306.1-4		"		
20307.1		"		
20309		"		
20576.1-19	P	E. Parsons	3.12.1872	-
21118	P	Messrs Colnaghi, Scott and Co.	6.7.1865	£3.13.6
21412.1-8	P	Molini & Grecu	15.1.1867	£0.12.0
21642.1-24	P	E. Parsons	17.12.1867	-
22553.1-2	P	Heppisley Sale[1] per C. Obach	28.5.1868	£0.4.0
22571.3	P	'Fourdend' Sale[2] per C. Obach	18.6.1868	-
22701.1-2 22728.1-2	P	Mr J. Smith of Florence, per H. Cole C. B	31.12.1868	-
23178	P	J. H. Parker	22.6.1869	-
24163	G	Sir W. Stirling Maxwell	31.5.1870	n/a
24334.A-B	P	E. Parsons	10.10.1870	-
24486.1-2	P	E. Parsons	15.10.1870	-
24488	"	"	"	-
24496.1-5 24496.7-25	P	E. Parsons	20.6.1870	£0.15.0
24792.1-3	P	E. Parsons Joseph Colbacchini Sale, London, Sotheby, Wilkinson and Hodge, 22 May 1871, lot not specified	22.5.1871	

Museum Numbers	P/B/G	Source	Date of Acquisition	Price
25016.7	P	E. Parsons	10.10.1871	-
25016.9	"	"	"	-
25016.134-6	"	"	"	-
25079	P	E. Parsons	10.10.1871	-
25511.1-24	P	Goupil and Co.	28.6.1872	£2.2.0
25928.C	-	-	-	-
26051-2	P	E. Parsons	26.7.1873	-
26216.5	P	E. Parsons	18.1.1874	-
26446.1-5	P	E. Parsons	22.4.1874	-
26458.1-10	"	"	"	-
26611	P	Heussner and Lauser	30.6.1874	£1.10.0
26773	P	Robert Jackson	9.7.1874	-
26803.1-12	P	E. Parsons	31.7.1874	-
26819	P	Robert Jackson	12.9.1874	-
26925	P	Robert Jackson	19.11.1874	-
27380	P	Heussner and Lauser	22.6.1875	-
27441.A-B	P	Robert Jackson	26.6.1875	-
27470.8	P	Robert Jackson	8.7.1875	-
27723.5	P	E. Parsons	24.3.1876	-
27724.12-13	"	"	"	-
27725.1-2	"	"	"	-
27736.1-8	P	Thos. Toon	5.12.1876	-
27899.1-2	P	Robert Jackson	1.6.1877	-
27964.1-20	P	S. Rendall	12.6.1877	-
27974	"	"	"	-
28193	P	Heussner and Lauser	7.9.1877	-
28263.67-68	P	E. Parsons	5.12.1877	-
28263.72	"	"	"	-
28457	P	C. Riette	14.6.1878	-
28612.A	P	J. C. Robinson	28.4.1879	-
28706	P	F. Boynton	24.5.1879	-
28795.E	P	E. Parsons	11.7.1879	-
28795.J	"	"	"	-
28800.A-E	P	F. Boynton	14.7.1879	-
28860.1	P	Heussner and Lauser	12.12.1879	-
28860.30	"	"	"	-
29291.G-I	-	-	-	-
29456.48	P	E. Parsons	1.2.1883	-
29458.23-24	"	"	"	-
29458.45	"	"	"	-
29459.8	"	"	"	-
29460.10	"	"	"	-
29460.12	"	"	"	-
29463	"	"	"	-
29468.3	"	"	"	-
29470.7-8	-	-	-	-
29522.A.1-15	P	E. Parsons	13.3.1883	-
29755.1-6	P	E. Parsons	14.3.1884	-
29900	P	E. Parsons	26.7.1884	-
29976.5	P	Robert Jackson	29.11.1884	-
30000.C		Found in Department	-	-
E.180-1885	P	E. Parsons	31.1.1885	£1.15.0
E.181-1885	"	"	"	£1.15.0
E.182-1885	"	"	"	£0.7.6
E.222-240-1885	P	E. Parsons	18.2.1885	£4.10.0
E.1527.A.75-82-1885	P	Robert Jackson	10.8.1885	-
E.1527.A.93-94-1885	"	"	"	-
E.1527.A.116-117-1885	"	"	"	-
E.938-1886	P	Robert Jackson	13.4.1886	-
E.46-1888	P	Robert Jackson	23.4.1888	-
E.598-1888	P	E. Parsons	5.6.1888	£1.0.0
E.823-832-1888	P	Robert Jackson	30.6.1888	£1.7.0
E.833A-J-1888	"	"	"	£0.15.0
E.631-1890	P	G. Lauser	9.10.1890	-
E.637-1890	P	G. Lauser	25.10.1890	-
E.57(12,14-17,21)-1896	P	J. Rosenthal	16.3.1896	-
E.1384-1897	P	E. Parsons	28.5.1874[3]	-
E.1389-1897	"	"	"	-
E.1395-1897	"	"	"	-
E.1407-1410-1897	"	"	"	-
E.1982-2114-1899	P	E. Parsons	15.11.1899[4]	£13.13.0
E.3605-1906	P	E. Parsons	23.7.1888	-
E.3624-1906	"	"	"	-
E.3629-1906	"	"	"	-
E.3630-1906	"	"	"	-
E.3672-1906	"	"	"	-
E.3729-1906	P	S. Calvary & Co.	23.10.1877	-
E.3793-1906	P	B. Quaritch	9.6.1885	-
E.3794-1906	"	"	"	-
E.3805-1906	"	"	"	-
E.3847-1906	"	"	"	-
E.2029-1908	P	Mathias & Cie., Paris	19.3.1908	12 Fr.
E.2036-1908	"	"	"	8 Fr.
E.2301-2323-1910	P	M. Rapilly	11.4.1891	75 Fr.
E.4660-1910	B	George Salting	1910	n/a
E.389-1911	P	Obach & Co.	13.4.1911	-
E.463-1911	P	Messrs Amsler & Ruthardt (per R. Gutekunst), Sale at Berlin, 3 May 1911	27.4.1911	52 marks
E.2462-1912	P	Sydney Vacher	18.12.1912	£0.5.0
E.2466-1912	"	"	"	-
E.2489-1912	"	"	"	£1.0.0

Museum Numbers	P/B/G	Source	Date of Acquisition	Price
E.2403-1913 E.2404-1913	P	R. Gutekunst, Sale at Stuttgart, 2–8 May 1913, lot not specified	25.5.1913	-
E.836-1916	G	Miss E. Gurney	25.9.1916	n/a
E.4314-1919	B	Bernard H. Webb	27.6.1919	n/a
E.4316-1919	"	"	"	-
E.2211-2222 -1920	P	Messrs P. & D. Colnaghi & Co.	16.6.1920	10,300 marks
E.2232-1920	"	Purchased at the sale of the Paul Davidsohn Collection at Leipzig, 3–8 May 1920, lots 172 and 811		280 marks
E.1076-1922	P	Mrs Alice C. Leary	20.7.1922	-
E.15-1923	P	Miss A. L. Haslegrave	22.1.1923	£1.0.0
E.1078-1088 -1923	P	Messrs Sotheby Wilkinson & Hodge	7/8.5.1923	£2.2.0
E.1160-1168 -1923	"	Purchased at the sale of the Rosenheim		£1.5.0
E.1237-1241 -1923	"	Collection, 7–8 May 1923, lots 65, 96, 148, 268,		£0.10.0
E.1469-1923	"	321, 357 and not specified		-
E.1511-1923	"			£0.8.0
E.1602-1619 -1923	"			£1.18.0
E.1841-1889 -1923	"			£0.8.0

Museum Numbers	P/B/G	Source	Date of Acquisition	Price
E.1156-1926	P	Francis F. W. Jackman	2.8.1926	£1.10.0
E.820-829 -1927	P	Francis F. W. Jackman	14.5.1927	£6.10.0
E.2529-1929	P	Messrs H. Gilhofer & Rauschburg	6.11.1929	225 Sw. Fr.
E.1127-1930	P	Purchased at the sale of C. G. Boerner at Leipzig, 6–8 May 1930[5] per D. A. Klipstein, lot 766	25.4.1930	34 marks
E.1538-1959	G	Lt-Col R. G. Elwes OBE	14.1.1960	n/a
E.1722-1979	P	Paul Grinke	30.1.1980	
E.473-1991	P	La Sirène, Paris	10.10.1990	
E.474-1991	"	"	"	
E.624-1991	"	"	"	
E.773-1991	"	"	"	
E.774-1991	"	"	"	
DYCE 1059	B	Reverend Alexander	1869	n/a
DYCE 1060	"	Dyce	"	n/a

[1] Not in F. Lugt, *Ventes*.

[2] Not in F. Lugt, *Ventes*.

[3] When acquired, these prints formed part of a 'scrapbook' containing '59 engravings of ornament' (Museum numbers E.1384–1442-1897). They were transferred to the Engravings collection in 1897.

[4] These prints correspond to the Lafrery Volume. They were transferred to the Engravings collection and accessioned on 15 November 1899 (see Introduction).

[5] *Dubletten der Kupferstichsammlung der Eremitage zu Leningrad und Anderer Staatlicher Sammlungen der Sowjet-Union.*

BIBLIOGRAPHY

FREQUENTLY CITED SOURCES

A. = de Jong, M. and de Groot, I., *Ornamentprenten in het Rijksprentenkabinet I, 15de & 16de eeuw*, 's-Gravenhage, 1988

B. = Bartsch, A., *Le Peintre-graveur*, 21 vols, Vienna, 1803–21

Berlin = *Katalog der Ornamentstich-Sammlung der Staatlichen Kunstbibliothek Berlin*, Berlin and Leipzig, 1939

Berliner = Berliner, R. and Egger, G., *Ornamentale Vorlageblätter des 15. bis 19. Jahrhunderts*, 3 vols, Munich, 1981; see also the review by P. Fuhring below

Brown University = *Ornament and Architecture: Renaissance Drawings, Prints and Books*, Exhibition catalogue, Brown University, Bell Gallery, List Art Center, Providence, Rhode Island, 1980

Byrne, J.S., *Renaissance Ornament Prints and Drawings*, Metropolitan Museum of Art, New York, 1981

Collijn, I., *Katalog der Ornamentstichsammlung des Magnus Gabriel de la Gardie in der Kgl. Bibliothek zu Stockholm*, Stockholm, 1933

E. = González de Zárate, J.M., *Real Colección de Estampas de San Lorenzo de El Escorial*, 10 vols, Vitoria-Gastiez, 1992–5

Fuhring, P., 'Ornament Prints' (Review of R. Berliner and G. Egger, *Ornamentale Vorlageblätter des 15. bis 19. Jahrhunderts*) in *Print Quarterly*, vol. IV, no. 2, June 1987, pp.190–4

Fuhring, P., 'Ornament Prints in Amsterdam' (Review of M. de Jong and I. de Groot, *Ornamentprenten in het Rijksprentenkabinet I, 15de & 16de eeuw*) in *Print Quarterly*, vol. VI, no. 3, September 1989, pp.322–34

Guilmard, D., *Les Maîtres ornemanistes*, 2 vols, Paris, 1880–1

Hind, A.M., *Early Italian Engraving*, 7 vols, London, 1938–48

Jean-Richard, P., *Ornemanistes du XVe au XVIIe siècles gravures et dessins:XIVe exposition de la Collection Edmond de Rothschild*, Exhibition catalogue, Musée du Louvre, Paris, 1987

Jessen, P., *Meister des Ornamentstiches, eine Auswahl aus vier Jahrhunderten, vol. 1, Gotik und Renaissance*, Berlin, 1924

Washington 1973 = *Early Italian Engravings from the National Gallery of Art*, Exhibition catalogue, National Gallery of Art, Washington (J.A. Levenson, K. Oberhuber, J.L. Sheehan), 1973

OTHER SOURCES

Aldrovandi, U., *Delle Statue antiche che per tutta Roma in diversi luoghi e case si veggono*, Venice, 1562

Amelung, W., *Die Sculpturen des Vatikanischen Museums*, II, Berlin, 1908

Baker, M. and Richardson, B. (eds), *A Grand Design: The Art of the Victoria and Albert Museum*, Baltimore, 1997

Bellini, P., 'Printmakers and dealers in Italy during the 16th and 17th Centuries' in *Print Collector*, XIII, May–June 1975, pp.17–43

Bellini, P., *L'Opera incisa di Adamo e Diana Scultori*, Vicenza, 1991

Bellini, P., *Dizionario della Stampa D'Arte*, Milan, 1995

Bellocchi, U. and Fava, B., *L'interpretazione grafica dell'Orlando Furioso*, Reggio Emilia, 1961

Berliner, R., *Ornementale Vorlageblätter des 15. bis 18. Jahrhunderts*, Leipzig, 1925–6

Bober, P.P. and Rubinstein, R., *Renaissance Artists and Antique Sculpture: A Handbook of Sources*, London and Oxford, 1986

Bolaffi, G., *Dizionario Enciclopedico Bolaffi dei Pittori e degli incisori Italiani dall'XI al XX secolo*, 11 vols, Turin, 1972–83

Boorsch, S., Lewis, M. and R.E., *The Engravings of Giorgio Ghisi*, Metropolitan Museum of Art, New York, 1985

Briquet, C.M., *Les Filigraines. A facsimile edition with supplementary material contributed by a number of scholars*, A. Stevenson (ed.), Amsterdam, 1968

Brummer, H.H., *The Statue Court in the Vatican Belvedere*, Stockholm, 1970

Bury, M., 'The Taste for Prints in Italy to c. 1600' in *Print Quarterly*, vol. II, no. 1, March 1985, pp.12–26

Byrne, J.S., 'Some attributions undone' in *Master Drawings*, vol. XIII, 1975, pp.240–9

Catalogue Chronologique des Libraires et des Libraires-Imprimeurs de Paris, Amsterdam, B.R. Grüner, 1969

Clifford, T., 'Polidoro and English Design' in *Connoisseur*, vol. 192, August 1976, pp.282–91

Collinson, H.C., *Documenting Design: Works on Paper in the European Collection of the Royal Ontario Museum*, Toronto, 1993

Dacos, N., *La découverte de la Domus Aurea et la formation des grotesques à la Renaissance*, London and Leiden, 1969

DeGrazia Bohlin, D., *Prints and Related Drawings by the Carracci Family: A Catalogue Raisonné*, National Gallery of Art, Washington, 1979

Dinsmoor, W.B., 'The Literary Remains of Sebastiano Serlio' in *Art Bulletin*, XXIV, March 1942, pp.55–91; June 1942, pp.115–54

Donati, L., 'Monogrammisti G.A., G.P.' in *Maso Finiguerra*, vol. V, 1940, pp.167–9

Ehrle, F., *Roma Prima di Sisto V La Pianta di Roma Du Pérac-Lafréry del 1577*, Rome, 1908

Evans, M., 'New Light on the "Sforziada" frontispieces of Giovan Pietro Birago' in *The British Library Journal*, vol. 13, no. 2, 1987, pp.232–47

Evans, M., *The Sforza Hours*, London, 1992

Evans, M. and Brinkmann, B., with a contribution by Hubert Herkommer, *The Sforza Hours* (parallel text in German with the title *Das Studenbuch der Sforza*), Faksimile Verlag, Lucerne, 1995

Ewart Witcombe, C.L.C., 'Cherubino Alberti and the Ownership of Engraved Plates' in *Print Quarterly*, vol. VI, no. 2, June 1989, pp.160–9

Faietti, M. and Scaglietti Kelescian, D., *Amico Aspertini*, Modena, 1995

Ferrara, S. and Bertelà, G.G., *Incisori Bolognesi ed Emiliani del sec XVI*, Bologna, 1975

Fifteenth Report of the Science and Art Department of the Committee of Council on Education, London, 1868

First Report of the Department of Practical Art, London, 1853

Fischer, M., *Kunstbibliothek Berlin, Staatliche Museen Preussischer Kulturbesitz, Katalog de Architektur- und Ornamentstichsammlung, Teil I, Baukunst England*, Berlin, 1977

Fowler, L.H. and Baer E., *The Fowler Architectural Collection of the John Hopkins University*, Baltimore, 1961

Frommel, C.L., *Der Römische Palastbau der Hochrenaissance*, 3 vols, Tübingen, 1973

The French Renaissance in Prints from the Bibliothèque National de France, Exhibition catalogue, Grunwald Centre for the Graphic Arts, University of California, Los Angeles, 1994

Frutaz, A.P., *Il Complesso Monumentale di Sant'Agnese*, Rome, 1992

Fuhring, P., *La Sirène: Ornements Architecture*, Paris, 1990

Fuhring, P., 'Ornement' in *Encyclopaedia Universalis*, Paris, 1995

Fürstenhofe der Renaissance: Giulio Romano und die Klassische Tradition, Vienna, Kunsthistorisches Museum, 1989

García, P.J., 'Las estampas de la biblioteca del Escorial' in *La Ciudad de Dios*, no. 142, 1925, pp.89–100

Giuliano, A., *Museo Nazionale Romano. Le Sculture*, I/2, Rome, 1981

Goddard, H. and Ritchkoff, D.S., *Sets and Series: Prints from the Low Countries*, Exhibition catalogue, Yale University Art Gallery, New Haven, 1984

Goldscheider, L, *Michelangelo Paintings, Sculpture, Architecture*, complete edition, Oxford, 1986

Gombrich, E.H., *The Sense of Order: A Study in the Psychology of Decorative Art*, London, 1984

Gombrich, E.H. *et al.*, *Giulio Romano*, Exhibition catalogue, Mantua Palazzo del Te, Milan, 1989

Grelle Iusco, A., *Indice Delle Stampe De' Rossi; Contributo alla Storia di una Stamperia romana*, Rome, 1996

Griffiths, A., 'Print Collecting in Rome, Paris and London in the Early Eighteenth Century' in *Harvard University Art Museums Bulletin*, vol. II no.3, Spring 1994, pp.37–59

Griffiths, A. and Hartley, C., *Jacques Bellange c. 1575–1616, Printmaker of Lorraine*, Exhibition catalogue, British Museum, London, 1997

H. = Hollstein, F.W.H., *Dutch and Flemish etchings, engravings and woodcuts, ca. 1450–1700*, Amsterdam, 1949–

H. XLVII = Fuhring, P., *Hollstein's Dutch and Flemish Etchings, Engravings and Woodcuts 1450–1700, Volume XLVI, I Vredeman de Vries, Part I, 1555–1571*, Rotterdam, 1997

Hajós, E. M., 'The Concept of an Engraving Collection in the Year 1565: Quicchelberg, *Inscriptiones Vel Tituli Theatri Amplissimi*' in *Art Bulletin*, vol. XL, no. 2, June 1958, pp.151–6

Hartley, C., 'French Watermarks' in *Print Quarterly*, vol. XIII, no. 3, September 1996, pp.312–13

Haskell, F. and Penny, N., *Taste and the Antique: The Lure of Classical Sculpture 1500–1900*, New Haven and London, 1981

Hedicke, R., *Cornelis Floris und die Florisdecoration*, 2 vols, Berlin, 1913

Heikamp, D., *Studien zur Mediceischen Glaskunst: Archivalien, Entwurfszeichnungen, Gläser und Scherben*, Kunsthistoriches Institut, Florence, 1986

Hind, A. M., *Nielli Chiefly Italian of the XV Century, Plates, Sulphur Casts and Prints Preserved in the British Museum*, London, 1936

Hofer, P., 'Illustrated editions of Orlando Furioso' in *Fragonard: Drawings for Ariosto*, New York, 1945, pp.27–40

Holman, B.L., *Disegno: Renaissance Designs for the Decorative Arts*, Cooper Hewitt, National Design Museum, Smithsonian Institution, New York, 1997

Höper, C., 'Vico, Enea' in *The Dictionary of Art*, vol. 32, London, 1997, pp.412–13

Hughes, P., *The Wallace Collection Catalogue of Furniture I*, London, 1996

Hülsen, C., 'Das Speculum Romanae Magnificentiae des Antonio Lafreri' in *Collectanea variae L.S. Olschki*, Munich, 1921

Jervis, S., *The Penguin Dictionary of Design and Designers*, Harmondsworth, 1984

Johnson, A.F., *A Catalogue of Italian Engraved Title-pages in the Sixteenth Century*, Supplement to the Bibliographical Society's Publications, no. 11, Oxford, 1936

Jones, D., *Paul Smith: true Brit*, London, Design Museum, 1995

Kren, T. (ed.), *Renaissance Painting in Manuscripts*, British Library/Getty Museum Exhibition catalogue, New York, 1983

Kristeller, P., 'Fra Antonio da Monza' in *Rassengna D'Arte*, i, 1901, p.161

Kristeller, P., *Die Lombardische Graphik der Renaissance*, Berlin, 1913

Laking, G.F., *A Record of European Armour and Arms through Seven Centuries*, 5 vols, London, 1920–2

Lambert, S., *Drawing Technique and Purpose*, London, 1981

Landau, D. and Parshall, P., *The Renaissance Print 1470–1550*, New Haven and London, 1994

Lang, J. and Middleton, A. (eds), *Radiography of Cultural Material*, Oxford, 1997

Laver, J., *Museum Piece*, London, 1963

Levron, J., *René Boyvin Graveur Angevin du XVIe siècle (avec le catalogue de son oeuvre & la reproduction de 114 estampes)*, Angers, 1941

Lewis, P. and Darley, G., *Dictionary of Ornament*, London, 1986

Limouze, D., 'Aegidius Sadeler, Imperial Printmaker' in *Bulletin of the Philadelphia Museum of Art*, vol. 85, no. 362, Spring 1989, pp.3-24

Loos, A., 'Ornament and Crime', 1908, in *The Architecture of Adolf Loos*, Arts Council Exhibition catalogue, 1985, pp.100–3

Lotz, A., *Bibliographie der Modelbücher: Beschreibendes Verzeichnis der Stick-und Spitzenmusterbücher des 16. und 17 Jahrhunderts*, Stuttgart-London, 1963

Lowry, B., 'Notes on the Speculum Romanae Magnificentiae and Related Publications' in *Art Bulletin*, XXXIV, 1952, pp.46–50

Lugt, F., *Les Marques de collections de dessins et d'estampes*, Amsterdam, 1921; *Supplement*, The Hague, 1956

Lugt, F., *Répetoire des Catalogues de Ventes Publiques*, 4 vols, La Haye and Paris, 1938–87

Lunning, E., 'Characteristics of Italian Paper in the Seventeenth Century' in Reed, S.W. and Wallace, R., *Italian Etchers of the Renaissance and Baroque*, Museum of Fine Arts, Boston, 1989

Maccari, E., *Graffiti e Chiaroscuri esistenti nell'esterno delle case riprodotti in rame per cura di E.M.*, Rome, 1876

McDonald, M.P., 'The Print Collection of Philip II at the

Escorial' in *Print Quarterly*, vol. XV, no. 1, March 1998, pp. 15–35

McGinniss, L.R., *Catalogue of the Earl of Crawford's 'Speculum Romanae Magnificentiae' now in the Avery Architectural Library*, New York, 1976

Marabottini, A., *Polidoro da Caravaggio*, 2 vols, Rome, 1969

Martineau, J. (ed.), *Andrea Mantegna*, Exhibition catalogue, Royal Academy of Arts, London, 1992

Massari, S., *Giulio Bonasone*, 2 vols, Exhibition catalogue, Istituto Nazionale per la Grafica, Rome, 1983

Minutes and Memos of the Committee on Rearrangement, 1908 (Typewritten manuscript in the National Art Library, pressmark VA.1908.0001)

Miller, E., *A Reassembled Volume of Sixteenth-century Italian Ornament Prints Published by Antonio Lafrery* (forthcoming)

Monbeig Goguel, C., *Francesco Salviati (1510–1563) o la Bella Maniera*, Exhibition catalogue, Villa Medici, Rome, 1998

Mortimer, R., *Harvard College Library, Department of Printing and Graphic Arts, Catalogue of Books and Manuscripts: Part II Italian 16th Century Books*, Cambridge, Massachusetts, 1974

Nagler = Nagler, G.K., *Neues allgemeines Künstler-Lexikon*, 22 vols, Munich, 1835–52

Nagler Mon = Nagler, G.K., *Die Monogrammisten*, 5 vols, Munich 1858–79

Norman, D., 'The Digital Recording and Manipulation of Watermarks' in *The V&A Conservation Journal* (forthcoming)

Oberhuber, K., 'Observations on Perino del Vaga as a Draughtsman' in *Master Drawings*, vol. 4, 1966, pp.170–82

Pagani, V., 'Adamo Scultori and Diana Mantovana' (Review of Bellini, 1991) in *Print Quarterly*, vol. IX, no. 1, 1992, pp.72–87

Parshall, P., 'The Print Collection of Ferdinand, Archduke of Tyrol' in *Jahrbuch Der Kunsthistorichen Sammlungen in Wien*, vol. 78, Vienna, 1982, pp.139–84

Parshall, P., 'Art and the Theater of Knowledge: The Origins of Print Collecting in Northern Europe' in *Harvard University Art Museums Bulletin*, vol. II, no. 3, Spring 1994, pp.6–35

Partridge, L., *The Renaissance in Rome 1400–1600*, London, 1996

Pasero, C., 'Giacomo Franco, editore, incisore e calcografo nei secoli XVI e XVII' in *La Bibliofilia*, vol. XXXVII, 1935, pp.332–56

Passavant, J.D., *Le Peintre-graveur*, 6 vols, Leipzig, 1860–4

Pertosa, A., 'Maschere teatrali nelle collezioni romane di antichità' in *Studi Urbinati*, vol. 60, 1987, pp.77–97

Pezzini, G. Bernini, Massari, S. and Prosperi Valenti Rodinò, S., *Raphael Invenit Stampe da Raffaello nelle Collezioni dell' Istituto Nazionale per la Grafica*, Rome, 1985

Pollak, F., *Print Quarterly Index Volumes I–X, 1984–1993*, London, 1995

Pope-Hennessy, J., *Italian Renaissance Sculpture*, London, 1958

Pope-Hennessy, J., *Learning to Look*, London, 1992

Popham, A.E., *Catalogue of the Drawings of Parmigianino*, 3 vols, New Haven and London, 1971

Pouncey, P. and Gere, J.A., *Italian Drawings in the Department of Prints and Drawings in the British Museum: Raphael and his Circle*, 2 vols, London, 1962

Rangström, L., *Riddarlek och Tornerspel* (Tournaments and the

Dream of Chivalry), Livrustkammaren, Stockholm, 1992

Ravelli, L., *Polidoro Caldara da Caravaggio*, Bergamo, 1978

R-D = Robert-Dumesnil, A.P-F., *Le peintre-graveur français*, 11 vols, Paris, 1835–71

Reed, S.W. and Wallace, R., *Italian Etchers of the Renaissance and Baroque*, Exhibition catalogue, Museum of Fine Arts, Boston, 1989

Riggs, T.A., *Hieronymous Cock (1510–1570): Printmaker and Publisher in Antwerp at the Sign of the Four Winds*, Garland Outstanding Dissertations in the Fine Arts, New York, 1977

Roberts, M. T. and Etherington, D., *Bookbinding and the Conservation of Books: A Dictionary of Descriptive Terminology*, Washington, 1982

Robinson, J. C., *Introductory Addresses on the Science and Art Department of the South Kensington Museum, No 5: On the Museum of Art*, London, 1858

Robison, A., *Paper in Prints*, National Gallery of Art, Washington, 1977

Roland, F., 'Un franc-comtois éditeur et marchand d'estampes à Rome au XVIe siècle, Antoine Lafrery (1512–1577)' in *Mémoires de la Société d'Emulation du Doubs*, ser. 5, 7, 1911, pp.320–78 (relies heavily on Ehrle)

Savage, N., Shell, A., Nash, P.W., Beasley, G and Coast, J. M., *British Architectural Library Royal Institute of British Architects Early Printed Books 1478–1840* , vol. 2: E–L, London, 1995

Schab, F.G., 'Bonasone' (Review of S. Massari, *Giulio Bonasone*, Rome, 1983) in *Print Quarterly*, vol. II, no. 1, March 1985, pp.58–62

Scheicher, E., 'Der Spanische Saal von Schloss Ambras' in *Jahrbuch der Kunsthistorischen Sammlungen in Wein*, vol. 71, 1975, pp.39–94

Shoemaker, I. H. and Broun, E., *The Engravings of Marcantonio Raimondi*, Exhibition catalogue, The Spencer Museum of Art, The University of Kansas, Lawrence, 1981

Snodin, M. and Howard, M., *Ornament: A Social History since 1450*, New Haven and London, 1996

Soden Smith, R.H. (obituary of) in *The Academy*, 5 July 1890

Stefani, C., 'Giacomo Franco' in *Print Quarterly*, vol. X, no. 3, September 1993, pp.269–73

TIB = Bartsch, A., *The Illustrated Bartsch*, University Park, Pennsylvania and New York, 1971–

Vasari, G., 'Marc' Antonio Bolognese and Other Engravers of Prints' in *Lives of the Painters, Sculptors and Architects*, translated by G. du C. de Vere, with an introduction by D. Ekserdjian, London, 1996

Victorian Church Art, Exhibition catalogue, Victoria and Albert Museum, London, 1971–2

Wagner, B., 'Zum Problem der "Französischen Groteske" in Vorlagen des 16. Jahrhunderts: Das Groteskenbuch des J.A. Ducerceau' in *Jahrbuch des Kunsthistorichen Institutes der Universität Graz*, 9/10, 1974/5

Ward-Jackson, P., *Some Main Streams and Tributaries in European Ornament from 1500 to 1750*, Victoria and Albert Museum Bulletin Reprints 3, London, 1969, reprinted from the *Victoria and Albert Museum Bulletin*, vol. III, nos 2–4, London, April, July & October 1967, pp.58–71, 90–103, 121–34

Ward-Jackson, P., *Victoria and Albert Museum Catalogues. Italian Drawings, Volume One 14th–16th century,* London, 1979

Warncke, C-P., *Die ornamentale Groteske in Deutschland 1500–1650,* 2 vols, Berlin, 1979

Wells-Cole, A., *Art and Decoration in Elizabethan and Jacobean England: The Influence of Continental Prints, 1558–1625,* New Haven and London, 1997

White, E., *From School of Design to the Department of Practical Art: The First Years of the National Art Library 1837–1853,* Exhibition catalogue, National Art Library, Victoria and Albert Museum, London, 1994

Woodward, D., 'The Evidence of Offsets in Renaissance Italian Maps and Prints' in *Print Quarterly,* vol. VIII, no. 3, September 1991, pp.235–51

Woodward, D., *The Panizzi Lectures 1995: Maps as Prints in the Italian Renaissance,* The British Library, London, 1996

Woodward, D., *Catalogue of Watermarks in Italian Printed Maps ca 1540–1600,* Florence, 1996

Zappella, G., *Il ritratto nel libro italiano del Cinquecento,* Milan, c. 1988

Zerner, H., *The School of Fontainebleau:Etchings and Engravings,* London, 1969

Zerner, H., 'Du mot à l'image: le rôle de la gravure sur cuivre' in J. Guillaume (ed.), *Les Traités D'Architecture de La Renaissance; Actes du Colloque tenu à Tours 1–17 juillet 1981,* Paris, 1988

Zonghi, A., Zonghi, A. and Gasparinetti, A.F., *Zonghi's Watermarks, Monumenta Chartae Papyraceae Historiam Illustrantia,* vol. III, E. J. Labarre (ed.), Hilversum, 1953

Zucker, M.J., *The Illustrated Bartsch 25 (Commentary), Formerly Volume 13 (Part 2), Early Italian Masters,* New York, 1984

Zucker, M.J., 'Nicoletto da Modena's Late Works Reconsidered' in *Print Quarterly,* vol. VIII, no. 1, March 1991, pp.28–36

WATERMARK APPENDIX:
SURVEY OF THE WATERMARKS IN
16TH-CENTURY ITALIAN ORNAMENT PRINTS

'In any work involving watermarks it is necessary to understand that it is the paper mould, not the paper, and certainly not the map or print, that is being identified by the watermark.'[1]

A watermark in a European sheet of paper is created as the result of sewing or soldering a wire shape to the wires of a paper-making mould. When viewed in transmitted light, a sheet of paper formed on such a mould will carry the imprint of the wire shape, since the layer of paper fibres that settles on the shaped wire will be thinner – and will thus allow more light to pass through – than the layer of fibres making up the rest of the sheet.

This survey covers only the impressions described in the catalogue which, when the survey began, were thought to be Italian and to date from the sixteenth century. Reissues, copies and reversed copies, which on the basis of the engraver or publisher were either not sixteenth-century or not Italian, were excluded. This was done to try to focus the study in such as a way as to render the results more useful to others who may wish to take the subject further. The table and the illustrations that follow are a compromise between a full-scale study of watermarks in sixteenth-century ornament prints – a project that would have consumed a disproportionate amount of resources – and making no reference to watermarks whatsoever.

Despite the precaution of limiting this survey to sixteenth-century Italian impressions, it has proved much more difficult to draw meaningful conclusions from the information gathered than was hoped or envisaged at the outset. This in itself is a useful lesson in what can and cannot be achieved by studying watermarks.

It is recognized that 'Watermarks are most helpful to the art historian when they are recorded in large numbers, using an artist or a publisher as a focus.'[2] There is no such focus in this survey. Even after narrowing it to sixteenth-century Italian impressions, a wide range of engravers and publishers fall within its scope. For this reason the evidence gathered does not present a single coherent picture; rather it amounts to a collection of case studies.

The prints were examined in the order in which they occur in the catalogue, that is, all impressions of Cat. 33a, followed by Cat. 33b, Cat. 33c, and so on. The only exception to this were the prints making up the Lafrery Volume, which were examined together.

As each watermark was found and examined, it was compared to the illustrations in the literature listed below and similar watermarks were noted. The anchoring of a watermark to a chain line (one of the more widely spaced vertical wires on a mould used to make a sheet of laid paper) is characteristic of seventeenth-century Italian papers.[3] The placing of the watermark centred on a chain line also proved to be a consistent feature of the sixteenth-century Italian papers examined in this survey. (The alternative is the positioning of the watermark between two chain lines, as seen in seventeenth-century French papers.[4])

Watermarks that were either severely cut by the edge of the sheet or otherwise resisted every attempt at even the most rudimentary identification were omitted from the list, although details of which prints these were are recorded in departmental files. The information gathered was then sorted according to the type of image used to make the watermark: anchor in a circle, crossbow, etc. The names used in the table are modelled on Woodward. The 759 prints examined yielded 132 'readable' individual watermarks. These 132 examples broke down further into thirty-four basic types, with each type corresponding to a motif used to create the watermark (anchor, crossbow, etc.). Some watermark types were found in a single example, the most frequently occurring type being encountered thirty times and the remainder somewhere between these two extremes.

The comparison of actual watermarks on particular sheets with drawn or traced illustrations in watermark reference books is a very inexact science. Not only does the fact that the illustrations are drawn or traced introduce the possibility of human error,[5] but the act of comparison itself depends on the skill and experience of the person making it. As the work progressed over an eighteen-month period we (Elizabeth Miller and Victoria Button) were conscious that we became more adept at locating and, more importantly, recognizing hard-to-discern watermarks. This was partly a matter of being able to mentally fill in the gaps on a specific watermark, on the basis of experience and having seen other similar watermarks.

During the Renaissance and Baroque periods the Italian paper-making industry was so firmly established that there was little, if any, need to import paper.[6] Consequently when comparing the watermarks on actual impressions of sixteenth-century Italian ornament prints against the illustrations in reference books on watermarks, preference was given to two collections of watermarks derived from Italian sources and covering the period up to 1600.

David Woodward's *Catalogue of Watermarks in Italian Printed Maps ca.1540–1600* sets a new standard in reference works on watermarks: 335 watermarks are illustrated in either radiographs or photographs. The value of this work to this survey also rests on Antonio Lafrery being a prominent publisher of both maps and ornament prints.

The next most valuable reference work was that by Zonghi (see *References*). Canon Aurelio Zonghi's researches were based on the holdings of the Municipal Archives at Fabriano, a major centre for Italian paper-making since at least 1280. The usefulness of Zonghi's ordering and dating of a collection of cuttings and tracings from the Fabriano archives relies on the principle that an administrative body would be using locally made paper in large quantities. It was our experience that similar watermarks to the ones we identified in ornament prints could be found in Zonghi in a significant number of cases.

On the same principle as that used for determining the bibliographical references in the catalogue entries, if neither Woodward nor Zonghi produced any suitable comparisons, then these were sought elsewhere.

The presence of both Woodward watermarks, 124 and 125, in the sets, Cat. 5, Cat. 33d and Cat. 55a, suggests that these two watermarks may correspond to a pair of moulds used to make a batch of paper. This paper was then used by Lafrery's printers for printing runs of impressions. Two of the other sets, Cat. 50f and 68b, share a watermark type, but the position of the watermarks make it impossible to verify which, if any, of the three similar watermarks in Woodward they correspond to.

From the radiograph it can be determined that the Anchor in a Circle watermark present in the Lafrery Volume, Cat. 62b pl. 3, is similar to – but, from the measurements, not the same as – Woodward 172.

In Lafrery's stocklist the vases, Cat. 68b, and the candlesticks, Cat. 62b, together form one set so that the fact that they are not on paper with the same watermark is noteworthy. The watermark present in the impressions of Cat. 62b in the Lafrery Volume (impressions that are noticeably more worn than everything else in the volume) is closest in appearance to an illustration in Piccard. The example in Piccard is associated with a date after Antonio Lafrery's lifetime. If this dating is correct, then this argues against these impressions having been pulled in Lafrery's lifetime (as is suggested in the catalogue entry) and in favour of an alternative explanation that these impressions are later replacements for other impressions of the same or other candlesticks, which were once part of the volume.

The information in the table that follows needs to be approached with extreme caution. This applies particularly to the information in the final date column. As Woodward explains, 'The dates for the maps in this catalogue are the dates engraved on the plates from which the maps were printed. They are not the dates of the impressions. Thus a map from a plate dated 1546, for example, might be printed on paper many years later. These printed dates, therefore, represent a *terminus a quo* for each paper mould, but not a *terminus ad quem*.'[14]

For this reason, the results of the watermark survey have not been used in arriving at the dating given in the catalogue entries. To do so in a catalogue full of reissues by later publishers of earlier plates would have threatened to engulf the reader in a bewildering mass of conflicting evidence.

Sometimes the date associated with a watermark does coincide with the dating of the ornament print on paper with a similar watermark. Such is the case for Cat. 25. In other instances, such as Cat. 57, the watermark reveals the printing of sixteenth-century plates on a seventeenth-century paper.

In the table, more than one museum number linked to a single watermark (as in the first example) indicates a sheet with one watermark but bearing the impression of more than one copper plate. The entries in the table are laid out in the same order as the catalogue to facilitate checking, if a particular catalogue number is found on a watermarked paper.

An asterisk in the column headed 'Illustrated' indicates that an image of this particular watermark is provided. The captions to the illustrations give both the catalogue entry and the museum number,

in order to differentiate between multiple impressions of the same catalogue entry.

References

B = C. M. Briquet, *Les Filigraines: A facsimile edition with supplementary material contributed by a number of scholars*, A. Stevenson (ed.), Amsterdam, 1968

H = E. Heawood, *Watermarks Mainly of the 17th and 18th Centuries*, Hilversum, 1950

P = G. Piccard, *Wasserzeichen Anker*, Stuttgart, 1978

W = D. Woodward, *Catalogue of Watermarks in Italian Printed Maps ca. 1540–1600*, Florence, 1996

Z = A. Zonghi, A. Zonghi and A.F. Gasparinetti, *Zonghi's Watermarks Monumenta Chartae Papyraceae Historiam Illustrantia* , vol. III, E.J. Labarre (ed.), Hilversum, 1953

Catalogue No.	Museum No.	Illustrated	similar watermarks	date span of similar watermarks
Frames and Cartouches				
Cat. 5 pl. 1 & 2	E.2026–2027-1899	*	W 125	1557–65
[tulips in shield under six-pointed star]			Z 1763	1570
			Z 1765	1572
Cat. 5 pl. 7 & 8	E.2032–2033-1899	*	W 124	1542–70
[tulips in shield under six-pointed star]			Z 1763	1570
			Z 1765	1572
Cat. 5 pl. 9 & 10	E.2034–2035-1899		W 125	1557–65
[tulips in shield under six-pointed star]			Z 1763	1570
			Z 1765	1572
Cat. 5 pl. 13	E.2038-1899		W 125	1557–65
[tulips in shield under six-pointed star]			Z 1763	1570
			Z 1765	1572
Cat. 6 pl. 1	21412.1	*	W 178	1580–94
[anchor with single-lined arms, shank in circle, lozenge trefoil]			B 567	1588
Cat. 6 pl. 1	21412.2	*	W 178	1580–94
[anchor with single-lined arms, shank in circle, lozenge trefoil]			B 567	1588
Cat. 6 pl. 2	21412.3	*	W 178	1580–94
[anchor with single-lined arms, shank in circle, lozenge trefoil]			B 567	1588
Cat. 6 pl. 2	21412.7	*	W 178	1580–94
[anchor with single-lined arms, shank in circle, lozenge trefoil]			B 567	1588
Cat. 7 pl. 1	E.820-1927	*	W.225	1577
[shield with unicorn]				

Catalogue No.	Museum No.	Illustrated	similar watermarks	date span of similar watermarks
Cat. 7 pl. 1	E.826-1927	*	W.107	1565
[fleur-de-lis in circle under six-pointed star]				
Friezes				
Cat. 9b pl. II	E.2099–2100-1899		W 125	1557–65
upper and lower			Z 1763	1570
[tulips in shield under six-pointed star]			Z 1765	1572
Cat. 9b pl. III	E.2101–2102-1899		W 125	1557–65
upper and lower			Z 1763	1570
[tulips in shield under six-pointed star]			Z 1765	1572
Cat. 11	E.1469-1923		W 158	1561–66
[anchor in double outline with star]			W 159	1564–66
			Z 1598	1549
Cat. 17	13249.1-2		W 274	1561
[crown with five points under a star with six points]			Z 284	1566
			Z 1604	1568
Grotesques				
Cat. 21	E.463-1911		Z 1622	1567
[anchor in circle]			B 471	1527
Cat. 25 pl. 1	19026	*	B 3320	1526
[stag]				
Cat. 25 pl. 2	19027	*	B 3320	1526
[stag]				
Cat. 25 pl. 4	19028	*	B 3320	1526
[stag]				
Cat. 25 pl. 5	19029	*	B 3320	1526
[stag]				
Cat. 25 pl. 6	20307.1	*	B 3320	1526
[stag]				
Cat. 29b pl. 11	26446.2		W 158	1561–66
[anchor in double outline with star]				1566
			W 159	1564–66
			Z 1598	1549
			Z 1604	1568
Cat. 29c pl. 1	16725	*		[See illustration]
[cross]				
Cat. 29c pl. 3	16788		[See illustration of Cat. 29c pl. 1]	
[cross]				
Cat. 33a	20306.3	*	W 203–13	1540–56
[crossbow in circle]			Z 523	1504
			Z 524	1560
			Z 525	1578

Catalogue No.	Museum No.	Illustrated	similar watermarks	date span of similar watermarks
Cat. 33b pl. 3	20306.4		W 216	1542–54
[crossbow in circle under fleur-de-lis]			Z 526-533	1526–39
			B 761	1533
Cat. 33b pl. 15(L)	E.233-1885		Z 1682	1573
[paschal lamb in double circle with crown above]			B 59	1548
Cat. 33c pl. 4	E.230-1885	*	Z 1688	1520
[kneeling man holding cross in circle]				
Cat. 33c pl. 4	16778		Z 1688	1520
[kneeling man holding cross in circle]				
Cat. 33c pl. 5	29755.1		W 256	1558–70
[ladder in shield under cross pommy]				
Cat. 33c pl. 5	E.237-1885	*	Z 1688	1520
[kneeling man holding cross in circle]				
Cat. 33c pl. 6	E.223-1885		Z 1688	1520
[kneeling man holding cross in circle]				
Cat. 33c pl. 6	16772		Z 1688	1520
[kneeling man holding cross in circle]				
Cat. 33c pl. 7	16775		Z 1688	1520
[kneeling man holding cross in circle]				
Cat. 33c pl. 7	E.240-1885		Z 1688	1520
[kneeling man holding cross in circle]				
Cat. 33c pl. 7	29755.3		W 238–41	1548–61
[ladder in a circle with six-pointed star]			Z 1556	1538
			Z 1557	1549
Cat. 33c pl. 9	29755.6		W 238–41	1548–61
[ladder in a circle with six-pointed star]			Z 1556	1538
			Z 1557	1549
Cat. 33c pl. 10	16787	*	Z 1688	1520
[kneeling man holding cross in circle]				
Cat. 33c pl. 11	16774	*	Z 1688	1520
[kneeling man holding cross in circle]				
Cat. 33c pl. 12	E.235-1885		Z 1688	1520
[kneeling man holding cross in circle]				
Cat. 33c pl. 12	16776		Z 1688	1520
[kneeling man holding cross in circle]				
Cat. 33c pl. 13	E.238-1885		Z 1688	1520
[kneeling man holding cross in circle]				

Catalogue No.	Museum No.	Illustrated	similar watermarks	date span of similar watermarks
Cat. 33d pl. 2	E.2063-1899		W 124	1542–70
[tulips in shield under six-pointed star]			Z 1763	1570
			Z 1765	1572
Cat. 33d pl. 5	E.2066-1899		W 124	1542–70
[tulips in shield under six-pointed star]			Z 1763	1570
			Z 1765	1572
Cat. 33d pl. 6	E.2067-1899		W 125	1557–65
[tulips in shield under six-pointed star]			Z 1763	1570
			Z 1765	1572
Cat. 33d pl. 8	E.2069-1899		W 124	1542–70
[tulips in shield under six-pointed star]			Z 1763	1570
			Z 1765	1572
Cat. 33d pl. 12	E.2073-1899		W 125	1557–65
[tulips in shield under six-pointed star]			Z 1763	1570
			Z 1765	1572
Cat. 33d pl. 13	E.2074-1899		W 125	1557–65
[tulips in shield under six-pointed star]			Z 1763	1570
			Z 1765	1572
Cat. 33d pl. 14 left and right	E.2075-1899		W 125	1557–65
			Z 1763	1570
[tulips in shield under six-pointed star]			Z 1765	1572
Cat. 33d pl. 15 left and right	E.2076-1899		W 124	1542–70
			Z 1763	1570
[tulips in shield under six-pointed star]			Z 1765	1572
Cat 33d pl. 16 left and right	E.2077-1899		W 124	1542–70
			Z 1763	1570
[tulips in shield under six-pointed star]			Z 1765	1572
Cat. 33e pl. 11	29755.5			
[letters AI in circle]				

Herms

Catalogue No.	Museum No.	Illustrated	similar watermarks	date span of similar watermarks
Cat. 35 pl. 1	22553.2		P, IV 53	1529
[anchor in circle]			P, IV 60	1514

Masks

Catalogue No.	Museum No.	Illustrated	similar watermarks	date span of similar watermarks
Cat. 39 pl. 1–4	E.2039–2042-1899	*	W 125	1557–65
[tulips in shield under six-pointed star]			Z 1763	1570
			Z 1765	1572
Cat. 39 pl. 9–12	E.2047–2050-1899		W 125	1557–65
[tulips in shield under six-pointed star]			Z 1763	1570
			Z 1765	1572
Cat. 39 pl. 13–16	E.2051–2054-1899		W 125	1557–65
[tulips in shield under six-pointed star]			Z 1763	1570
			Z 1765	1572

Catalogue No.	Museum No.	Illustrated	similar watermarks	date span of similar watermarks
Cat. 39 pl. 17–20	E.2055–2058-1899		W 125	1557–65
[tulips in shield under six-pointed star]			Z 1763	1570
			Z 1765	1572

Trophies

Catalogue No.	Museum No.	Illustrated	similar watermarks	date span of similar watermarks
Cat. 50e pl. 12	17311		W 238–41	1548–61
[ladder in circle with six-pointed star]			Z 1556	1538
			Z 1557	1549
Cat. 50f pl. 2	16810		W 289–296	1544–70
[lozenge containing six-pointed star in circle]			Z 1726–1732	1559–74
			B 6097	1566–7
Cat. 50f pl. 3 1580–90	17301		W 115–118	
			Z 592	1588
[fleur-de-lis in shield with six-pointed star]			Z 593	1588
Cat. 50f pl. 4	20302.4	*	W 199	1549
[arrows crossed under star]			Z 1248–9	1576
Cat. 50f pl. 4	E.2081-1899		W 28–30	1557–70
[man's head with headband]				
Cat. 50f pl. 5	20302.5	*	W 199	1549
[arrows crossed under star]			Z 1248–9	1576
Cat. 50f pl. 5	19023		W 289–96	1544–70
[lozenge containing six-pointed star in circle]			Z 1726–32	1559–74
			B 6097	1566–7
Cat. 50f pl. 6	20302.6	*	W 199	1549
[arrows crossed under star]			Z 1248–9	1576
Cat. 50f pl. 6	19021		W 289–96	1544–70
[lozenge containing six-pointed star in circle]			Z 1726–32	1559–74
			B 6097	1566–7
Cat. 50f pl. 7	E.2084-1899		W 28–30	1557–70
[man's head with headband]				
Cat. 50f pl. 9	16812		W 289–96	1544–70
[lozenge containing six-pointed star in circle]			Z 1726–32	1559–74
			B 6097	1566–7
Cat. 50f pl. 10	20302.10	*	W 199	1549
[arrows crossed under star]			Z 1248–9	1576
Cat. 50f pl. 11	20302.11	*	W 199	1549
[arrows crossed under star]			Z 1248–9	1576
Cat. 50f pl. 14	16814		W 289–96	1544–70
[lozenge containing six-pointed star in circle]			Z 1726–32	1559–74
			B 6097	1566–7

Catalogue No.	Museum No.	Illustrated	similar watermarks	date span of similar watermarks
Cat. 50f pl. 14 [arrows crossed under star]	20302.14	*	W 199 Z 1248–9	1549 1576
Cat. 50f pl. 14 [man's head with headband]	E.2091-1899		W 28–30	1557–70
Cat. 50f pl. 16 [lozenge containing six-pointed star in circle]	16816		W 289–96 Z 1726–32 B 6097	1544–70 1559–74 1566–7
Cat. 50f pl. 16 [arrows crossed under star]	20302.15	*	W 199 Z 1248–9	1549 1576
Cat. 50g pl. 1 [eagle displayed in circle under crown]	17308		W 59 W 75 Z 725	1602? 1602 1543
Cat. 50g pl. 2 [shield with mounts and F]	29522.A.13		B 11938	1582
Cat. 50g pl. 3 [shield with mounts and F]	25016.134	*	B 11938	1582
Cat. 50g pl. 4 [shield with mounts and F]	25016.135	*	B 11938	1582
Cat. 50g pl. 6 [shield with mounts and F]	29522.A.15		B 11938	1582
Cat. 50g pl. 8 [shield with mounts and F]	29522.A.10		B 11938	1582
Cat. 50g pl. 10 [shield with mounts and F]	29522.A.6		B 11938	1582
Cat. 50g pl. 14 [crown in a circle]	29522.A.11			
Cat. 51g pl. 2 [tulips in shield under six-pointed star]	24486.2		W 124 Z 1763 Z 1765	1542–70 1570 1572

Architectural Details

Catalogue No.	Museum No.	Illustrated	similar watermarks	date span of similar watermarks
Cat. 52 pl. 2 & 10 [king's head]	26458.1 26458.2	*		
Cat. 52 pl. 3 & 11 [king's head]	26458.5 26458.6	*		
Cat. 52 pl. 9 & 13 [king's head]	26458.9 26458.10	*		
Cat. 55a pl. 5 & 6 [tulips in shield under six-pointed star]	E.1986–1987-1899		W 124 Z 1763 Z 1765	1542–70 1570 1572
Cat. 55a pl. 9 & 10 [tulips in shield under six-pointed star]	E.1990–1991-1899		W 124 Z 1763 Z 1765	1542–70 1570 1572
Cat. 55a pl. 11 & 12 [tulips in shield under six-pointed star]	E.1992–1993-1899		W 124 Z 1763 Z 1765	1542–70 1570 1572
Cat. 55a pl. 15 & 16 [tulips in shield under six-pointed star]	E.1996–1997-1899		W 124-5 Z 1763 Z 1765	1542–70 1570 1572
Cat. 55a pl. 17 & 18 [tulips in shield under six-pointed star]	E.1998–1999-1899		W 124/125 Z 1763 Z 1765	1542–70 1570 1572
Cat. 55a pl. 19 & 20 [tulips in shield under six-pointed star]	E.2000–2001-1899		W 125 Z 1763 Z 1765	1557–65 1570 1572
Cat. 55a pl. 21 & 22 [tulips in shield under six-pointed star]	E.2002–2003-1899		W 125 Z 1763 Z 1765	1557–65 1570 1572
Cat. 55a pl. 23 & 24 [tulips in shield under six-pointed star]	E.2004–2005-1899		W 125 Z 1763 Z 1765	1557–65 1570 1572
Cat. 55a pl. 27 & 28 [tulips in shield under six-pointed star]	E.2008–2009-1899		W 125 Z 1763 Z 1765	1557–65 1570 1572
Cat. 55a pl. 29 & 30 [tulips in shield under six-pointed star]	E.2010–2011-1899		W 125 Z 1763 Z 1765	1557–65 1570 1572
Cat. 56 pl. 4 & 5 [letter M under star in shield]	25511.4 25511.5		W 324 Z 1778–1842	1569 1573–97
Cat. 56 pl. 6 & 7 [letter M under star in shield]	25511.6 25511.7		W 329 Z 1778–1842	1570 1573–97
Cat. 56 pl. 10 & 11 [letter M under star in shield]	25511.10 25511.11		W 324 Z 1778–1842	1569 1573–97
Cat. 56 pl. 12 & 13 [letter M under star in shield]	25511.12 25511.13		W 327 Z 1778–1842	1585 1573–97
Cat. 56 pl. 16 & 17 [letter M under star in shield]	25511.16 25511.17		W 331 Z 1778–1842	1580 1573–97

Catalogue No.	Museum No.	Illustrated	similar watermarks	date span of similar watermarks
Arms and Armour				
Cat. 57 pl. 8	26803.8		H 2838	1647–74
[paschal lamb in double circle with A above and N below]				
Cat. 57 pl. 9	26803.9		H 2838	1647–74
[paschal lamb in double circle with A above and N below]				
Cat. 57 pl. 11	26803.11		H 2838	1647–74
[paschal lamb in double circle with A above and N below]				
Goldsmiths' Work other than Vases and Ewers				
Cat. 61e	12977	*	W 238–41	1548–61
[ladder in circle with six-pointed star]			Z 1556	1538
			Z 1557	1549
Cat. 62a pl. 2	19016	*	W 216	1542–54
[crossbow in circle under fleur-de-lis]			Z 526–33	1526–49
			B 761	1533
Cat. 62a pl. 3	14987			
[fleur-de-lis in circle under crown]				
Cat. 62a pl. 4	19018	*	W 203–13	1540–66
[crossbow in circle]			Z 523	1504
			Z 524	1560
			Z 525	1578
Cat. 62b pl. 3	E.2096-1899	*	P, V 351	1593–4
[anchor in double outline with star]				
Vases and Ewers				
Cat. 66a pl. 3	16839			
[kneeling man holding cross in circle]				
Cat. 66a pl. 7	16841			
[kneeling man holding cross in circle]				
Cat. 66a pl. 10	16844	*		
[kneeling man holding cross in circle]				
Cat. 66a pl. 12	16846		Z 1688	1520
[kneeling man holding cross in circle]				
Cat. 66b pl. 3	29456.48		P, V 12	1559
[anchor in circle with cross]			P, V 13	1587
			P, V 14	1587
			B 536	1560
			B 538	1590
Cat. 66b pl. 10	29470.7	*	P, V 12	1559
[anchor in circle with cross]			P, V 13	1587
			P, V 14	1587
			B 536	1560
			B 538	1590

Catalogue No.	Museum No.	Illustrated	similar watermarks	date span of similar watermarks
Cat. 67a pl. 2	28612.A		W 164	1562
[anchor in double outline with star]			W 173	1545
Cat. 67a pl. 4	14889		W 193	1563–8
[arrows crossed under star]			W 196	1566
			W 200	1575
			Z 1226	1542
			Z 1227	1542
			B 6299	1554
			B 6298	1543–8
			B 6300	1551–6
Cat. 67b pl. 8	13222	*	W 104	nd
[fleur-de-lis in circle under crown]				
Cat. 68a pl. II	16847		W 219	nd
[crossbow in circle with loaded arrow]			W 220	1542
			Z 534	1559
			Z 535	1559
Cat. 68a pl. VIII	16850		W 219	nd
[crossbow in circle with loaded arrow]			W 220	1542
			Z 534	1559
			Z 535	1559
Cat. 68a pl. XI	16853		W 219	nd
[crossbow in circle with loaded arrow]			W 220	1542
			Z 534	1559
			Z 535	1559
Cat. 68a pl. XIII	16857		W 219	nd
[crossbow in circle with loaded arrow]			W 220	1542
			Z 534	1559
			Z 535	1559
Cat. 68b pl. III	E.2014-1899		W 28-30	1557–70
[man's head with headband]				
Cat. 68b pl. VIII	E.2019-1899		W 28–30	1557–70
[man's head with headband]				
Cat. 68b pl. XI	25928.C			
[three mountains in a circle]				
Cat. 68b pl. XII	E.2023-1899		W 28–30	1557–70
[man's head with headband]				
Cat. 69b pl. 5	27736.3		W 25	1618
[kneeling man holding a small cross in narrow shield]				
Cat. 69b pl. 8	27736.6		W 25	1618
[kneeling man holding a small cross in narrow shield]				
Cat. 69b pl. 9	27736.7		W 26	nd
[kneeling man holding cross in shield]				

Catalogue No.	Museum No.	Illustrated	similar watermarks	date span of similar watermarks	Catalogue No.	Museum No.	Illustrated	similar watermarks	date span of similar watermarks
Cat. 69b pl. 10	E.833.J-1888	*	W25	1618	Cat. 71 pl. ?	E.2489-1912			
[Kneeling man holding cross in shield]			W26	nd	[horn hanging from 2 letters S, below 3 fleurs-de-lis, and letters IWB below]				
Miscellaneous									
Cat. 71 pl. 1	16798		B 8071	1577					
[letter B in a shield]									

[1] Woodward, 1996, p.8.

[2] Lunning, p.xxxii.

[3] Lunning, p.xxxiii.

[4] Lunning, p.xxxiii.

[5] As Woodward 1996, p.7 puts it, 'Despite the obvious care in copying, the subtleties of watermark images are usually such that it is usually impossible to know whether differences in the watermarks are due to different paper moulds or small irregularities of tracing.' See also Hartley 1996, and Griffiths and Hartley 1997, pp.125–7.

[6] See Lunning, p.xxxiii.

[7] These radiographs were kindly taken by Janet Lang of the Department of Scientific Research at the British Museum. I should like to thank her and Dr Sheridan Bowman, Keeper of the Department of Scientific Research, for their help with this project. Janet Lang and Andrew Middleton (eds), *Radiography of Cultural Material*, Oxford, 1997, provide a very valuable introduction to the uses of radiography in a museum context, as well as having chapters devoted to 'X Rays and paper' by Vincent Daniels and Janet Lang, and 'An introduction to digital image processing' by Tony Higgins.

[8] Prints were scanned at 350 dpi (Greyscale) using transmitted light on a flatbed scanner (HP SCANJET 3C/T) The images were then manipulated using a Power Macintosh computer and Adobe Photoshop 3.0 Software. Within Photoshop, a dodge tool was used to enhance the watermark. The tool was used to select only the lightest pixels visible within the image corresponding to the watermark. Because of the nature of a watermark (being the thinnest part of the paper and visible when viewed in a strong light source), this could be used to bring out the details of the shape of the watermark. The image of the watermark is worked over using a very subtle setting on the tool. After repeated passes with the tool, the image slowly reveals itself. For further details see D. Norman.

[9] Unsuitability resulted either from prints being bound in a volume, having a sheet size larger than the size of the scanner or having backing sheets that it was not practicable or desirable to remove.

[10] Failures were due to factors such as the thickness of the paper and the position of the watermark in relation to the densest parts of the printed image.

[11] The similarities between the fibrousness and texture of these papers, possibly derived from a common batch of paper pulp, provides additional evidence of a link between these five sheets.

[12] Using Photoshop 3 software, points were plotted over the watermarks that needed to be compared. The points were approximately the same thickness as the lines of the watermark and were only plotted over parts of the watermark that were clearly visible. Once this was done, the set of points could be lifted off the watermark being plotted and laid over the top of another. Because the points were independent from the watermark they could easily be moved and rotated, as a set, over the comparative watermark image, giving an accurate way of matching them.

[13] Woodward, 1996, p.9.

[14] Woodward, 1996, p.9.

Cat. 5 pl. 1 & 2 E.2026-2027-1899

Cat. 5 pl. 7 & 8 E.2032-2033-1899

Cat. 6 pl. 1 21412.1

Cat. 6 pl. 1 21412.2

Cat. 6 pl. 2 21412.3

Cat. 6 pl. 2 21412.7

Cat. 7 pl. 1 E.820-1927

Cat. 7 pl. 1 E.826-1927

Cat. 25 pl. 1 19026

Cat. 25 pl. 2 19027

Cat. 25 pl. 4 19028

Cat. 25 pl. 5 19029

Cat. 25 pl. 6 20307.1

Cat. 29c pl. 1 16725

Cat. 33a 20306.3

Cat. 33c pl. 4 E.230-1885

Cat. 33c pl. 5 E.237-1885

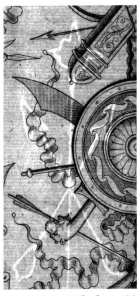

Cat. 50f pl. 4 20302.4

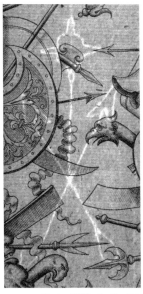

Cat. 50f pl. 5 20302.5

Cat. 50f pl. 6 20302.6

Cat. 50f pl. 10 20302.10

Cat. 50f pl. 11 20302.11

Cat. 50f pl. 14 20302.14

Cat. 50f pl. 16 20302.15

Cat. 50g pl. 3 25016.134

Cat. 50g pl. 4 25016.135

Cat. 52 pl. 2 & 10 26458.1

Cat. 52 pl. 3 & 11 26458.5

Cat. 52 pl. 9 & 13 26458.9

Cat. 61e 12977

Cat. 62a pl. 2 19016

Cat. 62a pl. 4 19018

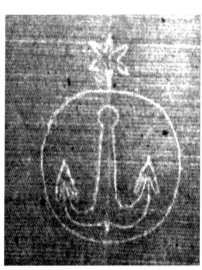

Cat. 62b pl. 3 E.2096-1899

Cat. 66a pl. 10 16844

Cat. 66b pl. 10 29470.7

Cat. 67b pl. 8 132220

Cat. 69b pl. 10 E.833.J-1888

INDEX OF NAMES